The Quiet Evolution

Library of Congress Cataloging-in-Publication Data

Wilson, Brent.
The quiet evolution : changing the face of
arts education / Brent Wilson.
p. cm.
Includes bibliographical references and index.
ISBN 0-89236-409-2
1. Art—Study and teaching—United States. I. Title.
N108.W55 1997 707'.073—dc21 CIP 97-8882

The Getty Education Institute for the Arts
1200 Getty Center Drive, Suite 600
Los Angeles, California 90049-1683

Printed in the United States of America.

The Quiet Evolution
Changing the Face of Arts Education

Brent Wilson

Professor and Head of Art Education
Pennsylvania State University

THE GETTY EDUCATION INSTITUTE FOR THE ARTS

LOS ANGELES

Contents

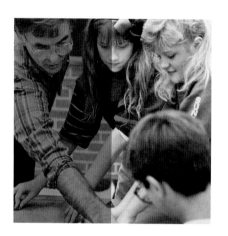

The Quiet Evolution

Changing the Face of Arts Education

Executive Summary

THE GETTY EDUCATION INSTITUTE FOR THE ARTS

LOS ANGELES

The Quiet Evolution: *Changing the Face of Arts Education*

A quiet evolution is taking place in arts education in thousands of elementary and secondary classrooms throughout the nation. The success of this far-reaching experiment holds real promise for advancing other school reform initiatives.

Known as discipline-based art education (DBAE), this comprehensive approach to improving arts education has become the cornerstone of efforts by the Getty Education Institute for the Arts (formerly known as the Getty Center for Education in the Arts), a program of the J. Paul Getty Trust, to transform the way students create and understand art.

The Getty Education Institute believes that art is an essential part of every child's education, speaking to students in a language that communicates ideas, reveals symbols, forges connections, and helps prepare them for life. DBAE builds on the premise that art can be taught most effectively by integrating content from four basic disciplines—art making, art history, art criticism, and aesthetics (the philosophy of art)—into a holistic learning experience.

This broad platform for the study of art promotes creativity and demands critical inquiry. It offers opportunities for relating art to other school subjects as well as to the wide range of personal interests and abilities of young learners. In laying the groundwork for this change in arts education more than a decade ago, the Getty Education Institute envisioned a sweeping transformation in theory and practice that asked educators to alter traditional ideas, learn to regard art in unfamiliar ways, and introduce new art programs in their classrooms.

The Getty Education Institute guided development of a model and then funded six regional consortia to create change communities and spearhead DBAE development and implementation in school districts. In less than ten years, these regional consortia have far exceeded expectations, becoming national resources for arts education reform.

The consortia have nurtured a new generation of DBAE educators who carried its principles forward as they reshaped its practices. As of 1996, they had served thousands of teachers and administrators from some 217 school districts in thirteen states who, in turn, serve more than 1.5 million students. They had attracted international attention and secured close to $15 million to match grants from the Getty Education Institute.

As an integral part of the initiative, the Getty Education Institute provided for an independent professional evaluation of the DBAE experiment. The results of the first seven years of that evaluation (1988–95) are the subject of this report—the first such analysis of the regional consortia for public review.

The results point to many successes. While challenges persist—particularly in changing deeply rooted education practices, developing sequential curricula, and assessing student progress—the regional institute experiment on the whole provides keys to educational improvement for all students.

MAJOR DBAE ACHIEVEMENTS The DBAE tapestry is still being woven, yet remarkable changes have already occurred.

The overarching outcome of the Getty Education Institute's ambitious regional consortium undertaking is that elementary, middle, and high school pupils receive an education in which works of art are permitted to make their unique contributions to students' knowledge of themselves and their place in the community and global society.

Evaluators found that schools that once had weak visual arts programs have since developed strong ones. In other schools, visual arts programs have moved from their customary place at the margins of the school curriculum to its core. Art teachers who were accustomed to working by themselves are now working as key members of school planning teams intent on broadening school instructional programs. And principals are using the DBAE initiative to reorganize entire elementary school curricula.

Art teachers, classroom teachers, and school administrators have become colleagues with art museum educators, artists, art critics, and university professors. Together they have planned programs that have symbolically removed classroom walls, virtually bringing the art world into classrooms. At the same time, students have gone into the art world to receive an authentic education in the arts.

Moreover, art teachers have joined in creating model units of instruction, tried innovative assessment processes, and in countless other ways shared the results of their curriculum and instructional experimentation.

The following summary explores how the quiet evolution of DBAE began and progressed, what obstacles arose, and what insights emerged. The report itself presents a detailed analysis of the initiative and a series of vignettes and case studies that elaborate on the findings.

THE ROLE OF DBAE IN REFORMING EDUCATION **The knowledge gained through the DBAE experiment has the potential to strengthen other school change initiatives and advance the goals of educational reform. If, for instance, professional development initiatives in other subjects were as whole, authentic, and effective as those seen in DBAE programs, evaluators believe the quality of education would improve immensely.**

They point to ten key findings in their assessment that have particular relevance to educational reform in general:

- **Change initiatives succeed when change is systemic—specifically, when school district leaders steer the initiative, change communities share ownership, and multiple reform efforts reinforce and enhance one another.**
- **Professional development as well as curriculum and instructional planning must be pursued simultaneously.**
- **Change occurs because of a continuous process of evaluation and with sufficient time for evaluation to guide refinement of professional development programs, instructional development, and implementation.**
- **Ongoing communication and collaboration within and among change communities lead to further improvements.**
- **Effective programs emerge from collaboration between teachers and experts in particular subject areas.**
- **The teaching of school subjects is enriched when museums and other community institutions provide content for instruction and settings for immersion in their respective worlds.**
- **Skills—even those of the highest order relating to critical thinking and creative invention—are not ends in themselves. They are the means for understanding human purpose and creating new visions of it.**

- The most important learning takes place when several school subjects are taught simultaneously within the context of the large themes that illuminate conceptions of human purpose and well-being.
- The content, organization of instruction, and inquiry processes associated with DBAE provide exemplary models for instruction and assessment in other school subjects.
- Ongoing assistance in the form of professional development institutes and workshops, expert consultants, opportunities for professional renewal, and other programs tailored to school and district needs are essential.

CREATING EDUCATIONAL CHANGE COMMUNITIES: THE REGIONAL INSTITUTES

Earlier programs designed to reshape arts education convinced the Getty Education Institute for the Arts that successful implementation of a comprehensive approach to art in classrooms would depend on grassroots initiatives led by consortia of school districts, universities, museums, and other arts and education organizations.

The Getty Education Institute established its Regional Institute Grant (RIG) program in 1987 to support the development and operation of the regional consortia. Through a rigorous review process, six of fifty-two applying consortia were selected to receive matching grants as regional institutes. The Getty Education Institute made a commitment to provide national leadership and long-term financial support to the six RIGs. Such extended, consistent support, the evaluators determined, ensures sufficient opportunity to progress from one phase of an initiative to another, resulting in more lasting educational change.

The six RIGs were expected to serve as research and development centers and to prepare a critical mass of school districts to implement DBAE districtwide over a five-year period. As research and development centers, the regional institutes were given the latitude to create innovative and effective professional development programs; provide technical assistance, instructional materials, experts, and other resources to schools; attract and mobilize school districts as partners and prepare them in DBAE; and forge strong links to their respective communities by finding local funding partners. The Getty awarded $3.5 million in seed money to the RIGs, while the institutes raised more than twice that amount from other sources.

Evaluators concluded that the most important contribution of the regional institutes during the seven-year evaluation period discussed in this report was their crucial role in transforming DBAE theory into exemplary practice. The RIGs, meanwhile, have emerged as important leaders and resources for arts education.

The evolution of change communities within and among the RIG programs over time persuaded evaluators that the reform of art education cannot be achieved in schools by art and classroom teachers working alone. Evaluators further determined that the RIG programs that functioned best were those whose directors saw the individuals, organizations, and institutions within their consortia to be equivalent shareholders and partners with significant responsibility for shaping DBAE practices.

THE REGIONAL INSTITUTES **Although the six RIGs have distinct qualities and supporting consortia of differing natures, evaluators found that they all facilitated broad-based instructional curricula. The regional institutes, which encompass urban, suburban, and rural schools in some 217 separate districts, include:**

- **The Florida Institute for Art Education, at Florida State University in Tallahassee, serving fourteen county districts through a network of ten area site programs located throughout the state.**
- **The Minnesota DBAE Consortium, at the Minnesota Alliance for Arts Education, serving forty-six school districts throughout the state.**
- **The Nebraska Consortium for DBAE, a program of the Nebraska Department of Education, known as Prairie Visions, serving nearly one hundred school districts that serve nearly 50 percent of the state's school population.**
- **The Ohio Partnership for the Visual Arts: Regional Institute for Educators, at Ohio State University, serving nineteen school districts through a network of four area sites around the state.**
- **The Southeast Institute for Education in the Visual Arts, one of three discipline-based institutes of the Southeast Center for Education in the Arts at the University of Tennessee at Chattanooga. Its sister institutes focus on discipline-based music and theater. The Visual Arts Institute works with thirty-two school districts in Tennessee and seven neighboring states.**
- **The North Texas Institute for Educators on the Visual Arts, at the University of North Texas in Denton, serves six school districts in the Dallas-Fort Worth area, including two of the nation's largest (Dallas Independent and Fort Worth).**

SUMMER PROFESSIONAL INSTITUTES **Evaluators concluded that one of the finest attributes of the RIGs is their summer institute programs for teams of school principals, art specialists, and general classroom teachers. These programs have become indispensable in redefining DBAE theory and practice and preparing participants to experiment with new ideas and implement programs in their schools.**

At their best, the summer institutes serve as rites of passage from traditional instructional approaches to the world of art and discipline-based art education, facilitating the introduction of DBAE programs in elementary and secondary schools.

The DBAE institutes are predicated on the belief that teaching art requires knowledge of artworks and of the inquiry process of the artist, art historian, art critic, and aesthetician. In the most effective DBAE institutes, learning takes place not in classrooms but in art museums, art centers, galleries, artists' studios, and other authentic art world contexts.

Of the one hundred individual summer institute programs evaluated between 1988 and 1995, those deemed best transported participants the farthest from their everyday worlds and provided the most complete experiences of what it is like to live in the art world. They encouraged participants to explore different dimensions of the

art world, play with art-related ideas, and create new instructional strategies.

Authentic art world encounters, evaluators believe, can radically alter beliefs about the meanings of artworks and inspire participants to return to their schools firmly determined to implement comprehensive art education programs.

THE CHALLENGE OF IMPLEMENTATION After participants are introduced to DBAE in the summer institutes, they face a formidable challenge: transforming their understanding of art into discipline-based instructional programs.

Evaluators discovered that at first the summer institutes did not always provide useful instructional models. The art disciplines were sometimes presented as separate subjects, and there was a lack of clarity about whether artworks or the art disciplines should be the principal content of DBAE.

Summer institute directors and faculty were encouraged to create programs that resembled the kinds of DBAE instruction they hoped to see in elementary and secondary schools. They were urged to find ways to present holistic and integrated models for artwork-centered instruction while simultaneously providing participants with an understanding of the individual art disciplines.

Another early stumbling block to implementation was that participants did not usually receive introductions to all four disciplines until near the end of the institutes. Thus, there was little time left for active exploration of the disciplines or for experimenting with ways of teaching them to students.

The institute programs were redesigned over the years to correct this problem. Most participants are now better able to practice DBAE from the onset. The improved programs frequently begin with an overview of what DBAE looks like in practice, giving participants an educational context for the art world information and experiences they will soon encounter.

The summer institutes also help promote implementation by placing art at the center of school curriculum and instructional planning. Teams made up of a school

principal, art teachers, elementary classroom teachers, and other members of the instructional staff participate in instructional planning and lay initial plans for the implementation of DBAE and involvement of other faculty.

Art instruction, formerly perceived as having little relevance to the school curriculum, is put at the core of the planning process, and art specialists, by being part of a school team, are removed from their customary "lone ranger" role. Placing art at the core of school planning gives it new importance, and administrators and teachers of other school subjects make plans to weave art into school instructional programs.

As the summer institutes continue to evolve, the content of their programs has become more integrated and whole. With increasing frequency, works of art with special relevance to participants in the various regions are the objects with which they learn inquiry processes. Art discipline presenters, institute staff, and facilitators have begun to plan inquiry activities and educational applications collaboratively. Facilitators, generally drawn from among prior participants, have taken on an important role in monitoring and guiding small group instruction and have become key members of DBAE change communities.

MULTIPLE FORMS OF DBAE The evolution of DBAE over the past decade has been far from a monolithic phenomenon. Evaluators discovered that it exists in a variety of forms and continues to be developed by communities of individuals directly involved in advancing its theory and practice. It has, in fact, become a two-way street where theory guides practice and innovative practices enrich and sometimes lead to the development of new theory.

Evaluators maintain that varied interpretations of DBAE are both healthy and desirable, especially if they become the basis for discussion of assumptions about the role of art in education. They argue that DBAE must remain an open concept, that some forms have equivalent merit, and that some will be superior to others.

DBAE evolved through the considerable interplay between the approaches devel-

oped within summer institute programs and the forms developed by art specialists and elementary classroom teachers. In implementing DBAE in their schools and classrooms, these educators devised new forms that began to affect thinking about DBAE curricular and instructional theory—a clear instance of practice shaping theory.

Past approaches to art education had a significant impact on the early forms DBAE took in the regional institutes. Works of art, the evaluators observed, were viewed too narrowly. Institute staff and teachers placed too great an emphasis on the elements and principles of design—on color, pattern, and composition and not enough on the significance, meaning, and philosophical issues the works raised.

Other problematic approaches included placing too much weight on the discrete character of the individual art disciplines and too little on the holistic understanding of the works of art. The evaluators remain concerned that such a preoccupation with the art disciplines actually draws attention away from works of art that students are supposed to create, understand, and appreciate.

As the institutes matured, more fully integrated models of DBAE instruction emerged. The evaluators observed that students develop holistic understandings of works of art when the disciplines are used as the means through which art objects are created and studied and not as the primary content. The directors and faculty of the regional institutes have encouraged the development of comprehensive DBAE units in which the disciplines are integrated; the content and inquiry methods from each discipline are emphasized as the needs of the artwork dictate.

In some institutes DBAE has played a richly interdisciplinary role when units of study also include content and approaches from other subject areas such as music, history, literature, anthropology, and the sciences, placing a work of art within its social, cultural, historic, and aesthetic contexts. The evaluators caution, however, that artworks should not be used to merely illustrate topics and concepts.

The evaluators concluded that the most effective curriculum would be built around works of art that have the potential to educate in powerful ways; students' work would reveal their reflections on and responses to the ideas, themes, subjects, and expressive characteristics of the works they study, but as modified, extended, reinvented, or countered through their own ideas and concerns.

IMPLEMENTING DBAE IN SCHOOL DISTRICTS AND SCHOOLS One of the greatest challenges in school reform is putting new ideas gained from professional development programs to work in the classroom. Despite their determination to implement educational initiatives, teachers encounter a variety of difficulties. The culture of the school, for example, reasserts itself, and colleagues in school discourage reform efforts, leaving teachers little time or energy to alter existing practices. The regional consortia encountered all of these problems.

The main principle underlying the DBAE initiative is that pervasive change cannot occur if individuals work alone. Far-reaching educational change will succeed only when individuals work collaboratively at all levels within a change community.

The professional development programs of the regional institutes, therefore, were available to teachers and schools only when their districts became members of one of the consortia. In successful districts, administrators agreed to implement DBAE in

the schools. Principals and DBAE coordinators, in turn, agreed to work with school faculty members to devise strategies for implementing the program at their sites. Throughout DBAE schools, evaluators saw that leadership and planning are paramount to successful implementation. Where district administrators do not fully understand or assume their responsibilities, programs do not flourish to the same degree that they do in districts where administrators have a strong commitment to and provide ongoing leadership for DBAE implementation. The validity of this approach is reflected in the fact that DBAE continues to develop in virtually every school district in which there is solid administrative support.

Evaluators found that the arts suffer when individual schools are freed from regulations and even from the expectation that they will implement comprehensive art programs. School district leadership remains essential to maintaining equity among school subjects, ensuring standards of excellence, and assuring that change initiatives will be implemented and sustained districtwide.

DBAE appears to have made the most impact in small- and mid-sized school districts where strong central office support is greatest. The enormous problems plaguing large city school systems prevented central office administrations from fully endorsing and providing sufficient resources to implement and sustain the initiative.

Evaluators found that the most important commitment a superintendent can make when a school district joins a regional consortium is to oversee development of a comprehensive five-year DBAE implementation plan. Most implementation plans share the following components:

- Appointment of a program coordinator.
- A plan to notify all district school administrators about the new program.
- A districtwide plan to send teams of teachers to summer DBAE institutes.
- Development of district goals and a new art curriculum.
- A plan for special purchase of reproductions of artworks and other materials.
- A plan to inform the public.

Evaluators observed another critical factor: the appointment of a district DBAE coordinator with genuine authority to initiate, facilitate, and monitor the change process. The higher up the coordinator is in the district hierarchy, the more assurance that the rest of the factors will be put in place.

They further noted that strong programs result when clear districtwide expectations are established for all subject-matter areas including art and when individual schools are encouraged to meet district goals using the means that work best for their local school community.

Implementation is also affected by the presence of other reform initiatives. Evaluators reported that new programs are most effective when they are integrated with ongoing initiatives. DBAE flounders when it is tacked on as a separate item to an already full agenda for educational reform.

Principals and teachers discover that the planning processes begun in the sum-

mer institutes can provide the impetus for restructuring entire school programs. Where it is most successful, the DBAE reform initiative has been able to move the art program from the sidelines of the school curriculum to its center.

There are two major shortcomings still to be remedied to strengthen the quality of DBAE implementation. One is the lack of meaningful assessment of student learning. Evaluators link this difficulty to the fact that the educational system doesn't yet require authentic performance assessment and that the collection of authentic performance assessment data is extremely time-consuming and exacting. If art is to take its place as a core subject, however, evaluators stress that more effective assessment strategies are needed.

The second shortcoming is the lack of sequential, K–12 curricula that reflect the approaches to DBAE developed in the RIGs. Development of such curricula was not part of the RIGs' original charge because of time and resource constraints. Unfortunately, at the outset, few textbooks reflected a discipline-based approach, and teachers did not have the time or resources to develop new instructional units. Even though efforts have been made in individual schools and districts to develop exemplary DBAE units, there are few if any satisfactory examples of comprehensive K–12 DBAE curricula. If curriculum issues are ignored, the development of the full potential of DBAE in districts and schools will be unmet.

DBAE PRACTICES IN ELEMENTARY SCHOOLS Evaluators visited more than one hundred elementary schools—many repeatedly—over a seven-year period to assess how DBAE programs are being implemented. They observed many exemplary programs and concluded that schools with successful programs have a decidedly different look from those where programs are less effective.

While the ideal DBAE elementary school is still rare, it emerges because administrators, art specialists, and classroom teachers have been willing, collectively, to assume new instructional roles and new responsibilities for coordinating the curricu-

lum in which art plays a central role.

In contrasting the ideal with the less-successful DBAE elementary school, evaluators explored a series of key issues about what kinds of art programs should be offered in the elementary school and who should teach them.

They learned that in strong DBAE schools, an entirely new role has been created for the art specialist. No longer isolated, the specialist has become a team member and consultant, knowledgeable about the instructional programs of colleagues and about how the study and creation of works of art might make significant contributions to those programs. Both art instruction and the general curriculum benefit.

One of the most promising patterns evaluators observed is when elementary classroom teachers and art specialists jointly plan and teach units of instruction that are centered on works of art and the content of art. This is occurring in about 43 percent of the DBAE schools and represents a marked change in the role of the art specialist.

Evaluators believe that when teachers plan and teach art collaboratively, there is a much greater likelihood that art will have a substantial character, will be taught regularly, and will be taught well.

As DBAE principles were implemented, art was soon seen to have importance both in its own right and for the contribution it could make to the overall instructional program. For example, themes derived from works of art became the core of a school's yearly curriculum.

Although exemplary practices proliferate, evaluators expressed concern that virtually no elementary school yet offers a comprehensive art curriculum consisting of six or seven years' worth of exemplary integrated units of art instruction. Units of instruction in kindergarten through sixth grade still remain isolated, and the challenge of developing a comprehensive DBAE curriculum with a sequence of art-based instructional units looms large. When art is integrated into classroom teachers' existing instructional units, too often artworks are still used to merely illustrate nonart themes and topics, rather than serving as a focus for teaching and learning.

DBAE IN SECONDARY SCHOOLS The road to reforming art in secondary schools appears to be rockier than the path at the elementary level. Nonetheless, secondary school art teachers have managed to reformulate their art programs in extraordinary ways to convey DBAE concepts. Evaluators also found that the challenges in developing secondary school DBAE programs are greater at the high school level than in middle or junior high schools.

One obstacle evaluators saw at the secondary level is the lack of models to follow, leaving art specialists to their own devices in conceiving and developing individual DBAE programs. Another is that secondary school art specialists have less-developed support systems than do their elementary school counterparts. The implementation of DBAE is seldom schoolwide in secondary schools. Except in a few instances, secondary school art teachers have worked alone to develop their individual curricula.

A whole series of factors affects the implementation of DBAE in high schools, including the way the curriculum is structured, the kinds of students who take art classes, the kinds of expectations the students bring with them, teacher assumptions and preparation, and attitudes about the role of art in a student's education.

Evaluators observed that art specialists have been able to introduce DBAE into their programs with relative ease in schools where the art curriculum is nonspecialized. Programs organized around highly specialized or media-specific courses appear more resistant to change often because these courses are directed toward the education of an artist.

High school art classes are often seen exclusively as places where students make art, not where they study and interpret art objects. Furthermore, a competitive climate prevails in which high school art teachers are judged in terms of the number of prizes and scholarships their students win in various national competitions.

Despite such barriers, there has been a growing awareness among high school art specialists who have attended DBAE institutes that knowledge of art history and issues that animate the contemporary world of art are essential ingredients in the education of their students—whether or not the students hope to become artists.

Middle and junior high school art specialists, on the other hand, have not had to deal with the issue of the preprofessional art student so they have had less of a struggle with the merits of DBAE. As a group, they are more eager to accept the idea of a comprehensive approach to art education.

Evaluators found, however, that the elements and principles of design still permeate instructors' thinking about art in middle schools. Art specialists still face the challenge of changing the way teachers think about works of art and about how they can provide the content for instruction.

Despite the difficulties, secondary school art specialists have moved toward full implementation of DBAE in a number of groundbreaking ways. Some have developed new units of instruction and shared them with others. Some have integrated the study of works of art within their art media and process art projects. Yet, evaluators stress that much work remains at the secondary level to build a comprehensive DBAE curriculum.

DBAE IN ART MUSEUMS The requirement that museums and art centers be an integral part of the RIG program set the framework for valuable collaborative initia-

tives. Formation of the partnerships offered assurance that neither museum educators nor art teachers would be isolated. Drawing on the rich resources of the art museum, cooperative projects could help DBAE programs become both authentic and strong. Not only do museums influence school programs, however, but collaborations between schools and museums have a positive effect on museum programs.

During seven years of observation, evaluators found many examples of innovative projects emerging from the school-museum relationships. The best of these are collaborative rather than cooperative in nature, enabling participating organizations to share ownership in the educational programs that result from their partnership.

Although some museum educators think DBAE is an effective approach, they do not feel the need to incorporate it into their museum programs because multidisciplinary approaches are already in place. But the programs of some museums and art centers have been transformed, and many of the school-museum programs of the regional consortia reflect the elements of true collaboration.

A vital element in developing these collaborations between museum educators and teachers is that the educators, regardless of where they work, recognize that each aspect of education contributes to the entire context of a student's experience. Evaluators noted that in RIG projects where art museum educators have been put in institute leadership programs, they have a vested interest in and responsibility for the success of the entire DBAE initiative. This situation enhances the collaborative mission of both museums and schools and leads to substantive dialogue between classroom teachers and museum educators.

Educators at medium-sized museums and art centers with less-established educational programs than the older, larger institutions are more likely to embrace DBAE, consider new approaches to museum education, and incorporate DBAE innovations into their programs.

Nevertheless, evaluators found that even in the large museums whose programs were not greatly affected by their involvement in DBAE activities, there was often increased awareness of the needs of school audiences.

Museum educators believe that their staff members perceive the role of teachers differently after attending a summer institute. Because of the experience, they build professional understandings and friendships that have not occurred in the past. Teachers, in turn, with newly gained confidence in dealing with the art world, can identify and communicate their needs to museum educators more easily.

One important result of museum involvement in RIG collaboratives is the improvement of docent presentations. More and more museum docents attend summer DBAE institutes each year, and museum educators report that participating docents come away with greater confidence in their ability and are eager to incorporate effective inquiry-based techniques in their tours. These docents are providing visitors with more-meaningful experiences and are increasingly satisfied with their work.

Evaluators also report overwhelming consensus among museum educators and docents that students from DBAE classrooms respond more positively to museums and their collections than do students whose teachers have not attended DBAE institutes. These students are more experienced in talking about art, more knowledgeable about art concepts, and highly inquisitive.

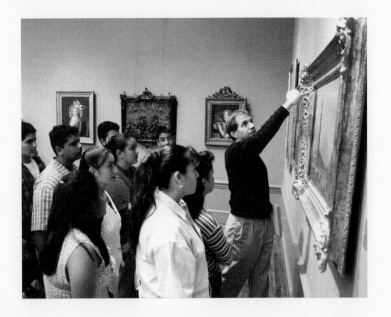

THE ROAD AHEAD The RIG programs have become unique agents for broad-based educational change, allowing the Education Institute to strengthen its efforts to improve the quality and status of arts education in America's schools. The RIGs' grass-roots network of individuals, schools, universities, museums, government agencies, foundations, and other arts and education organizations has given momentum to the reform effort and fueled a national movement for arts education reform. Their work, however, is not yet complete.

Building on the lessons learned through the evaluation, the Getty Education Institute and the RIG directors have developed a plan for the next phase of the DBAE initiative that focuses on filling two important gaps identified in this evaluation report: sequential K-12 curriculum and data on the impact of DBAE on student achievement. The plan will be carried out by the Florida, Nebraska, Ohio, Tennessee, and Texas RIGs along with the California RIG, which was established in 1994. The Minnesota RIG, which was unable to meet the Education Institute's annual matching grant requirement, is no longer a part of the RIG program.

During this phase, the RIGs will work as a national consortium of research and development sites supported by over $6 million in continuing support from the Getty Education Institute, a $4.3 million grant from the Annenberg Foundation, and other private and public dollars yet to be raised to meet Getty and Annenberg matching requirements. The Annenberg grant, part of a $500 million, five-year challenge to the nation to reform public education, is one of only three grants for reform through arts education.

From 1997 through 2001, the RIGs will work closely with thirty-six elementary and secondary schools that have made a commitment to improving student achievement by placing DBAE at the core of their curriculum and linking it to whole school reform. These Arts Partner Schools will also serve as demonstration sites and as the focus of an intensive national program evaluation and assessment of student achievement.

The schools' efforts will be supported by an annual infusion of new curriculum units, instructional resources, and professional development programs representing the "best practices" described in this report and developed by task forces with representatives from each of the six RIGs. The Arts Partner Schools will also benefit from sharing experiences, materials, and ideas with the partner school network.

To strengthen and expand comprehensive arts education programs in committed RIG partner schools and districts that are not Arts Partner Schools, the RIGs will continue to provide professional development and networking opportunities as well as the curriculum units to be developed over the next five years.

Through the RIGs, the evolution of comprehensive arts education will continue. It will be important for that evolution to be informed by changing societal, artistic, and educational conditions and by the interests of new individuals who join the ongoing task of forming and reforming DBAE.

This report, written by Dr. Brent Wilson, chief evaluator of the Regional Institute Grant (RIG) program from 1988 to 1996, discusses what the regional institutes are, what they have done, and what their work means for art education reform, the evolution of discipline-based art education (DBAE), and for general education reform. It is the Getty Education Institute for the Arts' first public report on this important and long-term initiative to reform art education in the nation's schools. Its present and future are briefly discussed in the epilogue of this report. To help prepare the reader for Dr. Wilson's rich and substantive report, the following brief history of the RIG program is provided.

HISTORY In 1982 the Getty Center for Education in the Arts (now the Getty Education Institute for the Arts) commissioned a RAND Corporation study of art education (reported in *Beyond Creating: The Place for Art in America's Schools* [1985]). The study provided the impetus to establish the Los Angeles Institute for Educators on the Visual Arts in 1983, which served as a research and development site for DBAE for seven years. (As discussed in detail in this report, DBAE is an approach to art education that includes content in the four disciplines that contribute to the creation and understanding of art: art production, art criticism, art history, and aesthetics.)

In 1986, the Getty Education Institute for the Arts began considering how the professional development and curriculum implementation model developed for the Los Angeles Institute could be used nationwide. Those deliberations resulted in the creation of the RIG program, whose characteristics were shaped by lessons learned from operating the Los Angeles Getty Institute, from funding a similar institute in another state, and from monitoring progress made by four school districts to which the Getty Education Institute provided grants for DBAE programs. Those lessons suggested that successful dissemination of DBAE would depend on grassroots initiatives led by consortia of school districts, universities, art museums, and other arts and education organizations supported, in part, by local funding sources.

The Education Institute's vision for the RIG program was twofold: that they act as sites for the research and development of DBAE theory and practice, and that through their professional development and curriculum implementation programs they build a critical mass of school districts where DBAE was implemented, districtwide, within five years. To achieve this vision, the guidelines called for regional institutes to:

- design and offer professional development programs to teams of teachers, art specialists, school administrators, and others;
- provide support services to participating schools to ensure that DBAE became a vital part of their core curriculum;
- monitor school districts' progress in implementing an art program;
- assess student learning in art;
- build a strong base of support in their communities by establishing advisory committees, and creating networking opportunities for consortium members and school district partners; and
- match the Education Institute's annual grant of $125,000 on a

one-to-one basis and, by the end of the five-year grant period, become financially independent.

In late 1986, the RIG program guidelines were released, inviting regional consortia to apply for one-year, $20,000 planning grants (see Appendix B). Ten years ago, DBAE was a relatively new paradigm in art education circles, and art educators knowledgeable about this approach were just beginning to emerge. As a result, only eight of the fifty-two proposals submitted for planning grants were funded. A year later, six of those were selected to implement their plans for up to five years supported by annual operating grants.

As an incentive to entrepreneurship among the RIGS, the Education Institute provided them with a secure foundation that included:

- clear expectations to function as research and development centers building on local resources and opportunities and to develop locally responsive forms of DBAE;
- a commitment to five years of funding;
- a means to share achievements and issues across sites through meetings of consortia teams during the first two years, annual directors meetings, and other special events;
- an intensive cross-site evaluation with results shared across projects; and
- an Education Institute staff person to monitor their work and serve as their liaison to the Institute.

Over time the Education Institute and the RIGS developed a symbiotic relationship, one in which information flowed to and from all parties. The RIGS evolved into dynamic "laboratories" for the research and development of DBAE theory and practice and into the Education Institute's most important link to schools. The Education Institute became a responsive partner, providing additional resources to support unanticipated needs and to capitalize on unexpected opportunities. For example, although the original guidelines stipulated that each RIG was to assess student learning in DBAE, it quickly became apparent that because of the cost and complexity of the task, the expectation was unrealistic. Believing that assessment was essential, the Education Institute created a supplemental student assessment grant program for the RIGS. It initiated the program by hosting a seminar for RIG directors and their project evaluators where they worked with national leaders in student assessment.

Since the regional institutes began their work in 1988, a tremendous amount has been accomplished and learned. The RIGS have met their research and development charge by establishing effective professional development and innovative curriculum implementation programs and developed different approaches to DBAE. In addition, they've produced high-quality instructional resources, created programs and materials focused on the work of local artists and art collections, stimulated unique school/museum partnerships for DBAE, and conducted pioneering work in discipline-based music, theater, and dance education.

In terms of dissemination, the RIGS have nurtured a new generation of teachers, administrators, scholars, and advocates committed to art education; served thousands of

teachers and administrators from more than 217 school districts in thirteen states who in turn serve more than 1.5 million students; emerged as national leaders and resources for DBAE; attracted interest from educators in Brazil, China, Italy, Japan, Switzerland, and elsewhere; and secured close to $15 million to match the Education Institute's grants.

ACKNOWLEDGMENTS The publication of *The Quiet Evolution* marks the Regional Institute Grant program's first-decade mark. Thanks are due, first and foremost, to the RIG directors whose work is discussed in this report—Dr. Sheila Brown of the Nebraska Department of Education; Drs. D. Jack Davis and R. William McCarter of the University of North Texas; Dr. Margaret DiBlasio of the University of Minnesota, Mr. Tom Mc-Mullen, of the Spring Lake Park, Minnesota, School District, and Ms. Susan Rotilie, of the Minnesota Alliance for Arts and Education; Drs. Anne Lindsey and Jeff Patchen of the University of Tennessee at Chattanooga; Drs. Nancy MacGregor and Michael Parsons of Ohio State University; and Dr. Jessie Lovano-Kerr and Ms. Nancy Roucher of Florida State University and Sarasota respectively—each of whom has contributed her or his own unique vision, impressive array of talents, flexibility, creativity, and dedication to what Dr. Wilson has referred to as "the largest and most important research and development effort in the history of art education."

Kudos are also due to those individuals and organizations whose efforts, passion, talents, and energy infused the RIG program and made its work truly important for the reform of arts education. They include the regional institutes' staff, faculty and consortium partners; their fiscal agents; and the administrators, faculty, parents, and school board members of the 217 participating school districts who recognized the importance of a discipline-based art education for their students. The names of these individuals, organizations, and school districts are provided in Appendix C of this report.

The accomplishments of the regional institutes were fueled by two kinds of capital: the creative and intellectual capital provided by the many individuals discussed above; and the financial capital provided by numerous individuals, foundations, corporations and local, state, and national agencies. The nearly $15 million provided by these individuals and organizations signals a growing awareness of and commitment to arts education as well as their recognition of the important leadership provided by the regional institutes. Please see Appendix C of this report for a list of RIG funders.

For making the evaluation of the RIG program his top priority for the last nine years, for enriching the program in numerous ways and for crystallizing his observations, conclusions, and beliefs about the importance of the RIG program in this report, an immense debt of gratitude is due to Dr. Brent Wilson. I am also grateful to Dr. Blanche Rubin who, as co-evaluator with Dr. Wilson since 1993 and chief evaluator as of 1996, has provided her own wisdom and commitment to the program. Thanks are also due to their staff and graduate research assistants, each of whom made important contributions to our understanding of the RIGs and to this report.

There are others at the J. Paul Getty Trust whose support has allowed the RIG program to flourish, to make mistakes, to chart new directions, and to develop into unique and important national resources for arts education. Thanks are owed to Getty Trust President and Chief Executive Officer Harold M. Williams and the Trustees of the J. Paul Getty Trust for their financial and philosophical sustenance of what turned out to be a

much longer initiative than originally envisioned; to Leilani Lattin Duke, Director of the Education Institute, for her strategic vision, openness to the unanticipated, and unflagging support; and to my colleagues at the Education Institute who often found ways to link their projects to the RIGS, thereby expanding the RIGS' exposure and influence. And, finally, thanks are owed to my staff—Julie Abel and Lori Weisgerber—whose assistance and sense of humor have made managing the RIG program not only possible, but fun.

Vicki J. Rosenberg
Senior Program Officer
The Getty Education Institute for the Arts

The Evaluation of Discipline-Based Art Education Regional Institute Grant Programs

Following its founding in the early 1980s, the Getty Center for Education in the Arts (now the Getty Education Institute for the Arts) adopted the ideas of art educators who, since the mid-1960s, had been calling for a more holistic, comprehensive, and multifaceted approach to art education. This approach, called discipline-based art education (DBAE), is not a curriculum (although it should lead to one in a school or district); rather, it is a set of principles based on the fields of study that contribute to the creation and understanding of art: art making, art history, art criticism, and aesthetics (the philosophy of art). The Education Institute believes that, because the creation of artworks and inquiry into the meaning of art are primary means through which human experiences can be understood and cultural values transmitted, the visual arts should be an essential part of every child's education.

The implementation of this new form of art education called for enormous changes in theory and practice. Educators would have to alter their beliefs about the role of art in education; learn to create, interpret, and evaluate works of art in new ways; and implement entirely new art programs. To bring about these changes, the Getty Education Institute commissioned a study of art education, established the Los Angeles Institute, and then funded six Regional Institute Grant (RIG) programs. The introduction of DBAE into more than 217 urban, suburban, and rural school districts participating in the RIG programs provided a challenging test of educational reform.

In the spring of 1988 I accepted an offer from the Education Institute to serve as national evaluator for its RIG initiative. That summer, an assistant and I visited the three RIG programs that had been established in Florida, Ohio, and Tennessee. Three more sites were later added, in Minnesota, Nebraska, and Texas. A seven-member national evaluation team (see Appendix A) conducted ongoing reviews of the work of the six RIG programs.

When I agreed to evaluate the RIG programs, among the first questions I asked the Education Institute were: What are these projects for? Have they been created to implement conceptions of DBAE and teaching practices currently being used in projects sponsored by the Education Institute? Or do they exist for the purpose of creating new conceptions of DBAE and experimenting with new instructional practices?

In response to these questions, the Education Institute unambiguously defined the RIG programs as research and development projects whose challenge was to build on the many valuable DBAE and professional development ideas and practices formulated in the Los Angeles Institute for Educators on the Visual Arts (1982–88; see Greer et al., 1993).

Over the seven years covered by this report, the RIG programs pursued goals that included such things as developing DBAE theory and practice, building effective professional development programs, integrating the visual arts with other school subjects, pioneering arts assessment procedures, forming innovative museum education programs, and instituting comprehensive school district implementation processes. Rather

than following a single plan mandated from one source, many individuals at all levels of the six projects were encouraged to engage in innovative practices leading to the achievement of shared research and development goals. This activity was regularly informed by national and local evaluation reports, annual program directors' meetings, and informal communication between the Education Institute, the program directors, and the national evaluators. The findings of the national evaluation team are the subject of *The Quiet Evolution*.

Evaluation: Matters of Substance and Quality

Although the evaluators are hired by the Education Institute, they act independently insofar as the major issues of DBAE are concerned. No issue or area of art education practiced in the six RIG programs is seen as off-limits. They are examined in light of their own goals and also judged by external criteria. When the evaluators see instruction that relates more to traditional art education practices, assumptions, and purposes that appear inadequate—out of keeping with the principles associated with DBAE—this is stated. The institutes are also examined in light of previous Education Institute projects and publications. Occasionally the evaluators criticize practices that have become associated with DBAE in some of the other projects supported by the Education Institute or DBAE concepts and practices found in materials published by the Education Institute. These criticisms are particularly difficult for some RIG program leaders to understand. They reason, "If it is in the Getty literature, surely it must represent acceptable DBAE theory and practice." The evaluators, however, take the position that their work is most valuable to the Education Institute if they hold open the possibility of questioning virtually every assumption, idea, theory, or practice associated with DBAE and art education—regardless of its source.

The one thing the evaluators do not question is the value of a broad-based approach to art education organized around the content and inquiry processes associated with art making, art history, art criticism, and aesthetics. Nevertheless, the evaluators do, for example, criticize some of the isolated and archaic ways the disciplines are used and point to the narrowness and shallowness with which the principles of DBAE are sometimes applied to the teaching of art. Occasionally the evaluators find that the disciplines are used too exclusively, that there is too little advantage taken of other disciplines—such as anthropology, archaeology, psychology, and sociology—that have contributions to make to the creation and study of works of art in educational settings. Still, the evaluative work has been based on the assumption that the art disciplines through which works of art are created, studied, interpreted, and evaluated provide the essential foundation for comprehensive education in the visual arts.

The evaluation process is a search for substance and quality and is directed toward things that can be observed. As education is primarily a matter of interpretations and values, it is important to remember that the observations of the evaluators are filtered through lenses tinted with values that have a variety of sources. Four sets of values can be described.

First, there are values derived from the world of art. Within the content and inquiry

processes of art making, art history, art criticism, and aesthetics there are complex groupings of concepts that, as Morris Weitz (1959) writes, are impossible to define once and for all. Art is a value-laden, open construct that changes as the boundaries of art are moved to incorporate new ideas, forms, and functions. Within the RIG programs there is an enormous variety of definitions of art and beliefs about how it should be created, taught, studied, and used.

Second, there are general assumptions about the role art should play in general education. Some school personnel believe art education should exist merely to enhance learning in other subjects. Others think the principal purpose of art education is essentially utilitarian—to sharpen and enhance perception, critical-thinking skills, higher-order cognitive processes, and imagination. Still others feel art should have a place in the curriculum because it is a source of knowledge, beliefs, and values about the self and the world essential to an educated citizenry.

Third, there are goals set by the institutes themselves. These are derived from the definition of DBAE and the Education Institute's grant guidelines (see Appendix B). In addition to formal guidelines, there are implicit goals for art education held by program directors, staff, faculty members, project participants, and even the students in their classrooms. The goals and values about art and art education held by these different groups of individuals sometimes coexist peacefully and sometimes openly clash. This report chronicles some of the conflicts and interactions of ideas and values that occur when the disciplines of art provide the catalyst for broadening the content of art education.

Fourth, there are the evaluators' general conceptions of what quality art education programs should be. Do the programs lead participants and their students to create works of art and interpret and evaluate works created by others in ways that expand their conceptions of art, of themselves, and of their worlds? Does the creation and the historical, critical, and philosophical study of artworks increase their sense of past and present societies and cultures? Does the creation and study of art deepen their sense of human purposes and aesthetic values, and do these complex acts lead them to think more about their own future and the future of humankind? These are some of the general values that the evaluators bring to the task, values in keeping with the essential promises of DBAE.

Ohio Partnership, Mansfield area site director Dennis Cannon and evaluator Brent Wilson in the classroom. A seven-member national evaluation team conducted ongoing reviews of the work of the six regional institute programs.

It is also worth noting that DBAE arrived on the scene during a transition from modernist to postmodernist artistic ideologies. Those who hold to modernist ideologies tend to see the value of art in terms of its originality. They take delight in the aesthetic experiences associated with formal and expressive properties of artworks. Those who hold postmodern conceptions of art may prize its political and ideological character. They interpret and judge artworks in light of their social context and do not expect all works of art to be original. The exhilaration of the aesthetic experience, although recognized by the postmodernist, does not by itself provide sufficient reason for the inclusion of art in education—at least not when compared with outcomes that result when works of art are created and interpreted from social, historical, and iconographic perspectives. This evaluation conforms more to a postmodernist than a modernist ideology.

Not only are there different and sometimes conflicting values relating to the purposes and practices of DBAE within and among the RIG programs, there are also differences between members of the evaluation team and individuals within the regional institutes. The resolution of these differences leads to the very heart of this evaluation.

Forms of Evaluation

From the program's inception, the evaluation team believed that differences in interpretations and judgments could have positive effects on the evolution of DBAE if all participants understood the purposes of evaluation and the bases upon which evaluation was being conducted—namely, that the interpretations and judgments of the evaluators were also subject to evaluation. Egon G. Guba and Yvonna S. Lincoln (1989) characterize four forms of educational evaluation:

Technical (the evaluator as technician)—The evaluation of programs is conducted primarily through the collection of data relating to student progress through means such as standardized tests. Evaluation is seen as the collection of facts considered objective and "scientific." Values are hardly recognized, because it is assumed that the same values are shared by everyone in the evaluative context.

Description (the evaluator as describer)—Programs are judged on the basis of the degree to which they meet their stated goals and objectives. Measurement of outcomes still plays a role in the assessment process. Judgments of goals are avoided.

Judgment (the evaluator as judge)—Programs are judged on the basis of external standards and criteria, sometimes far removed from the conditions and perhaps even the values that prevail in the local setting. The measurement of outcomes might provide one focus, but the goals that guide those objectives are themselves open to evaluation ("Something that is not worth doing is not worth doing well"). But there are problems regarding the question, Who is to judge the judge?

Negotiation (the evaluator as negotiator)—Programs are evaluated based on the examination of claims, concerns, and issues. Different stakeholders in a program (the evaluator being one of the stakeholders) might hold dif-

ferent values. Those values are brought to the fore, examined, and if not always resolved, at least understood by all parties.

The RIG evaluators employed the fourth form of evaluation. Responses to the conclusions of the evaluative reports were discussed at length with Education Institute officers and with program directors, faculty members, museum educators, and participants. In many instances a way was found to negotiate to common ground. In other cases an understanding and respect for differing positions was established. Occasionally it was agreed to disagree about the character of DBAE itself.

The evaluative reports look much like Eisner's (1991) "educational criticism." The RIG programs are texts to be interpreted and evaluated. Members of the evaluation team see events and documents as signs that point to conceptions of art and education. Questions that are asked include, What is going on here? What does it mean? Does it have merit? Does it reflect a disciplined approach to the study and creation of art? Does the practice represent an advancement for art education? The evaluation team is particularly on the lookout for innovative practices that broaden and expand conceptions of DBAE. The reports prepared for the Education Institute and the program directors are filled with judgments about the value of emerging practices.

Guba and Lincoln see evaluation as a "social-political process," a "learning/teaching process," a "continuous, recursive, and divergent process," a "process that creates reality," a "process with unpredictable outcomes," and a "collaborative process"; they note that "the agenda for negotiation is best displayed in a case-study format, with items requiring negotiation being spelled out in relation to the particulars of the case" (pp. 216–19). These phrases characterize the processes used in evaluating the RIG projects.

Outline of This Report

The Quiet Evolution reports on how art education was transformed in the six regional institutes during the first seven years of the RIG program. Chapter 1 characterizes how DBAE has evolved from a concept designed by a few thinkers in art education to a movement in which thousands of individuals contribute to both its theory and practice. It examines the differing characteristics of the six RIG programs and the nature of the broad-based consortia that support them.

Chapter 2 explores the role of authentic art content and inquiry processes in the reform of art education. The summer DBAE professional development institute is presented as an essential rite of passage into the world of art. In this rite of passage participants live and work in art world settings and create and inquire into works of art in the manner of artists, historians, critics, and philosophers of art. Participants also face the challenge of transforming art content and discipline-based inquiry processes into viable forms of DBAE instruction.

Chapter 3 is the most theoretical portion of this report. Through a series of diagrams, the various forms of DBAE that have emerged within the RIG programs are analyzed. The chapter also illustrates how DBAE continues to evolve through the influence of changes within the art disciplines, art educators' different interpretations of the art disciplines, the

conventional content of art education, art education textbooks, the practices of elementary classroom teachers, content from current educational reform initiatives, and state and local art curriculum guides.

Chapter 4 characterizes the implementation of DBAE in school districts and schools. Implementation plans developed cooperatively by district and school administrators, curriculum specialists, art specialists, and classroom teachers provide the basis from which educational changes have taken place. Implementation is relatively easy in small school districts and very difficult in large ones. Nevertheless, school district art programs have been transformed and the DBAE initiative has provided the catalyst for changing school instructional programs in all subjects.

Chapter 5 examines the issue of who should teach art in the elementary school—general classroom teachers or art specialists. The chapter also presents instructional programs devised collaboratively by art specialists and classroom teachers.

Chapter 6 discusses the difficulties middle and high school art teachers have encountered in developing DBAE programs. A variety of examples from these instructional programs shows how DBAE has changed secondary school art education.

Chapter 7 illustrates the central role that museums and museum educators have played within the RIG programs. It shows the manner in which schools and museums have moved from cooperative to collaborative projects and thus expanded conceptions of DBAE and enriched educational programs in classrooms and galleries.

Chapter 8 moves from the particular findings of this report to generalizations about their consequences to educational change across the curriculum. It examines the contributions of art and the arts to the vitalization of education and the contributions of the Getty's initiative to an understanding of the conditions that make educational reform efforts effective.

The epilogue characterizes recent developments in the RIG programs, such as national specialty programs, electronic networks, and new partnerships that place art and arts education at the center of current educational reform initiatives.

Conclusion

The DBAE change initiative characterized in this report is one narrative composed of thousands of stories about the events that have unfolded in schools, school districts, museums, and professional development programs. Throughout this report, the central narrative is enlivened by vignettes and illustrations where students, teachers, museum educators, and administrators have the opportunity to "speak" through the programs they have developed. Their voices testify to the value of the ongoing evolution and evaluation of DBAE.

The Evolution of DBAE in the Regional Institute Programs:
Creating Educational Change Communities

CHAPTER

1

How has DBAE evolved into a movement in which thousands of individuals contribute to both its theory and practice? It is impossible to understand this evolution without exploring the differing characteristics of the six RIG programs and the nature of their supporting consortia. The evolution of change communities within and among the RIG programs shows clearly that the reform of art education cannot be achieved in schools by art and classroom teachers working alone. The broad-based art instructional curricula developed in the RIG programs are the direct result of the collaborative efforts of schools, universities, museums, foundations, and other arts and education organizations and funding agencies. Without any one of these elements, the impact of the RIG initiative would be significantly lessened.

The Genesis of a Reform Initiative

The difficult path that led from old forms of art education to a new comprehensive one illustrates how hard it is for a promising idea—even a widely discussed one—to move from theory to widespread practice. The DBAE reform effort of the 1980s and 1990s grew out of a school reform initiative of the 1960s that was based on the ideas of Jerome Bruner (1960). He proposed that rather than simply learning facts about school subjects, students should be given "an understanding of the fundamental structure of whatever subject we choose to teach" (p. 11). Bruner's ideas about the structure of academic disciplines as the basis for educational reform entered art education in 1962, when they were expanded upon by Manuel Barkan at Ohio State University. Barkan (1962) pointed to the other art disciplines, which, in addition to art making, had the potential to broaden the content of art education: "There is the very strong probability that in the next several years, we will witness renewed and energetic attention to the teaching of insightful observation of works of art. It will not come in the form of art appreciation. . . . Rather, this renewed energy will be apparent in the creative development of teaching materials and courses in art history and art criticism" (p. 15).

The social and educational climate of the 1960s and 1970s was not conducive to a rigorous disciplined approach to visual art education, however. Because art instruction based on the content and inquiry processes of the artist, art historian, art critic, and aesthetician required knowledge, insight, and understanding that most teachers of art did not possess, the movement in the 1960s was limited to a few models and experimental studies that found their way into the literature of art education (Wilson 1966; Eisner 1968). Nevertheless, a small number of curriculum developers, researchers, evaluators, and theoreticians in art education continued to work with Bruner's and Barkan's ideas, and a few

tral trunk from which branches feed. Rather, when applied to organizations and projects, it is a network in which individuals with overlapping functions, responsibilities, and authority interact in ways that are nonhierarchical. Alexander attributes the value of this interactive network to its complexity: "A tree based on 20 elements can contain at most 19 further subsets of the 20, while a semilattice based on the same 20 elements can contain more than 1,000,000 different subsets. . . . This enormously greater variety is an index of the great structural complexity a semilattice can have when compared with the structural simplicity of a tree" (p. 70).

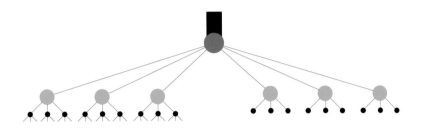

Figure 1.1 A top-down or inverted tree structure in which communication runs downward with minimal cross-communication (adapted from Alexander 1988, p. 75).

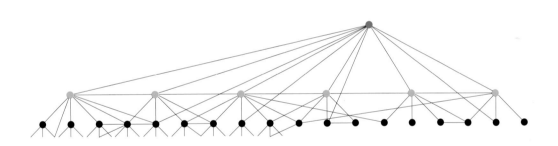

Figure 1.2 A latticelike interactive network in which communication travels up, down, and across levels–resulting in a vastly greater exchange of ideas than is possible in a top-down tree structure (adapted from Alexander 1988, p. 75).

The original RIG guidelines gave institute directors the option of either 1) implementing the Los Angeles DBAE initiative, with its treelike structure designed by a few individuals, or 2) developing new forms of DBAE. Even when RIG directors and their staffs made decisions that would lead to new forms of DBAE, the new versions could be designed with hierarchical treelike structures or allowed to take the form of a semilattice and grow in ways that were both unplanned and unpredictable.

As the evaluators observed the ways the six RIG programs came to be organized and functioned to change DBAE, something approaching the structural complexity of an interactive network was seen, not the simplicity of a tree. Alexander is concerned with the organization of physical space and with who should decide how it will be used—the designers or the people who must live in and use the space. In the RIG programs the territory was not the physical space found in a city, but conceptual territory.

The basic question was, "Whose thinking and whose ideas should determine the forms that DBAE might take?" Should the continued development of DBAE be in the hands of RIG directors or a few influential curriculum designers, or should its development be given over to thousands of individuals who work at different levels within the organizational structures of the RIG programs? Should many individuals be encouraged to assume a variety of roles, engage in overlapping functions, and have a direct hand in shaping DBAE?

Who Determined the Form of DBAE?

Several factors encouraged thousands of individuals to become involved in the shaping and reshaping of DBAE. First, the establishment of the RIG programs as research and development projects rather than implementation vehicles virtually assured the development of different forms of DBAE. Second, the requirement that each program be supported by a consortium composed of a variety of institutions and organizations assured the involvement of many individuals with differing ideas, interests, and values regarding the nature of art education and DBAE. Third, the passing on of significant responsibility for the shaping of DBAE to individuals within the institutions and organizations in the consortia led teachers, school administrators, museum educators, university art educators, discipline experts, individual students, and others to contribute to the development of different forms of DBAE. Finally, the emergence of change communities in which individuals assumed overlapping responsibilities and became change agents who joined together formally and informally to initiate projects and to share ideas within and across the boundaries of traditional educational organizations allowed a diversity of approaches to develop.

In the RIG program change communities, DBAE became an increasingly open concept where developing conceptions of DBAE incorporated new ideas emerging in art, education, and society. This research and development mode encouraged experimentation with new curricular and instructional alignments. At the heart of these developments and experiments, DBAE across the institutes maintained an adherence to principles derived from the disciplines of art and sound educational practice.

To transform art education, many individuals have been encouraged to assume a variety of roles, engage in overlapping functions, and have a direct hand in shaping DBAE.

In an interactive network everyone has an opportunity to influence the system, even students. This was certainly the case in the Prairie Visions DBAE institute. When Jeremy Emerson was a student in Linda Freye's second-grade classroom at Lost Creek Elementary School in Columbus, Nebraska, one of his crayon drawings, of a stand of trees through whose trunks one could see a train passing in the distance, was selected to be exhibited at the State Department of Education. Jean Detlefsen, the Columbus Public Schools' DBAE coordinator, met Jeremy at an open house at the department and talked with him about his drawing. As she told us later, "That's why I remembered it so well." After the exhibition, Jeremy's drawing was returned to his art portfolio.

In third grade Jeremy was taught by Barb Friesth, and in fourth grade by Marilyn Lamb. During both years he continued to add to his portfolio. Near the end of fourth grade, Jeremy and some of his fellow students were invited to present and discuss their portfolios in an evaluation session at which Detlefsen was present. As Jeremy laid out his works, she was puzzled, because the drawing she remembered from the earlier exhibit seemed different. The subject matter was the same, but the drawing's qualities were richer, and it had acquired a mood that evoked a sense of mystery. She looked again and saw two versions of the same work. She spoke with Friesth, who recalled that after studying American artist Philip Evergood's painting *Sunny Street*, Jeremy decided to rework his subject. When one of his classmates said, "Jeremy, that's the same thing you did last year," he replied, "I know how to make it better now." According to his mother, Jeremy was never happy with the first drawing, even when it was hanging at the State Department of Education, and had said at the time, "I can do better."

A Nebraska student's refinement of his artwork led to a new assessment technique.

Detlefsen, who served as a member of the Prairie Visions student assessment team, told us, "I kept thinking about how an elementary student had intuitively worked like artists work. Artists visit the same subject matter over and over again, they work in a series, they learn, and they play out what they have learned in a second artwork. . . . I tied my experiences [with high school students' portfolios] together with what Jeremy had taught me about elementary students and tried out my theory on colleagues." Subsequently, the assessment team developed a portfolio exercise based on Jeremy's process. Now, throughout Nebraska, each Prairie Visions student chooses an artwork from his or her portfolio, selects and studies the work of an artist, decides how the artist's work informs the student's artwork and "suggests" ways that he or she might revise it, makes a second version, and writes about the artist's work, what he or she has learned from the artist, and the way the study of another's work has influenced the student's artwork—the very process that Jeremy arrived at by himself.

Projects and Services in RIG Programs

The projects and services that developed within the RIG programs, and the ways they made it possible for individuals and institutions to communicate with one another, transformed the programs into educational change communities. These projects and services include professional development institutes and professional services and resources.

Professional development institutes—The RIG programs offer a variety of professional development institutes that have been tested and refined over the past seven years. Each region offers its member school districts a two-week introductory DBAE institute each summer. Some offer advanced institutes, symposia, and renewal workshops for experienced DBAE teachers and administrators; leadership seminars for administrators; special sessions for museum docents; workshops to acquaint artists (who serve residencies in schools) with DBAE; and study trips.

As the number of school districts participating in the RIG programs grew, most of them replaced centralized summer institutes with localized institutes housed in consortium-member school districts, museums and art centers, or universities. This decentralization caused a steadily expanding need for new institute directors, faculty members, facilitators, and evaluators as well as additional partners to assist in covering increased costs of organizing professional development projects. It also led to a greater emphasis on creating generic institute schedules, videotapes of key program sessions, and lessons based on works of art in local collections.

Professional services and resources—To help participating school districts with their DBAE implementation efforts, each regional institute offers a menu of services and resources. In one or more sites, these may include consulting and technical assistance often provided by specially prepared elementary and secondary art specialists, university art educators, school administrators, and state educational service center personnel; model instructional units; reproductions and instructional materials relating to works of art in consortia museums; student assessment models; pro-

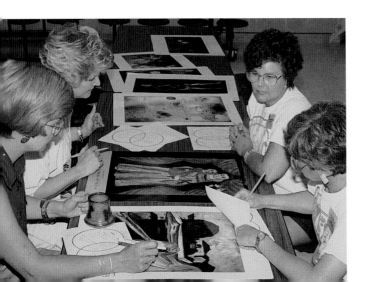

The projects and services developed within the RIGs, and the ways they made it possible for individuals and institutions to communicate with each other, transformed the programs into educational change communities.

gram evaluation models; DBAE resource centers; and information sharing and networking opportunities via electronic on-line services, newsletters, periodic gatherings, and video teleconferences.

Many of these projects and services offered professional growth opportunities to teachers who had seldom held responsibilities outside their own classrooms. Leaders emerged because there were so many new activities and functions created within the expanding consortia. Elementary and secondary school art specialists and classroom teachers, for example, became directors and codirectors of area site institutes. Other teachers assumed positions as institute staff members, faculty members, and facilitators. The RIG programs were transformed into change communities because so many of the individuals associated with them became change agents. They developed the four capacities required for education change: "personal vision-building, inquiry, mastery, and collaboration" (Fullan 1993, p. 12).

Reflections on Consortia-Based Change Communities

When the RIG programs were first established, they were probably designed more like trees—albeit six different trees—than as latticelike interactive networks. After all, hierarchical organizations are much easier to design and manage than complex networks. Nevertheless, through the establishment of consortia, conditions were set for the emergence of change communities. Almost immediately, the six different, broad-based consortia began to alter the character of DBAE, in some instances markedly and in other instances more modestly.

The RIG programs that functioned most effectively were those whose directors saw the individuals, organizations, and institutions within their consortia to be equivalent shareholders and partners. These programs also received the most from their consortium members, because they gave individuals in schools, school districts, museums and art centers, and universities the greatest responsibility for shaping DBAE and the professional development projects associated with it. When individuals within the consortia

The regional institutes offer a menu of services and resources, including summer institutes, advanced workshops, leadership seminars, and study trips. They also provide teachers with resources such as model instructional units, reproductions, and curriculum materials.

were given encouragement to experiment with the forms that DBAE might take—the same encouragement the directors of the RIG programs had been given by the Education Institute—the dynamic, open, and changing character of DBAE was assured. Richness, variety, and multiple versions of DBAE resulted because so many different individuals owned it. This evolution could happen only because several essential factors and conditions were present:

Time, resources, and planning—To succeed, art education reform efforts must be long-term, sufficiently and dependably financed, and accompanied by a plan to effect change systematically at all levels within education. The Getty Education Institute assured the RIG programs that as long as they were making satisfactory progress, support would continue—at the very least for a five-year period. The program directors were able to give the same assurances to their consortia members and to directors of their satellite, area site, and district institutes.

Systemic implementation—To be successful, change initiatives must take place simultaneously at all levels of art education. The plan should include initiatives at the national, regional, state, area site, school district, school, and classroom levels. Individuals, organizations, and institutions at all levels must be equivalent stakeholders. Educational reform must be given over to those who have the responsibility for implementation—it must move from a treelike structure to a trellislike one. This occurred in the RIG programs.

Contributions from complex consortia—Successful art education change is dependent on active and productive consortia that include individuals and institutions from schools, educational agencies, the art disciplines, arts and humanities agencies, art museums, arts organizations, and professional associations. The importance of consortia in the facilitation of change leads to the conclusion that even in a single school or school district, the establishment of a consortium would greatly facilitate the development and implementation of new art programs.

Research and evaluation—Educational reform must be accompanied by develop-

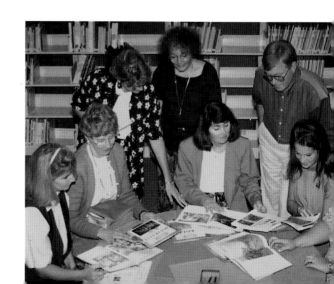

When individuals within the consortia were given encouragement to experiment with the forms that DBAE might take, the dynamic, open, and changing character of DBAE was assured.

ment, research, and evaluation conducted both across related projects and within individual projects. The results of developmental activities, research, and evaluation should be distributed throughout the entire network of projects and predicated on the assumption that things will change—that the initiative must be renewed continually.

Conclusion

The evolution of change communities within and among the RIG programs makes clear that the reform of art education cannot be achieved when art and classroom teachers work alone. The broad-based elementary and secondary school art instructional curricula described in later chapters were the direct result of the collaborative efforts and support of the wide array of individuals and organizations that constitute the RIG program consortia. Much of the remainder of this report exemplifies the results of these collaborative efforts.

Notes
1. I am grateful to Professor Arthur Efland, who pointed out the value of Alexander's metaphor to DBAE. Professor Efland used the metaphor to characterize the student assessment project undertaken in the Ohio Partnership for the Visual Arts.

The following is a description of the six RIG programs and their consortia. A listing of pertinent personnel can be found in Appendix C.

FLORIDA *The Florida Institute for Art Education*

The educational diversity in Florida matches the state's social, cultural, and ethnic mix. Each county has just one school district—some small and rural, others large and urban; some with district art coordinators and art specialists in the elementary schools, others with neither. Education and politics are in the same crucible; some county school superintendents are elected rather than appointed. Strong support for a DBAE program was even used as ammunition in an attempt to defeat a standing superintendent (he was reelected).

Florida State University (FSU) is the administrative agent for the Florida Institute for Art Education (FIAE). Along with participating school districts, FSU and the John and Mable Ringling Museum of Art are the principal institutions in which DBAE programs have been developed. The Florida Department of Education has been a key player from the time the institute was organized. The Ringling Museum has worked with a surprisingly large number of individuals from throughout the state in collaborative projects that are redefining museum education—projects described later in this report.

From the beginning, the FIAE's codirectors had a plan to decentralize its projects. Ten separate area site programs, including summer institutes, serve fourteen county districts. Directors of district and area site institutes are appointed with the approval of local district superintendents. The directors receive a comprehensive handbook relating to the conduct of institute programs. A generic summer institute schedule provides the basis for planning district institutes. However, district institutes are adapted to meet the requirements of participating school districts, local art museums and art centers, and the strengths of local consultants who represent the art disciplines. Major changes to the common summer institute schedule are negotiated with the FIAE's codirectors. In the local institutes, key faculty members who represent the FIAE work closely with the local institute directors and sometimes serve as discipline consultants in their areas of expertise. Their most important responsibilities are to conduct inquiry-based activities relating to the art disciplines and to illustrate the different ways the art disciplines may be integrated in DBAE.

In recent years much of the activity of the FIAE has centered on the development of procedures to assess what students learn in DBAE programs. Supported by special grants from the Jessie Ball du Pont Fund and the Getty Education Institute for the Arts, the initiative is based on the development of Comprehensive Holistic Assessment Tasks (CHATs)—units of instruction with embedded authentic assessment points. The assessment project has involved more than one hundred teachers in its development and pilot-test phases. The units not only provide new ways to think of assessment but also furnish highly coherent and comprehensive models for DBAE instruction that are in turn reshaping the institute's programs.

MINNESOTA *The Minnesota DBAE Consortium* ⁎

Much of the population of Minnesota and many of its cultural resources are concentrated in the Twin Cities of Minneapolis and St. Paul. Nevertheless, the Minnesota DBAE Consortium (MDC) has conducted its programs in forty-six school districts and cultural centers throughout the state. Consortium members have attended summer institute programs that focus on the outstanding collections of the Minneapolis Institute of Art and the Walker Art Center. School-year art discipline

seminars and other consortium programs have been held at the Minnesota Museum of American Art in St. Paul, the Tweed Museum of Art at the University of Minnesota (UM) in Duluth, the Goldstein Gallery at UM-St. Paul, the F. R. Weisman Art Museum at UM-Minneapolis, the Kiehle Gallery at St. Cloud State University, and the Talley Gallery at UM-Bemidji.

Minnesota has a decentralized educational system with a mandate for site-based management. Site-based councils composed of parents, students, community members, teachers, and administrators are given decision-making responsibilities. Consequently, if the arts are to be a basic component in the school curriculum, school council members must understand the essential educational role of the arts. School and district administrators are responsive to the opinions of their school councils and teach-ers because in Minnesota there is a strong belief that practitioners ought to be empowered—that they ought to take the lead in curriculum development. Initiatives taken within the MDC have been tied to outcome-based education and the arts assessment project of the Minnesota Department of Education.

Curriculum-writing seminars have been a unique feature of the MDC. In these intensive seminars, teams of art specialists and elementary classroom teachers have prepared comprehensive units of instruction in a single weekend's work. The curriculum *smArt* has provided an important basis for the development of DBAE instructional programs in many of the consortium's school districts. These districts range from Minneapolis and St. Paul, where DBAE outposts have been difficult to establish, to districts in the Twin Cities suburban communities and throughout the state, where DBAE programs are found in every school.

Some Minnesota school districts have policies that prohibit paying teachers for participation in summer professional development programs. Consequently, from its inception, the MDC planned a year-round institute in which academic-year professional development activities are as important as the two-week summer institute sessions. Regional weekend discipline seminars, which immerse participants in the inquiry processes associated with the art disciplines, have been a central feature of the consortium from the beginning. These seminars have focused on a variety of issues of inclusiveness—the stereotypes in photographic portraits of outstanding black American women, challenges associated with the exhibition of Plains Indian art and artifacts, and differing views of Ojibway cultural experience in the work of Native American women artists. Seminar participants have studied how art historians know what they know through an investigation of Rembrandt's Lucretia paintings, explored Western theories of aesthetics through the Fluxus movement of the 1960s, and engaged in architectural criticism by focusing on architect Frank Gehry's design for the Weisman Museum. A weekend seminar in Bemidji led by art critic Kent Nerburn and art educator Michael Day, which focused on critical interpretation and assessment of Bemidji's monumental folk art icon Paul Bunyan and his blue ox, remains as one of the most memorable RIG program workshops observed during the six years the evaluations were conducted.

＊In 1995 the Education Institute made the difficult decision of ending support for the Minnesota RIG, which had been unable to meet the annual matching grant requirement for two years.

NEBRASKA *Prairie Visions: The Nebraska Consortium for DBAE*

Nebraska is a state with an east/west split—"Lincoln-Omaha and all the rest," as Prairie Visions (PV) evaluator, the late Gary Hoeltke, characterized it. There are nearly five hundred school districts, each guarding its autonomy, even though some have but a handful of students. The school districts that have joined the Nebraska Consortium for DBAE account for nearly half of the state's school pop-

ulation. PV has drawn individuals and organizations together so effectively that participants in Scottsbluff and Chadron on the Wyoming and South Dakota borders feel every bit as much a part of the project as the participants in the Bellevue and Millard districts in suburban Omaha.

In one important respect, PV's organization is different from that of the other RIG programs. Whereas the central offices of the other institutes are located in universities, that of PV is in the Nebraska Department of Education. The central consortium comprises an advisory council, the Department of Education, nineteen educational service units, four PV regions, ninety school districts, nine colleges and universities, the state's major art museums and many of its community art centers, and the Nebraska Art Teachers Association. Other funding partners include the Nebraska Arts Council, the Nebraska Humanities Council, the Cooper Foundation, the Nebraska Art Association, the Phillips Petroleum Foundation, and the Woods Charitable Fund, Inc.

Perhaps what is most notable about the organization of Prairie Visions is that, as in a fractal, smaller components replicate the structure of larger components. The leaders of the four PV regional consortia have organized their areas so that they approximate virtually every component and feature of the central consortium. It is only at the school district level that some of the components begin to disappear from fractal-like replication of the regions of which they are a part.

Prairie Visions

Although some districts have managed to form consortia that have all of the components of the central and regional consortia, others have not.

Each of the consortia—from the central through the regional to the district—has clear responsibilities. For example, in the summer a central institute program is held in museum settings, where participants learn to inquire in the manner of artists, art historians, art critics, and aestheticians; receive basic DBAE theory; and investigate a few practical applications to their own teaching. Immediately following the central institute, the four regions each hold a one-week institute in which there is a continuation of the theoretical work of the first week and considerably more time and effort are directed to instructional planning and the practice of DBAE. Finally, in the third week, districts hold their own institutes, where they devote time almost exclusively to implementation and instructional planning.

Watching an annual PV consortiumwide symposium leaves the observer with the distinct impression that all participants, whether kindergarten teachers, museum educators, or university professors of philosophy, play equivalent roles. At the very least, they have the same stake in shaping the PV version of DBAE. Notwithstanding overlapping responsibilities and egalitarian sentiments, PV art discipline consultants have shown an unusual willingness to enter into collaboration with their public school and museum educator colleagues.

OHIO *The Ohio Partnership for the Visual Arts*

Ohio State University (OSU), where the central office of the Ohio Partnership for the Visual Arts (OPVA) is located, is where the general ideas on which DBAE was founded were first formulated by art educator Manuel Barkan in the 1960s. Now those ideas, grown more varied and complex, are debated, tested, and reformulated by the faculty members and doctoral students in the OSU Department of Art Education. Through the OPVA, OSU art education researchers and theoreticians have acquired new colleagues—the large number of art specialists and classroom teachers whose instructional practices have introduced new issues into discussions about the character of DBAE.

The spiral is the OPVA's guiding metaphor. Beginning with the central area site, composed of the large urban Columbus school district and its area suburban school districts, the OPVA has

spiraled outward to other urban, suburban, and rural regions of the state. In addition to the central area site in Columbus, area sites have been established in Cincinnati, Cleveland, Lima, and Mansfield. Following the OPVA's model, each area site has developed its own partnership of

The Ohio Partnership for the Visual Arts

schools, museums and art centers, and universities. The central area site includes the Columbus Museum of Art; the Cincinnati area site has the University of Cincinnati, the Cincinnati Museum of Art, and the Taft Museum; the Cleveland area site includes Cleveland State University, Case Western, and the Cleveland Museum of Art; the Mansfield area site has OSU-Mansfield, Ashland University, and the Mansfield Art Center; and the Lima area site includes OSU-Lima and ArtSpace/Lima. A total of forty-nine school districts have joined the OPVA.

Members of the OSU art education faculty have evolved into filling the dual roles of art discipline consultant and art educational expert. They have combined their inquiry and insights into the art disciplines with their practical knowledge about how these might be applied to the teaching of art. As key faculty members, they are able to lead institute participants back and forth between the theoretical and practical aspects of DBAE. Four videotape programs that include presentations by OPVA art discipline consultants, facilitator guides, and examples of classroom instruction are now available for use in each of the area sites.

Because of the strong commitment of OSU art education faculty members to cultural studies, from the time the OPVA was established, conceptions of art history presented in central institute programs have been given a decidedly anthropological and sociological slant. Issues of multiculturalism, gender, and diversity have been studied intently within the OPVA.

The assessment of student learning and evaluation of programs has also received special attention. A student assessment project has extended the theoretical boundaries of arts assessment. An evaluation team visits the area site summer institute programs and reviews school implementation of DBAE. Such activities indicate that the OPVA is a research and development center in the fullest sense.

TENNESSEE *The Southeast Institute for Education in the Visual Arts*

The Southeast Institute for Education in the Visual Arts (SIEVA) is located at the University of Tennessee at Chattanooga (UTC). Its territory currently encompasses Alabama, Georgia, Kentucky, Louisiana, Mississippi, North Carolina, Tennessee, and Virginia, where thirty-five school districts and a growing number of private schools are members of the consortium. Not only does the project cover a multistate area, but from the time it was created the SIEVA was part of a multiarts

center for the development of discipline-based art, music, and theater education—the Southeast Center for Education in the Arts (SCEA). SIEVA was the first to establish its institute program; consequently, it served as a model for the creation of music and theater institutes. Now the SCEA's three institutes have a symbiotic relationship. The SCEA offers consortium school districts comprehensive DBAE arts programming in the three arts. The three institutes have developed a highly successful articulated recruitment plan to bring new school districts into the fold. School district administrators who could be overwhelmed

The Southeast Institute for Education

in the Visual Arts

by the curricular and fiscal challenges relating to the implementation of comprehensive DBAE arts programs in art, music, and theater in their schools and districts are given guidance in developing strategies.

Through work conducted in the SCEA, a comprehensive approach to discipline-based art, music, and theater has been developed. In addition to introductory institutes in each of the arts,

a one-week renewal program is offered for participants who have attended institutes in one or more of the three arts. In these renewal programs, works of music, theater, and the visual arts provide the content for arts instruction that deals with substantial relationships among meaning, forms of artistic creation and criticism, and expressive similarities and differences among the three arts. Curricular and instructional innovations developed in each of the arts provide instructional models for the other arts. Most exciting of all, gifted teachers who have attended two or more arts institutes are beginning to make instructional linkages among the arts and are developing arts thematic units that have both deepened and broadened conceptions of arts education.

The SCEA offers an Administrators' Leadership Training Institute for school and district leaders who wish to develop a comprehensive approach to arts education. In partnership with the Allied Arts of Chattanooga and the Southern Arts Federation, the SCEA has coordinated its programs with the eight arts-in-education directors in state arts councils and has offered discipline-based arts programs so that artists who serve school residencies will understand what it is like to have school programs centered on historical, critical, and philosophical aspects of the arts as well as production and performance. Like other regional consortia, the SCEA has established satellite institutes. For example, a three-arts site institute program was begun with the Savannah Institute for Education in the Arts in 1993.

The SCEA and the SIEVA have established a broad-based consortium that enjoys exceptional support from UT-Chattanooga. From its inception, the SCEA and SIEVA have had the support of the Gherkin Foundation, the Lyndhurst Foundation (which supported the theater and music institutes for five years and, with the state of Tennessee, established an endowed chair for arts education at UT-Chattanooga), the Benwood Foundation, the University of Chattanooga Foundation, and the Jonas Foundation. The National Endowment for the Arts and the Tennessee Arts Commission have also supported the SCEA.

Notable among the collaborative efforts of the visual arts institute is a series of reproductions published with the Hunter Museum of Art in Chattanooga with the support of the Gherkin Foundation. The sixteen reproductions are accompanied by resource materials and instructional suggestions. They serve as content for institute programs and provide the starting point for model units of instruction. Now collections from museums throughout the Southeast are providing new reproductions and new content for DBAE.

52

TEXAS *The North Texas Institute for Educators on the Visual Arts*

The central office of the North Texas Institute for Educators on the Visual Arts (NTIEVA) is located at the University of North Texas (UNT) in Denton. Among the six school districts in the consortium, two of the nation's largest—Dallas Independent and Fort Worth Independent—struggle with every problem that besets large urban districts with diverse populations. Two other large school districts, Hurst-Euless-Bedford, located between Fort Worth and DFW International Airport, and Plano, to the north of Dallas, reflect their suburban communities. Denton and rural Pilot Point independent school districts complete the school portion of the consortium.

In North Texas, as in the other regional consortia, once the basic principles of DBAE were established, teachers and administrators from participating schools began to reshape their curricular and instructional planning based on DBAE principles. In the process, they also reshaped DBAE. In Texas, DBAE content was diagrammed into complex instructional webs and thus became thoroughly integrated into elementary school curricula. When the Plano district decided to engage in the "orderly dismantling" and replacing of the entire existing elementary curriculum, the experiences already gained through DBAE implementation influenced the process.

The consortium grew from one central summer institute in 1990 to five in 1993. The Dallas, Denton, Fort Worth, Hurst-Euless-Bedford, and Plano area sites all hold individual summer professional development institutes in which area site directors have the responsibility to adapt a basic institute format to the needs of their districts. A high standard of quality is assured through collaboration among the districts and the UNT. This collaboration is perhaps best exemplified by an ongoing seminar in which district curriculum specialists, art coordinators and supervisors, and elementary and secondary school art specialists—as institute directors, faculty members, and facilitators—plan and refine the structure and content of their institute programs.

There are nearly as many museums as school districts in the consortium. In Fort Worth, there are the Amon Carter Museum, the Modern Art Museum of Fort Worth, and the Kimbell Art Museum. Dallas has the Meadows Museum and the Dallas Museum of Art. From the time the NTIEVA was organized, the five museums provided the settings in which the DBAE introductory institute programs were offered. Now, through opportunities provided within the consortium, the five museums have begun a complex set of collaborative efforts with the institute, with individual districts and schools, and, perhaps most important, among the museums themselves. Through the efforts of the NTIEVA and a grant from the Edward and Betty Marcus Foundation, the five consortium museums and the institute have produced *ArtLinks*—a set of twenty-five reproductions of artworks consisting of five representative works from each of the participating museums. Information prepared by museum educators and printed on the back of the reproductions is used as students study the works, and comprehensive units of instruction are now being written for each of the reproductions. The nearly 380 schools in the consortium have each received an *ArtLinks* set.

The complex programs of the NTIEVA have been made possible through the support of the Amon Carter Foundation, the Edward and Betty Marcus Foundation, the UNT Foundation, the Crystelle Waggoner Charitable Trust, the Greater Denton Arts Council, the Arts Guild of Denton, the Texas Commission on the Arts, and individual donations.

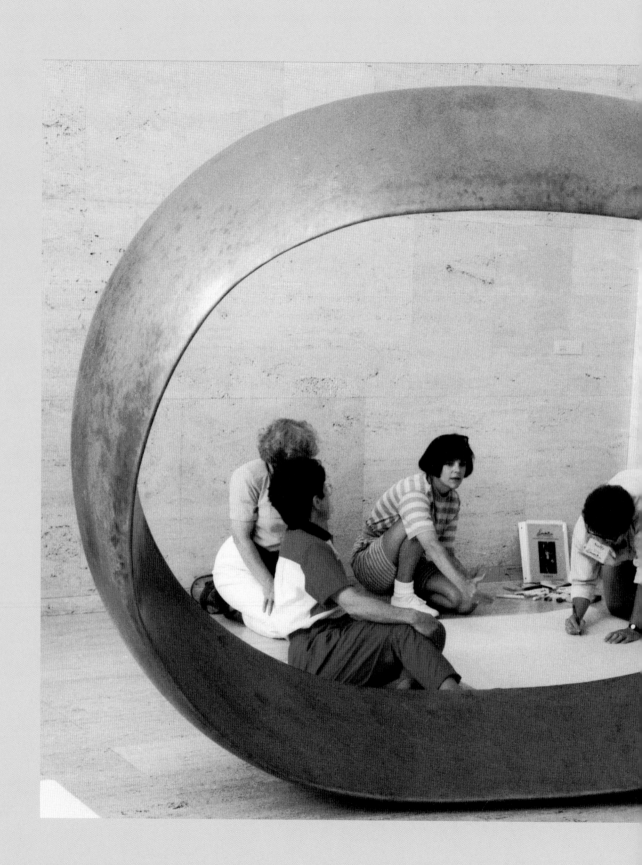

The DBAE Summer Professional Development Institute:
An Art World Rite of Passage

CHAPTER

2

DBAE institutes offered by the regional institute grant (RIG) programs are predicated on the belief that teaching art requires knowledge of artworks and of the inquiry processes of the artist, art historian, art critic, and aesthetician.

In the most effective DBAE institutes, participants' learning takes place in art museums, art centers, galleries, artists' studios, and other authentic art world contexts. Their inquiry is led by art educators and experts in the various disciplines. Because participants are exposed to the kinds of experiences shared by those who are accustomed to living their lives in the art world, their understanding develops rapidly. The participants' rite of passage into the art world is the subject of the first part of this chapter.

After participants are introduced to DBAE, they face a second challenge: to transform their understanding of art into discipline-based instructional programs. In the beginning, the summer institutes did not always provide useful instructional models. The art disciplines were sometimes presented as separate entities, and there was lack of clarity about whether artworks or the art disciplines should be the principal content of DBAE. How the institutes overcame these difficulties is the subject of the second part of this chapter.

DBAE Summer Institutes as Rites of Passage

In his classic work, *Les Rites de Passage*, Arnold van Gennep (1908/1960) presents a vision of life as regeneration where energy within any system gradually becomes spent and must be renewed from time to time. The rite of passage marks the transition from an older way of being, knowing, and acting to a new way. DBAE may be seen as that kind of transition within the field of art education. The RIG programs are among the most potent and influential places in which this transition is occurring. Indeed, features associated with rites of passage provide insight into the character of the DBAE seminars offered by the six RIG programs each summer.

Every change of state or social position, according to van Gennep, is distinguished by three distinct phases: separation, margin and liminality, and reincorporation (pp.

10–11). Van Gennep's terms, expanded and extended beyond their original meanings, may be applied to the DBAE institutes.

According to van Gennep (pp. 104–7), the first phase in the ritual process is *separation*—the time and place from which an individual or group is detached from an earlier fixed point within a social or ideational structure. The DBAE institute, especially when held in an art museum, occurs in a time and place radically apart from most participants' normal lives. Participants remove themselves from ordinary routines, leave family and friends behind, and spend this time as members of a school team with fellow teachers and an administrator. In the art world context in which they find themselves, participants have the opportunity to act differently toward colleagues, and they begin to think and respond toward art in ways previously unknown to them.

The second phase in the ritual state is *margin and liminality*—an ambiguous state in which neither the old values and knowledge nor the new prevail. In this state of flux, new symbols, knowledge, and ways of behavior are generated from the consonance of what was and what might be. This transition phase can be intense. In some institutes, participants are together sixteen or more hours a day. They work, eat, and play together. Both inside and outside of the formal program of the institute, they elaborate upon, reenact, and otherwise spin webs connecting the institute's esoteric art world information to their own lives and schoolroom practices. The result is the formulation of new aspects of DBAE that were neither planned nor anticipated by the organizers.

According to Turner (1969), the spirit of "communitas" that develops among the participants in this state of liminality is one of the most powerful features of the rite of passage (pp. 125–30). Communitas, as characterized by Turner, is "spontaneous, immediate, concrete . . . as opposed to the norm-governed, abstract nature of social structure" (p. 127). It is like the context of play described by Huizinga (1950), "the feeling of being 'apart together' in an exceptional situation, of sharing something important, of mutually withdrawing from the rest of the world and rejecting the usual norms" (p. 12).

The third phase of the rite of passage is *reincorporation*—once the transition is completed, the individuals reenter the structure. In tribal puberty rites, the boys who leave the village return, armed with the esoteric knowledge that is the province of men. If the institute has served as a rite of passage, the teaching of art will be different because of

57

In the most effective DBAE *institutes, participants' learning takes place in art museums, art centers, galleries, studios, public art spaces, and other art world contexts. Here, participants view George Sugarman's* Yellow Ascending, Joslyn Art Museum, Omaha, Nebraska.

The art museum is only one part of the world of art. Nevertheless, there is probably no other public place where components of the art world are so fully assembled and where such an authentic introduction to the art world is offered. The museum is where the works of artists are collected, where art historians conduct research, and where art critics and aestheticians formulate their opinions and theories. It is, therefore, an ideal place to introduce institute participants to DBAE. The following relates the experiences of participants at the 1989 Prairie Visions summer institute.

During the first week of the institute, participants spent four full days in the Joslyn Museum of Art in Omaha, Nebraska, and one day in the galleries and sculpture garden of the Sheldon Memorial Art Gallery in Lincoln. On the fourth day, art historian Dr. Martin Rosenberg gave this assignment to small groups of participants at the Joslyn Museum:

> You have found out at the last minute that you are going to have a bus to take your students to the museum tomorrow. Unfortunately, it is too late to arrange for a docent. Luckily, you have an hour before the museum closes. Your charge is to design a tour for your students that includes at least four works of art that are united by a common theme and were made in at least three different centuries. List the works. How are they similar and different? Can you think of any particular historical or cultural factors that might account for the differences? How could you broaden your tour multiculturally?

If this assignment had been given during the first days of the institute, the task would have been overwhelming. It was undertaken eagerly, however, by the groups of art specialists, elementary classroom teachers, and school administrators who had lived in the Joslyn's galleries for nearly a week, had become well acquainted with its collections, and felt at ease in tackling a variety of discipline-based inquiry problems.

One of the groups immediately constructed a laundry list of themes and topics around which they might organize their tour: children, landscapes, war and the military, travel, animals, portraits, friendship, romance, and love. Like most of the groups, they chose a theme first rather than selecting works of art that suggested unexpected topics. Many of the themes selected by other groups—mother and child relationships, horses—were predictable; others—works that showed a particular type of emotion, symbols of spirituality, or the role of women—were less so. One group's choice of a theme—"disruption of a relationship"—was highly unpredictable.

Members of the latter group explained excitedly that as they were walking through the galleries, they had stopped to look at a painting showing a cowboy being thrown from a bronco. With this one work, their theme was devised. From there, the group scoured the galleries for other works that showed disrupted relationships. A crucifixion and a painting of David with Goliath's severed head were easily added. Other candidates were more controversial. They discussed whether a Käthe Kollwitz lithograph of a mother and child, which some group members thought suggested that the mother and child would soon be separated, fit their theme. The boundaries of the theme were being tested "in the same way that curators have to determine boundaries when they make selections for exhibitions," Rosenberg later remarked when he learned of the group's discussions.

Most of the group members were reassured that their themes would work, so they turned their attention to the other conditions of the assignment: "Let's see, we have different centuries, some works are of the same subject; some have to do with the visual elements." One member talked about how to present the tour: "When we give this tour, will we fall into the old practice of telling our students about the theme and the works?" Another thought otherwise: "No, we would just identify the relationships and then have the kids analyze them."

THE DBAE SUMMER PROFESSIONAL DEVELOPMENT INSTITUTE

Once plans for the tours were complete, group members conducted them for other groups. Not only did the assignment lead to a synthesis of many of the things the participants had learned about art history during the week, it also gave individual participants the opportunity to show their own knowledge and expertise as they explored the historical and cultural contexts of works of art. The evaluators listened as a tour group leader gave an authoritative, highly detailed, and technically accurate exposition on Egyptian art. The tour was so masterful that the evaluators concluded that the group members must have asked one of the museum curators to give explanations of the works they had selected. It was later learned that the presenter was a middle school art teacher whose special interest was Egyptian art.

In summing up the work of the participants, Rosenberg characterized the enormous growth he had seen during the week. He reminded the participants that historians "haven't always paid attention to the historical and cultural contexts. Sometimes they have paid more attention to form. . . . The work of art is like the strand of a spider's web. Art is an intrinsic part of culture and cultural attitudes are revealed most fully through works of art."

Art museums are ideal places to introduce participants to DBAE. Because teachers are exposed to the kinds of experiences shared by those who live their lives in the art world, their understanding develops rapidly.

The Prairie Visions participants were able to work so readily and to exercise such high levels of critical thinking with pieces from the Joslyn's collection because they had been working with similar, albeit narrower, discipline-based tasks for the entire week. As an art criticism exercise, for example, participants probed both sides of an issue and distinguished between personal preference and artistic merit. In this activity, participants were paired up and asked to stand next to a portrait they did not like. One person was to try and convince his or her partner that the portrait was a good work of art. After arguing the case, the person was to switch roles and take the opposite side. The evaluators listened to two individuals arguing their cases for and against John Singer Sargent's *Portrait of Mrs. A. L. Rutch.* One participant took a line of reasoning that would have made a Marxist art critic happy: "I object to this even being in a museum. Yes, it may have nice color, but it is nothing but commercial art. It was only the wealthy who could afford to have their portraits painted." Quite a different line was taken in the counterargument: "No, it's the beauty. I feel as if I am right there with her. And why shouldn't everyone be represented in a museum? High society and low society are both parts of society. It's beautiful—elegant." The participants were demonstrating that art criticism is based on both social and aesthetic criteria.

It is important to remember that as the participants explored the discipline-based realms of the art world, they did so as adult learners. Later, they would have the task of developing art instructional activities that would be appropriate for their individual classrooms.

the new knowledge participants received and the new symbols generated in the transitional phase. Victor Turner (n.d.) has written that he has come to see rituals "as distinct phases in the social processes whereby groups become adjusted to internal changes [whether brought about by personal or factional dissensions and conflicts of norms or by technical or organizational innovations] and adapted to their external environment" (p. 4). The summer institutes have become important means through which individuals adjust to change and, more significantly, make changes within the field of art education.

Of the one hundred individual summer institute programs evaluated between the summer of 1988 and the summer of 1995, most have contained at least some of the features associated with rites of passage. The most effective institutes are those where the spirit of communitas prevails, where participants are transported the farthest from their everyday worlds, where the most complete experience of what it is like to live in the art world is provided, and where participants are encouraged to play with art-related ideas and create new art instructional practices. These institutes can radically alter participants' beliefs about the meanings of artworks through an enormous range of authentic art world encounters and can inspire participants to return to their schools with the determination to implement discipline-based art programs.

A Conceptual Model of Art and Related Worlds
Presented in DBAE Institutes

In "Living in the Art World" (pp. 58–59) snapshots are provided of some of the experiences that approximate authentic, discipline-based behaviors associated with the art world. These snapshots do not adequately convey the complexity of the worlds of art and related worlds to which institute participants gain passage. Individuals who view DBAE from perspectives outside the RIG programs may think that this broad-based form of art education focuses somewhat narrowly on content and inquiry skills associated with art making, art history, art criticism, and aesthetics. However, the evaluators' observations of institute workshops have revealed that the forms of art education and the art world to which the participants are introduced are vastly more complex than those typ-

Institutes can radically alter participants' beliefs about the meanings of artworks through an enormous range of art world experiences. Here, teachers watch an artist's demonstration in a museum's printing studio.

ically associated with art in elementary and secondary schools. Indeed, the best summer institute programs have shown that it is the broader world of art, not just the art disciplines or art education, into which the participants are initiated.

As the evaluators observed summer institute programs, sketches were made of the different conceptual models of the visual arts world; the worlds of cinema, dance, literature, music, and theater; and the realms of the humanities and sciences revealed in institute programs. The very process of diagramming these worlds revealed their unexpected complexity.

Figure 2.1 shows the composite art and art-related worlds found in DBAE institutes. An attempt to include all possible art worlds—like the ones presented by Howard Becker in his book *Art Worlds* (1982)—rather than the ones presented in DBAE institutes would necessitate the addition of more major dimensions and a vastly greater number of components. Nevertheless, Figure 2.1 gives some idea of the numerous individuals and institutions and enormous amounts of information participants encounter in a two- or three-week institute. Pointing to some of the features of the diagram will provide the opportunity to comment on the specific content of various summer institute programs.

THE PARTICIPANT AND THE CHALLENGE OF EXPLORATION The evaluators began to see the art world and related worlds almost as geography—as a marvelous, multifaceted crystal crater to be explored. With only a small stretch of the imagination it is possible to think of an individual—an elementary school classroom teacher, a principal, a high school art specialist, a museum docent, or an arts curriculum coordinator—at the bottom of the four-sided, stepped crater. From this starting position, the art world extends upward and outward. Directly above, the participant sees the realm of the creative artist, forms of visual art, and individual works of art and their attributes. To the left are the domains of individuals who inquire into works of art—historians, critics, aestheticians, archaeologists, anthropologists, and others. To the right are the physical contexts in which works of art are created, housed, exhibited, and preserved, along with some of the individuals who are charged with the conservation and presentation of those works. Finally, the quadrant at the bottom of the diagram is reserved for other forms of art—literature, dance, music, theater, and cinema—and the realms of the humanities and the sciences.

A COMMENT ABOUT INDIVIDUAL PARTICIPANTS

Summer institute participants begin their art world explorations with very different experiences and expectations. Some participants are art specialists who majored in art in college; others are practicing artists. Some attend art exhibitions frequently; others, through reading art-related publications, are aware of the most recent developments in the art world. Not all individuals who acquired degrees in art or art education have extensive knowledge of or experience in the world of art. Some art specialists know little of art beyond the traditions and practices of the field of art education. Moreover, some versions of art education, because they deal with only narrow slices of content, have a minimal relationship to the world of art.

Consequently, at least a few art specialists receive their first coherent and comprehensive introduction to that complex world during the first week of a DBAE summer institute.

Before they attend a DBAE institute, only the rare elementary classroom teacher or school principal has anything approaching a comprehensive vision of the art world—although there have been a few such participants whose

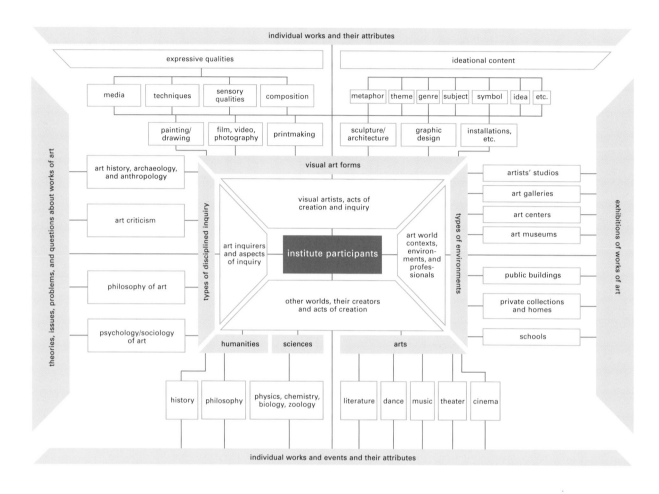

individual works and their attributes

expressive qualities

ideational content

| media | techniques | sensory qualities | composition |

| metaphor | theme | genre | subject | symbol | idea | etc. |

| painting/ drawing | film, video, photography | printmaking |

| sculpture/ architecture | graphic design | installations, etc. |

visual art forms

art history, archaeology, and anthropology

art criticism

philosophy of art

psychology/sociology of art

visual artists, acts of creation and inquiry

art inquirers and aspects of inquiry

institute participants

art world contexts, environments, and professionals

other worlds, their creators and acts of creation

types of disciplined inquiry

types of environments

artists' studios

art galleries

art centers

art museums

public buildings

private collections and homes

schools

humanities sciences arts

| history | philosophy | physics, chemistry, biology, zoology |

| literature | dance | music | theater | cinema |

individual works and events and their attributes

theories, issues, problems, and questions about works of art

exhibitions of works of art

THE DBAE SUMMER PROFESSIONAL DEVELOPMENT INSTITUTE

Figure 2.1

understanding surpasses that of many art specialists. Most initially find the art world alien and sometimes forbidding. Given its complexity, there is reason for their anxiety. Nevertheless, it is amazing how quickly participants begin to feel comfortable in their exploration of the art world, the complexity of which is beyond anything most participants could imagine before attending a DBAE institute.

What are some of the best ways to introduce individuals to artists, works of art, and the world of the artist? In the DBAE summer institutes, two general procedures and various combinations of the two have been followed. One, the breadth approach, is to provide a slide presentation of up to two hundred images showing the standard visual art forms and forms that are less frequently associated with the visual arts, at least in the minds of participants—product,

fashion, and graphic design; illustration; and architecture, landscape architecture, and urban planning. The second, the depth approach, is to invite an artist to show his or her work, talk about the problems artists attempt to solve, explain the processes and techniques artists use, and give an account of his or her career and artistic development. Either approach serves as a good introduction to the multifaceted world of art.

In its early days there was considerable criticism of DBAE on the grounds that it was Eurocentric—that it centered on the art of "dead white males." That criticism could just as well have been directed at art education in general. The enormous range of forms, styles, and genres of artworks notwithstanding, teachers of art typically organized instruction around a small range of works. In many instances, artworks studied in schools hardly extended beyond impressionism and postimpressionism, because these were the paintings most readily available in inexpensive, poster-sized reproductions.

In the DBAE institutes a new phenomenon has emerged—local artists and local collections provide the content of DBAE institute programs. Although the art world is unfamiliar to many participants when they enter institute programs, they soon discover that it is not some distant place. They learn that art is all around them and that works of art from their own communities are rich in meaning. The fact that summer institutes are frequently centered on works from local collections and local artists is indeed broadening the content of DBAE.

Between 1991 and 1993 the North Texas Institute invited three artists to discuss their work. The differences in these artists' art, interests, ideas, and processes provide a good example of the issues to which institute participants are introduced.

In 1991 sculptor Don Schol took participants, step by step, through the creation of a single work—a monumental crucifix. Using a series of slides, he showed the proposed location for the commission (a church), preliminary sketches, lamination of wood inside the artist's studio, the carving process, hauling the piece to the church, and the final installation. As he talked about the creation of the cross, he illustrated the way it was influenced by the work of German expressionist sculptors. In showing the creation of one artwork, he was able to convey a whole range of subtle insights into the creative process. Participants' responses to his presentation appeared uniformly positive.

Artist Lee N. Smith III explains his sketchbook drawings to a teacher for a videotape shown during North Texas's summer institute.

In 1992 Chicana artist Celia Muñoz made presentations in the North Texas Institute. Her feminist, social, multicultural, and political interests were evident in an extraordinary series of works. Many of the pieces she showed were quite beyond the experiences of the participants—books, more conceptual than narrative, that played with ideas relating social and cultural misunderstanding; large airbrush paintings based on photographs of front porches; constructions derived from memories of her aunt's makeup table, with titles like *Salud del Kress* and *Dimestore Health*. One of her works had her daughter's Christmas dress as its central feature. "I call this my Hispanic piece; it was done deliberately," she said. The piece, which was dedicated to friends who had entered into a "mixed marriage," was exhibited in a recent Whitney Biennial. She related another work, a front-porch scene in which flowers had been planted in a commode, to Duchamp's *Fountain*. She acknowledged that political aspects of some of her works had a close affinity to the prints of the Mexican

printmaker Posada.

During Muñoz's presentation, the evaluators watched the participants' puzzlement about her art and wondered about the extent to which they were able to appreciate postmodern works that deal humorously and sensitively with the artist's life in two cultures. To what extent did they understand that when ideas drive an artist's work, the form and the media can be almost anything? Were they sensitive to the autobiographical character of her work—that childhood experiences provided the basis for an adult's deep contemplation of self and world?

In 1993 there were five separate Texas summer institutes—more programs and locations than one artist could visit conveniently. Consequently, through a videotape, participants visited the studio of Dallas artist Lee N. Smith III. Most participants were already familiar with Smith's work, because one of his paintings, *China or the Devil*, from the collection of the Modern Art Museum of Fort Worth, was among twenty-five objects selected for reproduction and use in North Texas Institute schools. From the tape, participants learned about the ideas of another artist who, like Muñoz, worked from childhood memories. In *China or the Devil*, a group of boys, enveloped in the deep bluish purple of night, peer into a hole they have dug. A mysterious cylinder of orange light pierces the darkness and illuminates the boys' faces. The participants also learned that Smith is more comfortable discussing the formal structure of his works than their narrative features and symbolism.

China or the Devil, Lee N. Smith III, 1987, oil on canvas, Modern Art Museum of Fort Worth. This painting was one of twenty-five artworks selected for reproduction and use in North Texas Institute Schools.

The Chameleon (detail), Celia Alvarez Muñoz, 1990, Cibachrome photograph. North Texas Institute participants learned that when ideas drive an artist's work, form and media can encompass many things.

In DBAE institute programs, participants have the challenge of exploring the four sides of the vast crater—not so much by scaling the walls as by conceptually stretching lines from one point to another until the crater is crisscrossed with understanding. The task of extending lines between points and exploring their features is not undertaken alone; the participant has the help of a sizable number of competent guides—artists, historians, critics, curators, art educators, etc. In order to make connections between the various points within the art world and related worlds—where participants have been and where they might be going—guides have the frequent task of pointing to features soon to be encountered and to distant features on other sides of the crater that will be explored later. It is the business of noting connections among the many different features of the four dimensions of the art world that makes the task of any individual guide so difficult. Few guides, in fact, whether from the field of art education or one of the other major dimensions of the art world, have detailed knowledge of the entire art world. Nevertheless, the most adventurous and knowledgeable guides know how to lead participants through the crater. While they can point out an enormous variety of features on the four sides, it is ultimately up to the participants to assimilate and synthesize these components into their individual conceptions of the art world. The following sections discuss in depth the four sides of the art world crater.

The First Side: Artists, Acts of Creation, Art Forms, and Works of Art Figure 2.1 charts how the first side of the art world crater moves from visual artists, acts of creation and inquiry, and visual art forms to the specific features and characteristics of works of art— the media and processes with which they are made; their sensory and formal qualities; their subject matter, themes, and symbols; the styles and genres they reflect; and the ideas that surround them. The diagram illustrates the fact that works of art are frequently experienced in light of two general categories: their expressive qualities and ideational content. Observation of institute programs has revealed that within the field of art education there are tensions regarding the relative importance of these two areas. There is, for example, the art educational practice of making distinctions between the formal and sensory features of works of art and their subject matter and symbolic aspects. This distinction is shown by the placement of the heading *expressive qualities* above media, tech-

SPECIAL EXHIBITIONS THAT HAVE INFLUENCED DBAE PROGRAMS

Of the many ingredients that constitute the world of art, is there any one more essential than art itself? The same is true for DBAE— works of art are the essential component. The art worlds represented in RIG programs have from the beginning been populated by an extremely broad and eclectic group of artists and artworks. Because so many institute programs are based on special exhibitions that deal with the work of contemporary artists, DBAE institutes have tended to deal with ideas and issues at the art world's cutting edge.

Here are just a few of the special exhibitions that have shaped the content of DBAE professional development institutes:
• Part of an Ohio Partnership institute was based on exhibitions of local African American artists Elijah Pierce and Aminah Robinson. Participants gained insight into the workings of Robinson's mind as she told about her pieces: *Noah's Ark* was made in reference to the slave trade; *Catching Up on Gossip* speaks to the voice of a community; *Souls that Walk and Soles that Talk* symbolizes the accumulation of human experiences; and *Making Sweet Soap in the Backyard* provides a tangible memory of the

The Minnesota DBAE institute does not start in the summertime. Rather, it begins during the school year, with discipline seminars in art history, art criticism, and aesthetics that are conducted in three different locations around the state. At a workshop that took place in Bemidji in March 1990, art critic Kent Nerburn explained his discipline. Art educator Michael Day from Brigham Young University had the assignment of making the connections to instructional practice. When Margaret DiBlasio, the institute co-director, introduced Nerburn, she told participants, "He is not only famous but infamous, taking on sacred cows—or the sacred ox." Some participants already knew the meaning of her reference—the rest were soon to know.

Nerburn told the participants: "The purpose of this seminar is to go deeper into criticism and to demystify it. There is no better way than to get into the process itself." He outlined the three things that would be taken into account—the craft of criticism, the art exhibit, and the writing of criticism. Then he told the participants, "You are going to write criticism. You will write about what has been called 'the third greatest sculpture in the United States,' a fine piece of folk art, and what someone called 'tacky.'" Most of the participants already knew that the piece to which Nerburn was referring was Bemidji's most famous feature: the enormous folk sculpture of Paul Bunyan and Babe, his blue ox, which was built during the Depression by a group of the town's civic-minded citizens. Nerburn had had the gall to criticize the beloved icon in the local paper, and for weeks the Minnesota newspapers and the national press had been filled with criticism and countercriticism of Nerburn and his writing.

Participants were given a packet containing thirty pages of critical responses and letters to newspaper editors, most of which expressed outrage at Nerburn's criticism. He explained that the seminar participants would be given the opportunity to write their own criticism of the local icon and that the *Bemidji Pioneer* had already agreed to publish their writing in an upcoming edition. The participants were expected to act as critics.

Before the participants engaged in the critical act, they heard some theory. Nerburn described four types of critics—"kingmakers, exegetists, groupies, and educators"—and gave examples of each. He told the participants that in writing criticism "it is best to hide your knowledge, to say it in language that people can understand." Metaphor is the essence of Nerburn's approach to critical writing. He gave a lengthy theoretical explanation of metaphor and how it is applied to criticism.

Nerburn introduced his explication of the context in which *Paul and Babe* was created by asking the participants to ask themselves, "What are the artistic intentions that underlie the

THE DBAE SUMMER PROFESSIONAL DEVELOPMENT INSTITUTE

now-destroyed community of Poindexter Village. Robinson closed with a poetic vision: "Our hearts stretch through our hands and our minds stretch through our feet."
• The Ringling Museum of Art in Sarasota, Florida, presented three one-person exhibitions of works by contemporary artists Lewis Baltz, Jacqueline Ferrara, and William Wegman. Each exhibition served as the basis for a variety of programs in the Florida Institute.

• At the Joslyn Museum in Omaha, Nebraska, participants watched as the Weisman Collection of Contemporary Art was unpacked and installed in the Joslyn's galleries. Special arrangements had been made with the curators to allow the participants to peer through the doorways to view the works, which were leaning against the walls until they were hung. Because the exhibition did not open while the first week of the

Prairie Visions institute was in session, participants from North Platte reserved their school van two weeks later, drove the six hours to Omaha, and stayed overnight just to see the exhibition.
• At the Kimbell Art Museum in Fort Worth, Texas, a self-guided gallery activity was titled "Three-Dimensional Illusion of the Two-Dimensional Surface." The participants were asked to locate good examples of spatial concepts—

piece?—not the intentions of the artists." He showed the original design for *Paul and Babe* and asked, "Why didn't they build that?" Participants viewed *Paul and Babe* through the "windows of access" that Nerburn uses in the critical process. From the cultural window, he referred to the work's "mythic dimensions" and asked, "Does this Bunyan say something essential about its time and place?" Through the historic window, he asked, "How does it fit into the tradition of 'roadside colossi' or colossi in general?" Through the iconographic window, he asked the participants, "What is its significance?" He ended by asking, "Which window will you use?"

The critical pieces were to be written by participants working in groups. After a lunch break, the groups visited *Paul and Babe* and began to formulate their critical pieces. By mid-afternoon, they had reassembled in the auditorium for a panel discussion during which volunteers had the opportunity to express their tentative views of *Paul and Babe*. The discussion went on for more than an hour; it was more passionate than philosophically critical, but always lively. It was clear there was to be no reconciliation of the two major positions—one that held the work to be bad art, the other that believed, good or bad, that the work is an important cultural icon. There was, how-

An art critic's analysis of Paul Bunyan and Babe the blue ox served as subjects for a seminar.

ever, a minority group of individuals who viewed the cultural icon in quite another light—as a symbol for the way Minnesota's forests had been devastated by uncaring loggers.

At the end of the panel discussion, Nerburn reminded the participants that the editor of the paper was excited about receiving their critical pieces. He also reminded the participants that as a critic, "I have found that the second look is the truthful one. After I have written my first draft I like to take a second look. You may want to drive by *Paul and Babe* for a second look." The night was given over to writing. For some groups it was nearly an all-night task.

On Saturday morning, representatives from thirteen groups read the critical pieces. The editorial comments (from the readers and team members) were nearly as revealing as the critical writing. Some of the pieces were poetic; others were rhetorical. "The landscape and water are sacred, not Paul and Babe." "It represents every man's fear of not measuring up." "It has a oneness with Bemidji." "It's a parking-lot wonder."

As Nerburn commented on the participants' critical pieces, he reflected on his own controversial criticism: "The *Paul and Babe* piece was bad criticism. It did not confront the thing on its own terms. I used the *Paul and Babe* piece as a metaphor for downtown waterfront. . . . I was writing about the lack of artistic vision in this community."

Bemidji residents may not have the artistic vision that Nerburn wishes, but it was clear that the artistic vision of the participants in the Bemidji discipline seminar had grown tremendously in the space of three days. The pieces of the seminar worked together beautifully. There was a fine balance between theory and activity. The participants' critical writing, although produced in an educational setting, had an authentic purpose: it was to be published for an audience to read. The experience was vivid and intense—a rite of passage into the world of art.

niques, sensory qualities, and composition—the features typically considered to contribute to an artwork's formal and sensuous expressiveness. The heading *ideational content* is placed above metaphor, theme, genre, subject, symbol, and idea. Designing the diagram in this manner may perpetuate the split between expressiveness and content. In actuality, the full meaning of a work of art, sometimes referred to as "expressive content," results from a fusion of these two factors (Wilson 1971, pp. 503–4, 515–16).

A number of the institutes have followed the traditional art educational practice of presenting vocabulary that deals with the sensory, formal, and expressive elements of works of art. The practice is based on the assumption that although everyday experience enables individuals to understand the subject-matter aspects of works of art, that same experience has not prepared them to deal with these other aspects. Consequently, some institute directors and their staffs think it necessary to make presentations about art "vocabulary" and the elements and principles of design. In other institutes the focus is on the relationships among artworks' themes, subject matter, symbols, ideas, and formal and expressive features. In these institutes no special attention is given to the elements and principles of design.

Artists themselves have come down on both sides of the expressive/content issue. Some artists, even those like Texas artist Lee N. Smith III, whose work appears to be pervaded with ideas, prefer to talk mainly about technical and formal issues. Other artists, such as Celia Muñoz, talk mainly about the ideas that underlie their work. When they discuss the sensory and formal elements of those works, it is for their symbolic meaning, such as the shame of wearing an orange dress to a communion ceremony.

The evaluators have criticized the art educational practice of organizing art curricula around the elements and principles of design and using them as the principal route through which works of art are understood and created—an approach used infrequently by contemporary artists, art historians, art critics, and aestheticians. Artworks' sensory, formal, and expressive features are essential to the creation and understanding of works of art. Nevertheless, the conventional art educational preoccupation with the elements and principles of design tends to diminish rather than expand the possibilities for the creation and interpretation of works of art. This issue is discussed in greater detail in Chapter 3.

overlapping, diminishing size, vertical position, atmospheric perspective, and vanishing point. Through negotiations with the museum's curatorial and educational staffs, the directors of the North Texas Institute were able to make arrangements for a special exhibition of works from the Kimbell's collection. These works contained all the features having to do with the depiction of space outlined in the gallery activity. More impor-tant, works were selected to cover each of the twelve major historical periods the participants were to locate in another activity. How unusual it was for curatorial staff to organize an exhibition of their permanent collection expressly to meet the requirements of the institute program.

• At the Hunter Museum of Art in Chattanooga, Tennessee, Southeast Institute participants listened to a panel discussion of the artists featured in the exhibition *Artists' Interpretation of the River*, which had been organized by the Hunter. The exhibition seemed especially appropriate for an art museum built on a bluff overlooking the Tennessee River. Moreover, the exhibit proved to be particularly useful in challenging participants' definitions of art—one of the works in the exhibition was Joe Helseth's installation of river driftwood and sand.

The Second Side: Art Environments, Curators, and Exhibitions "Living in the Art World" (pp. 58–59) characterizes the museum as the most important art world environment, at least as far as summer institutes are concerned, and illustrates how participants learn to live comfortably in the public spaces of museums and art centers. Frequently they are also privileged to go behind the public face, to storage vaults and research libraries, where they listen to museum directors, curators, registrars, and exhibition designers tell about their jobs. Although institute art environments begin with art museums, they certainly do not end there. Participants routinely travel to artists' studios and commercial art galleries, take architectural tours, tour public art sites, and visit the homes of private collectors. From these visits, institute participants begin to see the many ways in which art is woven into economic and social life.

A particular feature of art museums—the special exhibition—is probably the most influential factor in expanding participants' conceptions of the contemporary art world. Museums and art centers use temporary exhibitions as a means of both reflecting current art world interests and shaping art world issues. They are the tool used by curators to shape opinion within the art world by calling attention to particular artists and art forms, aesthetic and ideological issues, collectors and collections. The special exhibition is one of the best ways to learn what is valued by influential individuals within the art world, and special exhibitions have provided the focus for summer institute programs.

The Third Side: Art Inquirers and Types of Inquiry An object, according to philosopher Arthur Danto (1986), "is an art work at all only in relationship to an interpretation. . . . Interpretation in my sense is transfigurative. It transforms objects into works of art. . . . If interpretations are what constitutes works, there are no works without them and works are misconstituted when interpretation is wrong" (pp. 44–45). Interpretation of works of art is the principal occupation in the third side of the art world.

The inquiry of art historians, art critics, and aestheticians into art has meaning as its raison d'être. In Figure 2.1, space did not permit an outline of the problems, questions, theories, evidence, interpretations, explanations, characterizations, structures, facts (about times, places, development, locations, attributions, actions, and so on), purposes and functions, antecedents and consequences, judgments, value, worth, etc., that are

* In the art gallery at Bemidji State University in Minnesota, participants were given the task of selecting the one work that revealed the overall essence of an exhibition of works by American women printmakers of the 1930s.

How have these special exhibitions changed DBAE? Works of art have the power to educate, although in many art classrooms, the works of art that are permitted to educate have often been limited to what is easily available through printed reproductions. When teachers attend DBAE institutes whose programs are shaped by contemporary exhibitions, several things happen: 1) the content of art instruction changes when teachers develop instructional units based on special exhibitions, 2) teachers receive art center and museum special exhibition schedules for the upcoming academic year and plan instructional units and field trips based on those exhibitions, and 3) because special exhibitions frequently display works of artists whose concerns are for gender, ethnicity, the environment, and other contemporary issues, whole new classes of artworks have been given a voice in the classroom.

Following an introduction to DBAE, participants at the 1990 Ohio Partnership summer institute received a presentation by faculty member Paul Sproll entitled "Art Production Concepts: Theory to Practice." Sproll showed slides of Vincent van Gogh's paintings of chairs contrasted with chairs designed by Gerrit Rietveld and those painted by Roy Lichtenstein and David Hockney. During his presentation, Sproll raised the question, "Are these chairs portraits of their artists?" With this, he set the stage for a culminating activity that was to provide an opportunity for participants to engage in a studio activity and at the same time fuse all the disciplines into one unit of art instruction.

Participants received the following assignment:

> During the breakout sessions you will work in your affinity groups to examine the idea of "The Chair as a Portrait." Consider art world references, nonart world references, possible media, social-cultural contexts, and matters of criticism, aesthetics, and art history. You will: 1) Produce a visual documentation of your thought processes and display this documentation, 2) Engage in a studio inquiry in which you explore selected ideas using the materials available to you in the Resource Center, and 3) Having "test piloted" your studio idea, work together to complete a lesson plan and a unit plan outline indicating where this lesson might fit within a unit of instruction.

The teams moved rapidly into the spacious studios of the Columbus Public Schools' Fort Hayes magnet high school for the arts and began their planning. "What are some types of chairs?" "I was thinking of an electric chair." "I was thinking of an educational chair." "We could make a human chair—a performance piece." One group listed the parts of a chair—"legs, arms, back, seat"; the kinds of chairs—"saddle, rocker, truck seat"; symbolic chairs—"throne, his-and-her chairs, electric chairs, chair personalities"; and more classifications—"historical chairs, emotional chairs, equalizing chairs, functions of chairs, histories of chairs." Another group mimicked Gertrude Stein: "A chair is a chair is a chair." Still another created a line of folded paper chairs that from the back all had the same anonymous look but from the front were all given separate personalities. There was a "learning chair" equipped, beneath its seat, with a "learning kit" containing resource materials for children, with references to literature, illustrations, journals, and books—all related to chairs. Another group created a unit on the history of art through chairs—cave chairs, Egyptian chairs, Greek chairs, Roman chairs, Renaissance chairs, and so on. A group of elementary school teachers planned a related set of units and explained, "As we talked, there was no end; we could go on for the whole year." "We already have nine four-week units of instruction—antique chairs, chairs of other cultures, the vocabulary of chairs, chair styles, chairs and poetry, chairs and feelings."

One of the most exquisite works was a constructed paper "Southwestern chair" attached to a wall. Whether it was a sculpture with painting or a three-dimensional painting, it was impossible to determine. The piece represented a unit of instruction in which the art and cultures of the American Southwest—Native American, Mexican, Anglo, and a modern fusion of the three earlier cultures—were combined in one piece. The unit's planners had gone beyond the visual arts to include language arts, social studies, and music.

A group of high school art teachers made a chair representing the Soviet Union. Its back was in the form of the Kremlin, its seat was a concrete paving block—labeled the "Soviet bloc" and decorated with hammers and sickles—and its legs were thin paper figures representing the put-upon proletariat, who, although expected to support the upper seat, were being crushed by its weight. After viewing the chair's twisted paper figures, one participant commented, "It looks like Rodin's *Gates of Hell*." As they explained their project, members of the group suggested that chairs could

be thought of as three-dimensional political cartoons, and the web of chairs they spun included a Magritte chair, a social context chair, a slavery chair, protest movement chairs, a chair for Picasso, one for Romare Bearden, an aesthetic concerns chair, and a chair of oppression.

Some of the plans for instructional units were notable for their inventiveness and expressiveness; others, for the ideas they encompassed. A group of high school art specialists created a chair that was a visual representation of Plato's idealist philosophy. They constructed a "high-tech chair," and above it, as a part of the same construction, they showed a vague vision of the "ideal chair" that artists and artisans try to emulate as they create actual chairs. It was obvious that one or more of the group members who planned the unit had a good understanding of Plato. The assignments they outlined for students reflected that understanding. They planned to send their students on an odyssey through the history of chairs to identify the perfect chair—"Plato's chair."

The assignment was to create a studio lesson and place it in the context of a larger unit of instruction containing lessons relating to art history, art criticism, and aesthetics. The teams of teachers were given the responsibility, literally, of developing the connections between DBAE theory and practice.

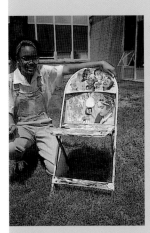

After Ohio teachers developed instructional units around "The Chair as a Portrait" integrating the art disciplines, they took the units to the classroom. Shown here are chairs produced by high school students.

The participants were also given the responsibility of relating, integrating, and even fusing the art disciplines into instructional units. Although the teams could have created separate lessons for each of the disciplines, and some of them did, many chose to present two, three, and even four disciplines—along with disciplines representing other school subjects—simultaneously. They removed the walls separating the art disciplines. Many of the units showed that it was possible to have an almost seamless integration of the four disciplines within individual lessons and within an entire unit of instruction. Through the initiative of practitioners, the structure of DBAE began to change.

directed to shaping conceptions of art. Nevertheless, these are the conceptions that are, in turn, used by humans to expand their beliefs about themselves and others, the past and present, and values both possessed and desired.

Changing art objects and events into works of art is a process in which anyone may participate. Although artists are usually the first interpreters of their own works, most artists are generally content to let the things they create speak for themselves, rather than writing about them. Consequently, the task of using the written word to transform objects into works of art falls to the art historian, art critic, and aesthetician. One of the most difficult undertakings of a DBAE institute is to give participants authentic discipline-based inquiry experiences that will help them to transform art objects into works of art.

The Fourth Side: Other Worlds Related to the Visual Art World In the regional institutes the art world is seldom an isolated phenomenon. Art is continually connected to other realms that are related to, the source for, and the borrower of ideas from the visual arts. Figure 2.1 shows some of those worlds—the humanities, sciences, and arts. Beneath the *Arts* heading in the figure are literature, dance, music, theater, and cinema. Under the *Humanities* heading are history and philosophy; religion and myth could also be added. Below the *Sciences* heading are physics, chemistry, biology, and zoology. (The social sciences of archaeology, anthropology, psychology, and sociology are listed with the art disciplines, reflecting their interdisciplinary role in art inquiry).

In the institute programs these other realms are brought into the world of art in several ways. The art discipline consultants—artists, historians, critics, and aestheticians—make continual reference to the other arts and to the history of ideas. Institute participants, however, are probably just as influential in expanding the borders of art to include the humanities, sciences, religion, and the other arts. Elementary classroom teachers and middle and high school teachers of subjects other than art continually make connections both to the units of instruction they teach and to their own personal interests. Through their contributions, the world of art presented in each institute is enriched.

From the Art World to DBAE

An authentic and intensive rite of passage to the world of art is only the beginning of an institute participant's journey toward DBAE. The next challenge is to transform knowledge and inquiry processes from the world of art into exemplary art instruction.

Although the principles of DBAE were well established by the time the summer institutes were founded, most of the forms that it might take awaited creation and ways it could be put into practice remained unexplored. To adequately provide participants with knowledge about DBAE theory and practice, institute directors and faculty members had to create institutes that came close to modeling the kinds of DBAE instruction they hoped to see in elementary and secondary schools. Ways had to be found to present holistic and integrated models of DBAE while simultaneously providing participants with an understanding of the individual art disciplines, translate DBAE theory into DBAE practice, and prepare administrators and teachers to devise plans for the orderly introduction of a new art (or arts) program when they returned to their schools and districts.

The Southeast Center for Education in the Arts at the University of Tennessee at Chattanooga offers individual discipline-based institutes in music, theater, and the visual arts. Because these institutes are held during the same two-week period, they share resources. An art educator with expertise in aesthetics and teaching philosophy to children, for example, has made presentations to all three institutes. School principals attend a special institute for administrators during which they attend selected portions of the institutes in each of the three arts and simultaneously develop plans for the implementation of comprehensive arts programs in their schools.

Since the summer of 1992, week-long renewal institute programs have been held for participants who attended one of the three arts institutes in a previous summer. The art, music, and theater institute directors have planned multiart activities that have a variety of overlapping organizational factors—an art form; an inquiry discipline such as history, creation, or criticism; and a theme or topic derived from a work or works of art. Each morning, all participants attend a performance or presentation of music, drama, or the visual arts. For the remainder of the day, they explore related ideas, themes, and inquiry processes in each of the arts. Because the participants understand the basic principles of DBAE as applied to one of the arts, they have shown themselves able to quickly apply those principles to two other art forms. The Tennessee renewal week provides a model for the study of substantive, not trivial, relationships among the arts.

In the summer of 1991 a day was devoted to the history of the arts, with the visual arts providing the springboard and the Hunter Museum of Art in Chattanooga providing the setting. In the morning, Hunter art curator Ellen Simak established the first part of the day's topic—the art of the 1930s—through her presentation of the historical context surrounding Reginald Marsh's painting *The Subway—14th Street*. After lunch, she presented the second portion of the topic—the art of the 1980s—through Louise Nevelson's *Cascades—Perpendiculars XXVII*. Following each of these sessions the participants had the opportunity to explore the time periods through the themes of "poverty and hard times" in both theater and music. Through songs such as "Keep Your Sunny Side Up" and "Brother Can You Spare a Dime" and Charlotte Chorpenning's antiwar Christmas pantomime, "A Letter to Santa Claus," the participants were presented with works of art that reflected both the difficulties of the Great Depression and the post-Depression years and escapist sentiment through allusions to wealth, good times, and happiness. The 1980s period provided the opportunity for the participants to study issues-oriented youth theater, with plays such as *Babies Having Babies, Newcomer, Runaway,* and *Addict.* In music, the participants explored the roots and branches of 1980s rock and MTV. The visual arts springboard set the stage for interesting and important topical explorations in the two sister arts—topics that probably would not have been considered without the impetus from the visual arts.

On another day, with theater as the springboard, aesthetics and criticism were explored through the topics of a play within a play, appropriation (art from art), and multiple interpretive productions of a single work of art. Both music and theater production involve the interpretation and reinterpretation of a work of art—a score or a script. Theatrical interpretation was dramatically illustrated when more than eighty participants gathered in the Ward Theater in the University of Tennessee at Chattanooga Fine Arts Center.

Kim Wheetley, director of the theater institute, told the participants that "theater is the past to which we can always return." It was a past to which the participants in the upcoming 1992 theater institute were to return often. For several weeks, a troop of players, composed of college students and amateurs from outside the college, had been rehearsing scenes from twelve plays from six historical periods. The renewal participants were to have the privilege of previewing two interpretations of the "rude mechanicals" scenes from Shakespeare's *A Midsummer Night's Dream*—one was to be an attempt to re-create an Elizabethan-era production, the second was to

be a unique contemporary interpretation conceived by Wheetley himself.

Wheetley provided insights into theater in the Elizabethan period, gave a synopsis of *A Midsummer Night's Dream*, and traced the history of the play's production. He was careful to explain that the scenes to be performed involved "a play within a play." In Shakespeare's work, a company of inept amateur players performs a drama of ill-fated love for Queen Hippolyta and her lady-in-waiting. This raises an aesthetics issue—if good actors set about to act badly and succeed marvelously, does the bad acting make the production good?

After the first performance, Wheetley provided an analysis of the ways in which directors go about finding new meanings, reinterpreting, and producing contemporary versions of historical plays in order to convey modern feelings. He explained that a director might relocate a play in an entirely different historical time period or use a neutral stage with historical costumes so that the audience is permitted or even forced to imagine the setting in which it might have taken place.

 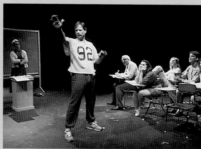

At a multiarts renewal institute for experienced discipline-based art, music, and theater teachers, participants viewed scenes from *A Midsummer Night's Dream* interpreted from traditional and contemporary perspectives as a means to explore aesthetics and criticism issues.

The second interpretation of the "rude mechanicals" scenes continued the play-within-a-play motif. The setting was a contemporary classroom, and the rude mechanicals were stereotypical students harassing the company manager/teacher. In an ill-fated attempt to make Shakespeare relevant, the class created an MTV-style version of the tragic Pyramus and Thisbe love story. The actors moved between makeshift set pieces, starting and stopping the action while being recorded by a roving video camera. The audience was able to watch both the actual live action and a simultaneous projection of each scene from the camera's point of view on a large overhead screen. Although Shakespeare's language remained intact, the setting and characters shifted to modern cinematic metaphors, culminating in the playing of the death of Pyramus and Thisbe as an appropriation of the famous shower scene from the film *Psycho*.

Next, the participants listened to an extensive critical analysis of the two productions and then joined in a free-wheeling discussion of the productions with the actors, the director, and the critic. All this took place before the participants began to experience a rotation through sessions in which the theme and critical processes on which the day was focused were played out in art, music, and theater.

SEEING THE WHOLE AND THE PARTS SIMULTANEOUSLY To plan and implement DBAE instruction, educators must acquire a basic knowledge of each of the art disciplines and the inquiry processes associated with them. Yet even a brief introduction to each of the disciplines takes time. In the early years of the summer institutes, participants usually did not receive introductions to all four disciplines until near the end of the final week. Consequently, there was little time left to actively explore the disciplines or experiment with ways of teaching them to elementary and secondary students.

Over the years, the institute programs were redesigned to correct this problem. Most now begin by letting participants experience a multifaceted DBAE lesson. This provides an overview of what DBAE looks like in practice, giving participants an educational context for the art world information and experiences they will soon encounter.

Effective introductions are holistic. They provide a general, but nevertheless complete, picture of DBAE in practice. Some institutes use videotapes to illustrate the highlights of a comprehensive exemplary unit of DBAE instruction. Often the tapes feature past participants in their own classrooms. The implication is, "If one of your peers who attended a DBAE institute can do this, you can too."

Some of the most successful introductions to the four art disciplines have been those in which participants practice DBAE from the opening minutes of an institute, rather than merely seeing or hearing about it. During the morning of the first day of the Florida institutes, for example, facilitators lead participants through a series of four, short, carefully articulated, and thematically integrated inquiry activities—an art-making task, responding to an art historical problem, producing a piece of art criticism, and dealing with an issue or puzzle relating to the philosophy of art. At the conclusion of the four activities, the participants are told, in effect, "You have just engaged in an introductory set of DBAE activities in which inquiry processes relating to the four art disciplines were all directed to works of art. Over the next two weeks, you will have the opportunity to study the four art disciplines in greater depth so that you can use them in your own teaching." But how do participants move from engaging in disciplined inquiry themselves to creating units of discipline-based instruction for their students?

A Model for Integration of Art Disciplines in DBAE Instruction

How did the art disciplines come to be integrated, first in institute programs and then in classroom DBAE instruction? When the RIG programs offered their first institute seminars, it was considered sufficient to 1) provide presentations and activities relating to each of the four individual art disciplines, 2) point to instructional models, usually the ones found in commercial art textbooks, and 3) assign small groups of classroom teachers and art specialists to prepare and teach a DBAE lesson for their peers. The group members, usually exhibiting signs of anxiety and often expressing it openly, searched for convenient models. The typical solution was for groups to go to one of the extensive instructional resource centers organized in each of the institutes, locate a textbook lesson, note the points at which the lesson did not cover the art disciplines adequately, add missing components, and supplement the lessons with printed poster-sized reproductions. In group

presentations one member would offer the art history portion of a lesson, another criticism, a third the aesthetics portion, and the final member would present a culminating art-making activity. These "DBAE" lessons were often unimaginative in their rigid relating of the art disciplines. Each discipline existed in its own little realm; almost never was there an overlapping or integrating of the disciplines.

Institute planning sessions became more exciting and DBAE instruction more imaginative when directors and their institute staffs ceased asking groups to teach lessons. In the place of peer teaching, institute teaching staffs substituted the task of outlining an entire instructional unit based on themes, topics, or concepts associated with specific works of art. The artwork-based thematic unit format gave participants a much more expansive canvas on which to paint. It also provided them with an opportunity to link art instruction to existing integrated instructional units that already contained language art and social studies components. Although these integrated units often had inquiry processes that were similar to those associated with the art disciplines, their less-rigid reliance on discipline-based inquiry permitted, for example, art history and art criticism to merge as one interpretive act. The unit tasks also seemed to break the implicit expectation that all DBAE lessons had to contain segments pertaining to the four art disciplines. Once the art disciplines were employed, not because they "had to be there," but because they made instructional sense, a new, more organic form of DBAE began to emerge.

The Summer Institute and Initial Planning for Implementation

Before attending summer institute programs, most art specialists were comfortable as independent agents. Schoolwide change initiatives did not usually affect them. They were free to devise their own instructional programs with virtually no scrutiny from school administrators or fellow teachers. Most taught whatever they wished whenever they wished, and no one seemed to care.

Some art specialists did monitor the instructional programs of their colleagues, especially in social studies, and when it seemed appropriate, they correlated aspects of their art instruction with colleagues' instructional units. This cooperation was typically one-sided, however. Seldom did other teachers plan their instructional programs around the art curriculum.

This is why the summer institute programs were so unusual. Art was placed at the center of school curriculum and instructional planning. The expectation was that art specialists would come to institute programs with a team consisting of a school administrator and other members of the instructional staff. Together they underwent their rite of passage to the art world, participated in initial instructional planning (such as outlining a unit of instruction and looking for places to infuse art into existing instructional units), and laid initial plans for the implementation of DBAE. Art instruction, generally perceived as having little relevance to the school curriculum, was placed at the center of the planning process (at least for the duration of the institute and often beyond), and art specialists were removed from their customary "lone ranger" role.

Art teachers reacted in a variety of ways to the prospects of their new place in the

school curriculum. Some were well prepared for their new instructional roles; others were not. In a 1990 summer institute program in Tallahassee, an elementary school art specialist who, for seventeen years, had existed on the sidelines of her Florida elementary school's instructional program, sat in a state of bewilderment as her principal and fellow classroom teachers laid plans to end her isolation. Under the leadership of the school principal, the team developed a plan to inform the entire teaching staff about the new art program, scheduled a September faculty-wide inservice meeting on the general program introduced by the DBAE team, planned an October faculty meeting in the art room where the team made a presentation about DBAE to the parents' advisory committee, made plans to use the art teacher as a resource, decided to acquire reproductions of artworks, and outlined a complex strategy for integrating the art and language arts programs. When an evaluator visited six months later, all the objectives had been achieved, and the art teacher and art program had moved from the margins to the center of the school curriculum.

The expectation, as simple as it is, that during a summer institute a team of teachers headed by their principal would plan for the implementation of a new art curriculum has proven to be an effective way to begin the transformation of the art program. Frequently, something else happened as well. With most of the attention directed to the art program, in many cases it acquired new importance as administrators and teachers of other school subjects made plans to weave art into school instructional programs. As shown in Chapter 4, for some schools, these initial implementation sessions provided the opportunity to reorganize and redirect entire school instructional programs.

New Developments in Summer Institute Programs

The summer institute programs continue to evolve. Programs that were composed of separate components have become more integrated and whole. Passive listening has been replaced by active learning—discipline-based inquiry and instructional planning. More important, some summer institute programs have begun to assume the character of well-formed comprehensive units of DBAE instruction. They are organized thematically around carefully selected works of art from consortium museum collections and exhibitions. With increasing frequency, works of art with special relevance to participants in the individual consortia are the objects with which participants learn the inquiry processes of the artist, art historian, art critic, and aesthetician. Through participation in institute programs that are organized like comprehensive units of instruction, educators can learn about the art disciplines while they simultaneously learn the characteristics of good DBAE instruction and how to create their own art-based units of study to present to their students. New developments in the summer institutes also include more collaboration between discipline consultants and art educators and the introduction of assessment units.

DISCIPLINE CONSULTANTS AND ART EDUCATORS: BECOMING COLLABORATORS

When the summer institutes were first established, more often than not the planners constructed the programs by inviting a collection of art discipline consultants, art educators, and others to make presentations and organize activities. Although the planners had overall visions of their programs, the individual presenters did not. With some frequency, pre-

senters changed their topics at the last moment, so if the institute planners had arranged related follow-up activities, coordination of presentation and activity was lost. Consequently, participants sometimes became confused about the relevance of art disciplines to their own instructional programs.

One solution to this problem was simultaneously arrived at and refined in a number of institutes. Art discipline presenters, institute staff members, and facilitators began to collaboratively plan discipline-based inquiry activities and educational applications. Consequently, inquiry-based activities began to be written out well in advance of the actual institutes. Presenters knew that the carefully defined tasks they had helped to prepare would immediately follow their presentations.

The addition of activities led to a new structure in these institutes. Time spent listening to lectures was reduced to provide time for inquiry-based small group activities. To monitor and guide these small groups, institutes added facilitators to their staff. Consequently, the facilitators of small-group activities have played an increasingly important role in the conduct of institute programs.

Institute facilitators, as many as fifty individuals in some of the larger institutes, are generally drawn from among prior participants. Although primarily art specialists and elementary classroom teachers, this role is also played by museum docents, school principals, college professors of art education, and even heads of college art departments and institute directors.

In some institutes, facilitators contribute to designing the institute program. Prior to most of the summer institutes, they attend workshops where they review the program, rehearse the inquiry tasks they are to lead, practice introducing and elaborating upon the written instructions that explain small group tasks, and role-play the various kinds of responses participants might give. These preparations provide them with clear conceptions of the desired outcomes, solutions, insights, and products that should result from the inquiry activities. Because the facilitators have clear conceptions of the desired results, they practice how to redirect participants' responses when they veer off course.

For example, if an exercise calls for the interpretation of a work of art, in the most successful institutes, facilitators know at least one insightful and acceptable interpretation. When they lead art-making activities, they have general conceptions about how the products might look and know how to lead participants toward meaningful, imaginative, and well-designed works. They anticipate the questions, issues, and solutions, both deep and superficial, that participants might raise. They even rehearse how to deal with both desirable and problematic responses. During practice exercises with each other, they improvise, challenge, question, and discuss participants' possible solutions. When they have completed these activities, facilitators know how to lead discussions relating to participants' responses and how to recognize and summarize the salient learning that should result from the activities.

The importance of facilitators extends well beyond the leading of small-group activities. They provide role models for new institute participants and, through working closely with the art discipline consultants, have become increasingly expert in the theory and practice of DBAE. Facilitators combine their knowledge of the art disciplines with their teaching expertise. Consequently, their classrooms have become the places where the most outstanding examples of DBAE instruction can be seen. The units of DBAE instruc-

tion they have created have extended the boundaries of DBAE; their well-informed practices have enriched and in some instances even led to the extension and modification of DBAE theory. Facilitators have become key members of DBAE change communities because of their practical expertise which has been enhanced through their collaboration with artists, art historians, art critics, and philosophers of art.

Assessment and Evaluation in DBAE Institutes

In a few institutes, the evaluators have observed the successful integration of assessment of DBAE learning within ongoing instructional activities. For example, in some of Florida's area site institutes, major portions of summer institute programs are now organized around units of instruction with embedded assessment points, so that instruction and assessment are thoroughly integrated. In Nebraska's central and regional institutes, a unique portfolio assessment process that uses students' previous creative work as the basis for subsequent assignments is leading to assessment, instruction, and institute programs that are highly integrated. When practical assessment tasks are built into many aspects of an institute, there is little need to devote special lectures to the subject. Rather, participants continually analyze the assessment activities in which they have participated and plan for the incorporation of similar processes into their own instructional programs.

Conclusion

DBAE institutes are predicated on the belief that the teaching of art requires knowledge both of works of art and of how to create, study, interpret, and evaluate works of art using the inquiry processes of the artist, art historian, art critic, and aesthetician. In summer institute programs, context is the operative word. Objects, artifacts, and texts that yield meaning when they are interpreted can perhaps be understood only when they are seen within their contexts. Through historical and philosophical study, the summer institute programs expand participants' understanding of the cultural contexts in which works of art are created. More important, the institute programs conducted in museums and art centers orient participants to the contemporary contexts in which works of art are studied, interpreted, and evaluated. After attending a summer DBAE institute program, participants are probably unable ever again to think of art objects devoid of contexts. Chapter 8 discusses the consequences of professional development initiatives set in authentic contexts, directed toward authentic objects, and conducted through multiple authentic inquiry processes.

Summer institutes play an indispensable role in the development of DBAE theory and practice. When institutes are conducted in art world settings, are attended by teams of teachers and administrators, are models of the innovative practices to be implemented in schools, are coordinated with year-round renewal and professional development activities conducted in participating schools and districts, are responsive to and incorporate innovative practices that emerge anywhere in an interactive network, and are a part of a continuing long-range plan for the reform of education, they are tremendously effective.

Multiple Forms of DBAE:
From Theory to Practice to Theory

The evolution of DBAE over the past decade is often discussed as if it were a monolithic phenomenon, but nothing could be further from the truth. This chapter analyzes and shows graphically the variety of forms, some problematic and some promising, that DBAE has taken as it has evolved in the RIG programs. Seven major factors that have interacted to affect the ongoing development of DBAE are also discussed:

- rapid change in the art disciplines,

- art educators' different interpretations of the disciplines,

- traditional content and conventional art education practices mapped onto DBAE,

- the content of art education textbooks,

- the practices of elementary classroom teachers,

- practices emerging from education reform initiatives, and

- state curriculum regulations and local curriculum guides.

Differing Forms of DBAE

Although some of the basic principles of DBAE have been in the literature of art education since Manuel Barkan outlined the concept in 1962, in the 1980s, more fully developed principles and characteristics of DBAE were presented in a variety of places—in reports published by the RAND Corporation (Day 1984) and the Getty Center for Education in the Arts (1985), and in books and journal articles relating to the disciplines of art (Clark, Day, & Greer 1987; Crawford 1987; Dobbs 1992; Kleinbauer 1987; Risatti 1987; Spratt 1987). These developments in the literature reflect the variations in DBAE that have evolved in the RIG programs. Several forms of DBAE have developed, each unique, but still in keeping with the general principles on which DBAE is based. Seven factors, discussed below, have affected the ongoing development of DBAE.

The Art Disciplines in a Time of Rapid Change Art and its related disciplines are always in a state of transition. DBAE, therefore, is constantly changing as well. It seems obvious to state that DBAE has evolved since its inception in the early 1980s, but it is worth noting because DBAE arrived on the scene during a time of transition from modernist to postmodernist artistic ideologies. Postmodernism in its various guises has led artists, art historians, art critics, and aestheticians to question nearly all of the assumptions of the modern period and to pose fresh content and inquiry processes to deal with new assumptions about art and how it should be studied. The consequences of these changes were

felt almost immediately within DBAE, because art discipline consultants working in the RIG programs and art educators who stay abreast of changes within the art disciplines brought the modernist/postmodernist debate to DBAE.

Art Educators' Interpretations of the Art Disciplines In the writings and practices of art educators, just as in the writings and practices of artists, art historians, art critics, and aestheticians, there are many different conceptions of the art disciplines. The evaluators' experience with the work of art educators, however, has led to the conclusion that educators tend to draw on more conventional rather than cutting-edge aspects of the art disciplines—and on general rather than specific theoretical aspects of the art disciplines. Consequently, it takes considerable time before new content and inquiry processes from the art disciplines filter into the writings and practices of art educators.

Traditional Content and Conventional Practices of Art Education Mapped onto DBAE Although DBAE provided the general principles for conceptualizing a structure for art education, in the early days of DBAE the gap between theory and practice was sizable. Elementary and secondary school art specialists frequently labeled the old things they had been doing all along with the new name of DBAE. Forms of DBAE developed in the RIG programs have moved a considerable distance beyond traditional art educational content and practices; still, the traditions of art education exert a powerful influence on the way DBAE is conceptualized and practiced.

The Content of Art Education Textbooks: A Viable Model for DBAE? DBAE is supposed to be based on "a written and sequentially organized curriculum consisting of lessons containing content drawn from the four foundational art disciplines" (Dobbs 1992, p. 10). Art education textbooks would seem the best source for such an approach. The evaluators found, however, that the planners of the summer professional development institutes took very different positions regarding commercial textbooks. In some institutes, textbooks were seen as the primary source for DBAE. In others, participants were told that most textbooks were inadequate—that they did not treat the art disciplines adequately or were organized around the elements and principles of design. Participants

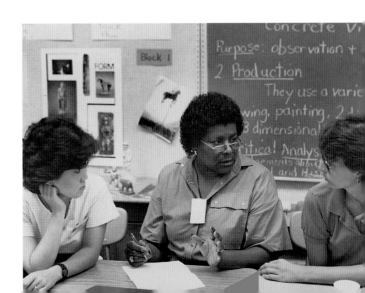

One factor that has influenced the evolution of DBAE is that art educators hold many different conceptions of the art disciplines.

were told that textbooks provided a useful resource for DBAE but that the content, curricula, and instructional strategies represented by textbooks required modification and supplementation if they were to be truly discipline based.

Content of the General Elementary School Curriculum and Practices of Classroom Teachers When classroom teachers were invited to join art educators in shaping DBAE, they brought with them the units of instruction they had taught, sometimes for years. When they became acquainted with DBAE, they began to infuse their instruction with works of art and a variety of discipline-based approaches to the creation and study of art. Consequently, DBAE is affected by the practices of elementary classroom teachers.

Practices Emerging from Educational Reform Initiatives Just as DBAE emerged during a time of rapid change in the art world, during the 1980s and 1990s education experienced a sizable number of reform initiatives: whole language, interdisciplinary instruction, the integrated curriculum, cooperative learning, higher-order thinking processes, outcome-based education, and technological literacy. Many of these reform initiatives have become associated with DBAE; consequently, DBAE has, to a greater or lesser extent, been altered by them, especially in elementary schools.

State Curriculum Regulations and Local Curriculum Guides The RIG programs were established in states with long traditions in art education. These traditions were reflected in both state and local school district curriculum guides. RIG program directors have made special efforts to show how DBAE is compatible with state guidelines and regulations. Usually they have argued that DBAE contains everything found in the regulations and guidelines—and more. The evaluators have observed that DBAE has tended to broaden the ways state and district guidelines are interpreted and to deepen their content. At the same time, these guidelines keep DBAE looking somewhat like the existing regulations.

Evaluating the Different Forms DBAE Has Taken

One of the principal aspects of the evaluation of the RIG programs was to analyze the merits of the various forms of art education that they brought into being. From the beginning of the assessment, the evaluators believed that DBAE must remain an open concept, that different forms of DBAE could have equivalent merit, and that some forms of DBAE would be superior to others. The evaluators established the following tasks for themselves:

- to determine the structures of the different forms of DBAE,
- to compare them with various aspects of content and inquiry processes found within the art disciplines,
- to determine whether the DBAE variations contain sound conceptions of education,
- to judge whether those conceptions will lead to the achievement of valid and enlightened art educational goals, and
- to assess the prospects of the different forms of DBAE for improving the way art is taught in schools.

These different points might be summarized in one question: Did the forms of art education observed in the RIG programs meet the promises implicit within this new and comprehensive conception of art education?

As initial observations of the RIG programs were made in the late 1980s, differing forms of DBAE were seen (as were forms of art education that, although labeled DBAE, appeared to be something else). To understand the structures of the various forms, diagrams were drawn. These diagrams are abstractions that schematize and simplify; consequently, they do not capture the subtlety of the conceptions that underlie them. There is a rough chronology to the diagrams, which are presented below as Figures 3.1–3.8. The first few depict patterns that were more apparent in the early years of the project; the later forms generally emerged in the 1990s.

Although the diagrams show distinct conceptions of DBAE, observations of the summer institutes revealed that sometimes several forms of DBAE were present within a single program. Visits to classrooms revealed that there was frequently more than one conception of DBAE in a single unit of instruction and sometimes within a single lesson.

THE DISCIPLINES AS CONTENT: SPIRALING THROUGH THE GRADES What should be the content of DBAE? Should it be the art disciplines themselves? Or should it be works of art created by artists and students? In the early days of the RIG programs, these two alternative conceptions of DBAE coexisted—not always peacefully.

As the concept of DBAE was introduced and began to grow, considerable attention was directed to the importance of the disciplines of art. In order to understand the foundations of DBAE, art educators undertook detailed investigations of what artists, art historians, art critics, and aestheticians do. Consequently, the art disciplines came to be seen as the new content of art education. Clark, Day, and Greer 1987, for example, states that "content for [art] instruction is derived primarily from the disciplines of aesthetics, art criticism, art history, and art production" (p. 135). This first dimension of content is followed by a second: "a broad range of visual arts, including folk, applied, and fine arts from Western and non-Western cultures and from ancient and contemporary times" (p. 135). Perhaps the listing of the art disciplines before works of art was unintentional. Nevertheless, that placement made it at least somewhat difficult to view the disciplines merely as the means through which works of art were created and studied. Figure 3.1, the first diagram, shows the art disciplines as content.[1]

Under this discipline-based structure the goal of art education could be to help each student function in a disciplined manner—in a manner reflective of the modus operandi of adult practitioners of each of the disciplines. The major problem with this conception of DBAE is that works of art toward which disciplined artistic inquiry might be directed have either ambiguous or undetermined positions in relation to the art disciplines. Sometimes, especially in early RIG program institutes, works of art were shown to illustrate the features of an art discipline. It was not clearly understood that the art disciplines are merely the means through which the principal content of art education—works of art—are created and understood.

This conception of DBAE was prevalent in the RIG programs during the late 1980s. Institute handbooks prepared for participants had statements asserting that the purpose of production activity is "so that they [students] will come to understand the artistic

process as it applies to their own art making experiences and the experiences of others."
An examination of the materials and suggested practices surrounding this and similar
statements revealed that, in essence, students were supposed to study what artists do not
so much for the purpose of creating works of art as to gain an understanding of the formal, technical, and imaginative processes involved in the creative act.

This conception of DBAE is still reinforced by practices found in some of the institute
programs. The discipline of aesthetics provides the best example. In most of the institute programs, the philosophy of art is studied as a set of issues and an inquiry process
quite separate from its application to the study of specific works of art. Typically, aesthetics presentations are organized around questions such as, What is art? By what criteria and standards should art be judged? What is the nature of aesthetic experience?
Although these questions are not inappropriate, they are often asked without reference
to specific works of art. Instead, participants are asked to discuss, for instance, whether
or not natural objects like rocks and fruit are works of art. The focus of these discussions is almost entirely on understanding the discipline of aesthetics through consideration of the issues addressed by aestheticians, not on discussing issues such as whether
Andy Warhol's Brillo boxes should be considered art.

The evaluators became concerned that the preoccupation with the art disciplines
actually drew attention away from works of art. The works of art that students were
supposed to create, understand, and appreciate were given short shrift through excessive attention to the disciplines themselves.

THE BASIC-VOCABULARY APPROACH TO DBAE In the first conception of DBAE,
shown in Figure 3.1, the disciplines were the principal content, whereas the work of art
had an uncertain status. In the second conception, discussed below, the disciplines themselves have uncertain status. Works of art are given billing at least equivalent to the means
through which they are studied.

Before explaining the second and subsequent forms of DBAE, it is important to define
carefully what the terms art object and work of art mean in this context and to see the art
disciplines as lenses through which works of art are created, interpreted, and evaluated.

The Work of Art: A Working Definition Works of art are commonly thought to be the
things that hang on walls, sit in cases, and rest on the floors of art museums, galleries,
and homes. To think clearly about art education, however, we must employ a more
dynamic view of the work of art. Here the common premise that underlies philosophies
of art such as Dewey's (1934) and Danto's (1986) is useful.[2] The physical art objects
found in museums, art galleries, artists' studios, and public spaces become works of art
only when they are transformed from mere objects through mindful activity. The work
of art is a physical art object or event that has been "worked" experientially, or, as Danto
(pp. 44-45) would say, has been interpreted as a work of art. In the most general sense,
DBAE programs function through assisting students in creating art objects and transforming their own art objects and the art objects of others into knowledgeably and
insightfully interpreted, appreciated, and understood works of art.

The evaluators observed in one of the summer institutes a docent who was guiding a group of administrators on a tour of a museum collection. The way the tour was conducted illustrates how the meanings of works of art can be diminished through a conscious decision to limit the number of factors to which viewers attend.

The docent told the group, "You may think the museum forbidding—overwhelming for elementary children. It's not so; we show them the lines, colors, shapes, and textures that they can find in all the art." The group proceeded to the first large work. "This is a painting from a Spanish church. What shapes do you see?" She went on to other works. "This is a wonderful example of what the artist will do with lines, colors, and shapes." The docent then explained that after students had been led through an analysis of the basic elements of the works, "we can get to the story. Who is she? Why is she kneeling?" She went on, "We don't necessarily get into that—the religious dimension with children." She commented that on the gallery tours children were encouraged to examine the differences and similarities in paintings. As she stood in front of two paintings, the docent asked, "What is the most prominent color in this one and this one?" A principal answered, "Red."

The works in which the administrators had been asked to find "the most prominent color" were Francisco Gallego's *The Martyrdom of Acacius and the Ten Thousand Martyrs of Mount Ararat* (painted between 1490 and 1510) and Hernando Yáñez de la Almedina's *Saint Sebastian* (from about 1506). Gallego's painting shows Acacius and ten of his ten thousand fellow martyrs nailed to crosses (the closely cropped edges of the painting suggest, however, that martyrs extend far beyond the depicted few). Yáñez de la Almedina's Saint Sebastian stands placidly looking heavenward with three arrows shot through his body.

Asking the administrators to choose the most prominent color in the two paintings is like asking them to read Shakespeare's *King Lear* and Homer's *Odyssey* and ignore that the works are about heroes. Choosing only one lens with which to view the two works of art results in an extremely limited art educational experience.

The Martyrdom of Acacius and the Ten Thousand Martyrs of Mount Ararat, Francisco Gallego, Spain, between 1490 and 1510, oil on wood panel.

Saint Sebastian, Hernando Yáñez de la Almedina, Spain, circa 1506, oil on wood panel.

Art Disciplines as Separate Entities

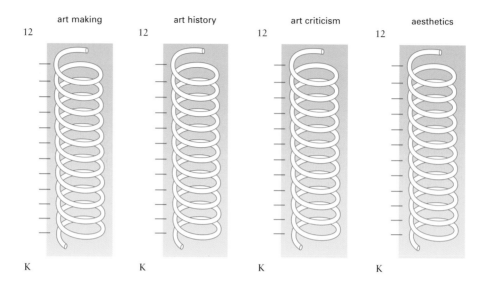

Figure 3.1 The four rectangles represent the four discrete art disciplines and the knowledge and inquiry methods associated with each. Some art programs may be composed of the four disciplines, each presented alongside but without any connection to the other three. Each rectangle is divided into segments representing kindergarten through twelfth grade. The spirals inside the rectangles stand for the increasing levels of sophistication that a student might gain in each of the disciplines.

MULTIPLE FORMS OF DBAE

88

THE ART DISCIPLINES AS LENSES Clark, Day, and Greer 1987 (p. 138) refer to the work of Broudy (1983), who sees the purpose of general education to be the preparation of "individuals to think in systematic ways, to view the world through the different lenses or templates that study of each subject implies." Clark, Day, and Greer 1987 continue: "Without formal instruction in the visual arts . . . students will not develop the avenues of thought, understanding, and expression that constitute the aesthetic lenses for construing meaning." In the following diagrams the notion of lenses is used almost literally; the disciplines are presented as lenses that are focused on art objects in order to transform them from mere art objects into works of art laden with meaning.

Before illustrating how the art discipline lenses function in DBAE, it is important to point to lenses that the evaluators judged to have little relationship to the discipline-based lenses of art making, art history, art criticism, and aesthetics. In Chapter 2, in discussing the nature of the art world, the point was made that few artists, art historians, art critics, or aestheticians approach works of art solely from a design perspective. Nevertheless, in some RIG programs the use of design-oriented, "aesthetic scanning" lenses masquerading as art disciplines was observed.

The first lens—the elements and principles of design—is nothing more than a part of long-standing art educational content. This way of organizing the content of art instruction is still found in most state and district art curriculum guides and art educa-

tion textbooks. In many instances, the elements and principles of design are the content of art education—virtually the only features to which students are taught to attend. The second lens—aesthetic scanning—as it was practiced by teachers, is so similar to the lens focusing on elements and principles of design that the two might be considered synonymous. Aesthetic scanning became closely associated with DBAE in the Los Angeles Getty Institute for Educators on the Visual Arts. Activities such as "aesthetic scanning practice in small groups"—the "brainstorming" practice of naming the sensory, formal, and expressive features of art objects—were among the principal activities for both three-week summer professional development institute programs and district inservice programs (Greer et al. 1993, pp. 32–33).

Different lenses have the capacity to reveal different aspects of art objects. When these lenses are used, the physical art object, at different times and for different individuals, reveals works of art differently. The work of art created by the viewer is actually a transaction between the viewer using a particular lens or set of lenses and what the physical art object has to "show" to the viewer, and thus results in different works of art (Pepper 1945, pp. 142–71). The work of art—the interpretation, experience, understanding, and appreciation—that results from the transaction between the art object and the individual who uses the lens can be represented graphically by a darkened oval within the art object. In Figure 3.2, the circle representing the interpreted or understood work is small when viewed in light of all the material associated with the art object, which has the potential to be transformed into a work of art. It is important to understand why the interpreted work is so small.[3]

It is possible, for pedagogical or other reasons, to limit the number of features in art objects to which individuals are asked to attend. If, for example, it is assumed that individuals need to have a basic vocabulary of terms in order to begin experiencing an art object, then the elements and principles of design can provide one starting place. If it is assumed that because individuals focus too readily on the subject matter elements of art objects while paying insufficient attention to the aesthetic qualities—the sensory, formal, and expressive features—then they might be asked to use aesthetic scanning procedures to divert their attention from subject-matter features. Nevertheless, the application of either the elements and principles of design or the aesthetic scanning lens results

PROBLEMS WITH THE ELEMENTS AND PRINCIPLES OF DESIGN

In various reports the evaluators argued against the use of the design and aesthetic scanning lenses in DBAE programs for the following reasons:

• The practice of using the design and aesthetic scanning lenses to focus only on a small group of sensory, formal, and expressive features is not in keeping with DBAE.

Although artists, art historians, art critics, and aestheticians must necessarily attend to these features, seldom, if ever, do they use them in the narrow and isolated ways found in conventional art instruction.

• The practice of using the design and scanning lenses established inappropriate patterns of behavior that drew attention away from the art disciplines and from the social, historical, thematic, symbolic,

metaphoric, and subject-matter aspects of works of art.

• When, in RIG programs, experienced art teachers encountered such lenses for studying art objects, the practice reinforced their use of conventional art educational content and practices. A familiar response was, "If this is what DBAE is, then I have been doing DBAE all along."

• Use of the lenses encouraged a "speed-reading" approach to

Aesthetic Scanning Lens

Figure 3.2 The oval to the left represents the lens through which a student or instructor views and interprets an art object or event. The work of art is represented by a series of receding rectangles. The first rectangle represents the art object when viewed through a particular lens. The rectangles behind the first represent the object awaiting the use of different lenses that could be used to reveal different aspects of the art object.

encounters with art objects while discouraging in-depth interpretations associated with the disciplines of art.

• Some institute participants thought that the elements and principles of design and aesthetic scanning were the very essence of DBAE.

• Embedded within the basic elements approach to experiencing art objects is the belief, at least to Pestalozzi, that every educational task should be broken into its simplest components and that the student should not go on to more complex components and processes until he or she has mastered the simpler ones. As with any skills-first, basic-vocabulary-first pedagogical approach, there is a danger that the skills and the vocabulary will become mistaken for primary content. Moreover, if the vocabulary has omitted certain important "words" (social and cultural context, subject matter, symbols, and so on), later on there may be difficulty in integrating these factors into the whole act of creating, interpreting, evaluating, understanding, and appreciating works of art.

Connecting the Disciplines in a Work of Art

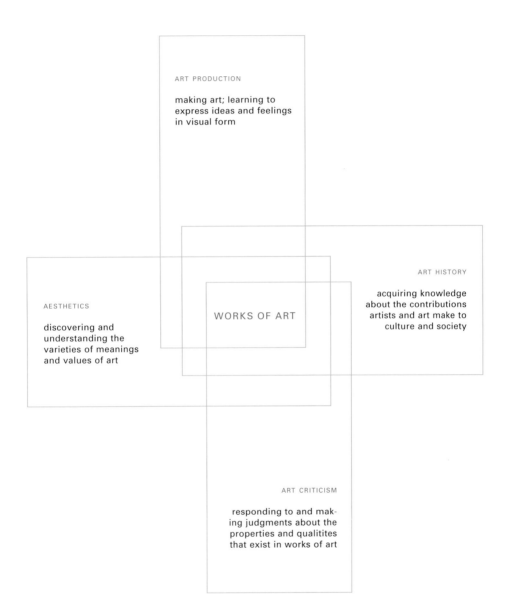

ART PRODUCTION

making art; learning to express ideas and feelings in visual form

AESTHETICS

discovering and understanding the varieties of meanings and values of art

WORKS OF ART

ART HISTORY

acquiring knowledge about the contributions artists and art make to culture and society

ART CRITICISM

responding to and making judgments about the properties and qualitites that exist in works of art

Figure 3.3 DBAE has been conceptualized in a variety of ways. In the North Texas Institute, DBAE is defined as "a comprehensive approach to learning in art that centers instruction on works of art and derives content from four foundational art disciplines: aesthetics, art criticism, art history, and art production." The relationship of the work of art and the art disciplines is presented in a diagram that shows the way the work of art is formed by the art disciplines and the way the disciplines are integrated during DBAE instruction.

Once the basic diagram was created, it was extended to show how DBAE incorporates aspects of the Texas Assessment of Academic Skills program relating to reading comprehension and written communication. Variations of the North Texas diagram are used to illustrate the relationships between DBAE and "Texas Essential Elements" for art, math, music, physical education, science, social studies, and writing.

in an extremely limited work of art, because there is no effort made to experience or understand the work in its entirety. Individuals positioned in front of art objects are asked, "What colors do you see? What kinds of lines and shapes do you see?" These lenses do not focus on the thematic, societal, historical, or subject-matter aspects of art and focus only indirectly on stylistic and symbolic dimensions.

As these methods are presented, especially to novice teachers, typically little or no effort is made to ask them to analyze the contributions the sensory, formal, and expressive features make to the principal issues, ideas, and concepts associated with a specific work of art. The evaluators concluded from their observations that the approach failed in practice because classroom teachers were usually unable to move beyond the entry-level activity they had been taught. This method is seductive because it makes it easy for beginners to say something about art objects. At issue is whether what they say has merit.

As the evaluators made their own observations, the following questions were raised: Does the use of the design and aesthetic scanning lenses qualify as DBAE? Are these methods valuable as entry-level activities that assure the subsequent successful use of the art discipline lenses? Is their use even compatible with DBAE? These questions led to some of the most heated debates that took place between the evaluators and some of the RIG program directors.

Among the institutes there were considerable differences of opinion regarding whether the traditional formalist approaches have a place in DBAE. In two of the RIG programs the design and aesthetic scanning lenses were not considered a part of DBAE and were never used. In the other four, initially at least, the design lens, the scanning lens, or some combination of the two was used.

The Importance of the Debate The evaluators saw the debate about the primacy of the design and scanning lenses to be tremendously important to the direction that DBAE development might take. At issue was whether DBAE should continue to incorporate, indeed be centered on, the conventional formalist content of art education or whether new discipline-based ways of thinking about content should be used. The evaluators thought that if the basic-element lenses were used, especially if they were given the same stature as the art discipline lenses, they would probably subvert any serious movement toward

"REVISIONIST" ART HISTORY

In the Getty Education Institute for the Arts' 1992 seminar titled "Discipline-Based Art Education and Cultural Diversity," art historian Alan Wallach characterized the current state of art historical inquiry as follows:

Twenty-five years ago, the practice of art history consisted primarily of connoisseurship, or the ability to identify and date works of art, formal analysis, and iconography, Panofsky's system of reading meaning in visual images. Underlying these methodological approaches were certain assumptions: Art was a product of (male) genius and Western art "derived from the classical tradition flowing through Greece, Rome, and the Italian Renaissance" [which] should be the primary focus of art historical inquiry.

The political struggles of the sixties led to persistent demands for greater institutional recognition of cultural diversity and alternative viewpoints. . . . This critical shift occurred after a long period of resisting even the most elemental discussions of theory. Today, however, new theoretical tendencies are often incorrectly and indiscriminately lumped together under the heading of "revisionist" art history. (Wallach 1993, pp. 47–48)

a truly discipline-based art curriculum. As the issue was being debated, several forms of DBAE that made substantial use of the art discipline lenses were already under way.

THE ART DISCIPLINE LENSES EMPLOYED INDIVIDUALLY Figure 3.4 presents the art disciplines as four lenses, each focusing on one or the other of two art objects: one made by a student, the other by an artist. The darkened areas representing the interpreted works of art show what Clark, Day, and Greer 1987 refer to in stating that "neglect of learning in any of the four art disciplines will result in an incomplete understanding of art. Therefore, a balanced treatment of the four disciplines is a goal of DBAE" (p. 171). Although the darkened areas representing the interpreted or understood works of art are considerably larger and more comprehensive than when a single lens is used, it should be noted that it is impossible for any work of art ever to be understood fully. The very fact that art objects exist in time means they will be interpreted in the future by individuals who will have quite different interests and insights from those of today, thus making a definitive understanding of these objects impossible. Nevertheless, at any given time, the fullest possible understanding of a particular work of art is a desirable educational objective. In this and subsequent figures, the undarkened areas of the art objects represent material that may be transformed into the interpreted work on other occasions or never be transformed.

It is also important to note that the lenses are directed toward both the artworks and the social-cultural-historical settings in which they were created and are interpreted. In other words, the context—the factors and conditions surrounding the creation and study of the artworks, including the artist, the audience for whom they were created, the roles and functions they have served, the functions they now serve, and the varieties of interpretations that have been made—can provide important insights into the meaning of works of art.

There are other important features of this diagram. The lenses are shown approximately the same size, as are the areas representing the interpreted works. (They could have been sized differently to represent variances in the amount of emphasis placed on the use of the individual lenses.) The lenses are also not focused on the same areas of the art objects, as could have been done, because of the desire to illustrate that the lenses

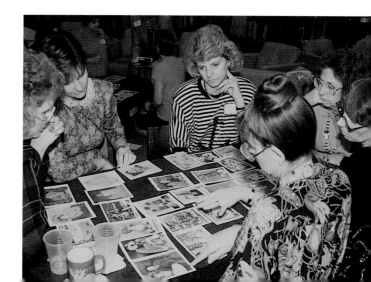

Institute participants supplement existing textbooks and curricula with content and instructional strategies they develop themselves.

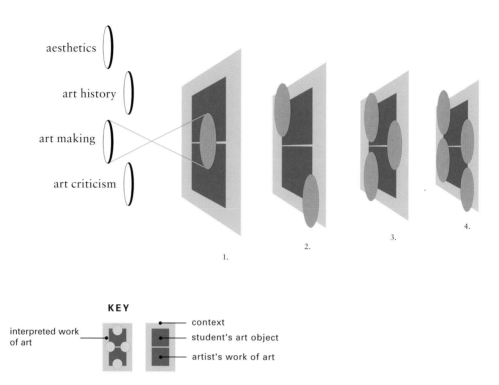

KEY

interpreted work
of art

context
student's art object
artist's work of art

Figure 3.4 In this approach to art education, the four art disciplines act as lenses, each focusing on one or the other of two art objects represented by two rectangles—one made by a student and one by an artist. Another rectangle, representing the two objects' individual and joint contents, surrounds the two art object rectangles. In the first rectangle, the art-making lens is directed to the student's art object, and the resulting oval on the object represents the interpreted work. In the second frame, which shows a second experience with the two objects, the art history lens is directed to the artist's object and the art-making lens to the student's. The art criticism lens comes into play in the third instance and the aesthetics lens in the fourth. The fourth instance illustrates the interpreted work of art that results from the sequential use of the four individual lenses.

may be used to study discrete factors in and about art objects. The diagram characterizes situations in DBAE institutes and classrooms where art is taught applying one discipline, another, and then another (teachers who use this approach should make sure that they cover each of the disciplines). Even though the art disciplines are focused on works of art and their contexts, as in Figure 3.1, the disciplines vie with works of art to be the primary content of DBAE.

Figure 3.4 shows only one lens for each of the art disciplines; it does not represent the varieties of inquiry methods and content that are associated with any one of the lenses. In the RIG programs the evaluators have listened to art discipline consultants characterize the very different lenses that might be used within a single art discipline. In art history, for example, the art historical lens provided by Erwin Panofsky (1955) is very

When the evaluators began to observe the creation of complex thematic units of instruction based on works of art, the power of the art disciplines during both instructional planning and teaching was immediately evident. A successful DBAE instructional unit is dependent on well-reasoned and insightful interpretations of the works of art on which it is based. In planning units of DBAE instruction, teachers must employ the art disciplines with insight and sensitivity in order to disclose the meanings of works of art used in instruction. If works of art are not interpreted well, their misinterpretations will lead to misguided instruction.

In institute programs, art specialists and classroom teachers working in groups frequently learn the rudiments of DBAE practice by quickly devising outlines for units of instruction. In the summer of 1993 the evaluators judged the results of one of these initial attempts to create an art-based unit of instruction.

In planning their unit, a group had decided to use the unit theme "People Working Together." Group members listed Ernest Oschner's *Ed and Jane Dadey* and Grant Wood's *American Gothic* as two of the principal works of art around which the unit would be organized. The names of twelve other artists, ranging from Rosa Bonheur to Bettye Saar, were also listed for inclusion in the unit.

American Gothic, Grant Wood, 1930, oil on beaver board, The Art Institute of Chicago

Ed and Jane Dadey, Ernest Oschner, 1982, oil on Masonite, Museum of Nebraska Art

On their unit plan outline under "Rationale," the group had written: "The theme 'People Working Together' leads to several different issues: changing roles in the home and workplace, interrelatedness of the community, and different work environments." Under "Narrative/Description of Unit," they had written: "In discussing artwork of various periods, it is possible to gain insight into the values of different groups. Looking at art allows the students to confront their own values, biases, and stereotypes and then work in a medium traditionally thought of as 'feminine' in a very contemporary vein."

Before the lesson was to begin, the students were asked to "keep a diary of the chores performed at home by family member[s] for a week." Five lessons were outlined: On the first day the students were to do things such as discuss the daily chores performed by members of their households. On the second day students would be asked to "discuss examples of art and literature from other times that portray the kinds of work done in different cultures and how those duties are assigned to various family members." On the third day the students were to "compare/contrast *Ed and Jane Dadey* with *American Gothic*, leading to a discussion of the changing roles of American women and art." On the fourth day the students were to sort works of art made by women into two classifications—those assumed to be created by women and those created by men. (The assumption underlying the assignment was that quilted and woven works would be placed in the stack students believed had been done by women.) On the fifth day the students

would be assigned to "begin a cooperative work using tie-dying."

The unit outline plan has both admirable features and problematic ones. Basing the work on the paintings of Wood and Oschner seems a good idea. The works are similar in some respects—Oschner's appears to have been derived directly from Wood's. Moreover, there are at least some similarities in the subject matter of the two paintings. Both show couples and work implements. The paintings, however, are very different in other ways. There is no question that *Ed and Jane Dadey* and *American Gothic* depict characters who are holding implements of work—a shovel and rake in the former and a pitchfork in the latter. Tools notwithstanding, are both paintings actually about work? Rather than being just about "people working together," they also present two couples that represent very different visions of America and Americans. In the case of *American Gothic*, the "portrait" is of pious, dour, upright, God-fearing, hardworking people. Its tone is critical and harsh. The meaning of Wood's painting is, perhaps, not so much about the relationship of the couple to the world of work as about human lives shaped by religious beliefs. Oschner's painting, on the other hand, although giving the appearance of having been derived from *American Gothic*, presents a positive, upbeat vision of America and Americans through the depiction of a pleasant couple. Neither the man nor the woman in Oschner's painting betrays evidence of piety, dourness, or religious commitment. The two appear to be happy in their work and in their relationship with one another. The "main idea" of Oschner's painting seems to be its optimistic portrayal of the couple and its almost gleeful countering of the negative view of American values and piety portrayed by Wood's painting.

The evaluators concluded that the unit theme, which pointed primarily to the topic of work, narrowed the meaning of both artworks. Moreover, it forced all the related works to be viewed only from the perspective of "women's work" and "men's work." Because the meaning of the unit's artworks was narrow, the opportunity was lost to embed within the plan the possibility of challenging students to work with things such as expressing complex critical attitudes and ideas about an entire group of people through the depiction of "representative" types. Also, the studio project, while involving the students in actually working together—the topic associated with Oschner's painting—did not ask students to deal with problems relating to the depiction or expression of ideas relating to working together. In other words, a desirable connection between the artwork the students studied and the artworks they were to make was missing.

From observation of this lesson planning episode and numerous others like it, the evaluators have concluded that, in the creation of units of instruction, the determination of themes, topics, titles, and concepts should be based on insightful interpretations of works of art. Works of art should never be forced to fit predetermined themes and topics if there is any danger of distorting the meanings of the works. The themes and topics of units of instruction should reflect full and unrestricted art historical and art critical interpretations of the works on which the units are based. If the development of a theme is paramount, then there is a danger that narrow, incomplete, or even wrong interpretations of works of art will be used to reinforce the selected theme. On the other hand, if works of art are interpreted openly, so that they reveal many of their meaningful facets, there is the possibility they will "subvert" the selected themes by "showing themselves" in complex ways that do not relate directly to the selected theme.

different from those provided by art historians such as Svetlana Alpers (1983), Michael Baxandall (1985), Norman Bryson (1983), T. J. Clark (1984), Linda Nochlin (1989), or Griselda Pollock (1988). There are dozens of different lenses for each of the art disciplines.

Some of the art discipline consultants who make presentations in summer institute programs have been careful to point out the consequences of using alternative lenses. It is important to note, however, that although one art history lens, for example, might be interchanged for another, the use of any particular lens will bring certain features of artworks into sharp focus while blurring others. The selection of a particular lens always has educational consequences.

OVERLAPPING DISCIPLINE LENSES AND HOLISTIC UNDERSTANDING As the evaluators observed DBAE institute programs and classroom instruction that used the discipline lenses independent of one another, they grew increasingly critical of the artificial way the approach fragmented understanding. There was still too much emphasis on the discrete character of the individual disciplines and not enough emphasis on a holistic understanding of works of art.

In Figure 3.5 the discipline lenses overlap. The portions of the lenses where there is no overlap represent the notion that even when the lenses are overlapped, each lens still retains its ability to function in unique and distinct ways. The overlapping of two, three, or four discipline lenses represents areas in which the lenses combine their power to transform the art object more effectively into an interpreted and understood work of art. Moreover, the overlapping of the discipline lenses provides recognition that in some and perhaps many instances there are no sharp distinctions among the ways some of the lenses function.

For example, in some instances, art historians' writings may be indistinguishable from those of art critics (Bryson 1988). Art critics may in turn make extensive use of historical and social information in interpreting and evaluating works of art. Creative artists often have extensive understanding of art history and either appropriate or adapt images, ideas, subject matter, and themes from the history of art in their works. The aesthetician reveals the assumptions that underlie the creative work of artists, art historians, and art critics. In the form of DBAE represented by Figure 3.5, some of the individual power of the separate discipline lenses is relinquished so that created and interpreted artworks become the primary content of DBAE. The disciplines are used primarily as the means through which art objects are created and transformed into works of art; they are not employed as the primary content of DBAE.

Variations Once diagrams were drawn of the basic way the disciplines overlapped in actual practice in institutes and classrooms where DBAE is taught, it was easy to see a sizable number of variations on the basic paradigm. Figures 3.6–3.8 show some of these variations.

Figure 3.6 shows discipline lenses of unequal sizes. Any one of the lenses could have been shown larger than the others in order to represent that particular art objects "call out" to be studied through particular lenses. This diagram dispels the notion that in DBAE the disciplines must be used in equivalent manners. The disciplines are merely means; the appropriate lens sizes should be based on what appears reasonable in the art learning context. In watching DBAE instruction, the evaluators have noted that the amount of

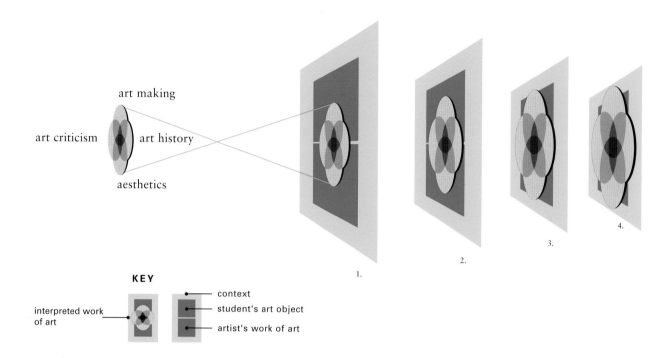

KEY

interpreted work
of art

context
student's art object
artist's work of art

Figure 3.5 In this figure, the discipline lenses overlap. On the rectangles representing art objects and their contexts, the pattern showing the interpreted works of art is whole and integrated. The wholeness continues and grows larger through the succession of experiences with the art objects.

time for which a particular art discipline lens is used is determined by what the art object itself appears to need.

Figure 3.7 shows the overlapping of two sets of two discipline lenses. The fact that the lenses are not focused where the student's work and the work of another meet represents that the art lesson or unit of instruction is not as fully integrated as it might be. The evaluators have frequently encountered situations where the focus of the art discipline lenses has not been coordinated. The forms of DBAE instruction implied by this diagram have less merit than forms where the four art discipline lenses overlap.

Figure 3.8 shows three overlapping lenses—aesthetics, art criticism, and art history—and an independent art-making lens. In the early days of observing DBAE instruction, the evaluators frequently saw examples of instruction represented by this configuration. In recent years the art-making and study portions of DBAE have become increasingly coordinated, so that the instruction looks more like that shown in Figures 3.5 and 3.6.

The class of first graders was engaged in a large unit of instruction relating to trees. The children had already drawn trees in different seasons of the year. As the evaluators entered the classroom, the children had just been asked how they knew the seasons from the evidence they saw in reproductions of paintings of trees. They were also asked the ubiquitous question, "How does it make you feel?"

Soon the children were divided into four groups to conduct analyses of four reproductions of paintings of trees. This part of the lesson was exemplary. Each group had a moderator and a secretary to record the ideas about the trees. One group of children managed with considerable competence to characterize features of the paintings—"The grass is turning green"; "The sky is pretty"; "The blossoms are red." Another group of students gave words to characterize their painting—"happy color, fall, cold, nervous." After ten minutes the full group reassembled, and

top: *Return of the Hunters,* Pieter Brueghel the Elder, 1565, oil on wood, Kunsthistorisches Museum, Vienna.

right: *Peach Tree,* Vincent van Gogh, 1888, oil on canvas, Van Gogh Museum, Amsterdam, The Netherlands.

99

on the board the teacher drew an oval in which she wrote "tree." Radiating outward from the center were four lines with four more ovals and four more words: "spring, summer, fall, winter." Then each of the four groups, assisted by the entire class, webbed outward from the seasons. The fall tree, for example, acquired an additional cluster of words: "cool, vacation over, changing, green, yellow" and the puzzling word "nervous." When the originator of the word was asked to explain his contribution, he explained, "Because you have to go back to school." Throughout the discussion the teacher never mentioned to the children that the paintings were created by well-known artists—that the spring tree was by Van Gogh, the summer tree by Constable, the fall tree by Utrillo, and the winter tree by Brueghel. She did not bring to the children's attention that the artists painted the trees in France, Britain, and Flanders, or that they painted them in different times and in different styles.

It was a good lesson; it was not, however, a good art lesson. Unfortunately, the reproductions served simply as illustrations of seasons of the year. They were presented as visual stimuli, not as works of art.

Discipline Lenses of Unequal Sizes

Figure 3.6 The art criticism lens is shown largest to demonstrate that when the objects of contemporary artists or students are studied, there is often no art historical writing about the works, because the objects have been completed so recently that they have not had time to enter a historical domain.

Two Sets of Two Overlapping Discipline Lenses

Figure 3.7 This figure shows the overlapping of two sets of two discipline lenses. Overlapping aesthetics and art criticism lenses could be directed to the study of an art object created by another culture. The overlapping art history and art-making lenses indicate that a student conducted research on an image, theme, subject, or idea from art history as part of the preparation for creating his or her own art object.

Three Overlapping Discipline Lenses and an Independent Lens

Figure 3.8 Shown in this figure are overlapping aesthetics, art criticism, and art history lenses and an independent art-making lens. The overlapping lenses are directed to the artist's work of art and the art-making lens to the art object created by the student. The implication of this diagram is that the student's art object is unrelated to the art object created by another—that one does not inform the other.

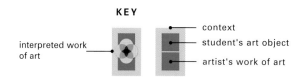

KEY

interpreted work of art

context

student's art object

artist's work of art

Ways to Integrate the Disciplines

From the time the RIG programs were first established, some institute directors and faculty members encouraged participants to create art lessons and units of instruction in which the four disciplines were integrated. This objective, however, was difficult to achieve, because in most institute programs the art disciplines were presented separately, and their distinctive characteristics were emphasized more than either their similarities or their relationships. Moreover, in the early days of the institutes fully integrated models of DBAE instruction had not been developed.

Chapter 2 illustrated how the art disciplines began to be integrated in summer institute programs when Paul Sproll gave participants the assignment to create instructional units on "the chair as a portrait" (see pp. 70–71). Another more complex approach to the integration of the disciplines was tried in Nebraska's Prairie Visions institute. In 1989, art discipline consultants Gary Day, Michael Gillespie, Martin Rosenberg, and Frances Thurber from the University of Nebraska at Omaha and Mark Thistlethwaite from Texas Christian University met with a representative group of art teachers, elementary classroom teachers, and administrators to consider ways to organize DBAE content. Teams representing each of the disciplines identified sixteen key concepts—four for each discipline.[4] Initially, in the Prairie Visions institute program, the sixteen concepts were related to four topics and subjects—landscapes, abstraction, narrative, and portraits. By selecting a single topic, the institute faculty members had the opportunity to coordinate their presentations and to focus the four disciplines on different dimensions of that topic. On one of the days of the institute, for example, the topic "narrative art" was approached through the concepts of iconography, interpretation, how art relates to life, and expression. The topic provided a means for illustrating the manner in which the discipline lenses could be integrated.

The Thematic Work-of-Art-Based Unit of Instruction: Paradigmatic DBAE

The evolution of DBAE can be seen to have taken place in two general phases. The diagrams shown thus far, those illustrating the relationship of the discipline lenses to art objects, were generally developed in the first phase. Most of that development took place in relationship to the summer institute programs. In the second phase there was considerably more interplay among the forms of DBAE developed within summer institute programs and the forms developed by art specialists and elementary classroom teachers who, in the process of implementing DBAE in their schools and classrooms, began to devise new forms of DBAE. The new instructional forms began to affect thinking about DBAE curricular and instructional theory. This is one of the most important instances of DBAE practice shaping DBAE theory.

Figure 3.10 presents a highly schematic representation of a thematic unit of instruction based on a key work(s) of art, three sets of related works, and a miniportfolio of student works based on the theme derived from the key work. Indeed, the numerous variations of this basic model have become the paradigm DBAE unit of instruction. Case

Prairie Visions' Concepts Related to Themes
and Topics of Works of Art

	selection	description, analysis, and classification	interpretation	evaluation
art history	HISTORICAL SELECTION what am I going to choose to study?	STYLISTIC ANALYSIS how can we think about style: general, historical, personal?	MEANING AND HISTORICAL CONTEXT what did it mean at its time?	HISTORICAL SIGNIFICANCE why is this still important for us?
art criticism	CRITICAL SELECTION is this interesting to me?	VISUAL ANALYSIS how can we think about style: general, historical, personal?	INTERPRETATION AND CRITICAL PERSPECTIVE how am I reacting to this and why?	EVALUATION how good do I think this is?
aesthetics	ART/NONART is this art?	AESTHETIC PERSPECTIVE what are the main approaches to art?	AESTHETIC CONTEXT how does art relate to life?	APPROACHES TO VALUE is this good?
art making	PROCESS what decisions am I making?	FORM what am I making?	EXPRESSION what am I trying to say?	INTEGRITY does this work?

Figure 3.9 In the Prairie Visions Institute, sixteen key concepts were related to four topics and subjects. By selecting a single topic, institute faculty members focused the four disciplines on different dimensions of the topic.

studies in Chapter 5 discuss several units of instruction that illustrate the various ways that art specialists and classroom teachers have integrated the disciplines in units that are variations of this model.

Figure 3.10 shows the results of focusing the art discipline lenses on the key work, related works, and student works. Obviously, it is impossible to focus all the lenses on all the art objects simultaneously. In the clusters of objects surrounding the key work(s), individual and overlapping lenses used to illuminate them are shown. Through a series of diagrams it would be possible to illustrate the progression of the unit of instruction by showing different sizes and combinations of lenses directed and redirected toward the different art objects.

It is important to note that all of the art objects in the unit are surrounded by a generous area representing the context. Each of the art objects selected for use in the unit or created by students as the unit progresses has its own context—factors such as the cir-

A Unit of Instruction Centered on a Key Work of Art

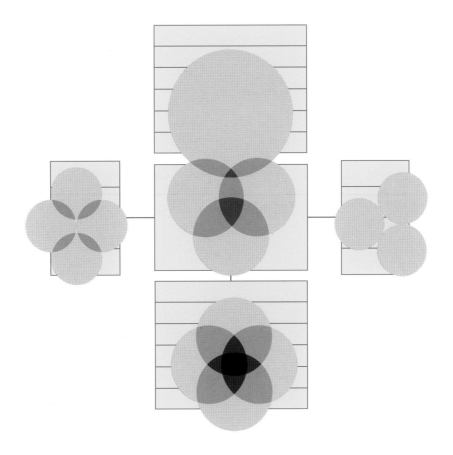

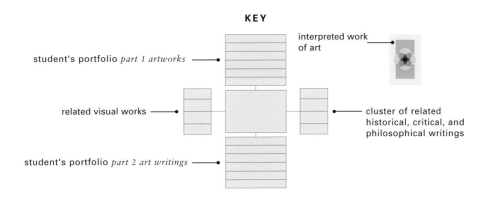

KEY

student's portfolio *part 1 artworks*

related visual works

student's portfolio *part 2 art writings*

interpreted work of art

cluster of related historical, critical, and philosophical writings

Figure 3.10 This figure shows the basic structure of the unit. The key work or works of art from which the unit's theme is derived is shown at the center of the diagram. To the left of the principal work, a cluster of related visual works of art is depicted; to the right is a cluster of critical, historical, and philosophical writings relating to the work of art. Above the principal work a large rectangle has been subdivided to represent visual works from a student's portfolio made during the unit of instruction. Below the key work are the student's own critical, historical, and philosophical writings pertaining to the key work of art and related works and to his or her own artworks.

cumstances surrounding its creation and the ways it has been used and interpreted over the period of its existence. When the objects are placed within a unit of instruction, they create an extremely rich composite context. The decision to study a group of artworks is usually preceded by an initial determination of one or more of the possible kinds of relationships that exist among them. These relationships among the works contribute to the composite context.

MULTISUBJECT ART-BASED UNITS OF INSTRUCTION WITH MULTIPLE LENSES

Figure 3.11 shows overlapping and related discipline lenses directed toward a comprehensive unit of DBAE instruction, a form of DBAE that is becoming increasingly common in elementary schools where art is taught jointly by art specialists and classroom teachers. Like Figure 3.10, this diagram shows a key work of art or a set of key works at the center of the unit.

In this diagram no attempt has been made to show the way such a unit of instruction unfolds. Nevertheless, it should be noted that when a unit such as this is taught, it combines features of nearly all of the diagrams presented thus far. Art discipline lenses are used individually and in a variety of combinations, including the overlapping of all four lenses. In this comprehensive DBAE unit of instruction there is also one important new factor; in addition to the art discipline lenses there are lenses from the other subject areas— music, literature, history, anthropology, and so on. The lenses for the other subject matter might be single lenses dealing with, say, literary criticism, or there might be a combination of lenses that illuminate an aspect of literary history and the process of writing a literary work.

The addition of lenses for other subjects emphasizes an extremely important point: lenses are used because they are needed, not merely because they exist. In DBAE units of instruction such as the one in Figure 3.11, key works of art and students' works are placed in their social, cultural, historical, artistic, and aesthetic contexts because their meaning is enhanced through showing their relationships to the objects, artifacts, and events from the other arts and other school subjects. In keeping with the spirit of DBAE, when objects and artifacts from other subject areas are studied in a DBAE unit, they too should be treated in a disciplined manner that includes illuminating their meaning through the application of appropriate lenses—lenses beyond those used in DBAE.[5]

In the evolution of DBAE the evaluators have noted an increasing willingness on the part of its practitioners to reject narrow and superficial definitions. They take a pragmatic approach and employ whatever means are necessary to make the study and creation of art substantial. Units of DBAE instruction are richly interrelated with other school subjects when those subjects enhance art. The art discipline lenses are employed flexibly in combination with lenses from other disciplines when there is the opportunity to make art education educationally important. Figure 3.11 represents the current high point of DBAE development as observed in the RIG programs.

UNITS OF INSTRUCTION USING ART OBJECTS AS ILLUSTRATIONS OF TOPICS AND CONCEPTS

It would, perhaps, be a positive sign of the maturity of DBAE if the illustration of its forms were to conclude with Figure 3.11. There is, however, one other instructional type—not classified as a form of DBAE—that has emerged in the DBAE insti-

Overlapping and Related Discipline Lenses
Focused on a Comprehensive Unit of DBAE Instruction

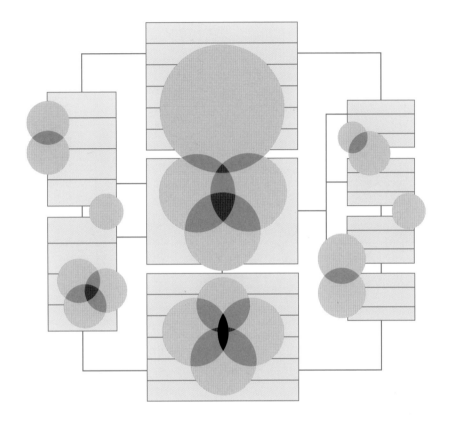

KEY

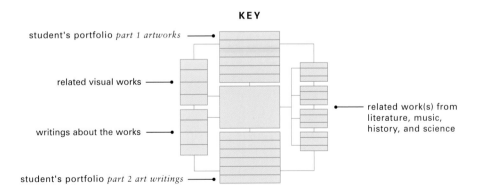

student's portfolio *part 1 artworks*

related visual works

writings about the works

student's portfolio *part 2 art writings*

related work(s) from literature, music, history, and science

Figure 3.11 As in Figure 3.10, a student portfolio is represented above and below the key work(s). The key work of art around which the unit is organized is surrounded by other works, but in this case the works are not just works of art but include works of music, literature, theater—anything to illuminate the key work of art, its theme, the factors that surrounded its creation, and the different interpretations that have been attached to it.

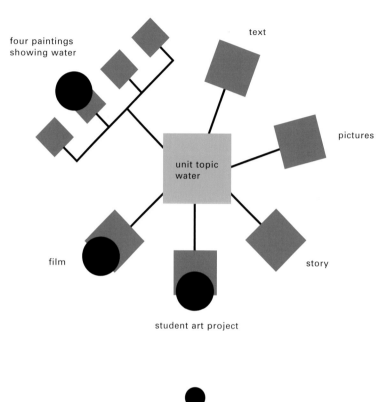

four paintings
showing water

text

pictures

unit topic
water

film

story

student art project

lens *not necessarily
from the visual arts*

Figure 3.12 The square at the center of the diagram represents a topic. The lines radiating from the topic terminate with a series of squares representing stories, experiments, activities, and so on, and four smaller squares representing art objects. The lenses used to study the works may not be art discipline lenses and may not relate to any discipline but are cobbled together to study ideas and topics treated in a non-discipline-based manner. When works of art are used to illustrate a topic or a theme, even if art discipline lenses are used, they can sometimes be employed in such a narrow way that the results cannot be classified as DBAE even though the instructional units may have originated in DBAE institutes.

tutes. Figure 3.12 is a diagram showing how works of art are used merely to illustrate topics and concepts. The figure takes the form of a web, much like the diagrams that elementary school classroom teachers use to plan units of instruction. In institute planning sessions the evaluators have watched classroom teachers become excited about including works of art in their instructional programs. Frequently, however, teachers do not create whole new instructional units; rather, they merely add art to units they already teach.

For example, a teacher who has already developed a unit on "water" sees seascapes by Winslow Homer, Claude Monet, and J.M.W. Turner and adds them to the unit web.

The paintings serve as illustrations of a "calm sea," "the ocean in a storm," and so on. When works of art are included in units organized around topics such as "water," "plants," or "families," typically there is no searching for larger and more profound themes that might be associated with works of art. For example, when the paintings by Homer, Monet, and Turner are used to illustrate a topic, typically there is no exploration of the paintings' larger thematic concerns—things such as human relationships to nature and expressions of aesthetic responses to the power, beauty, or subtlety of nature. It is difficult to determine just what type of lenses are used to study the paintings; they appear not to be art discipline lenses. Usually the lenses relate to no discipline whatsoever; they are merely means cobbled together to study ideas and topics treated in a non-discipline-based manner. When works of art are used to illustrate a topic or a theme, even if art discipline lenses are used, they are employed in such a narrow way that the results cannot be classified as DBAE even though the instructional units may have originated in DBAE institutes.

It is easy for an art educator to see that a unit of instruction in which art objects are used merely to illustrate a topic like water trivializes art and inhibits the insightful interpretation of works of art. Nevertheless, when art teachers use works of art to illustrate an element of art such as line or an art concept such as monumentality, they are often insensitive to the fact that they have trivialized art in much the same way as their classroom teacher colleagues.

During six years of observing the implementation of DBAE in the RIG programs, the evaluators have noted a gradual decline in these non-DBAE forms of art instruction offered by art specialists. The decline has been accelerated as coherent models of DBAE instruction have been developed by teachers who have attended DBAE institutes.

Forms of DBAE and Their Implications

Figures 3.10 and 3.11 exemplify the structures of some of the most-promising forms of DBAE to have been developed in the RIG programs. This chapter concludes by pointing to the curricular implications if these advanced forms of DBAE were applied:

DBAE would be based on units of instruction, not on individual lessons. Each of these units of instruction would have explicit relationships to each of the other units taught within a year or in a cluster of years (lower elementary, upper elementary, middle school, and high school). In effect, the DBAE-curriculum would consist of a series of carefully articulated thematic units for each grade from kindergarten through twelfth grade.

The DBAE curriculum would be built around works of art selected because they have the potential to educate in powerful ways. Works of art would provide the content of art education, and the disciplines of art would provide the means through which meaning is created, interpreted, evaluated, and understood.

Each unit of DBAE instruction would be based on two sets of works of art, those created by students and those created by artists. The artists' works of art might be selected both because they embody potent expressive and aesthetic qualities and because they carry ideas, themes, and subjects that

are deemed important to students and teachers in a school community. The students' works would reveal their reflections on and responses to the ideas, themes, subjects, and expressive characteristics of the works they study, but modified, reinvented, extended, redirected, and even countered in light of things such as students' interests, the goals of education, concerns of contemporary society, and the best interests of the global community.

In the exemplary DBAE curriculum the art-making projects would have a direct relationship to the themes and ideas as well as to the formal and aesthetic qualities contained within the works of art selected for study. In the exemplary program students would probably be found creatively relating the important ideas found in works of art from the history of art to the problems, issues, ideas, and events of their contemporary world and of their own lives. Attention to only the formal and expressive aspects of works of art is inappropriate for the study of art in general education programs.

The holistic assessment of students' abilities to interpret and make inferences through studio, historical, critical, and philosophical means would be an integral part of each unit of study.

Conclusion

The evolution of DBAE over the past decade is often discussed as if it were one monolithic phenomenon. As shown through the diagrams presented in this chapter and through the instructional units on which the diagrams are based, DBAE exists in a variety of forms. Through the diagrams, most of which are intended to be general representations that themselves point to dozens of similar forms, the evaluators have tried to indicate that among the various forms some have great promise and others are filled with problems.

DBAE is permeated by memories, echoes, transformations, and the residue of past

Each unit of DBAE instruction is based on works created by students as well as those created by artists.

values and assumptions about art education. It is also pervaded by genuine excitement about the changes occurring in the worlds of art and education. DBAE is being "written" by communities of individuals who are directly involved in the advancement of its theory and practice. DBAE is a two-way street where theory guides practice and where, through the innovative instruction of art specialists and elementary classroom teachers, practice enriches and sometimes even guides theory development.

DBAE is affected by the unacknowledged traditions associated with practices from art teachers' "collective consciousness," going back a century and beyond. The character of DBAE is also affected by its critics, both within and outside the projects supported by the Getty Education Institute. DBAE is at the intersection of beliefs, sometimes concordant and sometimes conflicting, about the nature of art, the evolving character of the disciplines of art, the purposes of education, the role of art in the general education curriculum—the special contributions of art to the educated individual, the nature of children and young people, how art might best be taught, the content of art education, and what is to be learned—and the relationships among skills, knowledge, and understanding.

Not only is it possible for the institute directors and their staffs, evaluators, museum personnel, administrators, and practitioners to build different conceptions of DBAE, it is expected. From the standpoint of the evaluators, varied interpretations of DBAE are both healthy and desirable, especially if they become the basis for discussion of assumptions about the role of art in education. Indeed, it is this variety of interpretations of purpose, theory, and practice that the diagrams capture.

Notes

1. In the 1989 Ohio summer institute, Laura Chapman presented a diagram similar to that shown in Figure 3.1. The evaluators owe their understanding of this particular conception of DBAE to her. This conception is also similar to one presented by Clark and Zimmerman (1978).

2. Dewey places great emphasis on the vividness and intensity of the work of art—an obvious bias toward expressive aspects of art. The present author wants to posit the possibility that the thematic, allegorical, symbolic, and subject-matter dimensions of works of art also add to the depth and intensity of aesthetic experience—that works of art that most merit attention are the ones that create vivid and intense experiences because of the fusion of their form and content.

3. In Figure 3.2 the art object is shown without any societal or historical context. In later figures the art object is placed within a second rectangle that represents the context or conditions surrounding its creation and interpretation.

4. Joanne Sowell, an art historian at the University of Nebraska at Omaha, would play a key role in refining and applying the sixteen key concepts.

5. In "The Origin of the *Tar Beach* Assessment Unit" (p. 157), there is a discussion of assessment units, such as one based on the quilted story paintings of Faith Ringgold, that have been developed in the Florida institute. All of these assessment units have the character and structure seen in Figure 3.11.

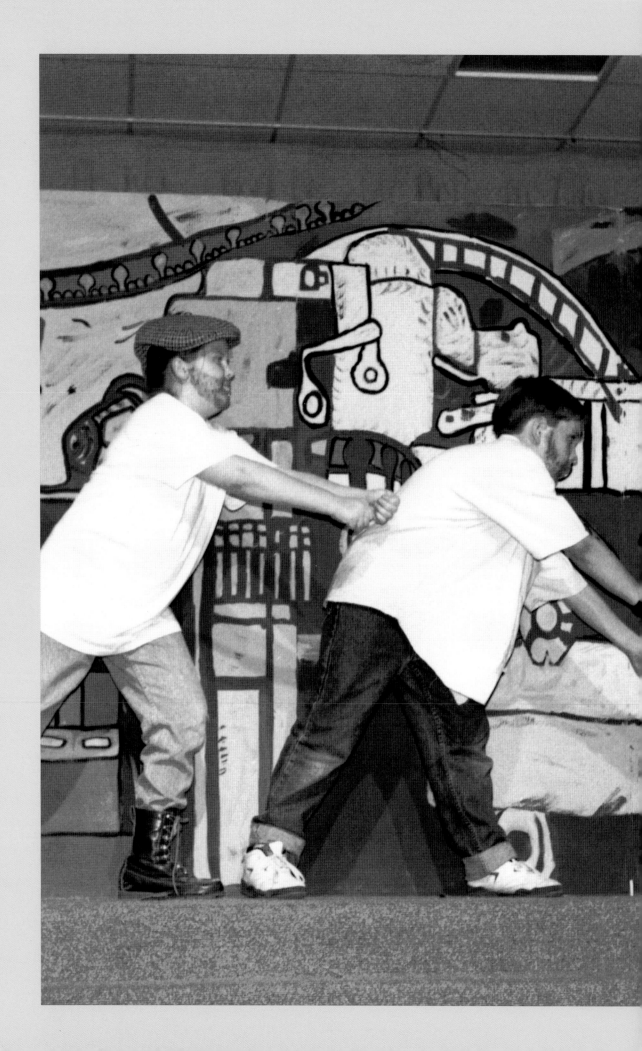

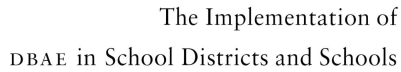

The Implementation of
DBAE in School Districts and Schools

CHAPTER

4

As Chapter 2 illustrated, summer professional development institutes and, to a lesser extent, school-year workshops provide teachers with their most important sources of information about educational innovations. How do teachers take what they have learned in the institutes and implement it in the classroom? The main principle underlying the RIG programs is that educational change will succeed only when reform is undertaken by individuals working collaboratively at all levels within a change community. This chapter describes the essential features of administrative leadership and comprehensive planning that, when present, lead to change and, when absent, impede progress. It also demonstrates that in the movement of art to the core of the curriculum, DBAE works most effectively when combined with other reform initiatives.

Implementation Constraints

How do teachers stay current with new developments in the various fields of knowledge? How do they translate that knowledge into sound pedagogical practice? Throughout the nation, summer professional development institutes and school-year workshops provide teachers with some of their most important sources of information about educational innovations.

These seminars are usually directed to the individual teacher. Indeed, focusing reform efforts on each instructor might seem a sound practice. After all, what teachers do behind the closed doors of their classrooms is the bottom line for educational reform.

The institutes and workshops do appear to affect teachers' ideas about their instructional programs. When they hear of new educational initiatives, many may resolve to change the ways they teach particular subjects and lay plans for developing and implementing new curricula and instruction. Experience has shown, however, that few of these resolutions are ever fully realized, because when teachers return to their classrooms determined to implement new educational initiatives, they encounter unexpected difficulties.

Back in familiar circumstances, teachers find that the culture of the school reasserts itself. Just coping with ongoing instruction—one lesson following another and, in the case of elementary art specialists, meeting with as many as eight hundred students in a single week—leaves teachers with little time or energy to modify existing practices. Also, there may be little encouragement for or even outright resistance to change. If administrators or fellow teachers have not attended a particular professional development workshop or institute, they may know little or nothing about the new initiatives. Consequently, they may have slight or no interest in seeing new features added to the school curriculum. In some cases, teachers who have not attended particular work-

shops or institutes may subtly discourage fellow teachers from making changes, sometimes out of fear that if the innovation catches on, they too might be expected to change. It is a case of the culture of the school inhibiting change, as Seymour Sarason shows so elegantly in his classic work *The Culture of the School and the Problem of Change* (1971).

There are ways to change the culture of schools, but pervasive change is not accomplished by individuals working independently. The main principle underlying the DBAE initiative is that educational change will succeed only when reform is undertaken by individuals working collaboratively at all levels within a change community. This chapter illustrates the important factors that have contributed to the implementation of DBAE in school districts and schools.

A Systemic Approach to Educational Reform

The professional development institutes of the RIG programs are not directed solely to individual teachers or even to individual schools. From their inception, the institutes were available to teachers and schools only when their school districts became members of one of the consortia. Once a district joined, its administrators agreed, often in writing, to implement DBAE in the schools. Principals and DBAE coordinators, in turn, agreed to work with faculty members to devise strategies for implementing the program at their sites. Art specialists and classroom teachers, working in teams, were given the responsibility to develop, adapt, and refine DBAE instructional programs.

How essential was each of these components? Can school visual arts programs (and arts programs in general) be transformed without the leadership of principals? Can new, innovative schoolwide programs be implemented by individual teachers? Is it necessary for a team of principals and teachers to attend professional development programs together? How important is it for a team of administrators to develop a written multifaceted plan for changing art programs? Is it better to approach educational change one initiative at a time, or does approaching several change initiatives simultaneously increase chances for success?

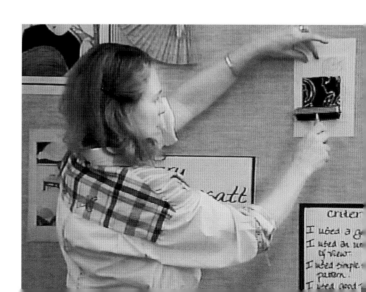

Art specialists, working in teams with classroom teachers, took on the responsibility of developing, adapting, and refining DBAE instructional programs.

In the six RIG programs there are at least 250 different district implementation stories to tell. Each story is unique, and there is no easy way to select a few illustrations to represent the diversity of the districts.

Every school district into which DBAE is introduced has a history of art and arts education. When DBAE programs begin to be initiated, they are grafted onto programs that already exist, fitted into existing patterns of administrative support, guided by supervisors and coordinators with varying degrees of experience in implementing programs, and affected by individuals' perceptions of the success of previous change initiatives. The school districts of Columbus, Ohio, and Columbus, Nebraska, illustrate the very different traditions, conditions, and settings into which DBAE has been introduced.

The DBAE program in Columbus, Ohio, makes a fascinating case study because of past arts education initiatives. The full story would go back a hundred years or so. This discussion will begin, however, with Arts IMPACT (Interdisciplinary Model Programs in the Arts for Children and Teachers).

In 1970 the Columbus Public Schools, with the leadership of Helen Sandfort, the district's director of arts education, received an Arts IMPACT grant from the U.S. Office of Education. The purpose of this program was to strengthen and expand arts education in a few selected school districts around the country through the hiring of school teams of drama, dance, music, and visual arts teachers who would establish comprehensive arts programs in individual schools. By 1972, when the final report on the project was delivered to the Office of Education, four Columbus Arts IMPACT elementary schools had been established. Under the conditions of the grant, the federal government initially paid the salaries of the arts teachers. At the end of the grant period, the Arts IMPACT schools were continued and two others were organized—all with district funds. Later, four other schools with Arts IMPACT-like teams were also established.

Much of the success of the district's arts initiatives can be attributed to Sandfort and Martin (Hank) Russell, who was supervisor of art from 1962 to 1977 and director of arts education from 1977 to 1990. Russell actively sought opportunities to involve the Columbus schools in new programs. He told the evaluators that he always wanted the district to be involved so Columbus could shape initiatives rather than be shaped by them. In the mid-1980s he applied to the Getty Education Institute for a DBAE district implementation grant and worked to create a consortium composed of the Ohio Department of Education, the Ohio Arts Council, and Ohio State University.

Russell wanted to show that a large urban district could transform its studio-based program into a new curriculum organized along the lines of DBAE. Consequently, he, Columbus art supervisor Sandy Kight, and Ohio Partnership director Nancy MacGregor presented the plan to assistant superintendent Howard Merriman, who said the program was just what the district needed. He believed it would establish the need for more elementary art specialists—an attitude that counters conventional wisdom that DBAE programs eliminate art specialists. Merriman liked the idea of a multiyear project with a team approach to professional development. Evelyn Luckey, another assistant superintendent, saw the possibility of linking DBAE to the district's Reading Recovery program. Because the district had been prepared for DBAE, Russell and his colleagues were ready to make Columbus the Ohio Partnership's lead district once Ohio State received one of the Getty Education Institute RIG program grants.

Although there have been five superintendents since the project began in Columbus in 1988, MacGregor told us, "It was just a given that the project would go on." The district's commitment is demonstrated by the fact that teacher teams from most of the district's hundred-plus K–12 schools have attended summer DBAE institute programs.

In cooperation with the Ohio Partnership, the Columbus district has allocated a sizable number of resources to the DBAE program. For example, during the 1988–89 school year Russell;

Kight; Bob McLinn, a high school teacher on special assignment; and district art consultant Doris Guay all devoted much of their time to the implementation of DBAE. Guay worked almost exclusively visiting, monitoring, and evaluating DBAE classrooms. Until she retired in 1992, Kight devoted a considerable portion of her weekly meeting with the elementary art specialists to DBAE issues and provided middle school and high school art specialists with "release-day" professional development time to work on DBAE during the school year. To her goes much of the credit for the development of the comprehensive collection of materials that are housed in the Columbus Public Schools' Art Resource Center and used extensively for DBAE instruction. McLinn spent five years working with secondary school art specialists to implement the DBAE program.

Members of this original team retired or took other assignments; in 1993 the new art supervisor, Connie Schalinsky, assumed responsibility for the Columbus program. With site-based management, which has become an increasingly influential factor in Columbus, there is little funding available to continue the districtwide DBAE initiative. Consequently, a plan is being developed where the Ohio Partnership, in cooperation with Ohio State's College of Education Professional Development School, will continue implementation in schools where cooperative programs already exist, in new "Schools of Excellence," where special initiatives are being undertaken, and in schools in close proximity to the Ohio State campus. It is remarkable that a district with eighty-five elementary schools, twenty-six middle schools, sixteen high schools, and all the attendant problems of a large city district was able to progress so far in the implementation of DBAE—before changing circumstances made it necessary to seek new, less systematic ways to continue the implementation process.

The second Columbus, in Nebraska, is a small, rural town, approximately seventy miles west of Omaha. It has eight elementary schools, one middle school, and one high school.

The Columbus, Nebraska, school district was judged by the evaluators to be well run. A well-run school district is characterized by such things as high expectations for all students, teachers, and administrators. Parents and other community members are partners in school planning. The central administration takes responsibility for all programs, including the arts, giving them status equal to any other subject-matter area.

In Columbus, both superintendent Fred Bellum and assistant superintendent of curriculum and instruction Larry Bradley spoke of the art program as if it were their program. Through discussions with them the evaluators learned of the district's curriculum and review process, in which years are designated for the review, evaluation, and development of each subject-matter area.

In 1988 the district began the curriculum review process for the visual arts. Even before the first Nebraska Prairie Visions summer institute, the decision was made that Columbus would develop a DBAE program. All five of the district's secondary art specialists served on the curriculum team, along with three classroom teachers, an elementary school principal, and a representative from the community. The committee reviewed the art textbooks available for the elementary grades and decided to adopt *Discover Art*. The committee also developed a comprehensive inservice program that included all-day and after-school workshops. With the organization of the Prairie Visions institute, one or more teams of teachers and administrators attended summer institutes between 1989 and 1993. All of the district's art specialists and elementary school principals have attended Prairie Visions summer institute programs.

The entire DBAE initiative was a collaborative effort; it was headed, however, by high school art specialist Jean Detlefsen. Although the district has no art supervisor, Detlefsen assumed most of the responsibilities associated with the implementation of DBAE. Because she had the full support of the district administrators and acted in their behalf, she was able to coordinate the entire process effectively. The activities included scheduling a professional development day for Colum-

115

bus teachers at the Joslyn Museum of Art in Omaha. The session was conducted by the museum's art educators and philosopher Michael Gillespie, the Prairie Visions aesthetics consultant.

The inservice day was organized much like the Prairie Visions summer institute program. Detlefsen's high school colleagues commented about how much the DBAE teachers who had attended Prairie Visions institutes knew about art and how successful they were in leading discussions about works of art. They were also impressed that the teachers were willing to entertain differing interpretations of art. A biology teacher commented, "On the field trip there was a sharing—there was no restriction on the answers that we could give."

After the teachers returned to Columbus High School, several began to incorporate art into their instruction. An English instructor used three classifications from the visual arts to illuminate forms of literature. A U.S. history teacher was motivated to assemble trunks of artifacts such as the ones created by the Joslyn Museum education department. He also used reproductions of works of art to show contradictory interpretations of historical events, such as the Battle of Little Big Horn. A biology teacher reported that at the Joslyn he had had a flash of insight: art is about feelings, and science is also sometimes about feelings. He decided that art could be used to help his students understand some of the value issues that surround science.

The visual arts initiatives already underway made it possible to take a next step—the development of an American studies course at the high school. The principal, Robert Dierman, is a scholar with a love for ideas, whether related to America or to his first interest, the medieval period. With the assistance of Detlefsen and other high school teachers, Dierman wrote a proposal and received a grant from the Nebraska Arts Council to develop a course that is modeled along DBAE lines. Each year more teachers are added to the team teaching the course, with the arts and humanities at its core.

At the Columbus Middle School, principal Dick Meyer was determined to create a place that was different from either an elementary or a high school; he used the term *transescent* to describe the transitional, adolescent stage of middle school students. He has encouraged teachers to consider new ways of organizing the school. In the fine arts area, the art and music teachers have experimented with two patterns of integration. In one, they have taught their students separately for seven weeks and then brought them together for two weeks of combined instruction. In the second pattern, the one the evaluators observed, the teachers provide art and music instruction separately for four days a week and then on Fridays bring their students together for joint instruction.

The evaluators observed a combined class of art and music students who were team-taught by an art teacher and a music teacher. Groups of approximately five students each were given a paradigm Prairie Visions "learning cycle" task—each group was allocated $25,000 and asked to choose from a collection of works of visual and performing arts the ones they might bring to their community. They had to make selections (while staying within their budgets) and provide the criteria for their choices.

One of the teachers, who made good use of the learning cycle approach to instruction, was asked when he had attended the Prairie Visions summer institute. His response was, "Oh, I haven't attended the institute; I'm the music teacher." Discipline-based approaches to inquiry have a way of infiltrating schools.

The art program in Columbus had several other notable features:

In Columbus elementary schools, art is taught consistently—as a distinct subject and in combination with other subjects.

The art program has strong ties to two local arts institutions—the Columbus Area Arts Council and the Columbus Art Gallery. Gallery docents have attended Prairie Visions summer institute programs. The Columbus district also makes exemplary use

of traveling exhibitions from the Sheldon Memorial Art Gallery.

Public relations is a major concern within the district. In December 1989, a forty-six-page special edition of the *Columbus Arts Tribune* provided a detailed description of the DBAE program. The article explained the goals of the program, along with the textbooks that would provide the basis for instruction; drew relationships between the basic program and the artist residency programs; and explained the student assessment program. The newsletter of the Columbus district, *Discoveries*, has a feature on the art program in almost every issue.

The district's professional development program is coordinated with the area's intermediate education agency, Education Service Unit 7. The Education Service Unit in Columbus even added a staff member to take care of Prairie Visions mailings, coordinate an artist residency program, and organize orientation and renewal meetings for Prairie Visions teachers in the Columbus area.

DBAE has been integrated into the fabric of the Columbus, Nebraska, school district. One elementary school principal remarked: "Prairie Visions has been the foundation of our professional development program. The participants come back from the institute committed. They have become the resource that has helped us to determine what and who should do things. They themselves have assumed the inservice role. They have taken what they have gotten from Prairie Visions and applied it throughout the district."

BECOMING A DBAE SCHOOL DISTRICT School districts were recruited to join DBAE consortia in a variety of ways. In Florida, Minnesota, and Nebraska, school districts across the state were notified that they had the opportunity to join a DBAE consortium. In Ohio and Tennessee, districts near Columbus and Chattanooga were recruited first. Districts further from these centers were recruited in subsequent years—in Ohio, in an outward-spiraling pattern to new area sites, which in turn spiraled outward to new districts; and in Tennessee, to area site locations throughout much of the southeastern United States. In the North Texas Institute a decision was made to work with districts within the Dallas/Fort Worth/Denton triangle—they joined the institute in its first year. New districts continue to join the regional consortia either through self-selection—individuals in school districts hear about the programs and ask to join—or through active recruitment—when institute directors make visits to districts to present information about DBAE and explain institute programs. Through these various processes, approximately 250 school districts had joined the DBAE consortia by 1993.

Individuals in school districts that join the consortia know their districts have access to summer institutes and a variety of other programs, resources, and technical assistance needed to implement DBAE. In return, the districts promise to provide administrative support, develop long-range plans, and give teachers the resources and time needed to implement the program. Each of the regional consortia informs school superintendents and other district administrators about their responsibilities to the consortium.

Where district administrators have not fully understood their responsibilities—or fully assumed them—programs have not grown at the same rate as those in districts where administrators have a strong commitment to a program's implementation. The importance of school district administrators providing leadership for the implementation of DBAE contradicts the current educational belief that site-based management of schools will achieve desired educational reform. When individual schools are freed from regulations and even from the expectation that they will implement comprehensive arts programs, the arts suffer. School district leadership remains an essential factor for maintaining equity among school subjects, ensuring standards of excellence, and assuring that change initiatives will be implemented throughout a district.

Arts programs require nourishment, and continuing administrative support is just

CHARACTERISTICS OF A QUALITY DBAE PROGRAM

The following points, taken from documents developed by the Southeast Center for Education in the Arts, address planning, curriculum, evaluation, and resources, the characteristics that most directly affect the quality of arts education in schools. They embrace the philosophical framework inherent in a comprehensive DBAE program and are not exclusive to any one arts area or curriculum development model.

• A long-range planning committee for the arts is in place to address program development. An arts planning committee—representing arts teachers, school administrators, parents, community arts resources, the school board, the gifted/talented program, the special education program, and community businesses and service organizations—meets regularly to make long-range plans for the improvement of arts education. Such a committee should be in place at both district and school levels.

• The local school board has in place a policy statement and goals and objectives for student learning that include the arts. The statement should address the importance of the arts in the general education of each student.

as important as initial support. The evaluators observed a small number of cases where DBAE was close to being implemented in every school in the district but ceased growing because administrative and supervisory support was withdrawn. Broad-based arts programs appear easier to dismantle than to construct.

One-Year and Multiyear District Implementation Plans Attendees at summer institutes, whether district administrators, school administrators, or members of teacher teams, are given specific one-year and multiyear planning formats that include tasks and activities, individuals responsible for completing the tasks, resources required, and proposed and actual completion dates. District and school teams begin to develop their plans during summer institute seminars, refine them when they return to their districts, and submit periodic reports to the RIG programs about progress made. In some of the most successful districts, administrators direct the completion of a DBAE self-assessment, five-year long-range plan, and one-year work plan and ensure that individual schools follow the same planning process.

When a school district joins a regional consortium, perhaps the most important commitment the superintendent makes is to oversee the development of a five-year DBAE implementation plan. Each of the RIG programs has developed individual specifications or suggestions for the districtwide five-year plan. Most of the implementation plans included the following components:

Appointment of a district DBAE coordinator (and in some cases an art or arts advisory committee)—Individual districts choose who will serve as their DBAE coordinator. In general, the higher the individual is in the district administrative structure, the more effective he or she is at implementing DBAE. Even visual art and arts coordinators are more successful when they have the active support of district administrators. In fact, when district art supervisors and coordinators set about to implement DBAE programs by employing their usual workshops for teachers, rather than working with administrators at both the district and school levels, implementation is impeded. Seldom has an individual art specialist, working from a school, been able to implement a districtwide program unless he or she had the full support of administrators and could call on the resources of the district office.

A plan to notify all district school administrators about the new program—When district

• A written, sequential K–12 curriculum exists for music, visual arts, and theater arts. The curriculum should address goals and objectives for each arts area, student learning outcomes for each discipline at every level of instruction, and how student achievement is measured for each discipline at every level of instruction.
• For each arts offering or unit of arts study, students are engaged in learning that focuses on produc-tion, history, criticism, and aesthetics.
• An arts education program evaluation is conducted annually, with results reported to administrators, the school board, parents, and the community. Information about student achievement, student participation, budget requests and allocations, fund raising, attendance at student performances, exhibitions, and parental and community involvement is reported annually.
• The arts are taught by qualified staff. At the elementary level, primary music and art instruction should be provided by certified specialists. Theater arts is integrated into the classroom by classroom teachers and language arts teachers. At the secondary level, certified specialists are in place for music and art instruction. Language arts and drama teachers are used for theater arts instruction. When appropriate, artists are used

administrators indicate that they expect DBAE programs to be implemented in each of a district's schools and provide introductory programs for building administrators, implementation often progresses quickly and evenly across districts.

A districtwide plan to send teams of teachers to summer DBAE institutes—Many small and medium-sized districts have devised plans so that at the end of three to five years, teacher teams from each school would attend a summer institute. Only one large school district has come close to achieving this goal. A considerable number of middle-sized and small districts, however, have established programs in virtually every school.

A districtwide professional development plan—In many districts, summer institute programs are coordinated with district DBAE workshops and a variety of renewal activities. The best district plans have a comprehensive program of DBAE professional development institutes and workshops held throughout the five-year implementation period.

Development of district DBAE goals and a new art curriculum—With the introduction of a DBAE program, individuals in many districts have realized that current curriculum guides are outmoded. Some districts have set aside just-developed guides and started to work on new ones that incorporate DBAE principles.

A plan for the special purchase of reproductions of artworks, slides, art resource books, art textbooks, art supplies, and funds for art museum visits—DBAE programs usually require resources beyond those that already exist within the district and its schools. District administrators realize that implementation of DBAE requires a variety of resources. In some districts, the implementation of DBAE has been accompanied by a substantial increase in financial support for art programs.

A plan to inform the public—Many districts develop programs to inform school patrons and community groups about the new plan, and DBAE teachers and administrators make presentations at regular school board meetings. Some districts have appointed individuals to provide information about

at all levels to reinforce instruction by school staff.

• A plan that provides for the continual improvement of staff members' knowledge and skills in DBAE is in place after being created collaboratively by the principal, specialists, and classroom teachers.

• Adequate resources are in place to support and enhance the quality of arts education in grades K–12. Resources include adequate time for instruction, qualified staff, sufficient space and facilities, and equipment, supplies, and reference materials.

• All students have access to school-sponsored live arts experiences as part of the arts curriculum. All students have the opportunity to visit museums, attend performances by professional artists or groups, attend theater productions, and have exposure to artists-in-residence.

• The arts are integrated into the general curriculum and are used by classroom teachers to reinforce instruction.

• Students with special needs are identified and provided with instruction in art, music, and theater at all levels. Programs are in place to identify special education students, gifted/talented students, at-risk students, etc., and provide for quality arts education experiences.

• The arts education program is administered and coordinated at

the project; the evaluators have been shown scrapbooks filled with newspaper clippings about DBAE programs.

With the introduction of DBAE, some district administrators become increasingly aware of the importance of art to their educational programs. They make plans to hire new elementary art specialists and organize their own summer DBAE institutes so that teachers can be prepared quickly to implement the program.[1]

Progress toward implementing DBAE in all schools within a school district was related directly to the extent to which each of the components of the planning process was instituted. One factor—the appointment of a district DBAE coordinator, an individual with genuine authority to initiate, facilitate, and monitor the change process—assured that the rest of the factors would be put into place. The districts where DBAE was most successfully implemented were usually those where a superintendent, assistant superintendent, or director of curriculum and instruction assumed the leadership role. This finding holds true just as much for the individual school as for the school district. In the school, however, to assure the arts programs' success, it is the principal who must assume the leadership role.

SCHOOL IMPLEMENTATION PLANS School implementation plans have virtually the same components as those listed above for district plans. Surprisingly, the evaluators found that many school principals have never worked with their teachers to develop any kind of yearly or long-range plan—in art or any other subject. In summer institute programs, differing degrees of emphasis were placed on planning for implementation. Consequently, the evaluators thought it important to investigate the contents of individual school implementation plans in each of the RIG programs. Was there a direct relationship between summer planning and school-year implementation? Did special planning sessions for school principals affect change initiatives in their schools? Did the special emphasis on assessment of student learning in institute programs find its way into implementation plans? To find answers to these questions, the evaluators conducted a survey of 278 schools in the six RIG programs about the implementation of DBAE in elementary schools.[2] The following is a summary of the findings.

the school and district levels. Appropriate administrative responsibilities are assigned to qualified staff to coordinate and administer the arts education program. Responsibilities should include facilitation of a long-range planning committee, curriculum development, resource identification and coordination, assessment and evaluation of student achievement and the arts program, and communication with school administration, parents, and the community.

• The school takes advantage of appropriate arts learning resources in the school and community. Schools offer staff, facilities, and supplies; community arts resources include artists, museums, galleries, and professional and community groups.

Marian Hughes is the art coordinator for the Santa Rosa District and the Florida Institute's area site coordinator for Santa Rosa and Okaloosa Counties. Each morning she teaches four high school art classes before beginning her art coordination responsibilities. The DBAE program has provided her with the direction and resources she needs to do her job more effectively. Now she plans joint programs with other subject-matter area coordinators—something that was not done consistently prior to the introduction of DBAE.

The DBAE institute program for Santa Rosa and Okaloosa Counties is at the center of Hughes's ongoing professional development program. As an extension of the institute, she holds spring and fall renewal seminars for her teachers. She has established a well-coordinated and highly successful public relations campaign that has resulted in a large number of newspaper articles favorable to the DBAE program. District schools

Teachers who form DBAE teams in Santa Rosa County, Florida, schools have a high commitment to transforming art education.

place the DBAE program at the center of their reform initiatives; more than a dozen received grants from a local educational foundation to support their DBAE activities. In the 1991–92 school year the grants totaled $6,300; in the 1992–93 school year they reached $25,000.

Teams from all the district's elementary, middle, and high schools have attended a DBAE institute program—seventy-five teachers and fifteen principals by the summer of 1994. Another five hundred teachers have attended school-year mini-DBAE institutes of ten to sixteen hours in length. In the 1987–88 school year, there were five art specialists working in the thirteen elementary schools. By 1991–92 there were nine art specialists; by 1994–95, ten.

Now Hughes has shifted her DBAE professional development efforts from the basic summer institute program to renewal meetings, teacher observations, the monitoring of yearly updated implementation plans, and meetings every two months for all DBAE participants in three regions of Santa Rosa County. With increasing frequency, professional development activities are held in schools, where they seem to be, as Hughes says, "more effective and many more people are inserviced."

When asked about the problems and difficulties that the program might encounter beyond the initial developmental phase, Hughes talked of the need to keep the DBAE initiative moving ahead. To this end, she has expanded the Santa Rosa consortium to include the local arts council, the University of West Florida, and other arts organizations. She provides School Improvement Advisory Councils with information about the DBAE program and encourages school committees to write art into their improvement plans. Hughes has worked with her colleagues in social studies to integrate art into their new curriculum guide—part of the project included taking social studies teachers to the local art museum. DBAE is being integrated into computer graphics programs, Head Start, and an integrated instruction initiative. It contributes to each of these programs and, in return, is reinvigorated through the new challenges and opportunities.

Hughes observed that the teachers who form the DBAE teams in each of the schools have a high commitment to the program. On the other hand, the teachers who have not attended a summer institute program "are not the same." She also indicated that at the beginning of the initiative some of the art specialists had a real concern. They asked, "Do the classroom teachers really understand the child's artistic development?" They were also worried about whether schools would "really need an art teacher. DBAE classroom teachers may take over." Their concerns diminished as new elementary art specialists were hired after DBAE implementation began. According to Hughes, the district's experienced art specialists now see the positive effects of DBAE instruction.

In Millard, a suburban Omaha district, the DBAE program is coordinated by Nancy Engdahl, a music specialist who has the assignment of supervising the district's seventeen DBAE "initiators." These school-based individuals have been assigned to coordinate the DBAE program in each of the district's elementary buildings. Evidence of the systematic approach to the implementation of DBAE is found in the fact that the DBAE initiators are appointed before they attend a Prairie Visions Institute. It is also worth noting that the district has altered its usual procedure for implementing new programs, which typically includes a two- to three-year study period prior to implementation. The DBAE implementation process, however, will extend over a five-year period.

Engdahl calls meetings of the initiators at least three times a year. Before school begins in the fall, the initiators meet for one day "to plot out the year." The yearly plan includes having teachers at each grade level teach at least two DBAE lessons during the year, the development of school DBAE inservice programs, plans for refamiliarizing teachers with the principles of DBAE, and the development of strategies for cooperative instructional planning among members of school staffs. To support the DBAE program, in addition to the textbook series, the district has furnished each elementary building with several sets of art reproductions and new sets of watercolors and other art supplies, so, as one of the initiators said, "We can call the staff together and say, 'Look what we have.'" To study the results of the Millard district implementation plan, the evaluators visited two elementary schools: Cody and Holling Heights.

Linda Weinert is the DBAE initiator at Cody Elementary School. The art she teaches is almost always coordinated with social studies units. During the study of Paleolithic times, students did animal drawings on the sidewalks around the school; while studying Egypt, they made hieroglyphic messages with Styrofoam prints; as they studied Greece and Rome, they worked on building columns; as they studied medieval times, they made illuminated manuscripts; and during the study of the Renaissance, they made "portraits like Raphael" and sketchbooks like Leonardo and studied several artists' depictions of Saint George and the dragon.

Weinert believes that at Cody, "every teacher has an interest [in DBAE] now. The teachers who have been here for three years are getting to the point where they think, 'I can get some real art into the unit.' This is why our teachers are so willing to do this, because they are able to work [art] into their units." The evaluators concluded that if DBAE initiators such as Weinert were left entirely to their own devices, they would have a difficult time mobilizing entire buildings. Fortunately, however, Cody Elementary School has a principal, Deb Mackie, who is an instructional leader. She located the art resources in Weinert's room in order to provide her with information regarding the art supplies and reproductions used by each teacher. Weinert also said that in the fall, Mackie "helped me to talk with each teacher in the building. I also had a subject day each month to model [art] instruction [for other teachers]. I have seen by what they have on their walls that the modeling has worked." She remarked, however, that DBAE is not working in every school across the district the way it is working at Cody. She noted, "Some principals support it and some do not."

Mackie stated that "Cody was a ready partner [for DBAE]; we conducted a survey. Our kids went to ball games and tractor-pulls, but had not been to a gallery or the ballet. We wanted to bring kids the things that they would not ordinarily have." She also said, "It's a long implementation process—it's probably wise, however, so that it's not just one more thing teachers have to do. This way they do a little bit more each year, but it does allow some people to jump ahead."

At another Millard District school, Holling Heights Elementary, the evaluators observed as DBAE initiator Carol Clark team-taught a DBAE lesson with two colleagues. The lesson, on the varieties of human contact as depicted in works of art, was a masterful production, with the three teachers all improvising on the basic script they had prepared earlier.

When asked how many of the teachers at Holling Heights teach DBAE lessons consistently on a weekly basis, Clark responded, "I'm tempted to say all of them." She then qualified her statement, "We still see 'cutesy' art products." The cutesy products were not much in evidence, however, as the evaluators marveled at the vivid art in evidence throughout the school. All of the teachers had become DBAE teachers through the school's open plan, which permits teachers in a cluster to cover for one another so they can observe DBAE lessons being taught in other clusters. At least one teacher in each cluster had become a dedicated art teacher, and because there is so much team-teaching at the school, each of the clusters has an art program.

Through the leadership of a teacher initiator and the use of the modeling process, exciting results have been achieved. We learned from Clark that her principal, like Deb Mackie, is an instructional leader who has supported and endorsed her efforts. Without the backing of a strong principal, most teachers who attempt to coordinate school DBAE programs will have only limited success. The two schools in the Millard District described here confirm the success that can be achieved when good DBAE teacher coordinators have the strong backing of principals who are instructional leaders.

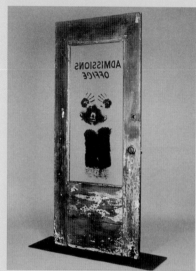

Sixth-grade students in Millard, Nebraska, created their own symbolic doors before discussing *Door* by David Hammons (1969, mixed media, California Afro-American Museum).

While in Millard, the evaluators had the opportunity to observe the different ways art is taught in the various grade-level clusters in Holling Heights Elementary School. The second-grade teachers have "DBAE days" during which instruction in all subject areas is centered on art. A fifth-grade teacher had spent the six weeks basing much of his instructional program on visual artists who worked during the past hundred years. The quality of students' artworks, writing about works of art, and research reports on artists were exceptional.

The evaluators listened to sixth-grade students explain the symbolic doors they had just created. There was a "museum door" with a symbol-filled grid to show what visitors could expect to find in the museum; a door with a lion on it that "looks into your heart and if you are good, lets you in"; a "no-pollution door"; a "door to music—that is always wide open"; "three apartment doors that look the same and the people behind them are all different—they stand for how people are all different when you look at them carefully"; and the work of a student who wished to remain anonymous and who had drawn an airy door with glitter decorations that fellow sixth-graders correctly identified as a "doorway to heaven." The teachers had developed the activity from David Hammons's *Door* in the Getty Education Institute's Multicultural Art Print Series, but as the students made their doors they were unaware of the work of art that inspired the studio assignment they had been given. When they were shown Hammons's *Door*, the students' discussion took some interesting turns. They talked about individuals having choices about which side of the door they might be on. At this point one of the four teachers who was leading the discussion probed more deeply and then explained that "when you are on the outside, it means that you do not have a choice." Another of the teachers in the cluster explained that Hammons's *Door* was "created during the civil rights movement," and then asked, "Which side do you think he was on?"

The Contents of DBAE *School Implementation Plans* Did the summer institute empha-sis on preparing written plans for the implementation of discipline-based art programs make a difference? Of the 245 elementary schools responding to the query, approxi-mately three-fourths (184) indicated that they had prepared a formal written implemen-tation plan. Even more important was the fact that in the Southeast Center for Education in the Arts, 97 percent of the schools indicated that they had a formal plan. Although time is devoted to planning in all the summer institutes, in the Southeast Center, school principals meet in a special ten-day institute where extensive time is directed to planning and other leadership issues. Just as important, in the Southeast Center, planning is direct-ed to all the arts, not just the visual arts. The combination of extensive leadership edu-cation and comprehensive arts planning had a significant effect on the actual imple-mentation plans prepared by schools.

The contents of the school implementation plans are informative. Between 85 and 90 percent of the written plans called for the special purchase of curriculum materials and reproductions of works of art. Half included the allocation of new funds for visits to art museums and art centers. Sixty percent outlined plans for notifying parents and school patrons about the implementation of new visual arts and arts programs. Only half, how-ever, included plans for presenting the new arts programs to school boards, either for information or approval. Over 80 percent of the plans called for the integration of DBAE with other school subjects, but fewer than half called for the development of a special new art curriculum for the school. More than 80 percent of the plans included strategies for introducing DBAE to all teachers in the school, and nearly 70 percent called for teachers to attend DBAE professional development programs outside the school. Just over half of the plans, however, included the expectation that all teachers in the school would offer a DBAE program. In short, the plans included new instructional resources and many opportunities for teachers to learn about the new art and arts programs, but the plans reflected a reluctance to insist that all teachers adopt the new program. Was it the case that some of the planners were in no position to insist that the new program be offered by all teachers in a school? This leads to the next important question, Does it matter who leads the change initiative in schools?

Who Leads the Arts Reform Initiative in DBAE *Schools?* When the survey of elemen-tary schools was conducted, the questionnaire was sent to the individual or individuals most knowledgeable about the DBAE program. In three of the RIG programs most of the questionnaires were completed either by art specialists or classroom teachers—79 percent in one (44 percent specialists and 35 percent classroom teachers), 84 percent (all art spe-cialists) in another, and 89 percent in the third, (58 percent specialists and 31 percent classroom teachers). In the other three programs, many more questionnaires were com-pleted either by school principals or specially designated initiators, facilitators, and coor-dinators working directly with principals—55 percent in one, 56 percent in another, and 69 percent in the third. Visits to elementary schools revealed that when art specialists or classroom teachers led the initiative, programs often remained in the classrooms of these individuals; they were not able to persuade their fellow teachers to join the DBAE initia-tive. However, when principals led the DBAE initiative, it was far more likely to pervade the school. This observation was reinforced by the survey data. Principals who attend-

In the Columbus, Ohio, public schools the evaluators have observed some of the most outstanding examples of DBAE seen anywhere in the country. The implementation of DBAE has been uneven, however. To illustrate, two elementary schools—Gables and Second Avenue—are described below. Their stories show the problems of leadership turnover experienced in all six RIG programs.

Gables Elementary School is located within the Columbus city boundary, but the pleasant middle-class neighborhood in which it is set is quite suburban. The setting contrasts sharply with the band of decrepit homes and apartment buildings that surround the city's business center. Despite the school's suburban location, the Columbus desegregation plan calls for a significant portion of the Gables population to be bused to the school from the inner city.

Principal Don Cramer told the evaluators that he led the school's team at the 1990 Ohio Partnership summer institute. He also noted that initially he was not that interested in DBAE. When the teachers became excited about the project, however, he decided that he did not want them doing things he did not know about. He decided he "had better get on board." During the summer the team began to develop a five-year plan that, in his words, "has become the guiding force, not just in art, but in all areas." Before Cramer and his team attended the Partnership institute program, Gables Elementary did not have a one-year plan, much less a five-year one, relating to the school's entire curricular and instructional program. The Partnership planning requirement provided the impetus for the development of a seventeen-page document titled "Exploring Social Issues through Art and the Environment: Gables Elementary School Five-Year Plan, 1990–1995."

The comprehensive school plan lists five themes—one for each year of the implementation process. One of the themes is "Flowers and Landscapes" and includes social concepts such as "Things in the natural and social world are interrelated"; "Cultural encounters influence cultural change"; and "Humans are part of the ecosystem (persons are responsible to the environment)." Although the concepts sound as much social as artistic, the plans agreed upon by the faculty included the study of works by Georgia O'Keeffe, Vincent van Gogh, Claude Monet, and Winslow Homer.

The plan also includes such things as a weekly meeting of the principal and nine teachers; planning meetings with Partnership staff members; the implementation of a new K–5 art curriculum; four days' released time for inservice activities; the design and planting (over several years' time) of an extensive school "discovery garden"; applications for grants; and alliances with the Columbus Museum of Art, Ohio State University, Color Columbus, and the Fort Hayes Career Center. The plan also includes the development of a network of community supporters; the purchase of classroom sets of the textbook series *Discover Art*, additional slide projectors, and a second set of the "Discover" print series; an artist-in-residence program; exhibitions; field trips; and press releases. Cramer and his teachers developed target dates, assigned personnel to specific tasks, and developed plans for the evaluation and reporting of each aspect of their five-year program. Although the plan pertained to every aspect of the school curriculum and instructional program, art was the starting point, so it had an influence on virtually every aspect of the plan.

The DBAE program altered the character of the school in other ways as well. From the time Gables Elementary first opened its doors, Disney cartoon characters had been its trademark. When the DBAE program was established, the Disney figures were removed. Large signs were hung from the ceilings of the school's kindergarten and grade-level clusters, identifying "Matisse Land," "Rousseau Land," and "Homer Land." The clusters were filled with reproductions of works of art, and the children's art was obviously related to the ideas found in the artists' works they had studied.

Students were also involved in designing a sculpture garden. Art teacher Brigid Moriarity described the children's original plans as fantastic but not very practical. Eventually the children sought help, and landscape architecture students at Ohio State became consultants to the pro-

ject, presented plans, and explained to the children why they had designed the garden in particular ways. Students did, however, get to see the results of some of their planning. They drew sketches for large metal sculptures that high school students at the Fort Hayes arts magnet high school built for them. These are now in the sculpture garden.

It was obvious the Gables plan could not have been developed without the full involvement of the instructional staff. Ten of the school's sixteen teachers have attended Ohio Partnership summer institute programs. Cramer stated that in addition to Moriarity, fourteen of the school's teachers are fully committed to the program, have a good understanding of DBAE, and regularly teach DBAE lessons. He also said that the same fourteen teachers jointly plan and implement DBAE instruction. All sixteen teachers plan DBAE lessons in regular grade-level meetings.

Most likely, Cramer has always been an instructional leader. Nevertheless, through the impetus provided by the DBAE planning program, Gables Elementary has a new direction, a long-range, theme-based plan that places art at its core curriculum. Through the influence of DBAE, the Gables Elementary School educational program has been transformed in significant ways, and that transformation continues. The school has received an Ohio Department of Education Venture Capital School Improvement Grant to direct the curriculum toward the study of the community itself and its pressing cultural and social needs. The new initiative, undertaken with the Professional Development School at Ohio State, will continue to use the arts and social studies as its core.

Second Avenue Elementary is located not far from Ohio State's campus on the near north side of Columbus. It is an area in which drug dealers, crack houses, and prostitutes are common. There is no need to bus children to Second Avenue; it already has a balance of Appalachian and African American children. When the evaluators asked one of the teachers about the stability of the school population, she replied, "By May there was not one child in the class who was there in the fall." The most telling fact about the social and economic status of the school is that only 8 of its 340 children are able to pay for their school lunches. It is obviously a school that could use the humanizing influence of a comprehensive visual arts program.

In the summer of 1988 the chances of a new art program for the coming fall appeared good. A six-member team, composed of principal Liz Burck, art specialist Ken Winstel, and four classroom teachers, attended the first summer institute of the Ohio Partnership. Before the school opened in the fall, however, Burck was assigned to another school (in which she developed a DBAE program) and a new principal was assigned to take her place. Although the new principal had also attended the 1988 Partnership institute with a team of teachers from another school, the problems of Second Avenue school were, unfortunately, so overwhelming that the schoolwide DBAE implementation plan was not initiated. To a greater or lesser degree, the specialist and four teachers who had attended the institute were committed to DBAE and began independently to teach DBAE lessons. From the observations made in the school in the fall of 1991, it seemed clear that no other teachers had adopted DBAE practices.

In the fall of 1990 the school got another new principal. As far as could be determined, he had little knowledge of or interest in DBAE. In the fall of 1991, Susan Barker became principal of Second Avenue Elementary. She was determined to assume the role of instructional leader in the school and to balance the disciplining of children with concern for the school's educational program.

In the art classroom, as the evaluators sat with children around their tables, the pupils' enthusiasm for art was evident. As one little boy bragged about his illicit exploits, however, it was also clear that the teachers at Second Avenue Elementary face challenges each minute of every school day.

In the various RIG programs, the evaluators have observed good DBAE practices in schools that, like Second Avenue Elementary, have many problems. These schools, however, have stable leadership—a characteristic of many suburban schools and too few schools in troubled neighborhoods.

No school district within the RIG programs has gone about educational reform in as systematic and thoughtful a manner as the Plano Independent School District. District art coordinator Lynda Alford plays a key role in the restructuring process. The programs of the North Texas Institute have provided one of the important bases for the district's curriculum restructuring program. She stated, "I shudder to think where we would be in this district if the North Texas Institute had not walked though the door. It was the project that prepared us for the curriculum initiative."

In 1990, when the Plano district joined the North Texas consortium, the superintendent supported implementation of DBAE and the hiring of six elementary art specialists, the first ever in the district. Then, because an insufficient number of Plano classroom teachers could be accommodated in the North Texas summer institute program that first year, the school board asked Alford, the elementary art staff, and the directors of the North Texas Institute to organize a separate summer DBAE institute in Plano. Since that time, DBAE has developed in Plano very much as it was envisioned during its first year. The components of the basic plan for the restructuring of the schools are as follows:

- an orderly movement away from textbooks and the usual ways of organizing the curriculum—the "organized abandonment" of the existing curriculum, as it is termed in Plano;
- a newly conceived integrated curriculum that incorporates a series of learner outcomes or "lifelong learning traits";
- a new curriculum supported by computer programs and systems;
- teachers who are involved in the creation of the interactive curriculum —a curriculum that can be continually revised and refined by the teachers and students;
- teachers who work with a team of curriculum designers and consultants who develop computer programs, pose curricular and instructional possibilities, and collaborate with the teachers through every step of the process;
- teachers who are released from teaching responsibilities in order to devote adequate time to the restructuring tasks; and
- a new curriculum development process directed to components such as student outcomes, curriculum mapping, the interdisciplinary curriculum, parallel teaching, integrated instruction, dimensions of learning, and global thematic instructional units.

EXPECTATIONS FOR SCHOOL PRINCIPALS: SOUTHEAST CENTER GUIDE

The RIG programs are clear about their expectations for school principals. For example, in the manual for the Southeast Center for Education in the Arts 1992 Administrators Institute, principals are informed that they are to do the following:

- Be committed to providing and improving arts education.
- Serve as the team leader in their school.
- Facilitate the implementation of DBAE as a part of the basic academic program.
- Provide discipline-based inservice opportunities for their teachers.
- Coordinate logistics to enable the teachers and their students to utilize community arts resources (i.e., attend a musical event, theater production, or a museum/gallery exhibit).
- Facilitate teachers' participation in institute workshops and inservices.
- Be receptive to institute directors and evaluators during on-site visits.
- Serve on the arts planning and assessment committee in their school.
- Complete the Southeast Center for Education in the Arts self-assessment and long-range plan

The evaluators watched in March 1993 as a representative team of approximately thirty teachers and administrators worked with the curriculum consultants to frame the big outcomes of education and to identify "themes" or global ideas on which the new curriculum might be based. The team encountered the same difficulties observed in DBAE institutes. The items labeled as "themes" at first included a mixed bag of topics—animals, survival, weird tricks/pranks/mischief, friendship, environment and ecology, and so on. After weeks of discussion, however, the staff recognized that these small ideas were not what they wanted. The writing staff progressed quickly to bigger, more global ideas that they now call "overarching concepts." They eventually identified nine concepts (patterns and models; communication; change; scale and structure; relationships and interactions; diversity; systems; energy and resources; and balance and stability) that would become central to all integrated studies in kindergarten through fifth grade for the Plano Independent School District.

The evaluators also found that the teachers were devising abstract themes and topics in the absence of specific documents, artifacts, events, or works of art in which human themes could be identified. The teachers who had attended DBAE institutes, however, recognized the problem. In DBAE institutes, teachers are taught to derive themes from works of art. The careful selection of works of art that carry with them subtle and sensitive treatments of themes of profound human importance is precisely what happens in the North Texas Institute. In Plano, thematic units of instruction are being developed based on the themes found in the North Texas *ArtLinks* reproductions. Discipline-based creative, historical, philosophical, and critical approaches to the study of authentic objects are providing an important model for the entire curriculum reform process in Plano.

ArtLinks reproductions produced by the North Texas Institute. In Plano, Texas, thematic units of instruction were developed based on themes found in the series.

for DBAE in their school.

The Southeast Center's *A Guide to the Development of Effective Long-Range Plans for Discipline-Based Arts Education Programs, 1994–95* outlines a comprehensive set of procedures and steps to follow during the DBAE planning and implementation process.

ed the two regional institutes with the most fully developed leadership seminars—designed specifically for school administrators—were much more likely than the principals in the other four RIG programs to return to their schools and develop workshops and other staff development projects. In the Southeast Center, for example, survey data showed that professional development programs were developed in 85 percent of the elementary schools (sixty-five buildings).

The conclusion is simple; the comprehensive implementation of a broad-based art or arts program requires the leadership of a school principal who works closely with members of his or her teaching staff. Art specialists and classroom teachers working without the active support of a building administrator have little success in implementing a schoolwide arts education program.

DBAE Curricula: A Continuing Problem

When the RIG professional development programs were established in 1988, they were expected to deal with matters of DBAE instruction but not with the broader issue of curriculum. The decision was guided by at least three assumptions: 1) acceptable written art curricula (primarily in the form of textbooks) were available for adoption and adaptation; 2) in a two- or three-week summer institute there was not time to address the curriculum issue while at the same time providing a basic introduction to the art disciplines and discipline-based art instruction; and 3) issues relating to art curricula should be left to states, school districts, and local schools. As the DBAE change initiative progressed, the evaluation team became increasingly critical of these three assumptions.

First, regarding curricula available in the form of art textbooks, some institutes, districts, and schools accepted art textbooks as the principle source for their DBAE programs. Almost always, however, users were cautioned that it was necessary to expand the content to include art criticism and aesthetics and to adapt the texts to fit newly evolving conceptions of DBAE. For example, when DBAE coordinators in 232 elementary schools were asked if they found textbooks satisfactory and if they thought textbook conceptions of DBAE to be complete, 41 percent disagreed—in effect stating that they thought

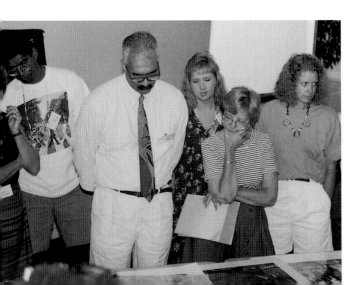

Arts programs require nourishment. DBAE *school districts provide administrative support and give teachers the resources and time needed to implement programs.*

textbooks were unsatisfactory—while only 29 percent agreed that they were satisfactory.

From the outset, some districts and schools rejected art textbooks, choosing either to develop new DBAE instructional resources or to adapt instructional units usually developed within the RIGS. When individuals were asked if their goal was to encourage DBAE teachers to develop their own art-based units of instruction rather than to rely on art textbooks and commercial curricula, only 16 percent agreed with the statement. Sixty-four percent indicated that they did not wish to encourage teachers to develop their own art-based instructional units and 21 percent were undecided.

There was indeed a problem; existing textbooks did not adequately represent the newly evolving forms of DBAE, and yet teachers did not have the time, the resources, nor the expertise to develop new DBAE instructional units—not to mention a comprehensive curriculum. If DBAE was to be characterized by a written sequential curriculum, then from what source would it come?

Second, the assumption that a two-week summer institute offers insufficient time to deal with substantial curriculum issues—especially the development of curriculum—is correct. The evaluation team found that schedules are already so crowded that participants, staff, and faculty members are often overwhelmed. If curriculum issues are ignored, however, participants are left with an inadequate understanding of where the units of instruction—either those provided by institutes or those that participants developed themselves during institute programs—fit within a larger curriculum framework. Consequently, DBAE as presented in professional development institutes and as practiced in many participating schools and districts consists of sets of free-floating instructional units that might be plugged in just about anywhere. Participants, for example, are told that they can adapt a unit prepared for the upper elementary grades to the lower elementary and middle school grades. Although the upward or downward adaptation of the instructional units is indeed possible, it undermines the notion of an orderly sequential curriculum.

The third assumption, that art curricula should be left to states, school districts, and local schools also proved to be problematic. State curriculum guidelines and frameworks specify content, goals, and objectives; nevertheless, they do not provide detailed sequential curricula that can be used by teachers.

Increased student competence in creating, understanding, and appreciating art is the bottom line for DBAE. Here, Columbus, Ohio, elementary students enjoy a sculpture garden designed by classmates. High school students fabricated the sculptures.

In a few instances the evaluation team found school districts and schools making attempts to develop orderly DBAE curricula. The practices included:

Teachers in an elementary school or district curriculum teams designated artworks to be studied at each grade level in the elementary school. The decision to designate grade-level works has usually been made so that the works of the same artist will not be studied at each grade level. Nevertheless, a comprehensive selection covering major historical periods, cultures, and styles is seldom made.

Works of art and art activities are integrated into currently existing social studies curricula, because it is relatively easy to select works that reflect historical periods, cultures, and social issues.

Works of art are selected to correspond to key works of literature in a school's or a district's language arts programs. Sometimes these programs are based on themes, topics, or concept-based interdisciplinary units that encompass social studies, language arts, science, mathematics, and the arts. When curriculum begins with topics, themes, or concepts, the evaluation team found, however, that there is a danger that works of art will be used to merely illustrate predetermined points rather than revealing their full array of meanings.

Even with these efforts undertaken in individual schools and districts, instructional practice in the form of exemplary DBAE units has far outpaced DBAE curriculum. Indeed, there are few if any satisfactory examples of coherent K–12 DBAE curricula in RIG districts. The absence of exemplary DBAE curricula, the evaluation team believes, hinders the comprehensive development of DBAE in districts and schools.

In light of the existence of a growing number of exemplary DBAE instructional units, the evaluation team asked the question: Is it possible to conceive of a curriculum consisting of a kindergarten through grade twelve sequence of art-based instructional units? If this were the case, what would that curriculum look like? What criteria should govern the selection and sequence of works of art, themes and ideas, concepts, countries and cultures, art forms and styles, periods, age-appropriate approaches to study and creation, connections to curricula and instructional programs in other school subjects, etc.,

132

THE IMPLEMENTATION OF DBAE

WHAT MAKES DBAE SCHOOLS SPECIAL?

In 1991 the evaluators asked different groups consisting of superintendents, assistant superintendents, directors of curriculum and instruction, and school principals to "characterize the features that distinguish a DBAE elementary school from other schools." They gave a fascinating set of responses, which were grouped into three classifications: general characteristics, curriculum and instruction, and learners:

General characteristics of a DBAE school
• The school is excellent in all instructional areas.
• DBAE takes over the whole philosophy of the school.
• There are greater demands and expectations.
• One hundred percent of the staff is involved.
• There is community involvement.
• The program is ongoing—it will never stop.
• Art is taught by classroom teachers as well as by specialists.
• The school conducts field trips to see museum exhibitions.
• There is a close relationship to the cultural resources of the community.
• Inservice faculty meetings are conducted for art.

that should constitute the comprehensive DBAE curriculum? How might the RIGS and the Getty Education Institute collaborate with schools and districts to create the much needed DBAE curricula?

The Assessment of Student Learning

The DBAE *Handbook* (Dobbs 1992) states: "The increasing competence of the student in creating, understanding, and appreciating art through DBAE instruction is the bottom line for DBAE, just as increasing competence is the bottom line for any school subject" (p. 47). When the RIG programs were organized, they were expected to create plans to help districts and schools develop methods to assess student progress. It soon became clear, however, that summer institute sessions devoted to student assessment were not leading to student assessment in DBAE schools. Consequently, in 1989 the Getty Education Institute held a special seminar on student assessment for directors and local evaluators of the RIG programs to apprise them of the latest developments and ideas for assessing student performance in the arts. The Institute also offered special grants to the six projects to support research and development in this area. Several of the RIG programs applied for and received grants from the Institute to develop student assessment programs.[3] These programs, designed around innovative portfolio assessment processes and the creation of comprehensive units of instruction with embedded assessment, are still very active in three of the six regional institutes. (The Florida approach to assessment units is presented on pages 157 and 159 of Chapter 5.)

When the amount of time and the number of resources directed to the assessment project is contrasted with the small amount of student performance assessment actually taking place in DBAE schools, the discrepancy indicates just how difficult it will be to alter the assessment practices of schools—in art or any other school subject. Ironically, as the survey showed, the three RIG programs in which the greatest amount of assessment effort has taken place were the same three in which schools reported most frequently that student assessment was not a part of their implementation plans. Even more discouraging is the fact that in the RIG program with the most fully developed assess-

- The atmosphere in the school is enthusiastic, flexible, and open.
- There is a concern for higher-order thinking skills and divergent thinking.
- In the past art was a frill, now it's an essential part of the school.
- The school has an inservice program for all teachers.
- There is a belief that the program is stimulating and will spread because of good modeling.
- The art teacher serves as an instructional leader.
- All teachers teach art.

Curriculum and instruction in a DBAE school
- The school is theory based.
- Instruction is holistic and integrated.
- There is textbook-free instruction.
- Instruction is based on a body of knowledge.
- Projects are not isolated.
- There is a connectedness.

- There are more units of instruction.
- There is a greater use of visuals.
- There is great intensity—lots of hands-on activity.
- Art is integrated with ongoing instruction, and in all subject areas.
- There are connections among different parts of the curriculum.
- Art is a learning tool for writing and speaking.
- Art is taught in a developmental, progressive, and sequential fashion.

ment model only 15 percent of the schools reported having student assessment plans. In the two others with active assessment programs, less than a quarter of their schools indicated that they had formal plans for the assessment of DBAE outcomes.

How can this lack of success in implementing assessment programs be explained? First, although in American education considerable effort has been directed to the desirability of moving away from the reliance on standardized achievement tests, few schools and school districts expect teachers to give formal evidence-based reports—either to students, other teachers in the school, parents and school patrons, or the school district—on the authentic performance of students. In short, the educational system doesn't yet require authentic performance assessment. Second, the collecting of authentic performance assessment data, especially the qualitatively rich findings resulting from units of instruction where students, for example, engage in complex critical analyses of their own artworks and the artworks of others, is extremely time-consuming and exacting. Why should teachers undertake difficult new assessment responsibilities for which they receive little recognition and no additional compensation when the educational system hardly knows what to do with the findings? The systematic approach to student assessment in the RIG programs cannot be considered a success. Nevertheless, the initiative points to the difficulty the entire educational system faces if it is to move away from reliance on easily collected but virtually meaningless scores from standardized tests as the means of assessing students' educational achievement.

The Relationship of DBAE to Other Reform Initiatives

Teachers and administrators in schools and school districts feel a great deal of pressure to reform education—to initiate new programs, make instruction in various subjects more rigorous, and to add new components to their instructional programs. The pace of educational reform has been so swift that when some principals and teachers receive their initial introduction to DBAE, they ask, "How can we do this new program along with everything else we are trying to implement?" When DBAE is added to the reform agenda, it can be seen as yet another initiative that will compete with those already under

Learners in a DBAE school
• The school is filled with inquirers who see themselves as learners.
• The school is child centered—teachers connect with kids.
• There is a more holistic view of kids and the educational experience for kids.
• Instruction addresses the right side of the brain—accommodates the learners.
• There are connections in the minds of kids.

• Students are motivated—they want to find out about the artists, what happened in their lives.
• Students have had to look at something to get information and then express it.
• Students drive the library acquisitions; they let the librarians know what art books they want.
• Kids ask to study art.
• Kids carry on lengthy discussions of artists' styles and compositions.

There are several fascinating fea tures of these characterizations of a DBAE school. Many of the respondents made virtually no distinction between the DBAE school and their conception of the ideal school—they were one and the same. They saw DBAE as an integral part of that ideal school. They also tended to connect DBAE to other reform initiatives. Although several of the administrators made reference to the study of art as well as the creation of art, not one

way—taking time, energy, and resources away from them; or it can be greeted as an opportunity to reinforce and contribute to those other initiatives.

On visits to school districts the evaluators hear references to cooperative learning, peer coaching, whole language, theme-based instruction, the integrated curriculum, curriculum alignment, multicultural education, teaching links to testing, thinking skills, and higher-order thinking skills. Indeed, of 242 elementary schools responding to a survey question, 90 percent indicated that in addition to DBAE they were involved with other change initiatives. When DBAE implementation is added as a separate item to an already busy agenda for school change, it does not fare well. When DBAE is seen in relation to other reform efforts—especially when it is seen to have strong structural, substantive, or qualitative connections to those initiatives—the chances for implementation are much greater. Most of the schools where DBAE implementation is successful see the art programs as an essential component within their change initiatives. Seventy-seven percent of the 242 elementary schools responding to a survey question indicated that DBAE has just as much value as other reform initiatives currently being undertaken.

Even more important, time and time again the evaluators have seen principals and teachers, especially in elementary schools, take the planning processes begun in DBAE institutes and apply them to the general curriculum and instructional programs of their schools. Consequently, DBAE has provided the impetus for restructuring entire school programs. (See Chapter 5 for five detailed snapshots of DBAE schools in Florida, Ohio, Nebraska, and Texas.)

Conclusion

DBAE has continued to develop in virtually every school district in which it has been introduced. The implementation process, however, has been uneven. In districts where central office administrators or directors of curriculum and instruction have led the initiative, implementation has generally been successful. Strong central office support has come primarily from small- and medium-sized school districts. The enormous problems that plague large city school systems have kept their central office administrations from

mentioned the art disciplines. Perhaps they took the art disciplines as a given; nevertheless, they saw DBAE in terms of its general outcomes rather than the components from which it is formed. From their comments it seems obvious that when instructional leaders assume ownership of DBAE, they place it within the larger curricular context of today's elementary school.

fully endorsing and providing sufficient resources to implement and sustain the DBAE initiative. In districts, regardless of size, where strong central office support for the initiative is lacking, implementation has progressed slowly and irregularly.

Generally speaking, the school districts that have developed the best programs are those that have prepared comprehensive plans for the implementation of DBAE. Even more important, comprehensive and articulated plans developed within the consortia— plans in which the regional DBAE institute, the school district, the individual school, and teams of teachers within schools all assumed clearly defined roles for both development and implementation—were tremendously successful.[4] District and school DBAE coordinators have less success working alone than when district administrators and school principals are actively involved in leading the change initiative. A change community depends upon the efforts of many different individuals working at all levels. Nevertheless, in most cases, the implementation of DBAE programs results only when district and school administrators become educational and instructional leaders.

The evaluators' observations concerning the necessity of strong school district central office and school board support for districtwide reform initiatives have important implications for the recent movement toward site-based management of schools. The educational programs in districts that do not have a strong central vision for all schools in the system have an uneven educational program—in the arts and in other areas as well. Districts such as Millard, Nebraska, illustrate the importance of district policies that facilitate the appointment of school DBAE coordinators who then work with school principals who are also strong instructional leaders; the importance of having both teacher-coordinators and principals who are instructional leaders cannot be overemphasized. The evaluators have seen the strong programs that result when clear districtwide expectations are established for all subject-matter areas and when individual schools are encouraged to meet district goals using the means that work best for local school communities.

The evaluators have also observed that new programs are most effective when they are integrated with ongoing initiatives, rather than each reform initiative being approached independently. The schools and school districts that have most successfully implemented DBAE programs have done so through combining them with general curriculum

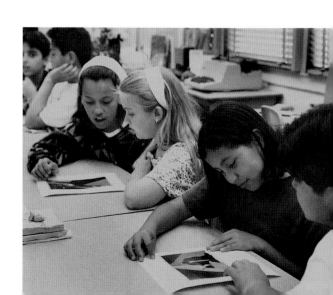

Schools and districts that have most successfully implemented DBAE programs have combined them with general curriculum reform initiatives such as integrated curricula and cooperative learning.

reform, as in Plano, Texas, and with specific initiatives, such as whole language, the integrated curriculum, cooperative learning, and writing across the curriculum. When reform initiatives are undertaken separately, they overwhelm teachers and are not given the attention needed to make them successful.

Where it is most successful, the DBAE reform initiative has succeeded in moving the art program from the margins of the school curriculum to its center. When art becomes a core subject in the elementary school, art specialists have the opportunity to play a new role. Art specialists no longer merely support the educational programs of their colleagues; rather, their colleagues have begun to support art specialists' programs. When art specialists become members of school instructional planning teams and jointly develop units of instruction centered on works of art, art finally fulfills its promise to change children's lives in substantial ways.

Notes

1. Fewer than half the elementary schools across the country currently employ art specialists. It is more common for elementary art specialists to be employed in the East, Southeast, and Midwest than in the West.

2. The survey was sent to 772 schools; 36 percent of the questionnaires were returned. In Ohio, only 23 percent of the questionnaires were completed, while in the Southeast Center, 48 percent of the schools responded. There is no way to judge whether the 278 schools are representative of all elementary schools in the six RIG programs. Nevertheless, data compiled from the surveys confirmed the qualitative data the evaluation team gathered through visits to hundreds of elementary schools in all six programs over a seven-year period. The number of schools responding to an individual item sometimes varied because of differing staffing patterns within the schools or because the individual responding to the questionnaire did not answer a particular item.

3. In addition to grants from the Getty Education Institute, the Florida Institute for Art Education received generous grants from the Jessie Ball du Pont Fund to develop assessment-embedded instructional units.

4. Chapter 6 presents examples of units of instruction planned and taught jointly by art specialists and classroom teachers.

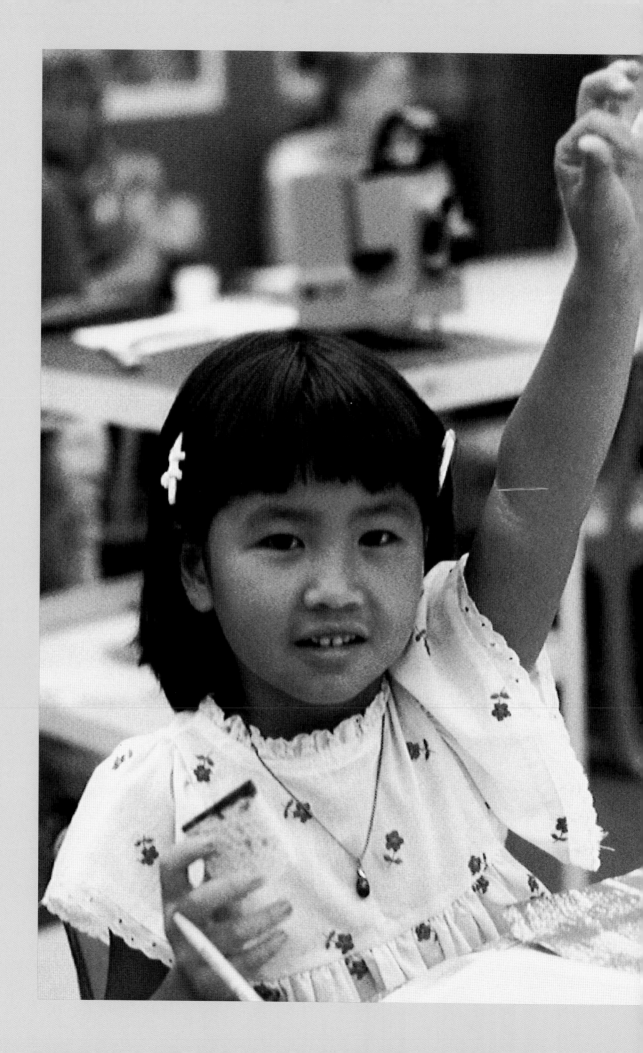

Exemplary DBAE Practices in Elementary Schools:
Issues and Instruction

What distinguishes the ideal DBAE elementary school from other schools? What are its characteristics? Asking such questions raises important issues about the kinds of art programs that should be offered in elementary schools and who should teach them. Such issues include the role of the art teacher in the DBAE classroom; collaborations between art specialists and general classroom teachers; cooperative planning between teachers; and assessment of individuals and their learning community. This chapter addresses these questions and issues as well as the challenges to developing meaningful, sequential curricula in all elementary schools, whether or not they follow a discipline-based approach to teaching art.

The DBAE Elementary School

Between 1988 and 1994 the evaluators have visited more than one hundred elementary schools in which DBAE programs were being implemented. Schools in which the programs were successful had a look that was different from those that were not. Eventually, the evaluators could tell within a few minutes of their arrival whether or not they were at a "DBAE elementary school."

In the DBAE elementary school the halls are filled with art, which of course is not unusual for an elementary school. In the DBAE elementary school, however, children's art is displayed alongside reproductions of the works of artists. The ways in which the children's works are informed by the artists' works is obvious. In their art, children respond to the themes, ideas, subjects, styles, and expressive qualities of the works they study. The displays of children's artworks are also accompanied by children's art writing—critical, historical, and poetic—about the artists' works, their own works, and the relationships among them.

Reproductions of works of art are displayed in every classroom of the DBAE elementary school, signaling that all teachers teach art. Classroom displays of children's artwork, like those in the halls, reflect, either directly or indirectly, works created by artists. Signs with artists' names and styles of art abound. Wall charts display the results of children's collective writing about works of art.

In the DBAE elementary school, teachers, whether the art specialist or classroom generalists, are at ease in holding extended discussions about works of art with their students, and they know how to pursue the "main ideas" that works of art might reveal. Often they and their students will place a work of art at the center of a graphic web from which

radiates the work's subject matter and sensory, expressive, and other meaningful characteristics. Teachers tell of students who, before DBAE, seldom said anything in class and who are now drawn into discussions of works of art because they are able to follow what is going on. Children who are lost when classroom conversation turns the least bit abstract begin to respond, because when works of art are discussed, their features are pointed to continually. This pointing to concrete references keeps the children from losing their places or helps them to relocate themselves within the discussion if they get lost. The concrete features of works of art also give them things to comment about. In DBAE elementary schools, children and their teachers have discovered that works of art are among the most intriguing and meaningful things in the classroom and the world.

In the DBAE elementary school, art is not confined to the few minutes a week scheduled with the special art teacher. If there is an art specialist, children visit him or her usually for forty or fifty minutes once a week, but in the general classrooms, art is also interwoven with language arts, social studies, science, and mathematics instruction.[1] In the exemplary DBAE elementary school, art is taught almost every day in every classroom.

The school just described is rare—an ideal still to be achieved in most districts. When it has appeared, it is the direct result of a school principal, classroom teachers, and the special art teacher (when the school has one) working toward a collective vision—to move art from the margins to the core of the elementary program. When the DBAE elementary school has emerged, it is because administrators, art specialists, and classroom teachers have been willing, collectively, to assume new instructional roles and new responsibilities for coordinating the curriculum in which art plays a central role.

The DBAE elementary school characterized above raises a series of important issues about what kinds of art programs should be offered in the elementary school and about who should teach them. Can a satisfactory art program be offered by elementary art specialists working independently from their classroom teacher colleagues? Can elementary general classroom teachers offer satisfactory art programs without the assistance of an art specialist? In the DBAE elementary school, is there a new role for the art specialist? What is the nature of collaborative instructional programs presented by art specialists and classroom teachers? Why is art taught in the elementary school: to impart aesthetic pleasure or societal understanding? What kinds of DBAE assessment programs are being

In DBAE elementary schools, teachers and students have discovered that works of art are among the most intriguing and meaningful things in the classroom and the world.

Ms. Gill and her second-grade students were away from the school during the evaluators' visit. It didn't matter; the appearance of the classroom reflected the instructional program. There were twenty-seven reproductions of works of art displayed around the room in virtually every available space—below the chalkboards, above the door, everywhere. But the reproductions were only the beginning. Every work of art was surrounded by a series of labels and sheets that invited the children's oral, written, and graphic interpretive interactions. Below Faith Ringgold's *Tar Beach*, for example, there was a large chart divided into two columns. The top of one column was labeled "Main Idea," the other, "And Detail." Different children had written their responses to the cues. Under a Thomas Moran nineteenth-century landscape were two card labels, "Setting" and "Place." Under another painting of American Indians, a child had written, "Indians are going to splash through the water." The writing was in response to one of two large labels, "Splash" and "Spruce," tacked beneath the painting. Next to Franz Marc's *Deer in the Forest* there was a large sheet on which children had written their interpretations and made drawings in response to the images of the painting. A Degas painting of dancers was surrounded by the labels "Character/Feeling," "Spin," "Spend," and "Pretend."

developed in the elementary school, and in the best programs, who is being assessed, individual students or a learning community? The answers to these questions will show just how thoroughly art instruction has been transformed in exemplary elementary schools and how art instruction is changing the elementary school.

Who Should Teach Art in the Elementary School?

When DBAE was first introduced into American schools, it was accompanied by a variety of concerns on the part of art teachers, especially elementary school art specialists. Would art lose its integrity and power as a unique school subject if it were integrated with other school subjects and taught by classroom teachers? Perhaps more worrisome, would there even be a need for art specialists if elementary classroom teachers could successfully teach a substantial form of art education?

The evaluators know of only one school within the more than 217 school districts associated with the RIG programs where an art specialist may have lost her position because of the successful art teaching of her classroom colleagues—but not for that reason alone (the school was under financial duress). Conversely, in several districts elementary art specialists have been hired largely because of the DBAE initiative—for example, Papillion-LaVista, Nebraska; Santa Rosa, Florida; and Plano, Texas. In school districts where staff reductions have been seen as a way of resolving financial difficulties, DBAE has actually contributed to the continuation of art specialist positions where they might otherwise have been eliminated (because DBAE programs were thriving and commitments had been made to support the new art program). The issue is not so much whether there should or should not be elementary art specialists (there should be). The more important question is, what contribution should elementary art specialists make to the instructional programs of their schools?

A NEW ROLE FOR THE ART SPECIALIST Some elementary art specialists are comfortable in the traditional art teacher role—working with classrooms of children arriving at the door of the art specialist lucky enough to have his or her own room (the unfortunate itinerant elementary art specialist travels from room to room teaching art from a cart). With or without an art room, the specialist may teach as many as eight or even nine hundred children a week. In the traditional role—presenting one art-making lesson after another—it is possible for the art specialist to remain almost completely isolated from the instructional programs of the school's classroom teachers. Other specialists, however, have traditionally talked with their classroom colleagues about what they were doing in social studies, science, or language arts, and whenever possible they have developed art lessons related to other teachers' instructional programs. Coordinating their programs to the instruction of twenty or thirty other teachers is a nearly impossible task, though, and yet this is only the beginning of the elementary art specialist's problems.

Many elementary school art specialists are not taken seriously by their colleagues. In many districts, elementary school art, music, and physical education specialists are hired to provide classroom teachers with instructional planning periods. Consequently, many of their teacher colleagues (and too many administrators) see specialist teachers not so

What might a comprehensive DBAE program look like in an elementary school? The evaluators saw some of the possibilities—and the richness and variety—as we made a series of visits to North Port Elementary School in a middle-income neighborhood in Sarasota, Florida.

The evaluation team first visited North Port because of specialist Debbie Herbert's "Art Cafe"—a series of in-house video programs she had produced and broadcast to all the school's classrooms at the beginning of the school day. The programs included "Artists in History: Images of the American West"; "Abstract Art and Realistic Art"; "Repetition, Rhythm and Balance: Patterns in the Art of Lichtenstein and Thiebaud"; the "Unicorn Tapestry"; and "Movement in Art: Delacroix's *Horse Frightened by a Storm*." Ms. Herbert created the programs following her attendance at the first Florida summer DBAE institute in 1988.

Each of the "Art Cafe" video programs was accompanied by a lesson outline prepared by Herbert that included objectives; a program outline; and student follow-up activities such as drama, language arts, and arts activities. The lesson outline was accompanied by a list of instructional resources and a note to classroom teachers that explained the optional nature of the activities and indicated that most of them would probably not take much more that twenty minutes of class time.

A consequence of the "Art Cafe" series was that the art program was continually brought to the attention of all the teachers and students in the school. Instead of being on the margins of the school program, art took center stage and made possible collaborations between Herbert and her colleagues.

In the art classroom, following the program on portraits, for example, we watched Ms. Herbert explain to Sue Mudle's fourth-grade students how American artists such as Andrew Wyeth and Thomas Sully conveyed mood through the use of color, the way models were posed, and the depiction of facial expressions. As the art lesson progressed, Herbert explained, "We are going to draw from a model. We'll have the model wear a hat to set the mood. I want the model to think about the mood. We will try to catch it, to mix colors, to show the personality, the mood." A model was selected, provided with a floppy broad-brimmed hat, which was pulled down to cover part of her face. With elbows on her knees and her chin in her palms, she managed to strike a very dejected pose, much like one found in a painting by Thomas Sully. The students make some very fine, carefully observed, highly detailed drawings that captured the "dejected" feeling of the pose. This, as we were to observe, was only the beginning of the lesson. After the drawings were completed and the drawing boards stowed away, the children filed back to their classroom.

Ms. Mudle was waiting at the door and as the students entered the classroom she invited them to sit in a semicircle on the carpet at the front of the room. There were two prints, one a depression-era photograph by Dorthea Lange, *Migrant Mother, Nipomo, California, 1936,* and the other van Gogh's *Portrait of Dr. Gachet*. Ms. Mudle asked questions about the media of the two works and the similarities in their poses were commented on by the children. The students characterized both works as "serious" and "not light-hearted at all." Ms. Mudle asked, "What does she have to be depressed about?" She then went on to tell the children that Lange had photographed a migrant worker who may be wondering "where does the next meal come from?"

Two reproductions, both portraits by Rembrandt, were placed before the children and they were asked to make comparisons between these portraits and the ones by van Gogh and Lange. Following an animated discussion, each child was given a laminated reproduction of Rembrandt's *Girl with a Broom*. (The reproductions were from the *Instructor* supplement of August 1988.) "This time," Mudle explained, "look at the painting for five minutes on your own. And then write about what she [the girl in the painting] sees,...what she was doing before she was painted, or write about the girl's thoughts. If you write about the girl's thoughts, write about them in the mood of the painting, try to make your words tell the mood of the painting. Let your mind go."

144

One of the children asked, "Can we have partners?" Ms. Mudle answered, "Yes, I was thinking that it would be good to brainstorm." The students divided themselves into pairs almost instantly; some headed for dictionaries and thesauruses. We observed as Brandy Sitts and Sara Ruggieri wrote a long story, "My Only Dream," that told about how Rembrandt came to visit Lucy as she was sweeping the floors in her home.

> "Hi," the man said with a Dutch accent, "What is your name?"
>
> Lucy looked up at the man, she could not believe her eyes, he had an easel and a palette filled with astonishing colors. They were the most beautiful colors she had ever seen.
>
> "Hello," Lucy said with a shy voice "Um, Um, who are you?" Lucy stuttered.
>
> "I am Rembrandt van Rijn."
>
> "You mean the famous artist?" Lucy said with eyes the size of golf balls.
>
> "Yes! The Royal King of Holland sent me to paint a portrait of Lucy Johnson. Do you know who she is?"
>
> "Why yes! That's me! Why does the King want a portrait of me?"
>
> "I have no idea."
>
> "I will be right back, I have to go get my mom."
>
> "Oh no," said the man. "You must not do that. The King wants no one to know about this."

The very long story ended when "Lucy's mother went to apply for a job at Anderson Art Gallery. Lucy had to wait in a gigantic room that must have had sixty paintings." The story continues, "Lucy began to look around the room. All of a sudden on an off-white wall, she saw a painting of her. She smiled happily. She was surprised. The painting was entitled *A Girl with a Broom.*" And in the end, "Her mother looked at the painting and smiled. She was so proud of her daughter. Lucy thought to herself, someday I will be famous."

A MOMENT WITH MONET In the spring of 1991 we paid another visit to North Port Elementary School. The integration of art and the general curriculum we had first observed in 1989 had become more complex and multifaceted. Art specialist Debbie Herbert and fourth-grade classroom teachers Sue Mudle and Laura Bradley had created a unit of instruction titled "A Moment with Monet." The unit topic was suggested by the book *Linnea in Monet's Garden,* by Swedish authors Christina Bjork and Lena Anderson (1987). The book is based on the garden Monet planted at Giverny that inspired so many of his later paintings.

In a summary of their unit, the three teachers noted that they had developed the unit as an aid to be used when incorporating discipline-based art education across the curriculum. The unit might be taught as a supplement or in place of the basal lessons for a period of time. "The intent," they noted "is to deepen the children's appreciation, understanding, and enjoyment of art through this interaction in children's literature. Depending on the structure of your classroom, you will find different ways to use this unit with students of all ability levels."

In the art program, students had been previously introduced to Impressionism as a painting style. In the classroom they introduced *Linnea in Monet's Garden* and read it to the students in daily intervals followed by comprehension discussions and activities. Some examples of curriculum ties include: **science:** water cycle, water's effect on weather, plants, environmental adaptations (water and plants), light; **writing:** cinquain poetry, adaptation of book to play; **reading:**

Linnea in Monet's Garden, oral reading of the script, research on Monet and France; **drama:** public oral speaking, stage directions; **social studies:** world geography, maps and globes, latitude and longitude, understanding cultural differences, economics—producer/consumer, law of supply and demand.

The results of the unit were marvelous. The cinquain poems the fourth-grade children wrote could be considered exquisite distillations of art criticism. For example, Stephanie Koenig, a fourth grader, wrote:

> Monet
> Powerful, active
> Full of enjoyment
> Nice, happy, unworried, joyful
> Impressionist

The children wrote a play based on their reading of the book and their study of art history. In addition to Linnea and Mr. Bloom, who accompanied Linnea on the trip to Monet's garden, the play included the artists Monet, Renoir, and Morisot. In scene three the students wrote:

> **Mr. Bloom:** Come over here Linnea, you have to look at this! This is an important painting in art history. It's called *Impression, Sunrise.* It is Monet's impression of sunlight reflected on the water. After that, the art critics started calling Monet an impressionist. And they didn't mean it in a nice way! They said his work was a waste of time! But Monet and his friends didn't think so.

(Lights go off for a second, artists come on stage in costume and with paintings; Linnea and Bloom freeze.)

> **Monet:** I don't care if they call me an impressionist, my canvases are alive because of the dabs of bright color, what do you say Renoir?

> **Renoir:** Your water paintings really do sparkle, and I love painting outdoors, especially catching the sunlight on children's faces.

> **Morisot:** They may not be buying our paintings now, but just wait, they'll see the light.

In these few lines from the much longer script, theater, art criticism, and art history merge.

About the studio portion of the unit of instruction, Debbie Herbert wrote: "Students studied the works of the Impressionists, with artists such as Monet and Renoir being key to our enthusiastic efforts. Students learned the following main objectives: 1. Near and far, i.e., showing distance through size changes; 2. Impressionistic painting techniques, i.e., students used their brushes, with an up/down motion, using dabs of paint. Students used bright, pure colors; 3. Identification of foreground and background; 4. Learning how to create interest in an image by repeating shapes (rhythm), 5. Learning how to use gloss medium to enhance the tempera paint colors."

One of the most important aspects of the Monet unit of instruction is that it is art-centered. The conceptions studied were derived from works of art, and although virtually every other subject matter area of the elementary school curriculum is included in the unit, the other subjects take their cues from Monet's paintings.

much as contributors to the school's basic curricular offerings but as providers of time periods without students. Even when specialists try to coordinate their art instruction with their colleagues' curriculum, they, not the classroom teachers, tend to make most of the overtures and do most, if not all, of the adapting.

In good DBAE schools, the situation is quite different; an entirely new role has been created for the art specialist. By necessity, specialists are members of instructional planning teams, and they work as consultants to other teachers. In a survey conducted in 138 elementary schools with art specialists, 65 percent reported that classroom teachers and specialists work together continually to plan and implement DBAE programs. In the new role of team member and consultant, art specialists must necessarily become knowledgeable both about the instructional programs of their colleagues and about how the study and creation of works of art might make significant contributions to those programs. In addition to being art teachers, they become consultants who recommend works of art. When these are studied for their historical, cultural, and social significance, they make the elementary school curriculum more substantial.

Art instruction benefits as well. When it is interwoven with other school subjects, it has the possibility of both enriching and becoming enriched through substantial relationships with the expanded range of subjects, disciplines, themes, topics, and ideas found in the elementary school curriculum. As indicated in Chapter 3, however, there is also the danger of art being made trivial by being used merely to illustrate classroom teachers' topical units of instruction.

COLLABORATIVE TEACHING One of the most promising patterns of instructional development associated with DBAE is when elementary school classroom teachers and art specialists jointly plan and teach units of instruction that are centered on works of art and the content of art. Although the practice is not as prevalent as joint planning, in a survey question responded to by 138 elementary schools with art specialists, 43 percent reported that art and classroom teachers frequently team-teach DBAE lessons. Although there is still a long way to go before collaborative teaching is the norm in DBAE schools, this statistic represents a dramatic change in the role of the art specialist in the elementary school.

Cooperative planning between art specialists and classroom teachers has several sources. It results from the initial planning for DBAE, which occurs in summer institute programs, as well as ongoing in-school planning. The latter is often influenced by the grade-level planning in which elementary classroom teachers customarily engage before attending DBAE institutes. Visits to schools have revealed numerous instances of the various ways grade-level teacher teams worked the new and more substantial forms of art education into their planning sessions. This practice, however, occurs in only about half of the elementary schools in the RIG programs. In response to a survey question, 48 percent of 115 elementary schools without art specialists reported that classroom teachers "work together continually to plan and implement the DBAE instructional program." Perhaps the more notable number—because it represents a more complex form of collaboration—is the 37 percent of schools reporting that classroom teachers, either within or across grade levels, frequently team-teach DBAE lessons.

When teachers plan and teach art collaboratively, there is a much greater likelihood that

In Monticello, Minnesota, district administrators were determined to have a strong elementary school art program. In addition to sending many of the district's classroom teachers to the Minnesota Consortium summer institute, they assigned middle school art specialist Karen Lundblad to assist teachers as they developed their art instructional programs.

The new elementary school in Monticello opened in the fall of 1992. Prior to the opening of the school, Monticello grade-level teachers had been encouraged to plan cooperatively and to instruct jointly, because the new school was designed to facilitate cooperative instruction. Fifth-grade teachers Kari Hanson, Kathy Mishler, Deb Patrick, and Jeanne Petermeier had attended the Minnesota Consortium summer institute together. If they had not already bonded as an instructional team before the institute, they had moved cooperative instruction to a point of near perfection by the time they were observed.

The teachers said that they spend part of each Friday afternoon planning the next week's program. They estimated that at least half of the school day is devoted to instruction in which their four classrooms are combined. Each of the four teachers takes the lead in planning and instructing in either art, language arts, science, or social studies. The other three teachers contribute continually to both the content of the units and lessons and to the actual instruction process. (When a teacher in a team accepts responsibility to prepare instruction in art, it is taught regularly— an expectation created by the team process itself. On the other hand, when teachers work by themselves, and if they have only modest commitment to DBAE, they are less likely to offer regular art instruction.)

As the evaluators joined a group of approximately ninety fifth-grade students, the pupils were just concluding a discussion of landscape paintings. The discussion of the works concerned the relationships between seasons and color. The students and their teachers met initially in a large space that has been identified as "the art room." Because this space had not yet been completely furnished, the students returned to their pod as soon as the discussion was completed. Before they left the art room, the students were assigned randomly to four groups, representing spring, summer, autumn, and winter.

The carpeted pod has a common area sufficiently large to accommodate at least one hundred students. Four smaller areas adjoining the common space can be made into individual class-rooms whenever the teachers wish to work privately with smaller groups of students.

As the four groups of students arrived back at the pod, they were greeted by four, large still-life displays arranged on big circular tables approximately five feet across. Each of the enormous displays held objects relating to a season of the year. The winter table, for example, had a tiered display of skis, ski boots, sleds, snowshoes, mittens, wool sweaters, etc. Students quietly took their places at desks that had been arranged in circles around the four displays and immediately went to work making light pencil drawings of the portion of the setup that they wished to paint. (During the briefing period the students had been given careful instructions relating to composition and initial planning—such as selecting an interesting portion of the display and then sketching it very lightly—before beginning to paint.) In the four sectors of the large pod there was virtual stillness, with the only sound that of a Debussy composition playing from a stereo.

In the "fall" group, the teacher who had taken the lead during the introductory presentation held up a student's painting of a branch to show all the students in the group how a textured effect had been achieved. Two other teachers moved to the circle and added their comments. This pattern was repeated in each of the four groups, as the teachers made comments to students individually and in small groups.

The quality of the work was amazingly high. The evaluators assumed that this was because of the careful preparation for the project, the many indications the students were given that the teachers expected them to do their best, and the formative evaluations offered by the teachers

throughout the process. The students, it appeared, were accustomed to producing high-quality work. When a group of students was asked how often they had art classes, they replied that it was not quite once a week. They also said that frequently an art lesson would take an entire morning—the length of time the seasons project was to take. The teachers stated that the students and their art projects keep getting better and better.

In Monticello, the pattern of expectation starts with the district administrators and extends to the students. The administrators indicate to the art specialists and classroom teachers that they want a good art program. They also set in motion the professional development plan. The art specialist works with her elementary classroom colleagues, and as a result of their team planning and mutual support, the classroom teachers are able to offer a substantial program of art instruction.

DBAE will have a substantial character and be taught regularly and well. When a team of two or more teachers cooperatively plan their instructional programs, the individual who is most confident and knowledgeable about a given subject, including art, usually takes the lead in both preparing for and presenting the instruction. Moreover, when team members divide responsibilities for planning and presenting instruction, the individual responsible for a given subject matter area usually makes sure that instruction is offered in his or her "specialty" on a regular basis. It is also the case that the other teachers in the team become more confident and competent as they assist the instructional leader in presenting DBAE instruction.

Moving Art to the Core of the Elementary School Curriculum

Before DBAE was introduced in elementary schools, it would have been inconceivable to most elementary classroom teachers that art would have anything substantial to contribute to the school curriculum. Things changed, however, when works of art were placed at the center of elementary school instructional programs; when the works of artists were interpreted in light of their historical and cultural significance; when they were related to works of literature, the humanities, and the sciences; and when children created their own artworks based on the themes and ideas found in artists' works. Art was seen to have importance both in its own right and for the contribution it could make to the general elementary school instructional program.

Discipline-based art instruction—with its emphases on the substantial study of art and the idea-based creation of works of art, its expectation that students engage in a variety of high-level critical thinking processes, and its relationship of works of art to humanistic and scientific themes on which other school subjects are based—has had the consequence of placing art at the center of the program in the classrooms of DBAE teachers. The substance and integrity of art, rather than being lost, are actually strengthened. Integrated instruction derived from the themes and content of works of art becomes more profound and value-laden than the usual instruction found in schools.

When works of art are placed at the center of elementary school instructional programs, art has importance in its own right and for the contribution it can make to the general program.

Fully articulated exemplary units of instruction developed by classroom teachers and art specialists who take their cues from the themes, topics, and content of works of art are still somewhat rare. It should be noted, however, that in a survey of elementary schools, 59 percent of 235 schools that responded claimed that the teachers in their schools organized DBAE into thematic units of instruction in which the content is derived from art or works of art. Over half of the respondents to the questionnaire also indicated that they thought it more desirable to base DBAE units of instruction on content derived from works of art rather than themes derived from other subjects such as social studies and language arts.

Elementary schools were surveyed to determine the extent to which art had become a part of the curricular and instructional core. Seventy-one percent of the individuals—school principals, art specialists, and classroom teachers—in 235 elementary schools indicated that they were working to make art a core subject whose contribution to the school was equal to that of language arts, mathematics, science, and social studies. In those same schools, art was seen to be a subject in its own right; over two-thirds of the respondents disagreed with the notion that "art makes its most important contribution to the school's instructional program when it is used to reinforce the content of other school subjects such as language arts, social studies, and science." The exciting art instruction that emerges from artwork-based thematic units contains the seeds of a revolution in elementary school art education—and perhaps even elementary education in general. This pattern of instruction does not preclude the linking of art with the content of other subjects; on the contrary, works from literature, music, social studies, and science often enrich the study of art—just as art enriches other school subjects. Nevertheless, when such linkages are made between art and other subjects, the content of art predominates in the art-based thematic units.

SHOULD ART BE STUDIED FOR ITS SOCIAL OR AESTHETIC VALUES? Elementary school classroom teachers who have little understanding of or concern for the tensions between modernist and postmodernist approaches to the study and interpretation of artworks have unknowingly brought the issue to the forefront. During their preparation to become art teachers, most elementary art specialists, like their colleagues in secondary schools, were taught that the principal reason for analyzing artworks was to reveal their underlying design, composition, and expressive qualities. This understanding was thought to be the foundation for appreciation and aesthetic enjoyment—two of the most desirable outcomes of experience with art, at least from the modernist perspective. The postmodern approach is to place artworks in context—to analyze them in light of their social, cultural, political, philosophical, and historical significance. When interpreted this way, the works reveal important things about society culture, politics, philosophy, and history.

As illustrated in Chapter 3, one of the early forms of DBAE—aesthetic scanning—was based almost entirely on the modernist premise (Figure 3.2, p. 90). Art educators who planned some of the early DBAE institutes made sure that the traditional modernist approach to the analysis of artworks was a central feature of these professional development programs. The design-feature/expressive-quality approach to artistic analysis was countered in institute programs by critics and art historians who, if not postmodernists, at the very least took a decidedly less formalist and more social/cultural approach

A PAINTING, LOCAL HISTORY, AND HUMAN VALUES
IN HAMILTON COUNTY, TENNESSEE

In 1989 Sher Kenaston taught fourth grade at Harrison Elementary School in Hamilton County, Tennessee—the county in which Chattanooga is located. In the first Southeast Institute for Education in the Visual Arts summer program she had learned about James Cameron's painting *Colonel and Mrs. James A. Whiteside, Son Charles, and Servants* (1858–59). It was one of the works reproduced in print form by the Hunter Museum of Art for use by Southeast Institute participants. This painting, made just before the Civil War, shows the wealthy Whiteside family on their spacious verandah high up on Lookout Mountain, with the city of Chattanooga in the background below. The painting is a fascinating document of antebellum society. At the summer institute Kenaston began to talk about how she might approach the study of the work. The evaluators were intrigued with her ideas and arranged a visit to Chattanooga to watch her teach a unit based on the painting.

Kenaston displayed the reproduction in front of her students, who were seated on the floor in a semicircle. The following conversation ensued:

> Kenaston: *Why are we looking at this again?* (The class had seen the
> print briefly the previous Friday.)
> Child: *It's in the Hunter Museum.*
>
> Kenaston: *But there are lots of works in the Hunter. Why study this one?*
> Child: *It's about Tennessee.*
>
> Kenaston: *How is it different from other works we have studied?*
> Child: *It's got people in it.*
>
> Kenaston: *Who remembers the artist's name?*

Kenaston reminded the students that the artist was James Cameron, that the picture was painted before the Civil War, and that when the artist returned to Chattanooga after the war he was so distressed by the destruction he found that he ceased painting. One of the students reminded the class that the Whiteside mansion had been torn down and apartments built in its place. Kenaston agreed, and explained: "Yes, but that was much later. I'll point out where the mansion was on the way to the Hunter Museum."

In the few minutes that followed, the students were given information about Cameron's early life—that he was born in Scotland and came to Pennsylvania with his family; that, like "lots and lots of artists, he studied in a foreign country [Italy], where he had gotten the idea for the verandah"—the imaginary one on which the Whiteside family had been painted. Then Kenaston led a discussion of the painting itself.

> Kenaston: *It's a picture of what?*
> Child: *A family.*
>
> Kenaston: *Yes, it's a family painted just before the Civil War. Do you think
> that they are happy or sad, or are they just . . .*
> Child: *Serious.*

Kenaston: *What do you notice between all these figures and Colonel Whiteside?*

Child: *He's about to open a book; he's got a letter; that's why they are sad.*

Kenaston: *I think they are just serious. Why do you think that Cameron painted it?*

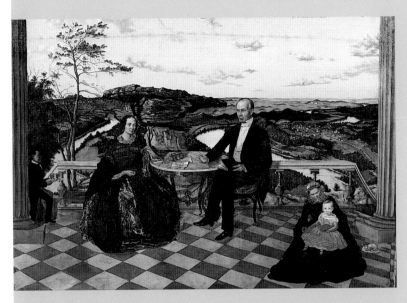

Colonel and Mrs. James A. Whiteside, Son Charles, and Servants, James Cameron, 1858-59, Hunter Museum of Art. Chattanooga, Tennessee, fourth-grade teacher Sher Kenaston explored social issues suggested by the painting.

Kenaston showed the students that the letter contains Cameron's signature; she noted that this was the artist's way of signing the painting, and that Cameron had probably been asked by Colonel Whiteside to paint his family's portrait. She then returned to her line of questioning:

Kenaston: *What do you think about the different people? Do you see the little boy? What is he doing?*

Child: *He is a servant.*

Kenaston: *Yes, this is just before the Civil War.*

Child: *The war was going to free the slaves.*

Kenaston: *Yes, we wouldn't see this today. Who is the young woman holding the infant?*

Child: *She's a slave too.*

Kenaston: *How do you think she feels toward the baby?*

Child: *They wouldn't let her hold the baby.*

Kenaston: *Yes, they would. Lots of babies were raised by servants.*

Child: *I'll bet they had lots of servants.*

Kenaston: *I'll bet they did. But remember what happened in three years. In eight years what would be missing from the picture? What two people would not be in the picture?*

Child: *The slaves.*

Kenaston: *Yes, they would be paid servants.*

Child: *Did the slaves fight in the war?*

Kenaston: *Some did. Remember, no person had the right to own another.*

Child: *Our parents own us.*

Another Child: *No, they don't.*

Kenaston: *These people were brought over from Africa against their will. After the war, would things look like this?*

Child: *No.*

Kenaston: *Why not?*

Child: *A big battle was fought on Lookout Mountain. The mansion might be destroyed.*

Kenaston: *If you were on Lookout Mountain, just what would you see? Remember, this was in 1859. What do you think is the most interesting thing about the painting besides the people?*

There were comparisons between the way Chattanooga looked then and now. One child commented on "the way the artist mixed it up—the way he puts the mountains—makes it look more real." Another said, "It looks like the cliffs are close." There were comments about the time of day depicted, the clothing worn by the Whiteside family, and then more discussion of the Civil War and comments about the colors of the painting and the contrast between the bumpy texture of the rocks and the smooth floor. A child remarked on the faces of the Whiteside family. Another asserted that the people and the rocks looked "quite natural." A child pointed, "over here, the people owned the land," and another pointed out where the train was. Kenaston told the children, "You will be surprised when we go to the Hunter and find out how big the painting is." Then she asked, "Does it look like a stage to you? What does Colonel Whiteside have in his hand?"

Child: *It's a Bible.*

Kenaston: *What impression did he [Colonel Whiteside] want to give?*

Child: *He was a Christian.*

Another Child: *He was a church man.*

Another Child: *Wait a minute; if he was a Christian, why did he have slaves right in his house?*

Kenaston: *Class, do you want to answer?*

Child: *Everybody did it then.*

Kenaston: *That's the argument you give your parents. "I want to go to the mall." Your parents say, "Why?" and you say, "Because everybody will be there." The colonel was ignoring his value system, or he ignored it because everyone else was doing it.*

Child: *Maybe they [the two servants] were his kids.*

Kenaston: *No, they were slaves—you can't get him out of it.*

Child: *It's not true that most people were doing it, because in the North they didn't have slaves.*

As the discussion drew to a close, Kenaston asked, "What have we discovered? There is a lot more to this painting than we thought at first." At this point she turned the discussion to families today, how different they are from the time of the Whiteside family—that there are families with single parents (one child told of his four parents—his divorced parents had both remarried), how an artist might depict today's families, and how the children might depict their own families. Ideas associated with today's families were to be the subject of the studio project related to the painting.

Some art educators have expressed the opinion that Kenaston's lesson "sounds like social studies, not art." It should be noted that many paintings are about social issues. Moreover, there are art historians who deal with little other than the social and historical dimensions of art (T. J. Clark, author of *The Painting of Modern Life: Paris in the Art of Manet and His Followers* [1984], is an excellent example). If children should be expected to inquire into works of art as some art historians do, then this classroom episode offers a model.

Although Cameron's painting is not an aesthetically distinguished work of art, it contains some important features that led to a particularly illuminating social-historical discussion. The work educated a group of fourth graders about slavery, human values, and local and national history in ways that few other artifacts might have—certainly more than most fourth-grade social studies texts. The students did a remarkable job of dealing with complex, value-laden social issues, particularly those relating to the fact that slavery was once a part of American society. Kenaston handled the discussion with sensitivity as she gently guided the children to the conditions that surrounded the creation of the painting, the values it represents, and how values and practices have changed since the Emancipation Proclamation.

to artistic interpretation. Although elementary classroom teachers were treated to both modern and postmodern stances, often it was the social/cultural and the historical approaches to interpretation that corresponded most closely to their existing curricula and instructional programs. Because classroom teachers did not have to outgrow a modernist bias toward formal analysis, some took readily to interpretation from social, cultural, and historical perspectives.

Other elementary classroom teachers are considerably less socially conscious, preferring to link art to science, mathematics, and literature—where it sometimes seems art is being used a bit too much in the service of the general curriculum.

The Elementary School DBAE Instruction and Performance Assessment

In elementary schools, assessment usually means standardized testing, in which students respond to multiple-choice questions in various subject-matter areas. Students' individual scores are ranked according to norms so that the teachers or parents might compare where a student stands in relation to other students in the classroom, school, or nation. The scores of students in a particular school are combined to compare an individual school's standing with school district averages or with other individual schools within a district. Standardized tests are often criticized, because students' correct or incorrect answers to just a few multiple choice questions can have a significant effect on their scores—placing them either considerably above or below a norm or average. Standardized tests provide little practical information about the subtleties of actual performance relating to everyday applications of knowledge.

There are no standardized tests in art—an absence for which many art educators are thankful. Such tests, if they were created for art, would tap little of the richness of this school subject, in which at least as much time is devoted to the creation as to the study of art—and where interpretation and creation are often interrelated in complex ways. Nevertheless, there is a downside to not having tests in art. Formal assessment validates a school subject; if students are not tested in a subject, then its importance to their education is questioned. If art is to take its place as a core subject in the elementary school curriculum, it is reasoned, then student learning must be assessed. More important, teachers, parents, administrators, and students need to have information relating to student achievement and progress. When student achievement is lacking, corrective action can be taken; when it is as desired, students, parents, and teachers can be justifiably satisfied.

The DBAE initiative began at about the same time that educators were criticizing standardized tests because they tapped so little of what education is supposed to be about. In order to make assessment more important to the educational process, educators started a movement toward forms of assessment that sometimes go by the names "authentic," "performance," and "portfolio." These forms of assessment, which attend to a full range of the ways students actually perform when given practical tasks, have provided the focus for assessment initiatives in several of the RIG programs. The assessment strategies being developed in the Florida Institute for Art Education illuminate the complex process involved in changing the nature of educational evaluation. They also raise some provoca-

As plans for exemplary units of instruction with embedded assessment points unfolded, the Florida codirectors were asked to think of teachers who had developed outstanding DBAE instructional units. Jessie Lovano-Kerr and Nancy Roucher described a unit based on Faith Ringgold's *Tar Beach* developed by Tallahassee classroom teacher Chris Tonsmeire. Eventually, Tonsmeire's unit was developed into one of the Institute's prototype Comprehensive Holistic Assessment Tasks (CHAT). The evaluators interviewed her in order to learn how she came to develop the unit.

Tonsmeire explained that she had a long-standing interest in art, and, as an institute participant, she was impressed with DBAE. "I started out as an integrated arts major and I hoped to teach all subjects through art. In the real world my enthusiasm was squelched." Furthermore, "I also wanted to do quilts. When key faculty member Marilyn Stewart [professor of art education at Kutztown University in Pennsylvania] showed Faith Ringgold's quilts during a summer Florida Institute program, I said, 'This is it.'" Tonsmeire remembered the event with considerable clarity. "We had just come back from lunch and looked at Faith Ringgold's *Church Picnic*; it was a slide show. We did do an activity. She [Dr. Stewart] had small color photocopies of Ringgold's work—but not *Tar Beach*. I found out about *Tar Beach* later." Tonsmeire asked a librarian friend of hers to help locate information. "She said, 'I think this is what you want; it's for kids.'" It was Ringgold's book *Tar Beach*, which is based on her quilted story painting in the collection of the Guggenheim Museum.

Tonsmeire planned a three-month unit. "I did lots of research. I tied all my subjects to this. She [Ringgold] was to be the artist, but then she became the focus of the entire unit." The children began to make their own quilt modeled after Ringgold's. But, Tonsmeire said, "they could not get the idea that a quilt is an art form. After we made our quilt one of the children said, 'I didn't know how much my grandmother loves me'" [to do so much work making a quilt for her bed]. As the unit progressed, Tonsmeire got more information on Ringgold's work. "A friend of mine, Linnie Osborn [an art specialist], went to an exhibit in Atlanta. She is my expert on art history." As the complex unit

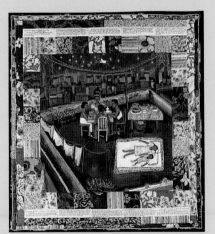

Tar Beach (Woman on a Beach Series #1), Faith Ringgold, 1988, acrylic paint on canvas bordered with printed and painted quilted and pieced cloth, Solomon R. Guggenheim Museum. Florida teacher Chris Tonsmeire developed a three-month unit with embedded student assessment tied to *Tar Beach*.

progressed, Tonsmeire explained to her children that *Tar Beach* echoed the theme of slaves flying to freedom in African American folk literature. As she explained, one of her students said, "That's just like *Follow the Drinking Gourd*"—a story of the Underground Railroad, by which slaves moved north to freedom before and during the Civil War. When the CHAT prototype was developed, *Follow the Drinking Gourd* (Winter 1988) was included. Before the prototype CHAT was completed, there were to be many contributors. Nevertheless, it is fascinating that a child made the connection that was later expanded upon by Tonsmeire, Lovano-Kerr, Roucher, and Mary Ellzey (the evaluator of the Florida Institute) in the Florida Institute and Joan Baron and Dennie Palmer Wolf from Harvard University, who served as consultants to the Florida Institute student assessment project.

tive questions regarding who is actually assessed when new forms of tapping student performance are developed.

A COOPERATIVE NETWORK: STUDENT ASSESSMENT IN FLORIDA The Florida Institute has undertaken a consortium-wide student assessment project supported with funding from both the Getty Education Institute and the Jessie Ball du Pont Fund. During an initial assessment "think tank" meeting, there was a discussion regarding the character of art assessment. As the ideas unfolded, it was decided that assessment should, first, have the appearance of an exemplary unit of art instruction, and, second, have embedded assessment points consisting of tasks whose products are evaluated using a variety of qualitative and quantitative means. Moreover, the assessment components of the unit should look no different from the non-assessment portions.

The Florida Institute assessment project has provided the means through which curriculum and authentic assessment are being developed, hand in hand—as they should be. The assessment project has focused the energies and talents of individuals throughout the Florida consortium toward an enormous multifaceted and extremely complex task of creating units of instruction with embedded assessment. As the project has unfolded, it has become clear that the insights of elementary art specialists and classroom teachers are as important to the project as those of assessment experts. Indeed, the development of authentic assessment should not be undertaken unless elementary art specialists and classroom teachers are full members of the development team.

The Work, Its Theme, and Assessment Unit Goals Throughout the development of the Florida Institute assessment unit, perhaps no other issue was the subject of greater debate than the meaning of the work to be used in the assessment. *Tar Beach*, Faith Ringgold's painted, quilted, and written piece, which depicts the tar roof of a New York tenement building, is both a work of art and a children's book (Ringgold 1991). Two adult couples are shown eating their supper (a picnic on a tar beach) and a young girl, Cassie, lies on a blanket with her younger brother. Cassie's eyes look upward to where an imagined version of herself is flying over the George Washington Bridge. In her imagination, Cassie can "own" anything she flies over. As she says, "I am free to go wherever I want for the rest of my life." The George Washington Bridge is her most prized possession, but she also flies over a labor union building and an ice cream factory. By owning the labor building, she will be able to put an end to the discriminatory practices that have kept blacks and Native Americans out of the union. Cassie's flight also echoes a motif in African American folktale literature, in which slaves dreamed of flying to the North and to freedom.

Through lengthy discussions, members of the assessment development team finally agreed that the work's "main theme" is personal and societal freedom—freedom from discrimination and freedom of the imagination. The team arrived at this conclusion through the application of processes from art history and art criticism; in other words, the art disciplines were essential to the development of the assessment unit.

First-Draft Interpretation and Art-Making Activities After students have an opportunity to examine *Tar Beach*, they are asked to write about what the work means and about how all the parts of the work help to convey its main idea. In the next "first-draft" activ-

In Sarasota the evaluators met for an afternoon with teachers who had administered early versions of assessment units in their classrooms. Their comments were illuminating. Manatee County classroom teacher Sheila Walker, who piloted the *Tar Beach* assessment unit in the fall of 1992, said that teachers unfamiliar with DBAE "will be touched by the literature; they will like the interdisciplinary base."

The discussion turned to whether teachers should have the option to modify the time modules in the assessment units, which led to an even more important issue. Sue Mudle explained her frustration with the time constraints and told how in her effort to follow the instructions she felt she was placed in a straitjacket that prohibited her from doing her best teaching. She was not satisfied with her students' writing and was especially displeased with the quality of her students' art making: "I think that the final exercises were too limited. There are some kids who work better in other ways." She also told the group, "I can get good work out of my children but I couldn't the way the instructions were written." The consensus of the group was that in an assessment unit about freedom, teachers ought to be given the freedom to make any alterations they feel are necessary. Nevertheless, the group agreed that if teachers were to be given that freedom, then clear conceptions of student outcomes needed to be established from the outset. In effect, they thought that teachers should be permitted to lead students to the goals of the assessment unit in whatever way worked best for them.

The discussion with the Sarasota teachers extended to issues of rating students' achievement and the amount of mentoring and tutoring that ought to be permitted during the final tasks in the assessment unit. On this last point, the teachers concluded that they ought to tutor and mentor all they wished; as one of them said, "That's what we do; we're teachers." This last point led to the question, Whose achievements are being assessed, the teacher's or the students'?

As the evaluators listened to the discussion regarding the extent to which teachers should be permitted to interact during the assessment points, it became clear just what might be assessed during a DBAE assessment unit. If teachers are to be encouraged to interact with students during all the instructional and assessment tasks, then it is the learning community that is being assessed, not just individual students. That learning community is composed of interacting individuals who help one another by taking advantage of their strengths and compensating for their weaknesses. The responsibility of the teacher is to enter into all aspects of the instruction/assessment process in order to encourage students' most advanced responses to every aspect of the task.

ity, students are invited to draw where they might like to fly in their imaginations—to show what the world they imagine is like.

Critical, Historical, and Cultural Study of Tar Beach The assessment unit's next phase takes place over several days. It consists of an extensive study of *Tar Beach*, including critical, historical, and cultural interpretations. Children have the opportunity to:

- read, study, and discuss the book *Tar Beach*,
- read critical writings about the book and the quilt/painting,
- study Faith Ringgold's biography,
- view a videotape of the artist working in her studio and commenting on her creations, including *Tar Beach*,
- examine the way the work's sensory, formal, and expressive qualities contribute to its meaning, and

160

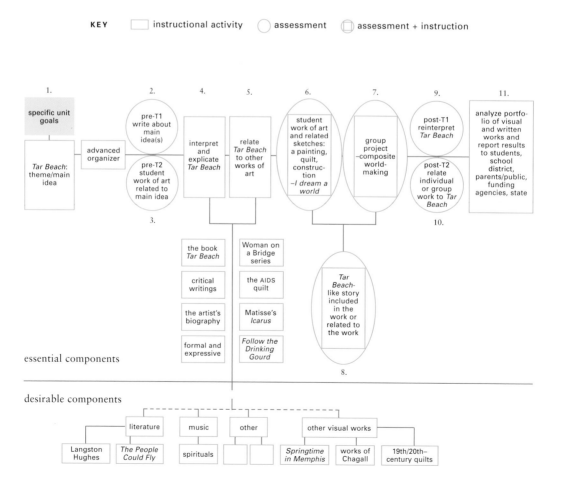

A Comprehensive Holistic Assessment Task Model:
Faith Ringgold's *Tar Beach*

Figure 5.1

- discuss whether quilts are art or craft and how *Tar Beach* is connected to both.

At the same time *Tar Beach* is interpreted, the work is placed in its historical context through the study of related materials, such as:

- writings about slavery and the Underground Railroad, including the story *Follow the Drinking Gourd* (Winter 1988),
- Martin Luther King's "I Have a Dream" speech,
- African American spirituals,
- a reproduction of Hale Woodruff's *Poor Man's Cotton*, a painting of African American field hands, and
- the poetry of Langston Hughes.

These are the essential things to be studied about *Tar Beach* and its context. Optional, but desirable, components include a series of works from the visual arts, music, and literature.

Students' Art Making: Individual and Group Projects The art-making process begins with the first-draft sketch and continues throughout the unit. Students make more sketches and then finally produce a communal work relating to the unit's theme. During the art-making process there are guidelines and checklists that encourage students continually to reflect upon and evaluate their progress by deciding whether their use of color, placement, size, and expressive qualities contributes to the main ideas of their artworks.

Final Assessment Tasks In the final assessment tasks, students are asked to view both *Tar Beach* and their own creations. They are asked:

How does your story quilt square compare to *Tar Beach*? What did you do? What did Faith Ringgold do? Think about the main idea, subject matter, composition, and interpretation.

Explain how your work compares; give good reasons for your opinions and organize your writing clearly.

There are no standardized tests in art; such tests would tap little of the richness of this school subject, in which at least as much time is devoted to the creation as to the study of art. Nonetheless, authentic assessment can show students, teachers, and parents how successfully students are learning to interpret and create art.

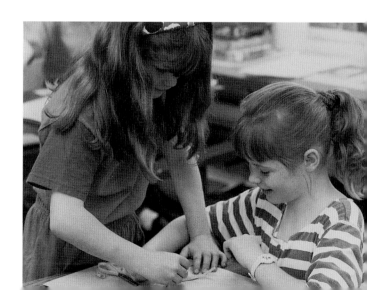

The teacher manual for the assessment unit, at one stage in its development, contained more than 159 pages of suggestions, resource materials, and guidelines. The outline above hardly begins to show the richness of the unit. The *Tar Beach* assessment unit is only one of nine developed and field tested in the Florida consortium. These assessment units exemplify what DBAE is in the process of becoming at the elementary school level. The Florida assessment unit also exemplifies the advanced form of DBAE shown in Figure 3.11 in Chapter 3.

The Florida assessment project is broadening conceptions of how student progress might be assessed. It also reveals how teachers, through their practical knowledge of students and the elementary classroom, are helping to make clear just who is being assessed when student performance is carefully analyzed.

Conclusion

The various forms of DBAE instruction presented in this chapter's case studies, especially the Florida assessment unit, show some of the most important developments in elementary school art programs. Just as DBAE is evident in the units of instruction, the influence of whole language, cooperative learning, and integrated instruction can also be seen. Moreover, the units provide outstanding examples of critical thinking—in its best sense. This critical thinking was not done for its own sake, but as the means through which children understood the meanings of works of art and, through those works—the ones they created and the ones they studied—came to understand important things about themselves and their worlds.

The units of instruction and instructional practice presented in this chapter, as exemplary as they are, point to an even greater challenge. Visits to elementary schools have revealed that virtually none offers a comprehensive art curriculum comprised of six or seven years' worth of exemplary integrated units of instruction. The isolated units of instruction provided in kindergarten through sixth grade do not constitute a comprehensive DBAE curriculum. Nevertheless, it is possible to conceive of a curriculum consisting of a sequence of art-based instructional units for kindergarten through sixth grade

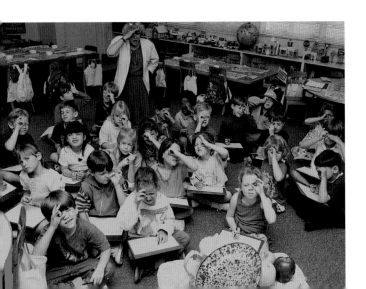

Virtually no elementary school offers a comprehensive art curriculum. What would such a curriculum look like? What criteria should govern the selection of artworks, themes, and ideas?

(or even twelfth grade). What would this curriculum look like? What criteria should govern the selection and sequence of works of art, themes and ideas, concepts, countries and cultures, art forms and styles, periods, age-appropriate approaches to study and creation, and connections to curricula and instructional programs in other school subjects that should comprise the comprehensive curriculum? This is the challenge faced in elementary schools in which DBAE is being implemented.

Notes
1. In a survey of 245 elementary schools, 136 (55.5 percent) indicated that the school had an art specialist. The percentage of specialists, however, was different in the various regional consortia. In Florida, for example, 62 percent of the elementary schools had art specialists; in Minnesota, 68 percent; in Nebraska, 40 percent; in Ohio, 100 percent; in the Southeast, 38 percent; and in Texas, 85 percent.

DBAE in Secondary Schools:
Issues, Problems, and Exemplary Practices

CHAPTER

6

Throughout the regional institute grant (RIG) programs, conceptions of DBAE are more fully and clearly formulated for elementary schools than secondary schools. In composing curricula, secondary school art specialists have also had less well-developed support systems than have their elementary school colleagues. They must also struggle against traditions that see high school art as preparation for the artist-to-be. These difficulties notwithstanding, secondary school art teachers have reformulated their programs in remarkable ways. This chapter characterizes the conditions that surround secondary school programs, the difficulties secondary school art teachers have encountered in developing DBAE programs, and promising instructional practices that have emerged in the RIG programs.

Implementing DBAE in Middle, Junior, and High Schools

When DBAE was first introduced in the Los Angeles Getty Institute in the early 1980s, much of the initial effort was directed toward the development and implementation of elementary school art programs. From the beginning, however, five of the six RIG programs offered workshops for middle and high school art specialists, as all six do now. However, conceptions of DBAE theory and practice are still more fully and clearly formulated for elementary schools than secondary schools.

Because there have been fewer DBAE models for secondary school art specialists to follow, middle, junior, and high school art specialists have been left with the task of taking the information they have received about the art disciplines, the art world, and elementary school models of DBAE and, from these components, conceiving and developing their own individual DBAE programs. As the secondary school art specialists have undertaken this task, they have also had less well-developed support systems than have their counterparts at the elementary school level, whose DBAE efforts usually involve a team of teachers and an administrator. In the most successful elementary schools, the implementation process affects every teacher, art is interwoven with instruction in other subjects, and in some instances, entire school instructional programs have become theme based and integrated as a result of DBAE. In secondary schools, however, the implementation of DBAE is seldom schoolwide. Except in a few instances, secondary school art teachers have worked alone to develop their individual DBAE curricula and have done so in the face of many obstacles having to do with traditional art educational practices, assumptions about the purposes of art education, and the kind of art teacher preparation they received.

Even with these difficulties, secondary school art teachers have reformulated their art programs in remarkable ways. It might seem logical to begin this account at the middle school, but the evaluation team has found that the issues involved in developing DBAE programs at the secondary school level stand out in greater relief in the high school.

The Challenges to Implementing DBAE in High Schools

There is an art program in virtually every high school in the United States, yet what goes on in these programs has not been studied extensively. From the evaluators' observations of high school offerings in the RIG programs over the past six years, the conclusion can be drawn that the interaction of a whole series of factors affects the implementation of DBAE. These include:

- the way the general curriculum is structured,
- the kinds of students who end up in art classes and the kinds of expectations they bring with them,
- teachers' assumptions about the conditions under which art should be taught,
- teachers' preparation to teach broad-based art programs, and
- attitudes concerning whether art should make a general contribution to students' education or prepare them to be artists.

How has DBAE influenced thought about each of these issues? The evaluators found that high school art programs are organized in two basic ways. In the first, the art curriculum is nonspecialized. Art classes are organized by general courses, "Art I" through "Art IV," with occasional advanced placement portfolio classes and art history courses. When the art curriculum is organized in this fashion, art specialists have been able to introduce DBAE into their programs with relative ease, at least when compared with programs that are organized around highly specialized media- and art-form-related courses. This second way of structuring the high school art curriculum needs a closer examination.

Many high school art classes are preprofessional, directed toward the education of the artist. Teachers intent on developing broad-based high school art courses for the general student face a daunting task.

An analysis of the high school art curriculum in a Nebraska school district revealed that all four of the district's high schools constructed their offerings from a standard but extensive menu of thirty-three separate courses. The 1993–94 *High School Course Description Guide* lists five separate drawing classes, four in painting, three in photography, two in commercial art, four in jewelry, three in fibers and weaving, four in pottery, five in sculpture, two in design, and one in art history. In most of these areas there are courses at the beginning, intermediate, and advanced levels.

Many of these offerings are preprofessional in character—they seem to be directed toward the education of an artist. In other words, rather than fulfilling the requirements of general education—where art is studied and created so that the students will gain insights into themselves, their world, human purposes, and values—art education is directed primarily to art process, media, and techniques. In the course outlines, however, there is the recognition that art making should be tied to historical and cultural traditions. For example, the description for Beginning Sculpture taught at two high schools reads: "The ability to recognize works by famous sculptors, identify important movements, and explain the influence of history on the work of the sculptor are central to learning."

Most of the teachers in the district to whom the evaluators talked expressed a commitment to a broadened DBAE art curriculum. They face a daunting task, however. If they were to make each of their courses truly discipline based, they would need to acquire basic knowledge of the history and critical traditions of ceramics, textiles, photography, drawing, painting, sculpture, jewelry, design, etc.

The problem is especially difficult in highly specialized areas such as textiles, jewelry, and design, where histories have barely begun to be written. Moreover, the histories that do exist are not readily available to art teachers. Criticism in the craft areas is notably underdeveloped; philosophical issues are infrequently addressed. It is no wonder that in many high school art classes, objects from the history of art are treated merely as visual stimuli rather than as works of art to be understood in light of their cultural, historical, philosophical, and even artistic significance.

Although this example comes from the secondary school art program in a single school district, the challenge of integrating DBAE into highly specialized art courses must be faced in high schools throughout the nation.

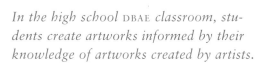

In the high school DBAE classroom, students create artworks informed by their knowledge of artworks created by artists.

In 1988, at the beginning of the third week of the first summer institute of the Ohio Partnership, high school art specialists, in their group discussions, were still struggling with the notion of DBAE. As they discussed what teachers would need in order to implement DBAE in their freshman survey courses, the teachers had listed on the board "accountability," "resources," and "status of art in the curriculum," but their attention was directed primarily toward very practical issues regarding the changes in expectations associated with the new curriculum, especially the consequences of their devoting less time to student art production. One teacher said, "We are worried that this will reflect negatively on the teachers." Another responded, "Will we get better 'products' from high schools involved in DBAE?" And a third teacher wondered about competitiveness: "The number of awards won on the high school level concerns teachers. Sometimes this is how we are recognized in the school system."

The most interesting part of the discussion was when the teachers began to reflect upon the effects that the new curriculum might have on art education in their schools. One high school art teacher asked, "How is this new curriculum going to affect the status of art? Will it remain an elective in the school system?" After a lengthy and sometimes heated discussion, most of the teachers concluded that the broadening of the high school art curriculum to include art history, art criticism, and aesthetics could result in more status for their programs and perhaps even change their standing from elective to required. Even with the prospect of positive outcomes, however, they were still uneasy about what they were getting themselves into.

As the high school teachers discussed their concerns for the coming year, they had a more immediate duty to perform. At the end of the week they had to make a presentation to their school and school district administrators about the programs they were planning. The agenda they developed for the session included:

- an overview of DBAE,
- planning for implementation,
- soliciting support for implementation and the resources needed (which included art magazines, slides, and reproductions, especially those relating to African American and multicultural imagery; blinds to darken the rooms; two slide projectors and two screens; a world map; and history timelines), and
- teacher release time to visit other DBAE schools.

Before the meeting ended, the teachers delegated a representative to call their principals to be sure they would attend the orientation meeting.

As the high school teachers presented their new art program to their principals and other administrators, there was barely a hint of the struggles they had experienced as recently as two days earlier with the consequences of implementing DBAE. One teacher told the assembled group, "DBAE means the antithesis of what I was brought up to do. DBAE is academic; it is using history, criticism, and aesthetics. I'm still a production man, but I'm convinced." He went on to say, "We want to broaden our model for art teaching and our clientele. The bottom line is that students will understand art." A high school principal asked, "You say the program should expand the clientele; what will happen to the kids who might be turned off by the text?" The answer was, "We will have to be creative, not use the text as they [texts] are used in other areas. We hope that by having a more specific curriculum, the general student, the academic student, will want to take art."

The teachers were pleased by the interest of their principals. One teacher, warming to their responses, engaged in a bit of promotional discourse: "We have been selected to write the guide—to make the plan for the entire nation—a pioneer effort." This comment may have been an over-

statement, but it indicated that some teachers had become committed to DBAE.

In the Ohio Partnership there was never another group who struggled with DBAE as the first group did. Indeed, it was as if the first group had resolved the issue for the secondary school art teachers who attended Ohio Partnership institutes in subsequent years. The acceptance of DBAE by this group seemed to make it easy for most other high school art teachers to accept.

The evaluation team has seen some of the most interesting developments in high school DBAE in the Ohio Partnership. Three of these programs are described below.

During the spring 1991 implementation visits, the evaluators made a special effort to identify and study high school art teachers who had caught the vision of DBAE and developed imaginative programs. Susan Shafer is one such teacher. Her teaching was organized around units of instruction, and the conceptually oriented course that she created for high school college-bound seniors was exemplary. Shafer attended the Partnership summer institute in 1990; it helped her to consolidate her beliefs about the role of history and criticism in high school art.

On entering Shafer's classroom, the evaluators saw that the space was one part art gallery and one part art studio. A look to the right revealed a display of student paintings and drawings in a variety of media and sizes. Each was highly accomplished and had an individuality of style and subject that proclaimed the high standard of excellence and originality students were expected to achieve. Above the windows on two sides of the irregularly shaped classroom, reproductions of works of art were displayed in clusters. Above the clusters were the names of the major styles of nineteenth- and twentieth-century American art—American impressionism, the Ashcan school, social realism, American abstract, surrealism, abstract expressionism, pop, postmodern. Along with the reproductions were juxtaposed groups of student works that demonstrated that students had understood an important segment of the history of this country's art through their own re-creation of ideas and concepts associated with the various styles.

The evaluators learned that Shafer taught two distinct types of courses—one for students who take a series of four art classes because they have a special interest in and often a talent for creating art, and "Introduction to Art" for students who wish primarily to learn about and appreciate art. One of her units of instruction for the introductory course is called "EAST & WEST: Remembering the Old, Learning the New." Working with other art teachers and the director and education staff of the Mansfield Art Center, Shafer developed a two-part unit of instruction based on *Sakura in Buckeye Country*, an exhibition at the Center of work by Japanese American artists. The unit began with a questionnaire to determine students' knowledge of Japanese culture, values, history, and art. The students were asked a similar set of questions about U.S. culture. Students then visited the exhibition and wrote critical analyses of works on display. They saw a series of films, participated in hands-on experiences, and also heard speakers, including a visiting Korean American ceramic artist, a recent graduate of Japanese American descent, and a Japanese exchange student. They were given readings, held discussions, and even experienced a Japanese meal, "to give students a myriad of sources of information about Japanese history and life," as Shafer said. Students were divided into research groups to investigate different dimensions of Japanese art—ceramics, printmaking, painting and calligraphy, paper making, sculpture, and architecture. Each group explored the history of one of the art forms and prepared a class presentation, with handouts for the rest of the class, and each individual student created a work of art related to the art form that he or she had studied.

In the second part of the unit, two threads were interwoven. Shafer explained: "We launched into a study of American art. I gave students a survey of American art and each chose an individual artist to study. They researched the life and concerns and the creative process of their artist, prepared handouts on their artist, presented them to the class, and created their own work in the

spirit of the artist, explaining how it connected to that of the artist." The titles of the individual lessons for the second part of the unit reveal how intensely Shafer led her students to inquire into the relationships between East and West. In the lesson "Windows of Nature," students compared and contrasted Japanese landscape paintings with nineteenth-century paintings of the American wilderness, particularly the Hudson River school. From the works of art, students were asked to identify features that indicated Japanese and American attitudes toward nature and life, to examine the symbolism in both groups of works, and to make inferences from that symbolism. In another lesson, "High Drama at Sea," students analyzed the differences in how an American artist—Winslow Homer—and a Japanese artist—Hokusai—depicted the sea.

During this unit of instruction, as throughout the course, students kept daily diaries and minutes of group activities and assembled an individual portfolio of his or her preliminary sketches and plans, as well as finished projects. In Shafer's words: "The posttest was absolutely amazing, as students revealed in writing discoveries they had made about both cultures. Many knew so little about Japanese history and culture before this unit. Many looked at their own culture and values with new eyes, having discovered that there is something special about a culture that treasures tradition. Through the written word they revealed personal insights openly which had not always surfaced in classroom discussions."

Outside the door to Janet Reger's art room at Dublin High School, posted for students and visitors to see, was a list of the awards and scholarships her students had received in the spring of 1993. More than twenty awards were listed—a $30,000 scholarship to the Cleveland Institute of Art, one for $24,000 to the Columbus College of Art and Design, another for $18,000, and a variety of awards and prizes from the "Governor's Show." When the evaluators commented on the awards, Reger characterized a "spontaneous learning situation." "Students," she said, "set deadlines for themselves. They work after school." She noted that "students learn to win or lose. It is a team spirit when they enter shows." Reger's success has not gone unnoticed. She told us that "the community—parents—are coming in and asking for art [for their children]."

At the entrance to Reger's classroom there was more to see than the list of her students' awards. In the space around the doorway, there was an installation documenting one of her students' latest projects, a multimedia conceptual piece that incorporated two adjoining tanks of water—one filled with pure water and fish, the other with water polluted by discarded tires, dirty oil, and medical waste. This water, Reger told us, had been obtained from a nearby creek. A large rendering of a tree served as a backdrop for the water-tank sculpture. The space around the tree was filled with students' critical writings.

Reger explained that the project grew out of a larger unit titled "Social Problems in Dublin." The particular subunit was titled "Water." She drew a diagram with the titles of the unit and subunit in the center. Surrounding the core, she sketched a series of circles, which she explained represented aesthetics and philosophy; art criticism; paper making and recycling paper; several types of background research, including research into artists through books, videos, and guest speakers; and students' planning of the installation. Reger told us that having the new Wexner Center (a contemporary art museum) nearby at Ohio State University is helpful in showing her colleagues and students what she is up to. Previously, she would return from visiting galleries in Chicago with ideas about contemporary art forms and no one would understand them. This problem has not been completely resolved, however. She indicated that "the kids had difficulty accepting the installation as a work of art."

It was apparent that Reger is attuned to the contemporary art world and the implications it has for her teaching. In relating the work of artists to the work of her students, she said, "I can see where the students' artwork is not just emulating the work of artists. When relating their work to

artists they will understand their own work better—and not just artwork, science and other fields too, and how it affected the artists." Like many other outstanding teachers, she works from an encyclopedia of images; she someday hopes to organize all her resource materials through the use of video and computer.

Reger told the evaluators that "many high school teachers do not recognize the role that DBAE might play in their programs." She was convinced, however, that "DBAE helps students recognize the validity of the work they are doing. It's important for me that they demonstrate their knowledge and not just through their art work." She also noted that because of the DBAE programs in the elementary and middle schools, the students she has been seeing in recent years are different from the students she used to have—they are more ready to engage in the study of works of art.

The evaluators were interested in the goals Reger was striving for through her program. She listed several. First she mentioned the preprofessional education of the artist. This goal was followed by "better appreciation of life in general, through art," "cultural background and general awareness," and an understanding that "art leads to problem solving." She indicated that students going on to major in other subjects sometimes needed portfolios of artworks to help them get into colleges and universities. For students not going to college, she mentioned the usefulness of art as a hobby. From the work of her students, it appeared to the evaluators that she had successfully integrated the preprofessional and general education components of high school art. Indeed, these two components seemed to reinforce each other.

Colerain High School is located in the Northwest Local School District in suburban Cincinnati; the school is characterized by one of its art teachers as middle class, and about half of the students who graduate go on to college. Of the district's eighteen art specialists, ten have attended either an Ohio Partnership institute program or a Getty Education Institute-sponsored professional development institute for art specialists at the Cincinnati Art Museum.

Art instructors Pat Bruns and Marge Hilliard are a dynamic duo. Together, they attended an Ohio Partnership summer institute program, accepted the basic principles of DBAE, and began to modify their teaching practices. They also worked with Anne El-Omami in the education program of the Cincinnati Art Museum and served as facilitators in the Cincinnati professional development institute for art specialists.

Both Bruns and Hilliard have taught art for more than twenty years. Hilliard used to teach mainly techniques and skills. She told the evaluators, however, that when she started a master's degree program at the University of Cincinnati, she thought, "There must be more to art education." She explained that she began to realize that the outcomes of art education involved more than merely having students create art: "You can't tell what is going on in students' heads just by looking at their artwork." As a result of her master's study with Laura Chapman, Hilliard "became a lot more philosophical [in her teaching]." Bruns told us that although her background was mainly in studio, she started to approach art education from a philosophical point of view when she began her master's degree studies and began examining her teaching style and the content of her curriculum.

When Bruns moved to the high school from a middle school, the Hilliard-Bruns collaboration began. Together, these two teachers have changed students' perceptions of the school's art program and raised its status within the school. Hilliard told us that "for the last five years we have been attracting the upper academic students. . . . All students appreciate a course that is interested in what they think, not just their technical and recall knowledge. . . . I end up teaching geography, history, poetry, philosophy, psychology. If you are going to connect art to their lives, you have to do all these things."

When asked about the art curriculum, Hilliard said that they begin with a large overall concept—the landscape or social issues, "things like gender or age." Bruns described a unit in which the students make proposals for sculptures for public areas. The proposals are accompanied by statements of "what you want to say" and rationales for the projects. She continued, "When they do related research, they tie their concepts to history." Going back to the issue of gender, Hilliard added, "The work of art takes on a whole new role. We have always taught figure drawing; this year we approached it through issues of gender." When asked about the students' responses to the broadened curriculum, Hilliard said, "The students think they have enough studio time," and went on to explain the concept of layering, where several things are taught at the same time: "When they walk into the class they just expect to deal with intellectual content, which encourages more profound studio experiences."

It was obvious to the evaluators that the art program at Colerain had come from a variety of sources. When asked about this, Bruns and Hilliard told a fascinating story. At the Partnership institute, they, along with colleague Audrey Hartman-Kardasz, were given the assignment of developing one DBAE unit and a five-year art advocacy plan for their district. Bruns asked, "How many teachers have long-term philosophical and advocacy goals for their programs?" The implication of her comment was that they, like most teachers, were not used to long-range planning. "We were sitting there in that little hotel room, brainstorming, thinking about what we were doing. How could we measure if kids increased their appreciation of art? This was the beginning of the collecting project."

The "collecting project," as they described it, evolved from the desire to assess, in a concrete way, student learning in areas of creation and appreciation of art. At the beginning of the school year, in their respective classes, they spent three days discussing works of art and the art world. Then they presented the students with a situation: "You have just come into an inheritance—a collection of works of art from which you may select four pieces." The collection of works from which the students could select were black-and-white copies of postcards made on the school photocopier. These copies stood for actual works of art.

The students were asked to write why they had selected their specific works. Next, they were informed they could acquire money and add to their collections throughout the year in a variety of ways. They were awarded standard amounts of money for the grades they received on their assigned projects. The teachers also carried stage money with them, and if a student made a particularly astute critical remark during class time, he or she might be awarded thousands of dollars on the spot. (Bruns and Hilliard commented that some students practiced sounding erudite so they would be awarded additional amounts of money to use in adding to their collections.) Students could also increase their finances by selling works from their collections to other students.

At different times new works would come on the market and auctions would be held. Students who had begun to question their initial selections could also put works from their collections up for sale. Critical writing exercises, in regard to personal and cultural aesthetics and art historical references, were an ongoing feature of the project, as was the task of writing catalogue descriptions for the works to be purchased. Prior to the auctions, "students sometimes formed cartels and pooled their money to buy the works they wanted" (a typical student might have $80,000 to $90,000 at midterm). "One time we had a group of students who were working as shills to raise the price." At auction, "drawings go for $20,000, $30,000, $40,000. When works are sold, the auctioneer, banker, recorder/accountant each get a cut of 10 percent."

One of the most interesting aspects of this project is that it continued over several school years, with new works being added to the collections. Thus, the students had ample time to increase their knowledge about specific works and to develop a broad understanding of art as a

record of human development and accomplishment. Over the course of the project, students' tastes and preferences changed, and they planned strategies for selling certain works and buying new ones.

When asked what makes certain works valuable to students, Hilliard indicated that students' choices, especially in the beginning, are often based on their preferences for certain types of subject matter. Works relating to the themes of the studio assignments are also highly desirable. Familiarity also changes preferences. Hilliard noted that "after we have studied an artist, the price on that artist's work will rise as more kids bid." Students' tastes, these teachers claim, are not narrow. "There seems to be no prejudice against art from other cultures. They acquire African, Hispanic, Asian works of art. By the third year, some students have thirty-six or more works. They may add to their collections through their actual purchase of postcard reproductions in museums."

The ongoing collecting of works of art is accompanied by other activities. "We study careers and issues relating to the museum—ethics and politics." Students work on exhibitions of their collections: "They are assigned to write labels, and catalogs, and they can borrow works from other collections." We were told how some students spend large amounts of time working on historical references for their works. Bruns added, "The biggest surprise to us has been the students' sense of genuine ownership of works in their collections and their expanded appreciation of art."

The most intriguing thing about this project was that it encompasses areas of the art world that are almost never a part of art education—the sociology and psychology of collecting and the economics of art. These are the very aspects of the art world in which at least some students will participate when they become adults. The evaluators were somewhat concerned, however, that the commodification of art appeared to have equal billing with issues relating to the meaning of the content of the works of art. Did the discussions that ensued during the course of the "collecting project" encourage students to examine the philosophical paradox inherent in the simultaneous perception of art as a commodity and as a form of expression that belongs to all humankind?

STUDENT SELECTION, PURPOSES, AND THE ART-MAKING TRADITION Many high school art teachers see their classrooms as places where students make art. Typically, their students are self-selected because of their extraordinary interest or talent in art, take art courses to fulfill an arts graduation requirement, or are counselor selected because they are assumed to be unqualified for more "academic" courses. High school art specialists often see all three kinds of students as either wanting or needing the kind of education that an artist would require. Frequently the central purposes of high school art classes are to help students understand the problems of art making and to help them make art.

Students, school administrators, parents, and art specialists all have the expectation that high school art classes should exist for the purpose of making art. Consequently, anything that interferes with that process is an unwelcome intrusion. In the early days of the RIG initiative, high school art specialists voiced concern that students would not tolerate interruptions in their art making for the study and interpretation of art objects. They worried that, because time would be taken from studio activities, the quality of their students' artwork would decline. Their doubts were assuaged after high school art teachers known for the advanced quality of their students' artwork began to develop and implement DBAE programs.

HIGH SCHOOL ART AND THE CULTURE OF CONTESTS High school art teachers seldom have the opportunity to visit other schools and generally do not have much first-hand information about what goes on in art classes other than their own and those of colleagues in the same school. They often know, however, how well their colleagues in neighboring high schools and even in high schools across the state are doing. Like the high school athletic coach, the high school art teacher's reputation is established through a win-loss record. Although art teachers do not enter teams of students in competitions, they do send the works of individual students to a variety of contests, exhibitions, and portfolio reviews. High school art teachers are judged in terms of the number of prizes and scholarships their students win in area, state, and even national competitions.

In this competitive climate, the introduction of a DBAE program can pose a threat, real or supposed, to an art teacher's reputation. The historical, critical, and philosophical study of the art of others takes precious time away from students' creation of works to fill portfolios and enter exhibitions. High school art teachers at Ohio's 1988 summer institute expressed this concern along with feelings of being ill-prepared to teach art history, criticism, and aesthetics. They were also worried that their students would reject the scholarly dimensions of art, believing that when students enroll in art classes, they expect to make things, not think.

These teachers were used to giving students technical assistance in the use of media and processes; they provided instruction in the formal aspects of design and composition and typically treated the thematic and ideational aspects of art making in a less systematic manner. This had to do with their preparation as teachers. Many of the high school art specialists the evaluators encountered, especially during the early years of the RIG initiative, had accepted the values and beliefs of their college and art school studio professors. They still believed that artistic creation is a highly personal act directed toward production of original works of art—works that reflect the distinctive feelings, ideas, and experiences of their individual student-artist creators. Perhaps most prob-

One of the most important works in the John and Mable Ringling Museum of Art in Sarasota, Florida, is Lucas Cranach the Elder's *Cardinal Albrecht of Brandenburg as St. Jerome* (1526). Susan Hazelroth, director of school and family programs at the Ringling, and Barbara Kenney, a high school teacher at Southeast High School in Bradenton, Florida, collaborated on a unit of instruction in which students examined their personal values as they created a work of art modeled after Cranach's Northern Renaissance painting. In a description of their joint undertaking, Kenney and Hazelroth wrote about the background of the painting:

> By choosing to have himself represented as St. Jerome, a translator of the Bible, Cardinal Albrecht self-consciously conveyed his personal values through the medium of this Renaissance portrait. Students at Southeast decided to reexamine Albrecht's choice: If the cardinal were alive today, as what public figure would he choose to represent himself? The study began with a review of the values embodied in both the cardinal and the saint. Students went on to examine other historical figures from that period, identify achievements and clarify personal and sociological values of that era. Inevitably, the list of social values compiled by study groups also began to embrace modern ethic[al] paradox[es]. This avenue of study ultimately led to a discussion of personal views and values held by the students themselves.

The goal of the unit was stated as follows: "To enhance and enrich understanding and appreciation of the Museum's painting *Cardinal Albrecht of Brandenburg as St. Jerome* through an interdisciplinary unit." The aims of the unit included the following:

- to move beyond values clarification and decision making or the teaching of particular values to learning about ethical inquiry (ethical inquiry is an investigation of an open-ended, sustained consideration of the values, standards, and practices by which one lives);
- to aid students in the understanding of their wants, needs, and desires;
- to show the relevance of such thinking to the problems that confront us; and
- to help students learn to think in ways that search out fresh alternatives and that open new options.

176

Together, the goal and the aims pointed explicitly to the values, knowledge, and understanding that students were to acquire through the study of Cranach's painting.

The instructional unit was conducted from January 9 to March 27, 1992. The following is an outline of some of the activities associated with it.

On the first day of the unit, Hazelroth visited the high school classroom and initiated a self-guided activity during which students began to explore *Cardinal Albrecht of Brandenburg as St. Jerome*. The session concluded with a discussion of values and the role society plays in the formation of individual values. On January 22 Kenney gave each student a fake $150 bill and asked the students to list ten things they would do with the money. In the students' answers at least some of their values would be revealed. Part of the analysis of their answers included listing the values they admire in others and that they themselves possess. The following day, the students began to create mixed-media "self-portraits" of their values. On February 5, the students paired off and read a short biography of a famous person who exemplified a particular value. In the discussion that followed, students commented that some famous people possess more than one admirable value-related trait.

Next, the class was divided into three groups. One group interpreted the symbols found in the painting—the possible meanings of the pair of partridges, beaver, lion, deer, writing tools,

grapes, apple, pear, hare, and peacock. Another group analyzed the work's setting and perspective, and the third group was given the assignment of selecting a contemporary individual who embodies the qualities and values that Cardinal Albrecht might embrace if he were alive today—the individual he would wish to be depicted as in his portrait. The group chose Arnold Schwarzenegger, and members of the other groups concurred with the selection. Other choices had included General Schwarzkopf (Desert Storm was unfolding as the students worked on the project), Christ, Santa Claus, the Easter Bunny, Donny and the New Kids on the Block, Mother Teresa, and an assortment of boyfriends and girlfriends.

The students had their reasons for choosing Schwarzenegger, most notably his work with handicapped children and his promotion of physical fitness. "He was Mr. Olympia three times, he made that happen [through his own effort]"; "his drive"; the fact that "little kids look up to him." When asked if there were negative factors that made Schwarzenegger a problematic choice, the students were just as quick with their answers: "Yeah, the violence and gore"; "What he thought of girls when he was a teenager," to which another student added, "Girls were just there for sex"; and "Arnold Schwarzenegger didn't go to see his father when he was dying." They knew their hero's flaws.

Cardinal Albrecht of Brandenburg as St. Jerome, Lucas Cranach the Elder, 1526, John and Mable Ringling Museum of Art, and *Cardinal Albrecht of Brandenburg as Arnold Schwarzenegger* by Southeast High School Students, Bradenton, Florida, 1993.

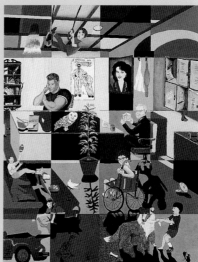

177

From February 11 through 14, the students scoured the school, county, and community college libraries for information about Schwarzenegger. Students paired off to determine the values possessed by the actor, came together to compile a final list, and then began to decide the ways that each of the values could be symbolized—just as in the painting. The plan, as it unfolded, was for the students to make their own painting in which Schwarzenegger was to be depicted in a setting much like the cardinal and surrounded by symbols that represented his life and values. The students began to make individual drawings of the various components for their work. Between March 9 and 26, the students completed their individual drawings and began to negotiate among themselves about the composition of the overall painting. According to the students, "Everyone had an idea of what part of Arnold's life they wanted to do." "We all made individual sketches and then had to decide where they would fit." "The composition took forever; we had difficulty with that car." "The ceiling, I remember that we argued about it forever—the lighting." "We knew we wanted the wheelchair and we couldn't figure it out; should it be electric?" In the end, each student contributed his or her design to a full-scale plan for the painting, and it was decided that each would paint one of the twenty, eight-by-eight-inch, individual gesso panels

that would constitute the complete work.

Although the students agreed to follow the basic composition and symbols agreed upon by the group, throughout the painting period there were continual discussions and frequent checks to make sure that the styles, colors, techniques, and symbols of the individual panels related satisfactorily to their immediate neighbors and contributed to the unity of the whole. It was during the painting process that the students began to cement their relationships within the group. They reflected on the responsibility they began to feel for the project and to the other members of the team. "People had their ideas on paper and I didn't even have mine." "Every morning we were down on the floor critiquing." "That's what made it fun—working with everyone else." Not everyone, however, had such a cooperative attitude. "Kathy was the one who said, 'Give me the whole thing; I'll do it.'" Another student reflected, "That was the learning process—learning that everyone had to do his or her part." Perhaps the most significant comment was, "Word got out to students who were not in the class that we were doing this. We had to explain the symbolism."

The two cardinals on display in the Ringling Museum gallery.

Comparisons between Cranach's painting and the students' work are fascinating. According to the students, they chose Schwarzenegger because of the strong values he possesses. A lion identifies Albrecht with the revered saint; Schwarzenegger is surrounded by the images he attributes to the American dream. Both paintings are set in offices; Cranach's rendition of the office interior shows typical sixteenth-century Northern Renaissance architecture, whereas the students' is a combination office and locker room with sophisticated twentieth-century office furniture. The animals with whom the cardinal/saint shares his office in Cranach's painting would probably not coexist peacefully, but perhaps neither would the symbols collected in Schwarzenegger's office. In the painting of the cardinal as St. Jerome, the beaver represents industriousness and constancy; the pheasant and peacock symbolize immortality and redemption. In the students' painting of Schwarzenegger, the owl represents knowledge and the importance of education, the collie and the cat represent friendship and loyalty, and the white doves represent peace and love. For the cardinal as saint, apples and pears represent original sin and Christ incarnate; the grapes stand for the Eucharist. For the cardinal as Schwarzenegger, a box of Wheaties and scattered barbells symbolize dedication to health and physical fitness. In the students' painting, movie posters and sports cars represent the drive and determination of a self-made man. A portrait of Schwarzenegger's wife, Maria Shriver, stands in for that of the Virgin. A back three-quarter view of a disabled child in a wheelchair (shown larger in the painting than Schwarzenegger

himself) represents Schwarzenegger's interest in the disabled and the part he plays as a role model for America's young people.

By March 20 the individual paintings were nearing completion, and in place of a third-quarter examination, the students were given a reproduction of *Cardinal Albrecht of Brandenburg as St. Jerome* and asked to write to Arnold Schwarzenegger to explain the project they had undertaken. On March 27 the finished painting was critiqued, and on April 11 it was displayed in the lobby of the Ringling Museum. For several weeks in November 1993, *Cardinal Albrecht of Brandenburg as Arnold Schwarzenegger* was even displayed alongside Cranach's painting—the only instance the evaluators know of in which students' work was accorded a status, albeit temporary, similar to that of an old master.

On a Saturday in March almost a full year after the Cardinal Albrecht/Arnold Schwarzenegger unit of instruction was completed, the evaluators met with eight of the students who had participated in the project. Some of the students were still at Southeast High School; others had graduated the previous spring. The evaluation team wanted to find out what, in retrospect, the students thought they had learned from the project. When they were asked, "What about the background—the history of Cranach?" the students said they had learned to look at what a work of art means. One student explained, "You see a picture, it is more of an idea, not just a pretty picture"; and another added, "meaning of all the animals." When asked, "Would you choose Arnold again?" a number of the students answered with an emphatic no. However, they were not sure who their choice would be. One explained, "I would have to do research."

In almost everything they said, the students conveyed their warm feelings for the unit, yet they were not easily able to explain how the unit contributed to their education. Just as certain aspects of the students' learning appeared to remain below the level of their consciousness, there are other aspects of the project about which questions could be raised. For instance, what if Kenney and Hazelroth had asked the students to select a female role model for the cardinal? With this kind of task, would the students have gained an increased understanding of Cranach's painting and the social structure it reinforced? Would the meaning of the students' own artworks have been enhanced with the introduction of specific gender issues?

lematic was the fact that many of the high school art specialists did not have a good grasp of the numerous connections and rich relationships among art making, art history, art criticism, and aesthetics.

The high school art specialists who have attended DBAE institutes usually outgrow the belief that the study of art and artists will unduly influence or detract from students' personal visions. There has been a growing awareness that knowledge of art history and issues that animate the contemporary world of art are essential ingredients in the education of their secondary school art students, whether or not the students become artists.

DBAE in Middle and Junior High Schools

Middle and junior high school art specialists have not struggled with the merits of DBAE nearly as much as their high school colleagues. Since they have not had to deal with the issue of the preprofessional art student, they have been able to devote their energies to the education of the general student. Consequently, as a group, middle and junior high school art specialists seem more ready to accept the idea of a broad-based art education.

In middle schools there is considerable excitement about ways to organize DBAE curricula. The evaluators have talked to middle school principals and curriculum specialists about how instructional programs now emerging within DBAE—artwork-based thematic units that focus on personal, social, and cultural issues—would make an important contribution to their schools. The evaluators have also encountered a few instances where schools are organized into "houses," with teams of teachers collaboratively formulating thematic instructional units. Here some middle school art specialists are beginning to work with their colleagues in other subject-matter areas. To date, however, these programs have not developed sufficiently to merit a full analysis. It is still through the efforts of individual middle and junior high school art specialists that the boundaries of DBAE are being stretched.

A Comprehensive Approach to DBAE

In middle and junior high schools, how is DBAE different from traditional art education programs? Obviously, it is not easy to characterize what happens inside art classrooms across the country. Many traditional programs have been directed toward art-making projects—activities in drawing, painting, pottery, sculpture, and printmaking. The elements and principles of design still provide the primary way of thinking about art. If works of art are studied, they are often studied separately rather than being integrated into art-making activities. Consequently, if a middle school teacher decides to implement a DBAE instructional program, he or she is faced with developing new units of instruction to cover nine-week, semester, and year-long courses.

Perhaps the even greater challenge middle school art specialists face is changing the way they think about works of art and about how they can provide the content for instruction. The first task is to come to an understanding of what works of art mean (or meant) to their creators and what relevance those works of art have to students' lives. The

next challenge is to construct units of instruction that address, in a disciplined manner, the themes, ideas, concepts, and issues found in those works of art.

Creating an Arts/Humanities-Oriented Curriculum: Some Challenges

Many secondary school specialists were educated during the time when art education had as its principal goal either 1) personal development through creative expression, 2) the education of the artist, or 3) using the elements and principles of design as a way of perceiving and understanding the visual environment. These conceptions of art education are still strong. The art school-oriented learn-what-it-takes-to-be-an-artist attitude still pervades many secondary art programs, especially in the high school. Students with talent are viewed as the ideal occupants of high school art classrooms. For many high school art specialists, the general student still appears genuinely problematic, and he or she is frequently given the same technical art education as the student who aspires to become an artist. Nevertheless, there is a tremendous difference between the purposes and goals of the traditional secondary school studio art program and the emerging DBAE secondary art program. There is also an enormous difference between the goals for art education directed toward all students in a high school and goals directed toward the interested and talented few.

At least some secondary art specialists who have attended DBAE institutes still do not understand how to implement a DBAE program that is not media and project oriented. DBAE places works of art at the center of the curriculum and employs the art discipline lenses as the means to create and understand them. To develop DBAE instructional programs, art specialists frequently have to approach their field in ways quite entirely different from the ways they were educated. They have to "get inside" works of art, interpret their meanings, read the writings of art critics, historians and aestheticians, and explore the consequences of these interpretations to the new instructional programs that they must build.

At the same time, it seems unreasonable for secondary art specialists to be expected

High school art specialists learn that the study of art and artists does not unduly detract from students' personal visions.

In the spring of 1991 at Ordean Junior/Middle School in Duluth, Minnesota, the evaluators found that art specialist Erv Kuutti had developed a truly broad-based DBAE curriculum for his eighth-grade students. At the beginning of a class he told his students, "Today you will be working on your storyboarding. Take a two-minute scene from your movie and consider the dialogue, the shots, the angles, the distance. As a director/cinematographer you can control everything—the distance, the angle." To explain what he meant, he showed, surprisingly, panels from the Unicorn Tapestry. He reminded students that the works were "not cinema" as he asked them to analyze the angles: "Is it high?" "How about the distance?" "Is it a long shot or a mixed shot?" He asked students to explain why a scene was shown "through a long shot." He also drew students' attention to a reproduction of a Remington painting so that they could analyze the action.

Next, the students viewed a video clip from Stephen Spielberg's *Raiders of the Lost Ark*. Kuutti explained how the set had been built in London, how the snakes were used, and so on. He also noted, "Spielberg can't draw his way out of a paper bag, but he understands composition." After seeing this kind of interplay between the traditional arts and the fine arts, the evaluators were intrigued to find out more about Kuutti's program.

Kuutti told us that his program is focused on particular time periods rather than on individual artists. During the year, he presents units of instruction based on the following:

The surrealists and "dreamscapes," supplemented by the study of Dali and Bosch. (This has since evolved into the unit "Cyberscapes," which combines futuristic and surrealistic elements with one- or two-point perspective to create a panoramic scene from a virtual environment.)

The medieval period, with dungeons and dragons, the cathedral, rose windows, radial symmetry, the relationship between ornamentation and functional decoration, stained glass—"the glowing image," as he called it—sculpture, and medieval costumes. One of the principal resources for this unit is David Macauley's video *Cathedral*, which includes a story about a monk who kept a diary. The studio assignments associated with this unit are to create a simple or compound gargoyle and then to design a modern adaptation of a Gothic cathedral that includes a rose window, grotesques, flying buttresses, pointed arches, and spires.

Art and world affairs. The fall of the Berlin Wall and the turmoil in the Persian Gulf region provided the opportunity to link art and politics. The students design currency for emerging countries.

Science and art. Science and art are combined through a study of Leonardo da Vinci as artist and scientist, with particular emphasis on the models made from Leonardo's sketchbooks. The students are asked to design a Renaissance amusement park ride using the technology available to Leonardo. They are required to do mechanical drawings that include the overall structure of the ride, its source of power, and its gearing, and they have to write a description of the project that discusses the restraints under which they have to work. In addition to the technical aspects of the assignment, the students do a "decorative design" for their ride in which they depict its location in the park, passengers, and structural elements. The evaluation criteria for the unit include the extent to which the students take into account various elements of the time: the beliefs and mythology, modes of transportation, artworks, scientific knowledge, building materials (stone, wood, fabric, iron, leather, water, and so on), and power sources (human, wind, animals, water, gravity, and so on). Kuutti wants his students to understand what the world was like before electricity, plastics, motors, and other aspects of modern technology.

A painting project. Each student paints a small object, in acrylics, from three points of view using a modern abstract or cubist style, pointillism, or another style.

Kuutti said of his students, "I want them to have a 'friendly' experience with each time period." During the evaluators' visit, he was working toward a unit of instruction associated with each major time period in Western civilization. Kuutti has since moved to Duluth Central High School, where he now teaches art to students from the seven to the twelfth grades. Consequently, he has expanded his program so that eighth-grade art covers the prehistoric through the Roman period, with three intertwined units relating to non-Western cultures. The ninth-grade course continues with the Byzantine through the modern period, again with three non-Western cultures. With the two-year curriculum he is able, for example, to include the Spanish architect Gaudi's evolution and adaptive process from pointed to parabolic arches, Frederick H. Evan's photographic design studies of Gothic interiors, and Duluth architecture that incorporates Gothic elements.

The projects Kuutti has developed for his students have their basis in artworks from various time periods, but the tasks and problems he assigns his pupils move them continually from the past to the present through a process that involves extrapolation, transformation, extension, and invention. His curriculum is everything expected of the traditional middle and junior high school art curriculum—his students are actively involved in making things—but in addition to constructing works of art, they are also engaged in deconstructing and reconstructing Western civilization.

Two works by Central High School students in Duluth, Minnesota, taught by Erv Kuutti. The assemblages were inspired by Picasso's Cubist constructions.

Jeff Stern, an art teacher at Westridge Middle High School in Grand Island, Nebraska, has a strong commitment to DBAE. He is also interested in helping elementary school classroom teachers integrate art into their instructional programs. Through a proposal written by Betty Nelson, district DBAE coordinator and elementary school principal, the Nebraska Arts Council provided a grant to the Grand Island School District. The grant permitted Stern to undertake a curriculum development project directed to his colleagues in the district's sixth-grade classrooms. Before the project was completed, it involved nearly the entire community.

Stern's first step was to review the social studies text currently used in all Grand Island sixth-grade classrooms. He wanted to base the instructional materials on a text that would continue to be used in the school. He decided to relate a unit of study to the Mexican Revolution of 1910 and Mexican muralists.

The thirty-eight-page package of curriculum materials Stern developed for the sixth grade is both comprehensive and coherent. The list of instructional objectives for the unit indicates the importance of the ideas presented to students:

- students will compare and contrast the mural to other forms of art
 (art history, art criticism, aesthetics).
- students will study the theme of political art (art history, art criticism,
 aesthetics).
- students will study the political, social, and economic context in which
 the murals were created (art history).
- students will study biographical information about Diego Rivera, José
 Clemente Orozco, and David Alfaro Siqueiros and view examples of
 each artist's work (art history).
- students will complete a visual analysis of *Flower Day* by Diego Rivera
 (art criticism).
- students will produce a mural depicting some aspect of Mexico's historical
 and/or cultural heritage (art production).

To provide a context for the Mexican murals, Stern included in the instructional package an introduction containing an overview of the history of murals. The package also includes a section for each of the major instructional objectives in addition to vocabulary and definitions, handouts and readings for students, a set of slides for each classroom, a guide to the analysis of works of art, questions for students to answer, and an overview of themes in art. The sample tests that Stern prepared reveal his deep understanding of the purposes of DBAE and the high expectations he has for students.

Once the curriculum package was complete, Stern held an inservice meeting with twenty-seven sixth-grade teachers. When asked about the level of cooperation he received, he answered, "I was not aware of holdouts. Three called me to get more information. I got cards and notes of appreciation from the teachers."

The unit culminated with a multiarts festival of Mexican culture held at the high school. (The festival was coordinated by Betty Nelson.) A sizable number of individuals from the Hispanic community were among the seven hundred attendees who listened to Mexican songs and music, watched students perform Mexican dances, and viewed an enormous collection of murals done by groups of students, paintings created by individual students, and displays of art and crafts created by members of the Hispanic community.

When the evaluators arrived in Grand Island, weeks after the festival had taken place, members of both the Hispanic and the Anglo communities were still praising the festival and the con-

tribution it had made in healing wounds of misunderstanding that had divided the two communities for many years. Coverage of the festival in the *Grand Island Independent* stated:

> [Yolanda] Nuncio said she feels the project has helped create a real awareness of the community's Hispanic culture and its talents. She said it's helped its members feel special and is a positive move toward something much bigger. "We're giving the Hispanic children a chance to kind of be stars and non-Hispanic children a chance to find out about another culture," she said. "This is important because we are becoming a global society. I think this sharing is a great beginning."

The evaluators wondered if the festival would even have taken place without the influence of DBAE in the Grand Island School District. Likewise, Stern's initiative and the substance he brought to the unit of instruction probably would not have happened without the foundation of theory and practice he had received through the Prairie Visions institute.

to discard their entire curriculum after a summer institute and to proceed with a whole new approach to the teaching of art. The scholarship, the new knowledge that many would need to acquire about works of art and the discipline lenses through which they might be created and studied requires an enormous amount of time and energy, not to mention motivation and interest.

While elementary school classroom teachers, if they are to implement DBAE programs, need only to think in terms of a few hours a week of curricular and instructional revision, secondary school art specialists face the prospect of reorganizing their instruction in several different courses. They must reformulate the curriculum and the instruction they deliver for five or six periods a day, week in and week out, term in and term out for an entire year.

The teachers' programs characterized in this chapter meet the goals of general education while at the same time accommodating the interests and needs of the pre-professional art student. Nevertheless, we are just beginning to glimpse what the models for comprehensive DBAE curricula, especially at the high school level, might look like.

Conclusion

This chapter has indicated the enormity of the problems to be faced if DBAE is to be developed fully at the secondary school level. Difficulties include the curricular structure, artist-to-be expectations, outmoded teacher preparation programs, and the culture of contests. There are, however, several ways that secondary school art specialists have moved toward full implementation of DBAE. These include:

Some secondary art specialists have developed new units of instruction and shared them with others. Through summer institutes and academic year symposia, the Prairie Visions consortium in Nebraska, for example, has developed a number of comprehensive DBAE units of instruction at the secondary school level.

Secondary school art teachers have taken their art media and process art projects and integrated within them the study of works of art. In drawing pro-

Secondary school students' artworks can be a means for understanding personal, social, cultural, and normative issues.

jects, for example, students can receive an introduction to artists from the history of art who excelled at drawing. At the same time, they can study the meanings of those drawings in their cultural and aesthetic contexts. There is still the additional problem of helping secondary school art specialists understand that in DBAE courses that advance the goals of general education, students' artworks are employed as means for understanding personal, social, cultural, and normative issues.

Development of high school DBAE curricula and instructional programs appears more easily accomplished when the courses are general rather than related specifically to art forms and media. Although DBAE can be directed both to general education and to preprofessional goals, the general educational approach to art education appears to provide a more useful model for high school art than the preprofessional approach. It might be that a good DBAE program will actually prove more beneficial to the artist-to-be than the typical media/process/design-oriented high school art course.

The evaluators have seen some truly marvelous units of instruction created and taught by secondary school art specialists. At present, however, these units do not yet constitute a comprehensive curricula. If DBAE is to consist of a "written curriculum with sequential, cumulative, articulated, districtwide implementation" (Clark, Day, and Greer 1987, p. 134), then there is still much work that remains to be accomplished at the secondary school level.

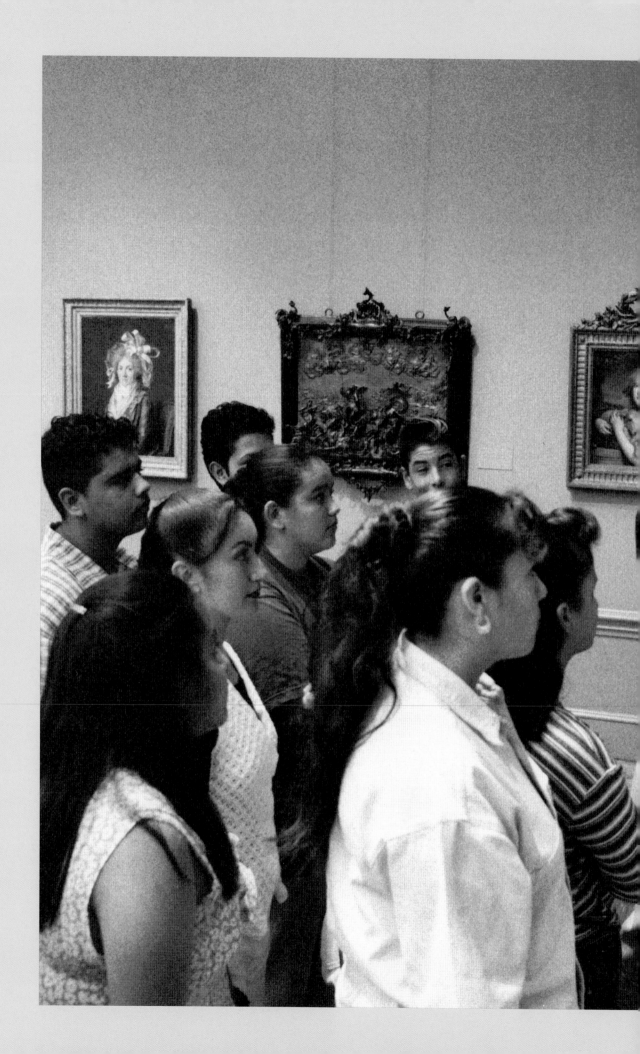

DBAE in Art Museums:
Collaboration with Schools

by **Juliet Moore, Melinda Mayer, and Brent Wilson**

CHAPTER

7

Thus far, analysis of the regional institute grant (RIG) programs has focused primarily on the role of museums in relation to the summer professional development institutes and the implementation of DBAE in the classroom. This chapter analyzes the influence of museums on school programs and their effect on museum education programs through an examination of collaborative and cooperative working models.

Museums: An Essential Component of DBAE

As one of the prerequisites of the initial funding of the RIG programs, the Getty Education Institute for the Arts stipulated that the consortium members should include not only school districts but also universities and museums. This criterion represented a shift away from many professional development programs in the arts that have addressed pedagogical changes in the classroom but neglected to place those developments in the larger context of the worlds of art and education. Art teachers' resultant intellectual and physical isolation from other professionals has meant that they have often been unable to sustain the impetus required for the full implementation of educational innovations.

The requirement that museums and art centers be a part of the RIG programs established the context in which collaborative initiatives could be undertaken. The partnership carried the promise that neither museum educators nor art teachers would be isolated. Through cooperative projects that draw on the rich resources of the art museum, there was a greater chance that school DBAE programs would be both authentic and strong. There was also the possibility that newly emerging broad-based forms of art education would have a positive influence on museum education programs. Were these promises fulfilled?

Collaborative and Cooperative Working Models

In ever-increasing numbers, children experience art museums for the first time through school field trips. Too often, however, the museum visit is an activity that is without connections to the rest of the student's life and schooling and is, therefore, all too easily forgotten. While many museum educators strive to make school tours more meaningful by preparing background materials for teachers, providing teacher workshops, creating resource centers, advertising special thematic tours, and requiring docents to contact teachers in advance of visits, the one-shot tour is still the cornerstone of museum education. Teachers and museum educators continue to work together to get students to the museum, but they find few occasions in which they can truly collaborate on the content of the museum experience. Some art museums have tried to establish repeat-visit programs or advisory councils of teachers with whom their education staff may consult, but these are only the first cooperative steps.

The terms *cooperation* and *collaboration* help to explain what the evaluators have seen in their observations of school-museum relationships in the RIG programs. Over the past ten years, these words, as well as *consortium* and *coalition*, have recurred in the literature of organizational and interorganizational working models. Although these terms are sometimes used interchangeably, it is useful to make careful distinctions among them—especially between what it means to work cooperatively and collaboratively. Educators, researchers, and managers appear to agree that the collaborative model is the ideal, but the cooperative is both easier to achieve and more common (Hord 1986).

Cooperation exists when two or more individuals or organizations agree to work together on a project with the anticipation of mutual benefit. Although the organizations agree to help each other, there is little expectation that either organization will change in any substantial way. The organizations may agree to share resources, time, or capital, but the primary shared commodity is expertise.

Collaborative enterprises require much more of participants than do cooperative relationships. Hord notes that they demand:

- shared needs and interests;
- commitment of time to the process;
- energetic individuals imbued with the collaborative spirit;
- ongoing communication;
- pooled resources, including staffing and funding;
- relinquishment of personal control, resulting in increased risk;
- continual checking of the perceptions of those involved in the collaboration;
- positive leaders; and
- the personal traits of patience, persistence, and willingness to share.

Just how closely have museums and schools managed to collaborate as they have worked together within the RIG programs? What factors seem to have encouraged or discouraged collaboration?

In the RIG programs the potential for collaboration has been achieved. Gail Davitt of the Dallas Museum of Art (an institution that has moved beyond the isolated tour in

Museums play an essential role in regional institute programs, establishing a context in which collaborations can take place.

Each year, the Sheldon Memorial Art Gallery in Lincoln, Nebraska, organizes an art exhibition that travels to communities around the state. The plans for establishing the traveling exhibition program occurred at about the same time as the organization of the Prairie Visions DBAE consortium. This serendipitous development has led to rich cross-fertilization and more powerful and effective use of the programs of each institution.

Sheldon Gallery educator Karen Janovy has served as a leader in Prairie Visions and as codirector of one of its institutes held at the Sheldon. She reported that DBAE teachers have "capitalized on having the 'museum' in their town." The teachers know the themes of the exhibitions well in advance, so they can plan their programs accordingly. The Sheldon has had wonderful attendance at the exhibitions—beyond their expectations had Prairie Visions not existed. The overall success of this program, and its enthusiastic reception by Prairie Visions teachers, provided the necessary stimulus for the creation of a community programs coordinator position. Nancy Dawson currently holds this job, which entails coordinating the education programs of "Sheldon Statewide," including the training of local volunteers and docents. She says:

> The awareness and excitement generated by DBAE has had a profound impact on the success of Sheldon Statewide in the past seven years. Taking quality works of art from the museum to communities throughout Nebraska would have been frustratingly difficult without the enthusiasm of Prairie Visions-trained teachers. Their enlightened appreciation of the possibilities provided for students to see and respond to a variety of works of art has been very gratifying.

For small towns such as Columbus, Nebraska, the exhibitions provide opportunities for Prairie Visions teachers to give their students in-depth experiences with original works of art. While the 1992 show, titled *Fish, Fowl, and Fauna*, was at the Columbus Gallery, the evaluators watched third-grade students, led by their teacher, Barb Friesth, engage in a "treasure hunt." In pairs, they had been assigned to explore the exhibition to find such things as "animals that were anatomically correct," "animals that had a practical use," works that had "heavy brush strokes," and "animals that took the form of unusual letter shapes."

Following the students' reports about their findings, Ms. Ernst, the docent assigned to lead the children through the exhibit, began her portion of the program. Her comments were directed almost entirely to the meanings of the works, their character, and the reasons they were created. She explained how Audubon's drawing of a rabbit would have been sent back East in a saddlebag and transformed into a lithograph so people would know what the rabbit looked like; she characterized the warmth of a painting of dogs in a Victorian living room; she engaged the children in a discussion of the differences between two paintings of horses—one from the 1930s showing heavy workhorses drinking at a trough, the other a 1940s romantic depiction of abstracted horses and riders; and she got the children to discuss why an artist might make a nearly abstract, heavily impastoed painting of a calf. (The children concluded that it was "just an impression," and that "he is a lonely calf.")

The evaluators learned that before *Fish, Fowl, and Fauna* closed in Columbus, 1,500 schoolchildren from that small town received tours. The team also learned that Prairie Visions has influenced the education program of the Columbus Gallery. Ernst and two other docents have attended Prairie Visions summer institutes. Through the programs offered by these three individuals, all fifty-five docents have become acquainted with DBAE.

The exhibition demonstrated the high degree of cooperation that exists among the Sheldon, the Columbus arts organizations, the schools, and Prairie Visions. It also illustrates how museum educators' participation in DBAE consortia has allowed some museums to serve distant audiences. In Nebraska and Florida, especially, the influence of museum programs such as those at the Joslyn, the Sheldon, and the Ringling are felt throughout entire states.

some of its programs) reported that "one of the benefits of the collaboration was having increased access to teachers with whom we could work and who were more willing to participate in our workshops. The links established through the consortium allowed us to do our job better."

Davitt's insight is indeed correct. The RIG programs have provided museum educators with a growing core group of elementary and secondary teachers, along with art specialists, all focused on a common goal—developing the best possible art curricula they can imagine. The teachers hope to extend DBAE throughout the school and district and want, even need, the involvement of museum educators. Seldom have museum educators been presented with such a large group of focused and committed teachers seeking to advance mutually held goals.

OBSTACLES TO COOPERATION AND COLLABORATION Just as the least effective way for students to experience a museum is for them to be taken on an annual field trip that does not connect to the classroom, the least committed level of cooperation between museums and the RIG programs is when a summer institute field trip to a museum is organized and the participants receive only a tour from docents. Although this activity brings the participants into the museum to view original works of art, it tends to reinforce the stereotype of the museum as a place to look and listen passively rather than as a source of continuing knowledge and pleasure. By contrast, Karen Janovy of the Sheldon Memorial Art Gallery in Lincoln, Nebraska, has noted the positive effects for teachers when significant portions of the summer institute occur in the museum setting: "A transformation occurs in the lives of the teachers. Within two days the teachers are comfortable with the collection. They 'own' the collection. They 'own' the works."

Perhaps one of the primary reasons for the absence of widespread collaboration between schools and museums is a lack of understanding about how the educational missions of schools and museums could reinforce one another. One of the objectives of the evaluators' analysis of the relationship between the RIG programs and museums was to assess the extent to which these partnerships could use DBAE to break with tradition and allow the evolution of symbiotic, mutually beneficial educational alliances.

For six years the evaluators observed museum and school relationships directly. In

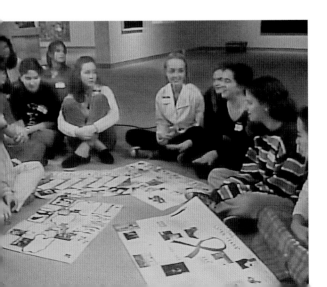

High school students immersed in the world of art: Florida students display timelines of artist Eric Fischl's life in a gallery in the Ringling Museum in Sarasota.

order to confirm the observations, a telephone survey was conducted in February and March 1994 with nineteen educators from museums and art centers in each of the RIG programs. The survey was designed to elicit information about museum educators' perceptions of their role in the organization of the programs, relationship with school districts, and goals for future developments. Here are some of the things that were found.

MUSEUM EDUCATORS' LEADERSHIP ROLES IN DBAE CONSORTIA A vital element in the development of strong collaborations between museum educators and teachers is that the educators, regardless of the institutions they work in, recognize that each aspect of education, whether it is a school painting lesson or a museum afternoon spent in front of a painting, contributes to the entire context of a student's experience. In RIG programs where art museum educators have been put in institute leadership positions—in Nebraska's Prairie Visions, for example—they have a vested interest in and responsibility for the success of the entire DBAE initiative, not just the good of their institutions. This enhances their vision of education as a whole as well as the collaborative mission of museums and schools.

Effects of Summer Institute Attendance on Museum Education Programs

Generally speaking, when museum educators attend DBAE summer institute programs, they develop a commitment to DBAE. Museum educators who have not attended institute workshops are markedly less enthusiastic about their involvement with the RIG programs than are those who have attended. Even partial attendance is an effective indicator of a high level of interest and participation in activities with other members of the programs. It is, of course, difficult to ascertain the extent to which individuals were interested in DBAE before they attended the institutes or the effect the institutes had on motivating their interest. It is notable, however, that those museum educators who have not had DBAE institute experiences have tended not to serve on institute committee boards or to send staff members or docents to summer DBAE institutes. This means that the process of

In the regional institutes, museum educators have a vested interest in and responsibility for the success of the institutes' art education programs. At Prairie Visions, museum educators such as Anne El-Omami held leadership positions within the institute.

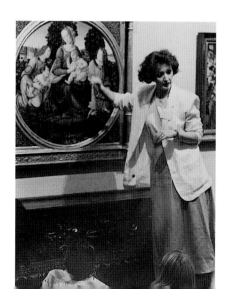

The Mansfield area site in the Ohio Partnership is among the best organized and most active to be found in the six RIG programs. Mansfield Art Center educator Lois Flinn and Mansfield area site director Dennis Cannon have developed their programs collaboratively. The evaluators asked Flinn to tell about the ways in which the Ohio Partnership has affected her educational programs. Among the things she described were the following:

- Special exhibitions at the Art Center have been coordinated with the summer institute program, and the Mansfield area site institute program has been organized around those special exhibitions.
- Because of the DBAE initiative, there is now an active summer art program at the Art Center.
- Before the DBAE program was initiated, student attendance at major art exhibitions numbered about a hundred, and approximately five hundred students visited the Art Center during one year. Now roughly three thousand students attend a major exhibition, and about five thousand make visits to the Center each year.
- Children participate in pre- and postvisit activities in their schools related to the exhibits they see at the Center.
- The Art Center has completed studio facilities that are now used by children and adults.
- A new full-time position of Director of Education, held by Flinn, has been created.
- A visual arts resource center has been opened to serve area teachers.

The relationship between the teachers who have attended the Florida Institute for Art Education and the educators at the Ringling Museum of Art in Sarasota, Florida, represents the epitome of school-museum collaboration. Three recent projects, of many that could be cited, demonstrate how DBAE can be used to translate a traditional museum exhibition, designed for the typical educated adult audience, into a language that can be understood by students in the schools.

In 1991 the Ringling Museum hosted a traveling exhibition of works by the contemporary photographer Lewis Baltz, whose images depict industrial society in decay. Part of the impact of the show, titled *Rule without Exception: A Retrospective Exhibition of the Photographs of Lewis Baltz*, comes from its large number of pictures. It was the responsibility of the museum curator to organize their configuration in the gallery.

According to the traditional mode of interaction between museum departments, no educational activities would take place until after the opening of the exhibition. However, Susan Hazelroth, the Ringling's director of school and family programs, decided to approach the curator of contemporary art with an innovative idea; she suggested that a group of high school students be allowed to install and interpret the Baltz exhibition. This project would involve the collaboration of the curator, the artist, the museum educator, and high school teachers and students, all of whom would be expected to work in ways that would take them outside the normal pattern of their respective roles. Hazelroth said the curator, Ileen Shepherd, agreed to the experiment only after exclaiming, "I must be crazy to do this!"

The establishment of a tradition of risk-taking is characteristic in strong collaborative relationships; participants learn to trust that they will neither gain nor lose resources, including such indefinable investments as professional reputation. All of the participants in this project already knew about successful educational programs that had previously taken place between the Ringling Museum and Florida Institute DBAE teachers, so they were willing to take the risks involved in this project.

In many cases, Hazelroth's role as an educator involves her acting as a liaison between groups of people and the objects in the museum. As this project progressed, the collaboration among the participants was facilitated by her ability to bring together their various perspectives into a coherent unit that was also a wonderful example of how DBAE can be implemented. High school students and a team of four teachers (anthropology, world history, English, and video) from the Pine View High School in Sarasota analyzed the issues addressed by Baltz in his photographs. Six students were then selected to work with Baltz, Shepherd, and the museum's installation crew to hang the exhibition in an intelligent and challenging way. The entire installation process was documented in a video produced by other high school students.

Another group of students produced critical texts about Baltz's work. Writing about a photograph of a barren landscape, one student wrote, "The nihilistic tendencies of life are brought to a fiery crescendo in this wasteland outside a fabled cowboy town. Baltz's vision of the Wild West shows an area screaming from the torture of a society that has passed it by. Perhaps the desert is where society dumps its trash, leaving reminders of a pitiless and unmerciful past." When Baltz was shown the students' work, he said, in effect, "I want it to be a part of the exhibition." The students' writing was transformed into wall labels that corresponded in format to Baltz's photographs. The hanging crew had the additional challenge of integrating the prominent wall-text pieces into the design of the exhibition. Unlike most wall labels, which merely provide title, name of artist, and the year a work was created, these labels were examples of seriously considered, well-written critical interpretations that gained the endorsement of the artist and con-

tributed to the public's understanding of the art.

As a conclusion to this project, Hazelroth organized a meeting of all the participants. Building on an already established tradition of holding "dialogues" between students and artists in the museum, this "dialogue" provided the participants the opportunity to discuss the experience in a public setting. Students were also able to ask Baltz more questions about his work, and the artist had the opportunity to talk with a rare audience—one that was truly informed and insightful.

The success of the project with Baltz provided Hazelroth with the resources, in terms of peo-

 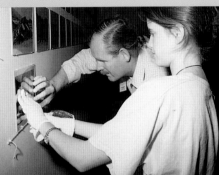

Pine View High School (Sarasota, Florida) students install an exhibition by photographer Lewis Baltz.

ple, enthusiasm, and experience, to develop another program in the autumn of 1991. The exhibition *William Wegman: Paintings, Drawings, Photographs, and Videotapes* was the focus of a pretour package for parents and children that was developed by elementary teachers and Hazelroth. Included in the package were such DBAE activities as the writing of a fable based on a moral of contemporary life, a historical timeline, and other exercises to lead children to an interdisciplinary interpretation of works of art in the exhibition.

Hazelroth again collaborated with a team of eight teachers, representing various subject areas, from the Pine View High School, whose students wrote wall labels interpreting the works of Wegman. These interpretations took the forms of poetry, drawings, and prose and were collated into a booklet that was made into the printed guide for the exhibition. Perfectly echoing the tone of humor and pathos that characterizes Wegman's photographs of his dogs, one student wrote a wall label titled "Guise":

Look! I am a tiger. Being a tame animal, Fay sometimes feels insignificant and therefore disguises herself as a tiger. Fay feels that as a tiger she can conduct herself in ways not allowed if she were a dog. On the one hand Wegman might be trying to create an aura of mystery and intrigue, but on the other hand he may be trying to criticize the world and those who take things at face value.

Another aspect of this multifaceted project was the installation of "mini-exhibitions" in participating schools. Each of the pretour packages for teachers included a calendar of reproductions of Wegman's photographs. One of the collaborating teachers suggested that these images could be used by schools to model the work of the museum in mounting an exhibition. Students laminated, framed, and hung the images, for which they wrote interpretive wall labels and gallery guides; all of these materials were then exhibited in the classroom or school. The culmination of these intensive interpretive activities was a "dialogue" between Wegman and one hundred elementary and high school students. Organized by one of the teachers on the collaboration team, the dialogue was held at the museum, where students were able to view the exhibition of Wegman's art. This project served effectively as a tool to help accustom students to the concept of the museum and as a way of preparing them for the particular exhibit they were later to visit.

In the autumn of 1993 a traveling exhibition titled *Four Friends* was held at the Ringling Museum. It showed the work of four contemporary artists—Eric Fischl, Ralph Gibson, April Gornik, and Bryan Hunt—who are linked not by artistic similarities but by ties of friendship. As with the exhibitions of Baltz's and Wegman's work, this show was originally conceived and curated with the sophisticated adult viewer in mind; as with the previous two exhibits, however, collaboration between the museum education department and the teachers from regional and district schools resulted in interdisciplinary materials and activities that enabled elementary school children to develop meaningful interpretations of the art and to analyze their own values and roles in the world.

A total of twenty-two teachers collaborated with Hazelroth on the development of the teacher package, which, like other packets, was disseminated not only to teachers in the Sarasota area but also to teachers and students throughout the Florida consortium. Infused with the four art disciplines of DBAE, as well

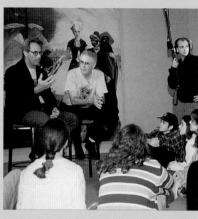

Students interview artist Eric Fischl in a Ringling Museum gallery as part of a teleconference with the artist about his work.

as material relating to other subject areas, the teacher package contained information and activities that encouraged students to consider such important concepts as the values of friendship, experiencing rites of passage, and methods of storytelling. Instead of learning about school subjects as unconnected topics of memorization, teachers and students could use this package, and the art that it describes, to see how English literature, geography, history, and the four disciplines of DBAE can illuminate the great philosophical questions of life.

After students had explored in depth the concepts connected to the exhibition, those who could visited the museum to experience the original works of art and to participate in a "friendship wall" activity, in which students wrote messages of friendship to each other. Two Ringling School for Art and Design students arranged the display of more than two thousand messages, which was shown in a room adjoining the galleries.

The culmination of the museum visit was the opportunity to participate in a "dialogue" that took the form of a teleconference between Fischl and guest curator Bruce Ferguson in Fischl's studio in New York and students in the Ringling exhibition galleries. The questions the students asked of the artist and the curator display the depth and sophistication of the understanding that was the result of their intensive work with the art. Typical of the questions addressed to Ferguson were the following:

- Do you see any relationship between *Manhattoes* and *Kowdoolie* in the Fischl exhibit?
- You obviously consider the work of all of these artists important. What merits do you see in the works of all four artists, and why do you think their exhibits, individually or as a group, are so effective?
- Why do you feel that the exhibit of *Four Friends* featuring Mr. Fischl's work was representative of him as an artist, assuming it was your aim to represent him; and which paintings of the exhibit do you feel are the strongest in conveying him and why?

Students asked the following questions of Fischl:

- Do you find that your paintings could have sound? For example, in your painting *By the River*, the camel in the foreground looks like it's baying, mouth agape. Thus the viewer, if he is imaginative, hears the sound in his mind. Can we find that in other works and is it intentional?
- How would you respond to Holland Cotter's article in *Art in America* [April 1991], describing *Manhattoes* as "artificial, strained," and which said that it "never entirely worked"? What did you intend to say in this work and what inspired it?
- In your paintings, three certain items seem to occur frequently: patio furniture, dogs, and nude figures. Is there a thematic significance to their placement in your work?
- One of the reviewers of your work said that you were influenced by the work of the American painter Robert Henri. The Ringling has a work by this artist, and Maura has chosen it for her in-depth study of a painting in the museum's permanent collection. Would you mind looking at Henri's *Salome* with us to see if you agree with the reviewer, and if so point out any connection you see between this painting and your own work?

A collaborative relationship is characterized by the taking of risks and the sharing of leadership in order to achieve a mutually held goal. If all the participants in a project are not committed to the endeavor, then it is not likely to be completed successfully. Hazelroth's remarkable ability to inspire and motivate effective collaborations is only one of the vital ingredients in the development of the types of projects described here. She has defined DBAE as "an approach that makes art a profoundly serious subject of study . . . giving students opportunities to develop skills of critical thinking, problem solving, interpretation, judgment, and a uniquely effective way to make history and culture vital to young people." It is this emphasis upon the value of a discipline-based approach, combined with a willingness to experiment and develop innovative ideas, that translates a traditional museum exhibition into a language comprehensible to students and makes the collaboration between the Ringling Museum and the teachers from the Florida Institute for Art Education one of the most consistently exciting models of DBAE seen by the evaluators.

incorporating DBAE into museum education programs and collaborating on implementation projects with teachers has not occurred among these educators.

Factors Affecting Museum Educators' Commitment to DBAE Programs

The evaluators have investigated the factors that affect museum educators' willingness to collaborate with DBAE institutes. Where only moderate interest has been found, it has been difficult to determine whether lack of greater interest on the part of some museums is the result of personal or institutional disinclination. Nevertheless, it is notable that the museum educators with low levels of commitment to DBAE have been from older and larger museums with long traditions of substantive educational programming. These major museums have complex educational programs that must be maintained. Even when they have considerable involvement in one of the RIG programs, their DBAE activities constitute only a small portion of their total educational operation.

Conversely, educators at medium-sized museums and art centers with educational programs with shorter traditions were far more likely to embrace DBAE, consider new approaches to museum education, and incorporate DBAE innovations into their programs. In smaller museums and art centers, educational programs and the DBAE initiatives became one and the same.

In places where school/museum relationships were not well developed, the RIG programs provided the arena in which collaborative projects could begin. Museums that already had well-established systems of communication were less likely to want to change those systems to accommodate new programs. Nevertheless, we found that even in the large museums whose programs were not greatly affected by their involvement in DBAE activities, there was often increased awareness of the needs of school audiences. As DBAE teachers became aware of the resources that museums have to offer, museum educators began producing more materials and increasing the size of their programs to meet the increased demand. In medium-sized museums working enthusiastically within the RIG programs, the demand for museum services has been even greater. For example, Carol Wyrick, formerly of the Joslyn Art Museum in Omaha, reported that the

biggest benefit to the museum has been through tremendous increase in our outreach to the region through trunks, portfolio prints, and teacher packets

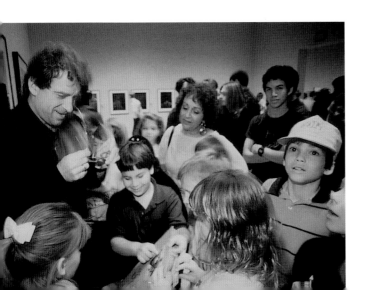

Artist William Wegman engages in a dialogue with Florida elementary school students during a multifaceted project developed around a Wegman retrospective at the Ringling Museum in Sarasota. At right: Students created a quilt interpreting the artist's work.

based on our permanent collection. They were used by just under fifty thousand students in school year 1992–93. In general, for me personally and for the Education Department at the Joslyn, the collaborative, consensus-based approach, which is a Prairie Visions hallmark, has inspired us to find new and innovative ways to meet the diverse needs of our ever expanding and constantly changing audiences. It has been tremendously rewarding from a professional and personal standpoint to be a part of the important work being done in Nebraska for arts education.

Influence of dbae on Museum Staff Members From discussions with museum educators, it was apparent that they believe the involvement of their staff members in the rig programs has led to positive attitudinal changes, including increased awareness of the importance of helping students to have holistic experiences with works of art through a discipline-based exploration of original works in the museum. All the way up to museum boards of directors, museum educators have experienced increased acknowledgment and understanding of their work. Jack Davis, codirector of the North Texas Institute for Educators on the Visual Arts, was invited to join the board of the Dallas Museum of Art. Museum educator Gail Davitt told us, "The connection between the university and the museum board has benefited us. Jack Davis is at the board's education committee meetings. He is able to detail how museum education is consistent with education theory. This validates what we do. The board listens to Jack."

When museum educators have taken positions of leadership in the rig programs, they have also been influential in bringing their museum curators and directors into substantive dialogue with classroom teachers and educational administrators. This means that members of the world of art education actively participate in the identification and implementation of the best methods of dbae. Kate Johnson, chair of the education division at the Minneapolis Institute of Arts, summed up the aspect of dbae that facilitates effective collaboration between schools and museums: "Because the program insists on bringing every Minnesota child face-to-face with real works of art from all cultures and historical periods, visits to museums are an essential part of a dbae curriculum." Recognizing the far-reaching implications of dbae for museums, Johnson organized a meeting

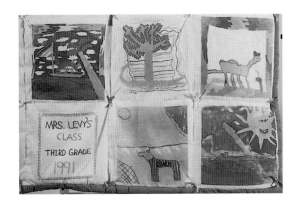

of representatives from twenty-two cultural organizations throughout the state of Minnesota. This meeting, held in 1991, convened museum directors and educators to learn about the content of DBAE and the ways in which it can affect their institutions in terms of the expansion of audiences and changes in their expectations of the museum experience. As Johnson has noted, "There is a need for both teachers and museums to learn what services and resources are really needed by schools." It is the identification and development of these services that will foster a still more effective relationship between museum educators and teachers.

The RIG programs have even provided the opportunity for museum educators to communicate with museum directors and curators about the educational role of the art museum. There are instances in which curators have come not only to appreciate and respond more fully to the interests of teachers and students but also to perceive them as genuine patrons of the museum. This is certainly the case at the John and Mable Ringling Museum of Art in Sarasota, Florida. Museum educator Susan Hazelroth explained that at staff meetings, those curators who have worked with her on educational programs are enthusiastic about DBAE and are supportive of ideas for new programs. This creation of a collective network of support among museum staff members begins to build a system of cooperation through which innovative ideas and behaviors become a regular mode of existence in the museum.

Museum educators clearly believe that their staff members perceive the role of teachers differently once they have attended the summer institutes. Because of the experience, they are able to develop links of professional understanding and friendship that do not occur in the traditional, limited mode of interaction. The shared experience of the institute and the development of common knowledge means that museum educators are more able to empathize with the role of the teacher and are more interested in adapting their programs to the teacher's needs. Because of their increased confidence in dealing with the world of art, the teachers are, in turn, more able to identify and communicate those needs to the museum educators.

Orange Lamp and Oranges, *Janet Fish, 1982, oil on canvas, Hunter Museum of Art. A reproduction of this painting was packaged as part of a Southeast Institute for Education in the Visual Arts teaching set.*

THE HUNTER MUSEUM REPRODUCTION SERIES AND THE SOUTHEAST INSTITUTE FOR EDUCATION IN THE VISUAL ARTS

The alliance between the Art Education Department of the University of Tennessee at Chattanooga and the Hunter Museum of Art actually began the year before the Southeast Institute for Education in the Visual Arts was established. Four reproductions were jointly

MUSEUM DOCENTS AND DBAE The number of docents that museums send to summer institutes varies regionally. With each passing summer, the cumulative effect is that a growing number of docents have attended DBAE institutes. Museum educators repeatedly state that the goal of increasing docents' formal knowledge of a sound and viable approach to museum education has been achieved through their institute experiences. The educators have also reported that attendance at DBAE seminars provides docents with increased confidence in their ability to perform their tasks. For example, Linda Yerbury, at the Hunter Museum of Art in Chattanooga, Tennessee, noted that the museum's docents are "more independent in getting programs going and more confident with materials and information; they are now consciously integrating DBAE into their tours." From the Meadows Museum in Dallas, Maria Theresa Pedroche reported that she has observed "a change in the docents who attended the summer institute. The institute docents are better. They talk to the other docents about their experience, and this helps the whole group."

Because most docents do not come from educational backgrounds, it is generally true that they tend to provide museum visitors with "canned" lectures, rather than leading the visitors to develop meaningful interpretations of their own. In contrast with this traditional approach, museum educators have reported that once docents have attended DBAE workshops, they are eager to create tours that are characterized by effective inquiry-based techniques, through which they elicit observations from tour group members and help them to develop their own interpretations of works of art.

Because this inquiry-based approach is informed by knowledge of the art disciplines that comprise DBAE, museum educators report that the docents are providing visitors with more meaningful experiences and are increasingly satisfied with the results of their work in the galleries. As one Amon Carter docent reported, "My DBAE training has helped me to look at works of art with a more discerning eye and, in turn, helps me to work with the viewers in the museum. DBAE has also given me a 'bag of tricks' for student tours, such as creative writing ideas, dramatic opportunities, and questioning techniques."

There is an overwhelming consensus among museum educators and docents that students from DBAE classrooms respond more positively to museums and their collections than do students whose teachers have not attended DBAE institutes. Allison Perkins, director of education at Fort Worth's Amon Carter Museum, stated, "A change has

produced by the institutions as resources for the teachers in Chattanooga. The subsequent planning grant from the Getty Education Institute included provision for sixteen more reproductions. Selected by institute director Anne Lindsey and her staff and Hunter curator Ellen Simak and members of the museum's education staff, the reproductions were packaged as a teaching set.

This series of images, in which

great attention has been given to color fidelity, includes works by American artists such as Charles Burchfield, Alexander Calder, Janet Fish, Robert Henri, Hans Hofmann, Winslow Homer, Louise Nevelson, and Miriam Schapiro. Each teacher attending the Southeast summer institute receives the teachers' guide, and each school receives a set of reproductions and a guide for their use. Information in the guide includes a historical and cul-

tural timeline, classroom DBAE applications for both primary and secondary students, a bibliography, and a list of other helpful references and resources. All of this information is collected in a loose-leaf notebook, a format that allows the material to be added to, updated, or replaced.

For two years, North Texas Institute codirectors D. Jack Davis and William McCarter sought funding to create a set of study prints to be used as focal points in the Institute's programs and for DBAE instruction in participating schools. Finally, in 1992, the Edward and Betty Marcus Foundation in Dallas granted the funds needed for the project. The resulting collection, called *ArtLinks*, contains twenty-five eighteen-by-twenty-four-inch reproductions of works from museums in the Institute's consortium: the Amon Carter Museum, Dallas Museum of Art, Kimbell Art Museum, Meadows Museum, and Modern Art Museum of Forth Worth. Five works from each of the museums were reproduced, with background information and study questions on the backs of the posters. *ArtLinks* could not have happened without the joint efforts of the North Texas Institute and consortium museums.

ArtLinks project director Nancy Berry proved to be a key factor in the successful collaboration. A nationally recognized museum educator, Berry is on the staff of the North Texas Institute and a member of the University of North Texas art education department. She was also the first curator of education at the Meadows Museum, a former director of education at the Dallas Museum, and a consultant for the Amon Carter, Modern Art, and Kimbell museums. Most important, Berry was well-acquainted with every museum educator involved in the consortium.

Throughout the spring of 1993, Allison Perkins from the Amon Carter Museum, Gail Davitt and Aileen Horan from the Dallas Museum of Art, Marilyn Ingram from the Kimbell Museum, Maria Theresa Pedroche and Adrian Cuellar from the Meadows Museum, and Linda Powell from the Modern Art Museum of Fort Worth met with Berry on at least seven occasions. Together they chose the works from their respective museums, keeping in mind the strengths of each of the collections, key works, periods, styles, themes, subject matter, art forms, media, and cultural and gender diversity. Their twenty-five choices included Frederic Remington's *A Dash for the Timber* and Grant Wood's *Parson Weems' Fable* from the Amon Carter Museum; the Mayan Wall Panel: Royal Woman and Frederick Church's *The Icebergs* from the Dallas Museum; Caravaggio's *The Cardplayers* and Munch's *Girls on a Jetty* from the Kimbell; Goya's *Students from the Pestalozzian Military Academy* and Miró's *The Circus* from the Meadows Museum; and Deborah Butterfield's *Hina* and Roy Lichtenstein's *Mr. Bellamy* from the Modern Art Museum.

Once choices were made, the museum educators had to decide the form in which they would present information about the works. They agreed on a format and decided to address the disciplines of art making, art history, art criticism, and aesthetics holistically, not as separate entities. Berry believes that an important benefit to museum educators of working with the university-based institute was the occasion to study the art disciplines and conceptualize classroom use of the reproductions. She stated, "*ArtLinks* provided an opportunity for museum people to stay current on the art disciplines. Also, the museum educators were thinking about other disciplines in the schools. They had to consider the way reproductions will be used in the classroom for other disciplines for rich learning." North Texas DBAE teachers reviewed mock-ups of the museum educators' work and provided immediate feedback. The selection of artworks was revised, and the corresponding instructional material rewritten.

One of the most valued aspects of the collaborative effort was the opportunity for peer learning and evaluation. All of the museum educators shared their writing about the five works in their museums' collections—something that occurs only rarely. Indeed, in their study of art museums titled *The Uncertain Profession*, Eisner and Dobbs (1986) note the great need for museum educators to "conceptualize, share, and critique ideas." The *ArtLinks* project provided an opportunity for collaboration not only between the DBAE institute and the museums but also among the five museums. The museum educators took full advantage of the opportunity. Ingram succinctly and eloquently encapsulated the experience when she said, "The association with the other museums

was a great delight. In this we have truly gained."

Repeatedly, the museum educators commented on how worthwhile it was to hear the observations of their colleagues. The kinds of questions created by one museum educator inspired the writing of another. Powell remarked on the benefits that resulted from the project, indicating that the process had changed her way of thinking about the production of museum resource materials.

When the *ArtLinks* reproductions were introduced to North Texas Institute participants during the 1993 summer institute, they were received with great enthusiasm. Each participating school was given a boxed set of the twenty-five reproductions. The reproductions were given center stage on the opening day of the institute, and they became the center of DBAE instruction at each of the North Texas area site institute programs. Teachers began to develop units of instruction based on individual works and groups of works reproduced in *ArtLinks*.

On the days the museums hosted the institute, the participants got to see the original paintings and sculptures and engage in gallery activities designed by museum educators, utilizing those originals. They also took the opportunity to develop deeper interpretations of the works of art than could be provided in the information on the backs of the reproductions. The interpretive process did not end with visits to the museums. The day following a visit to the Meadows Museum, one of the evaluators joined a group of elementary classroom teachers who were vigorously debating two alternative interpretations of Goya's painting *Students from the Pestalozzian Military Academy*. The day before, the teachers had listened to the museum's director interpret the work. The director hadn't mentioned the possibility that in the painting the little figure swinging from a vine might represent the boy from Jean-Jacques Rousseau's pedagogical novel *Émile*. If the boy was Émile, then Goya was making a direct reference to Rousseau's influence on Pestalozzi's educational theory. How could the Rousseau connection be confirmed? The teachers were learning that some interpretations are impossible to confirm—or to reject.

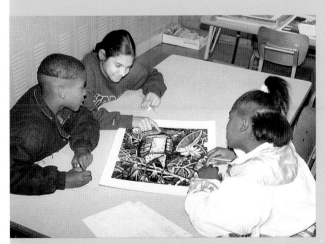

Museum educators from five Dallas-Fort Worth museums collaborated to develop the *ArtLinks* poster series. Fort Worth elementary students explore one of the twenty-five reproductions.

205

occurred in the quality of tours at the museum. Students from institute schools are eager to ask questions, they are better prepared, and they think in a more critical manner." DBAE students are more experienced in talking about art, more knowledgeable about art concepts, and highly inquisitive. Docents are receiving questions from first- and second-grade students that in the past came only occasionally from fifth or sixth graders. Students' enthusiasm and knowledge, in turn, motivate docents to improve their own skills, knowledge, and flexibility in designing tours.

Collaboration between DBAE Institutes and Art Museums

The incorporation of the museum into the structure of the RIG programs constitutes a link between institutions. The character of the museum has affected the nature and substance of the consortia. When, in turn, DBAE institutes and the programs in districts and schools begin to affect the structure of museum education programs, then true collaboration results. The intensity of the transactions between schools and museums reflects the degree to which the collaboration has evolved. There are instances in which the relationship between museums and the RIG programs is so close that their characteristics permeate each other's structures.

Collaboration between museums and the RIG programs is most fully developed when teachers, museum educators, and institute staff work on projects together throughout the year, rather than just during the period of the summer institute. Included among such projects are teacher inservice days that are jointly organized by teachers and museum educators. Such ventures require mutually held goals and funding, as well as the investment of similar levels of resources, time, and energy—all characteristics of collaboration (Hord 1986). It is these innovative projects that demonstrate that new, systemic conventions of behavior in museums and schools are being established within the context of the RIG programs.

206

EXPANSION AND ENRICHMENT OF MUSEUM AND ART CENTER EDUCATION PROGRAMS

Involvement with the RIG consortia can lead museum educators to enrich their already existing programs and develop new ones, as can be seen in the Sheldon Art Gallery's traveling exhibition program (p. 192). For example, the importance of new technologies in the museum setting has been reinforced through collaboration between museums and the RIG programs. During the construction of a new education resource wing at the Dallas Museum of Art, museum educator Gail Davitt had a conversation with North Texas Institute codirector William McCarter. Their discussion came to center on the technological advancements in cognitive systems and computer intelligence that are involved with distance learning. The new educational resource wing is now fully wired for distance learning.

Conclusion

During the past six years the evaluators have observed many examples of innovative projects emerging from the relationship between the museums and schools involved in the RIG programs. The best of these relationships and practices are characterized by a collaborative nature that enables the participating organizations to share ownership in the educational programs that result from their partnership. Not all museum educators believe that DBAE has greatly changed the content and practice of their programs, however. Some believe that, although DBAE is a good approach to use in the classroom, it is not necessary to incorporate it formally into their programs, because multidisciplinary approaches to museum education were already in place prior to the introduction of DBAE. Those educators who have said that the content of their programs has not been influenced by DBAE tend to have cooperative, rather than collaborative, relationships with the RIG consortia.

The programs of other museum programs have been dramatically altered through their participation in the DBAE consortia. It is just as Becker (1982) writes: "The history of art deals with innovators and innovations that won organizational victories, succeeding in creating around themselves the apparatus of an art world, mobilizing enough people to cooperate in regular ways that sustained and furthered their idea." The evaluators have seen just this type of organizational victory since the regional institute initiative was developed.

The elements found in true collaboration—shared needs and interests, commitment of time, energetic individuals imbued with a collective spirit, ongoing communication, and willingness to share—characterize many of the school-museum programs of the regional consortia. It has become a matter of course for people from the related, but very different, institutions of the school and museum to work together to examine and develop new dimensions of DBAE.

The Role of DBAE in Reforming Education

Educational reform is a means, not an end. All of the efforts of the RIG programs have been directed toward one primary goal: to deepen and broaden the education of students in U.S. schools through the study of art. The consequences of this experiment in educational reform extend beyond art or even arts education. This chapter discusses the general implications the DBAE movement has for education in other school subjects and relates it to additional school reform initiatives. The chapter also explores the relationships among the content of education, the means through which instruction should be conducted, and the factors within and beyond schools that must be activated if educational reform is to succeed.

Summary of Key Findings

If applied to education in general, the knowledge gained through the RIG programs has the potential to inform other successful school change initiatives. Ten key findings of this evaluation are as follows:

Change initiatives succeed when change is systemic; specifically, when school district leaders steer the initiative, when change communities formed of individuals and institutions at every level of education share ownership, and when multiple reform efforts reinforce and enhance one another.

Professional development and curriculum and instructional planning must be pursued simultaneously.

Change occurs not only because of a continuous process of evaluation but also because there is sufficient time for evaluation to inform the refinement of professional development programs and the instructional development and implementation aspects of the initiative.

Ongoing communication and collaboration within and among educational change communities leads to the refinement and improvement of educational reform initiatives.

Effective programs emerge from collaboration between teachers and experts in particular subject-areas.

The teaching of school subjects is enriched when museums and other community institutions provide settings for immersion in their respective worlds and content for instruction. Actual artifacts, primary documents, and texts viewed from multiple perspectives hold the greatest power to educate.

Skills, even those of the highest order—relating to critical thinking and creative invention—are not ends in themselves. They are the means for understanding human purpose and creating new visions of it. The arts place

the relationship between the acquisition of understanding and the acquisition of skills in proper perspective.

The most important learning takes place when several school subjects are taught simultaneously within the context of the large themes that illuminate conceptions of human purpose and well-being. Works of art provide these themes.

The content, organization of instruction, and inquiry processes associated with DBAE provide exemplary models for instruction and assessment in other school subjects.

Ongoing assistance in the form of professional development institutes and workshops, symposia, model instructional units, evaluation of district and school plans, newsletters, expert consultants, opportunities for professional renewal, and other forms of special assistance tailored to school and district needs are essential components of a successful change initiative.

The lessons learned from the RIG programs should be of interest to individuals in many different groups and organizations, including parents and the general public; legislators and policy makers at the national and state levels; school leaders and teachers; individuals who work in national, state, and local arts agencies; museum, art center, and arts institution directors and educators; members of professional associations; artists, art historians, art critics, and philosophers of art; and members of philanthropic organizations committed to K–12 educational reform. Representatives of all of these groups have become major stakeholders and members of the change communities that have developed in the RIG programs.

Reflections on an Experiment

These pages have depicted the unprecedented events that have occurred in institutes and schools in the RIG programs supported by the Getty Education Institute for the Arts. Through the efforts of individuals working in these complex consortia, schools that once

Professional development and curriculum and instructional planning must be pursued simultaneously for change to occur in school art programs.

had weak visual arts programs have developed strong ones. In other schools, visual arts programs have moved from their customary place at the margins of the school curriculum to its core. Art teachers who were accustomed to working by themselves, with little attention being paid to them and paying little attention to what their colleagues did, are working as key members of school planning teams intent on broadening school instructional programs. Principals have used the DBAE initiative as a means of reorganizing an entire elementary school curriculum. Because of their involvement in an art education professional development project, school principals and district administrators, some of whom had not previously engaged in formal long-range planning, now lead their teachers in constructing one- and five-year plans for comprehensive art and arts education programs that are integrated thematically with other school subjects and coordinated with other change initiatives.

Art teachers, classroom teachers, and school administrators have become colleagues with art museum educators, artists, art critics, and university professors of art history, art education, and philosophy. Together they have planned programs that have symbolically removed classroom walls, so that the art world has come into classrooms. At the same time, students have gone into the art world—to communities, museums, and art centers—to receive an authentic art education.

Within states and even among several states, art teachers have joined in creating model units of instruction, experimented with innovative assessment processes, and in numerous other ways shared the results of their curriculum and instructional experimentation. With the assistance of their colleagues in the DBAE consortia, hundreds of thousands of students, thousands of teachers, and many hundreds of school and district administrators have contributed to this far-reaching experiment in educational reform.

The evaluators have concluded that if professional development initiatives in other school subjects were as whole, authentic, and effective as those found in DBAE institutes, the quality of education would be improved enormously. A synthesis of the findings of this report sheds light on the significance they could have for the improvement of education in general.

Within states and even among states, art teachers have joined in creating model units of instruction, experimented with innovative assessment processes, and shared the results of their experiments.

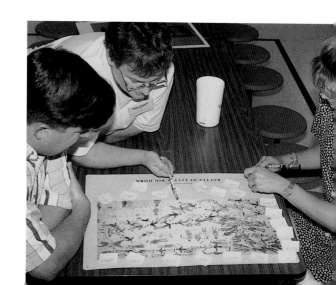

The Regional Consortia, DBAE, and Educational Reform

Educational reform is not an end in itself; its purpose is to improve the lives of all Americans. All of the efforts of the RIG programs have been directed to one primary goal: to deepen and broaden the education of students in U.S. schools through the creation and study of art. The consequences of this experiment in educational reform extend beyond art or even arts education. There are general implications for education in other school subjects and implications pertaining to school reform initiatives. Specifically, the experiment provides insights into the essential content of school subjects and how that basic content ought to be studied by students, and the essential conditions that must be present if educational reform initiatives are to succeed. In the educational change experiment conducted in the RIG programs, these two basic components and their multiple strands have been woven into a single tapestry. The following summary shows the relationships among the content of education, the means through which instruction should be conducted, and the factors within and beyond schools that must be activated if educational reform is to succeed.

ART, ART EDUCATION, AND HUMAN PURPOSE: ISSUES OF CONTENT AND SKILLS The evaluators' observations in schools throughout the RIG programs have led to the conclusion that there is considerable confusion about the goals of education, and not just in art education. Frequently, education is directed toward helping students to acquire basic skills—reading, writing, calculating, and, in the visual arts, designing. The rationale for this is the belief that if students acquire these basic skills, they can then apply them to almost anything, in school or beyond. But to what are those skills to be applied? Unfortunately, the emphasis on skill development has permitted educators to avoid the difficult task of prioritizing the different possible contents of education, and it has also detracted from the importance of selecting subject matter worth knowing about. For example, if the emphasis is on inquiry skills, then a unit of instruction on how bubble gum is manufactured holds the same importance as a unit based on how the destruction of rain forests affects the ecology of the planet and the well-being of humankind. Although students can develop and practice inquiry skills in either instructional unit, honing their

UNIVERSAL THEMES, INDIVIDUAL INTERESTS, AND MORAL IMPERATIVES

Over the course of the evaluation the evaluators observed a shift in the RIG programs from a preoccupation with the art disciplines as the content of art education to a collective realization that the art disciplines are the means through which the meaning of works of art may be understood. With the awareness that works of art educate when they are insightfully created, studied, interpreted, and evaluated came the realization that different works have different meanings and thus educate differently. Consequently, with increasing frequency;

• school, museum, and university educators make carefully reasoned selections of the works of art that should be studied in DBAE schools and institutes;

• decisions about the works of art around which to develop DBAE instruction are made on the basis of the themes, topics, and subject matter associated with specific works of art and the potential of those works and their themes to educate;

• works of art that reflect themes having to do with human purpose and issues of importance to contemporary society have come to be selected for study;

inquiry skills on things that are trivial miseducates students by making the trivial and the profound appear to be equivalent.

Content and skills are both essential to education. Chapter 2 describes the difficulty art educators have had in deciding whether the art disciplines and the inquiry skills associated with them are the content of DBAE or merely the means through which works of art, also considered primary content, might be created and studied. The fact that many individuals in the RIG programs have grappled with this issue and developed important insights has implications for education in general.

The essential outcome of the DBAE initiative is that elementary, middle, and high school students receive an education in which works of art are permitted to make their unique contributions to students' knowledge of themselves and their place in their own communities and the global society. In thematic units of instruction based on works of art, students create their own artworks while simultaneously studying those of artists in world cultures from prehistoric to contemporary times. Students' creations are thus connected to images that reveal the subjects, ideas, issues, themes, and expressive character that expand conceptions of human purpose (Boyer 1992).[1] Through the special attributes of visual symbols, students study and create works of art that explore relationships of the self to other selves, the self to family and society, the self to the forces and aesthetic characteristics of the natural and designed worlds, and the self to human aspirations and the desirable futures humans might construct for themselves.

When it comes to the content of instruction, what are the implications of this experiment in art education for other school subjects? The artifacts, documents, texts, experiments, theories, and works of history, geography, literature, science, math, theater, music, dance, etc., matter very much. They are the content through which the human quest for knowledge is revealed. Often, students are thought to be incapable of dealing with the original sources of knowledge—it is assumed that artifacts and texts by adult creators are beyond the capabilities of most young people. Consequently, too often students get generalizations and synthesized versions of original works in schools, not the works themselves.

In DBAE there is no sharp distinction between the works studied at school and the works that are of interest to adults. In DBAE, young people are presented with the same

• works of art are selected for study because they have relevance to both the actual communities and the communities of interest in which students live; and
• students are encouraged to create works of art in which the themes and topics, subjects, and ideas found in the works of artists are adapted to their own interests and the interests of contemporary society.

Through this process, DBAE has acquired a depth that is lacking in much of contemporary education. It has taken on what Goodlad calls "moral imperative," and the things that Goodlad's colleague Sirotnik lists as moral requirements—inquiry, knowledge, competence, caring, freedom, well-being, and social justice (cited in Fullan 1993, p. 9). Fullan posits "moral purpose" along with "change agentry" as the two essential ingredients of educational reform (pp. 8–18).

The Regional Consortia, DBAE, and Educational Reform

Educational reform is not an end in itself; its purpose is to improve the lives of all Americans. All of the efforts of the RIG programs have been directed to one primary goal: to deepen and broaden the education of students in U.S. schools through the creation and study of art. The consequences of this experiment in educational reform extend beyond art or even arts education. There are general implications for education in other school subjects and implications pertaining to school reform initiatives. Specifically, the experiment provides insights into the essential content of school subjects and how that basic content ought to be studied by students, and the essential conditions that must be present if educational reform initiatives are to succeed. In the educational change experiment conducted in the RIG programs, these two basic components and their multiple strands have been woven into a single tapestry. The following summary shows the relationships among the content of education, the means through which instruction should be conducted, and the factors within and beyond schools that must be activated if educational reform is to succeed.

ART, ART EDUCATION, AND HUMAN PURPOSE: ISSUES OF CONTENT AND SKILLS The evaluators' observations in schools throughout the RIG programs have led to the conclusion that there is considerable confusion about the goals of education, and not just in art education. Frequently, education is directed toward helping students to acquire basic skills—reading, writing, calculating, and, in the visual arts, designing. The rationale for this is the belief that if students acquire these basic skills, they can then apply them to almost anything, in school or beyond. But to what are those skills to be applied? Unfortunately, the emphasis on skill development has permitted educators to avoid the difficult task of prioritizing the different possible contents of education, and it has also detracted from the importance of selecting subject matter worth knowing about. For example, if the emphasis is on inquiry skills, then a unit of instruction on how bubble gum is manufactured holds the same importance as a unit based on how the destruction of rain forests affects the ecology of the planet and the well-being of humankind. Although students can develop and practice inquiry skills in either instructional unit, honing their

UNIVERSAL THEMES, INDIVIDUAL INTERESTS, AND MORAL IMPERATIVES

Over the course of the evaluation the evaluators observed a shift in the RIG programs from a preoccupation with the art disciplines as the content of art education to a collective realization that the art disciplines are the means through which the meaning of works of art may be understood. With the awareness that works of art educate when they are insightfully created, studied, interpreted, and evaluated came the realization that different works have different meanings and thus educate differently. Consequently, with increasing frequency;

• school, museum, and university educators make carefully reasoned selections of the works of art that should be studied in DBAE schools and institutes;

• decisions about the works of art around which to develop DBAE instruction are made on the basis of the themes, topics, and subject matter associated with specific works of art and the potential of those works and their themes to educate;

• works of art that reflect themes having to do with human purpose and issues of importance to contemporary society have come to be selected for study;

inquiry skills on things that are trivial miseducates students by making the trivial and the profound appear to be equivalent.

Content and skills are both essential to education. Chapter 2 describes the difficulty art educators have had in deciding whether the art disciplines and the inquiry skills associated with them are the content of DBAE or merely the means through which works of art, also considered primary content, might be created and studied. The fact that many individuals in the RIG programs have grappled with this issue and developed important insights has implications for education in general.

The essential outcome of the DBAE initiative is that elementary, middle, and high school students receive an education in which works of art are permitted to make their unique contributions to students' knowledge of themselves and their place in their own communities and the global society. In thematic units of instruction based on works of art, students create their own artworks while simultaneously studying those of artists in world cultures from prehistoric to contemporary times. Students' creations are thus connected to images that reveal the subjects, ideas, issues, themes, and expressive character that expand conceptions of human purpose (Boyer 1992).[1] Through the special attributes of visual symbols, students study and create works of art that explore relationships of the self to other selves, the self to family and society, the self to the forces and aesthetic characteristics of the natural and designed worlds, and the self to human aspirations and the desirable futures humans might construct for themselves.

When it comes to the content of instruction, what are the implications of this experiment in art education for other school subjects? The artifacts, documents, texts, experiments, theories, and works of history, geography, literature, science, math, theater, music, dance, etc., matter very much. They are the content through which the human quest for knowledge is revealed. Often, students are thought to be incapable of dealing with the original sources of knowledge—it is assumed that artifacts and texts by adult creators are beyond the capabilities of most young people. Consequently, too often students get generalizations and synthesized versions of original works in schools, not the works themselves.

In DBAE there is no sharp distinction between the works studied at school and the works that are of interest to adults. In DBAE, young people are presented with the same

* works of art are selected for study because they have relevance to both the actual communities and the communities of interest in which students live; and
* students are encouraged to create works of art in which the themes and topics, subjects, and ideas found in the works of artists are adapted to their own interests and the interests of contemporary society.

Through this process, DBAE has acquired a depth that is lacking in much of contemporary education. It has taken on what Goodlad calls "moral imperative," and the things that Goodlad's colleague Sirotnik lists as moral requirements— inquiry, knowledge, competence, caring, freedom, well-being, and social justice (cited in Fullan 1993, p. 9). Fullan posits "moral purpose" along with "change agentry" as the two essential ingredients of educational reform (pp. 8–18).

authentic works of art that capture the interest of art historians, art critics, and aestheticians. As they deliberate about the merits, meanings, and consequences of artistic creations, they study the writings of historians, critics, and philosophers. There is no watering down of the works of art and the writing about them studied by young people, just a careful selection of authentic works whose meanings are important to their education. This is the first important lesson of the DBAE experiment.

THE DESIRABILITY OF MULTIPLE INTERPRETATIONS The creation and interpretation of meaning are at the heart of the DBAE projects developed in the RIG programs. The very fact that meaning is sought through the use of the four basic art disciplines, each having the potential to reveal different aspects of works of art, results in the understanding that knowledge is multifaceted and that one object may have several different interpretations.

In DBAE, understanding comes when students and their teachers use the inquiry models provided by the art historian, art critic, and aesthetician to interpret the multiple meanings of works of art—what they meant to the individuals who created them, what they have meant to those who have sought their meanings as the artifacts traveled through time, and what they mean to us today. Students' and teachers' multifaceted interpretations reflect the fact that works of art, even those done in other times, have something to say about our own time. Teachers and students learn that there can be more than one acceptable interpretation of a single work of art.

Students and their teachers also learn that there are several desirable ways to express one idea. The ideas and themes on which DBAE students base their works are similar to those found in the works of adult artists (when they are appropriate to the student's level of understanding and interest). In good DBAE programs, works of art are treated respectfully—to use Rorty's phrase, as "honorary persons." To misunderstand a work of art is to miss the opportunity to learn and the chance "to change your purposes, and thus to change your life" (Rorty 1992, p. 106). As has often been observed in DBAE schools, when students use the mindful imaginative processes of the creative artist, their works reveal essential human themes and purposes, thus adding to the store of visual images that provide new sources for human understanding.

THE FUSION OF CONTENT AND SKILLS: FROM ART TO GENERAL EDUCATION

One of the basic conclusions of this study of the RIG programs is that when education is comprehensive and whole—when education provides students with an essential understanding about themselves and their worlds—it is based on carefully selected artifacts and texts that are rigorously and skillfully interpreted and evaluated in multiple ways. What is the implication of this conclusion for education in general? It is simply that the study of a scientific theory, an experiment, a poem, a map, a mathematical formula, a historical document, a report on a psychological experiment, an anthropologist's account—any document deemed to contribute something important to the education of a young person—will be enriched enormously if it is seen to yield more than one "truth." There are, after all, scientists, historians of science, critics of science, and philosophers of science. Shouldn't a science program give attention to all of these essential aspects of the scientific world? All educational programs would be enriched if they were based on original source materials interpreted through multiple disciplines.

How do the creative and inquiry skills learned by students in DBAE classrooms relate to current educational objectives? Critical thinking and problem solving are among the skills most prized by today's educators. These processes are essential to the work of the artist, historian, critic, and philosopher. Many students in DBAE schools have learned to think and act critically. There are also extraordinary examples of cooperative learning in DBAE schools, another practice currently being encouraged within education. Chapter 3 illustrates how, in one of the most complex forms of DBAE, art is integrated with other subjects, so that relationships between art and other disciplines are revealed. Indeed, DBAE programs have frequently been tied to a variety of current educational reform initiatives.

Nevertheless, there is one important difference between the goals of DBAE programs and the objectives associated with some of the current reform initiatives. DBAE is not taught to develop critical thinkers, problem solvers, and cooperative learners. Rather, these and other skills and inquiry processes are the mental attributes needed to understand and create works of art. Like the disciplines of art in DBAE, educational skills and processes become the means to a good education, not its end.

Placing subject-matter content—the interpretation of works, documents, and original texts—at the center of educational reform presents a serious challenge to schools and school districts. It is necessary to have educators who are able to take the content and inquiry processes from the academic disciplines and translate them into instructional programs. At the middle of this century, every large school district, nearly every medium-sized district, and many small ones had an art supervisor or district coordinator who could play the crucial role of translator/facilitator. Now, relatively speaking, there are few district art or arts coordinators. At the school district level, either school subjects have no coordinator or a single individual is asked to coordinate several subject-matter areas. Consequently there is a notable lack of expertise relating to the specific content of all subject-matter disciplines currently available to the teachers in school districts of almost any size.

In the early days of the RIG programs various types of expertise and technical assistance were offered to cooperating school districts. As more districts and schools joined the consortia, the directors of the RIG programs were unable to keep up with the genuine

Students learn critical thinking and problem solving skills in DBAE classrooms.

need and demand for assistance in school districts. If meaningful educational reform is to proceed, school districts must return to the practice of providing subject-matter coordinator/facilitator experts.

Issues Associated with Top-Down and Bottom-Up Change Initiatives

When it began, DBAE was essentially a top-down initiative. There was the distinct possibility that it would continue to be this way when it was introduced in the RIG programs. Top-down initiatives, however, have many major drawbacks. Because top-down change assumes that there are known solutions leading to educational reform and that reform will be accomplished once teachers adopt those solutions, there was the danger that practitioners would be expected merely to implement the already prepared blueprints of art educational theoreticians and curriculum experts. Just as well-functioning complex cities cannot be designed by a few individuals, successful educational reform initiatives cannot be designed by a few theoreticians.

Among the most serious drawbacks of top-down change initiatives is that teachers and administrators are given insufficient encouragement to adjust the initiatives to the interests, needs, and requirements of their own schools and students. A still greater shortcoming is that even if practitioners do adjust the program to their own individual schools, the important modifications they make may have virtually no way of moving back to the top. Consequently, there is little opportunity for practice to inform theory. Indeed, this is also one of the greatest drawbacks of grassroots initiatives—although they may have enormous local consequence, they fail to inform entire systems.

When the RIG program directors were told that they were to establish research and development centers, the Getty Education Institute for the Arts sent the important message that although DBAE is based on a set of principles, its forms and practices had not been definitively circumscribed. DBAE was presented as an essentially open-ended concept that could take a variety of viable forms, a signal that no single individual or group of individuals knew what DBAE should look like or how it should be implemented. Implicit within the

217

All of the efforts of the RIG programs have been directed to one primary goal: to deepen and broaden the education of students in U.S. schools through the creation and study of art.

charge to the directors was the notion that within and among the RIG programs, individually and collectively, answers could be found, even though, at least in the early days of the programs, many of the questions were unknown. The directors were informed that they and their colleagues could play a role in developing the concept, and it has transpired that, at every level in the RIG programs—from young students to leading scholars and creative artists—individuals have exerted their influence on the shape of DBAE.

Because DBAE is no longer assumed to be a monolithic entity with fixed sources, content, and practices, it has the possibility of remaining vital, with continued modifications to meet changing educational and societal conditions and artistic and aesthetic interests. When the answer to the question of who should determine the character of DBAE became "Everyone involved with it," practice began to guide theory within an interactive network. Because DBAE evolved within a system of art educational change communities, the developments within one community had a variety of ways of traveling to other communities.

Because the RIG programs were established during a three-year period, those formed later could take advantage of the developments of those formed earlier; some did so much more than others. Also, because new school districts are continually added to the RIG projects, new individuals with new ideas and new contexts presenting fresh challenges and resources continually enrich DBAE.

Creating Agents of Change

Some of the lessons learned from the DBAE change initiative correspond to what Fullan (1993, pp. 19–41) calls the eight basic lessons of the new paradigm of change. Fullan's fifth lesson is, "Individualism and collectivism must have equal power" (pp. 33–36). He points to the fact that "professional isolation of teachers limits access to new ideas and better solutions, . . . fails to recognize and praise success, and permits incompetence to exist and persist to the detriment of students, colleagues, and the teachers themselves." When DBAE teachers from nearly one hundred school districts within a single consortium begin to discuss with colleagues from museums and universities the selection of works of art around which to create units of instruction, to debate alternative interpretations of the works of art to use in their instructional units, to define collectively the differences between themes and topics associated with works of art, and to offer their instructional units for criticism by their peers, a marvelous end to teacher isolation is signaled. The same can be said when a hundred teachers in another consortium collectively develop and test assessment units designed to evaluate achievement in learning communities.

Fullan's sixth lesson is, "Neither centralization nor decentralization works. . . . Both top-down and bottom-up strategies are necessary" (pp. 37–38). The interactive networks developed within and among the RIG programs have both. The institutes have become unique broad-based educational change organizations. Housed in universities and a state department of education, they had no means of regulating the projects of schools and museums. They could only offer programs and other kinds of resources and assistance. Nevertheless, with the expectation that participating districts and schools develop one-

and five-year plans, consensus was created throughout school systems—consensus among administrators, teachers, school board members, parents, and other stakeholders—regarding the kind of art program that should be provided and how it should be achieved. There were numerous programs and services that both created consensus and built on it: the symposia and renewal workshops for experienced DBAE teachers and administrators, leadership programs for administrators, special seminars for museum docents, consulting and technical assistance services for participating districts and schools, programs and support for the establishment of district and area site institute projects, model instructional units and student assessment modules, program evaluation models, reproductions and instructional materials relating to works of art in consortium museums, DBAE resource centers, newsletters, and e-mail networks. All of these programs and services provided opportunities for the growth of grassroots initiatives.

DEFINING INSTITUTIONS AND STAKEHOLDERS There is a tendency to think that the realm of education consists primarily of schools, curriculum, teachers, and students. When educational reform initiatives are undertaken, the notion that the educational establishment extends to community resources, nonschool educational institutions, and discipline and creative experts in different content and subject-matter areas is often not taken into account. Consequently, the context of educational reform is too narrowly defined, and valuable resources, perhaps essential ones, are too often ignored.

The creation of six complex educational consortia that include a central institute, school districts, colleges and universities, state departments of education, art museums and art centers, state and local arts and humanities agencies and organizations, evaluators, and grant-giving foundations and trusts has vastly expanded the context in which the reform of art education has unfolded. Individuals in all of these institutions have become stakeholders, with sometimes overlapping and joint responsibilities within an interactive network. In many instances cooperation has become collaboration. When collaboration has been greatest and has involved the largest number of stakeholders representing different institutions, innovative practices also have been greatest.

The consortium model can be replicated within smaller and smaller change units. Area sites and regions within the RIG programs have functioned most successfully when

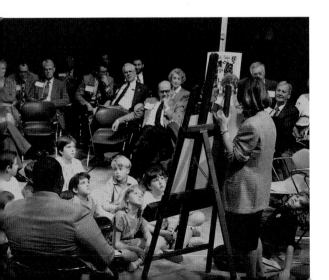

Education reform takes place within the community as well as within the schools. Chattanooga, Tennessee, teacher Sher Kenaston and her class demonstrate a model lesson to local education stakeholders.

they have replicated and made full use of all the features of the central consortia. This is also true for school districts. A considerable number of them, both large and medium sized, have managed to develop most of the components of the large DBAE consortia. The most interesting development, however, has been that a number of individual schools have also managed to develop miniconsortia that replicate many of the features of the larger consortia. The DBAE consortium appears to have great potential for educational change beyond art education.

Who Should Lead Educational Reform Initiatives?

In educational change initiatives, given that individual teachers are the ones who have the responsibility to broaden the content of their art curricula and change their instructional practices, conventional wisdom might suggest that professional development should be directed primarily toward individual teachers, whose beliefs, attitudes, and practices must be changed if school reform is to succeed. As noted before, chances that reform efforts will succeed are greater when they are activated by individuals working throughout the entire educational system. The singular focus on teachers diminishes the crucial role that must be played by other individuals. In order to succeed, educational reform must have the support of individuals in every part of the formal educational establishment. Most important, reform must be led both by individuals who are in leadership positions and by individuals who, within the context of the change initiative, assume leadership responsibility even though they do not hold positions of authority.

BROADENING THE POOL OF CHANGE AGENTS Fullan (1993) describes "change agentry" as "being self-conscious about the nature of change and the change process. Those skilled in change are appreciative of its semi-unpredictable and volatile character, and they are explicitly concerned with the pursuit of ideas and competencies for coping with and influencing more and more aspects of the process toward some desired set of ends" (p. 12). He also lists four "core capacities" required as a generative foundation for building greater change capacity: "personal vision-building, inquiry, mastery, and collab-

Inquiry through the art disciplines encourages individuals to discover multiple meanings of works of art.

oration" (p. 12). Each of these capacities relates directly to the experiences of individuals in the RIG programs.

The evaluators found that two compelling factors contributed to individuals' personal vision building in the DBAE consortia. First was the authenticity, wholeness, and coherence of the art world presented in the summer institute programs; individuals found the art world a fascinating place to be and discovered the power of works of art to give meaning to education. Second, as educators taught DBAE, they found that their students developed similar enthusiasm for the art world and the power of art to educate. The validity and value of DBAE were recognized because of the desirable changes DBAE made in the lives of both teachers and students.

Inquiry and mastery came through the use of art disciplines that encouraged individuals to enter into the process of discovering the multiple meanings of works of art. This was only the beginning; DBAE institute participants applied those inquiry processes to the development of instructional units. Because these units were organized around interesting works of art that revealed important insights, the process became self-validating for both educators and students.

Collaboration was the essential outcome of the interactive networks that developed within the RIG programs. In the various collaborative efforts that transpired in and among schools, museums, institutes, and other agencies and organizations, individuals who had genuine mastery of knowledge and inquiry processes relating to both art and education willingly worked together and shared their expertise. Because so many individuals were contributing to and reinforcing the efforts of so many others, widespread change agentry resulted.

THE LEADERSHIP FACTOR IN THE IMPLEMENTATION OF DBAE The DBAE consortia mobilized individuals from every part of the formal educational establishment. Of special importance was the fact that they brought together art content experts, policy makers who regulate education at the local level, and teachers. In the summer institute programs, art specialists, classroom teachers, and district art coordinators frequently developed strong commitments to DBAE. As the program unfolded, new leaders emerged. In school after school and district after district, individuals who had not previously played leadership roles began to work voluntarily to implement the program in their schools and sometimes in entire districts. Nevertheless, when individual art teachers and school district art coordinators, working by themselves, tried to implement DBAE programs in schools and districts, they had less success than when school principals, district curriculum coordinators, superintendents, and assistant superintendents either strongly endorsed their efforts or led the implementation effort themselves.

Educational reform is affected by the establishment of a clear set of expectations, an essential factor that typically emanates from the top. If a change initiative is to succeed, administrators must communicate to educators throughout a school district that a given reform initiative has high priority. But expectations from the top must also be supplemented by expectations that come to be held by individuals throughout an entire system.

The creation of districtwide and schoolwide one- and five-year plans is a highly effective means through which expectations can begin to permeate districts and schools. In school districts where these plans have been created and implemented, DBAE programs

have tended to flourish. The evaluators found, however, that only district administrators are able to see to it that plans are known throughout an entire system and assure that they are initiated, modified when necessary, and evaluated so that progress can be charted. School districts with site-based management generally have not developed the same high-quality art programs found in districts where expectations have been communicated to all schools.

Absence of the Critical Mass Needed to Initiate Change

Individual teachers who attend workshops and institutes to learn about new educational programs are often unable to integrate the new information successfully into their instructional programs. Although they may resolve to change their instructional practices, factors encountered when they return to their schools keep them from implementing new programs. The task of just keeping up with ongoing instruction, the inability to move from theory to practice, lack of a support system, and lack of understanding of the new programs by fellow teachers and school administrators all diminish the chances that changes will be made in the way an individual teacher may teach.

When a team of teachers and an administrator attend a DBAE institute together as a group, they develop initial plans to implement the program. The evaluators found a direct relationship between successful implementation and the number of teachers and administrators who attend an institute together. Implementation is almost always successful when a team of institute participants returns to school with plans for involving the remainder of the faculty in the initiative, plans for assuming clearly defined roles in the implementation process, and plans for informing students and the school community of the new initiative. When DBAE programs are the topic of discussion in elementary school faculty meetings, when teachers at a grade level jointly plan units of instruction based on key works of art, when more than half of the teachers in a school begin to display reproductions of works of art in their classrooms, when teachers have students create their own ideas in relationship to artists' ideas and read and write about works of art,

Changing school art programs is almost always successful when a team of teachers and an administrator attend an institute together and return to school with plans for the new initiative.

most of their colleagues become DBAE teachers too. The school becomes a DBAE school; it looks different from other schools and educates differently. The team-planning approach to professional development in art has broad application to other professional development initiatives.

INITIATING REFORM INITIATIVES ONE AT A TIME There are many different interest groups within and outside of education, all representing different societal interests and values, who seek to influence schooling. Because of the pressure exerted by these groups and because of the needs of society, there is a tendency for schools to undertake several reform initiatives simultaneously. Sometimes the change initiatives conflict with one another, often competing for the time and attention of school administrators and teachers. These reform initiatives are seldom coordinated and integrated and thus can overwhelm and frustrate teachers; each new initiative becomes a potential competitor within their instructional programs. Many teachers are also threatened by change, and each new change initiative vies for time in a crowded school day. These are the school conditions into which DBAE was introduced.

When DBAE was first initiated there was concern that its potency would be diluted if it were integrated with other school subjects. Consequently, it was presented as a distinct and separate change initiative. However, when large numbers of teachers, especially elementary classroom teachers, were invited to formulate DBAE programs, they immediately saw the connection to the whole language programs they were already implementing and to other initiatives—theme-based instruction, cooperative learning, the integrated curriculum, critical thinking, and technology. They frequently merged their DBAE planning with these other initiatives.

When superintendents, district curriculum coordinators, and principals were asked to characterize DBAE schools, they listed the features of other change initiatives along with those specifically associated with art. The evaluators concluded that DBAE was strengthened, rather than weakened, through its association with other change initiatives. Moreover, through the layering of new initiatives—so that when students were writing art criticism they were also studying language arts, for example—objectives associated with different school subjects could be fulfilled simultaneously. When DBAE was layered with other change initiatives, it became less threatening. When classroom teachers and their principals decide that they can implement a DBAE program while simultaneously implementing other programs they also care about, there is greater likelihood that art will be given a place at the table.

The evaluators have become increasingly convinced that the piecemeal approach to educational reform should be abandoned altogether. When a new initiative is contemplated, one of the first acts undertaken should be the determination of its relationship to change initiatives already underway. Ways should be explored for weaving new initiatives into old. Such a practice would probably eliminate the unfortunate habit of dropping previous initiatives, even though they may have great value, in favor of new initiatives. The practice would provide a rational approach to educational change. It would also provide a way of revitalizing previous initiatives with new challenges.

In the United States, educational change initiatives typically have short periods during which they receive funding and attention. Before an initiative has a chance to take hold, the next change effort begins. Although many educators may understand that the changing of educational practices takes considerable time, long-term commitment of resources is rare. Nevertheless, the short-term approach to educational change makes it unlikely that lessons learned during the early phases of an initiative can be used to make later phases more successful.

When the Getty Education Institute decided to encourage art educators to adopt comprehensive forms of DBAE, it agreed to support that effort for the long term. When the RIG programs were organized, the Getty Education Institute allocated funds for an initial five-year period, provided that matching funds were secured and sufficient progress was made. It is worth noting that in addition to the $3.5 million the Getty Education Institute granted to the RIG programs, $10 million has been raised by the programs with the assistance of school districts, foundations, and public agencies. With the initial assurance of basic five-year funding from the Getty Education Institute, the directors of the RIG programs could look five years into the future. They could also look six years into the past. The RIG programs were built on developments from previous Getty Education Institute initiatives, especially the professional development model from the Los Angeles Institute for Educators on the Visual Arts, established in 1982.

The different phases of the DBAE reform initiative have been based on the findings of earlier phases. Thus the findings in this report are based on twelve years of development, experimentation, and evaluation, first in the Los Angeles Getty Institute for Educators on the Visual Arts (beginning in 1982) and then in the RIG programs (beginning in 1988). The need to establish broad-based regional consortia grew directly from insights gained in the Los Angeles Institute, where only a partial consortium had been established. The RIG program directors, their staffs, and consortium members are currently planning new phases of the initiative that will take them into the new century. At the same time, quantitative data are currently being collected regarding the progress of the RIG programs to supplement the qualitative findings and conclusions presented in this report.

There is an obvious lesson here for educational policy makers, politicians, other private funding agencies, and state and national governments. Where support is consistent and long-term, and where there is an opportunity to develop from one phase of an initiative to the next, remarkable changes can be made in education.

Moving from Theory to Practice

Providing art specialists, classroom teachers, museum docents, and school administrators with intensive experiences in the world of art and teaching them to inquire into art in a variety of disciplined ways were only the first steps in developing a viable art educational program. One of the most difficult problems faced by the directors and faculties of the DBAE institutes has been how to help teachers to transform discipline-based creation and inquiry processes into effective art education programs. If they are asked to rely primarily on already existing art curricula, this sends the signal that the answers to ques-

tions about DBAE are already known. Their task then becomes one of implementing the already developed programs of others, which is quite different from developing their own programs. The challenge assumed by individuals throughout the six consortia has been to accept a set of principles and from them develop something new, and to keep developing new things. New things, however, need models.

The most successful summer institutes and discipline seminars have come to be taught like the very best units of art instruction. Institute programs have come to be centered on key works of art—often works that are important to the areas in which institutes are held or works that have been exhibited in consortium museums and art centers. In these institutes, which are increasingly organized like model study units, participants are not merely told or shown what artists and art discipline experts do when they create and study art. Led by discipline experts, participants begin to do what experts do. After participants in summer institutes have experienced a series of articulated activities in which the art disciplines are employed to reveal or create meaning—both separately and in an integrated manner—they have vivid models to follow. At this point, they are invited to create their own instructional units by extending the models, combining them, adding new features, and applying them to new content and contexts. Through this process, DBAE is continually expanded and modified. The models of DBAE that are now presented in the summer institute programs are so powerful and their value so self-evident that many participants become committed to leaving behind much of their old content. At the very least, most resolve to begin working their way out of their old instructional content while creating new instructional programs. Because of the support system established in their schools, their school districts, and their DBAE consortia, a surprising number of participants are able to move from theory to practice.

Old Forms of Art Education with a New Label

In the early days of the RIG programs, much of what went by the new name of DBAE still retained the content of older forms of art education. If the content of DBAE had not changed significantly from the previous content of art education, the distinct possibility existed

The challenge assumed by individuals throughout the six regional institutes has been to accept a set of principles and develop something new—and to never stop inventing.

that the reform initiative would be little more than a case of the emperor's new clothes.

The forms of DBAE that have developed in the RIG programs have, in many instances, now become markedly different from earlier forms of DBAE. This distinctiveness, and the obvious contributions DBAE makes to education, provides a clear focus for the reform initiative. Educators sense that they are a part of something important. Moreover, the initiative has given new stature to art programs in many school districts in which it is being implemented. Through DBAE programs, art is seen as a basic school subject of substance, a subject that has the power to educate in essential ways. The level of commitment to the program, the level of energy, and the amount of time individuals at all levels of the consortia devote to the development of DBAE are directly related to the comprehensiveness, substance, and quality of the professional development initiative.

INSUFFICIENT EVALUATION OF REFORM INITIATIVES Change initiatives are frequently underevaluated. Consequently, the full range of outcomes resulting from the initiatives remains unknown. If initiatives are not carefully evaluated during their formative phases, there is a paucity of information on which to base subsequent decisions having to do with both policies and programs.

Approximately one-sixth of the budget for the DBAE change initiative project has been directed to evaluation. An independent cross-site evaluation team has worked alongside local site evaluators to provide continual critical analysis of the project. The evaluation conducted during the first years of the project has taken its cues from DBAE itself. The evaluators have tried to create vivid and intense narrative reports. There has been a chronicle, not unlike a historical account, of the development of the initiative in the RIG programs. There has been a philosophical and theoretical examination of the educational values and conceptions of art that underlie the programs in the six sites. The evaluation has also been what Eisner (1991) calls "educational criticism." The evaluators have approached each of the DBAE consortia as if it were a work of art, trying to interpret its meanings and merits while attempting to avoid any misunderstanding of its significance and value. The evaluators' reports have provided the basis for long discussions with many hundreds of individuals, from institute directors to classroom teachers. Through negotiations around areas of disagreement, ideas about the meaning and pur-

To remain healthy and vigorous, DBAE *will have to respond to changing societal, artistic, and educational conditions and to the interests of new individuals who decide to join in the continuing task of forming and reforming* DBAE.

pose of art education have expanded enormously.

Educational change in the RIG programs and their 217 school districts indeed constitutes the enormous tapestry described at the beginning of this chapter. This report has tried to interpret the tapestry by pointing to its parts, showing how they have been composed, and explaining how they affect one another. Exquisite details, consisting of exemplary models of what art education has become in some places, have been described. In directing attention to the exemplary, the sometimes larger and duller background areas that represent the less exciting and less innovative versions of art education that still occur in districts and schools throughout the RIG programs have been ignored. Only occasionally, to illustrate or to make a point, have less-than-exemplary features been described.

Conclusion

The DBAE tapestry is still being woven. If the progress to date is any indication, new and significant surprises will emerge. Individuals throughout the RIG programs have realized that change is the basic theme of the DBAE initiative. To remain healthy and vigorous, DBAE will have to respond to changing societal, artistic, and educational conditions and to the interests of new individuals who decide to join in the continuing task of forming and reforming DBAE. To paraphrase a director of one of the RIG programs: Art documents change; in the RIG programs, models for continually responding to change are being created.

Notes
1. Two of the institutes, Nebraska and North Texas, used Ernest Boyer's (1992) "human commonalities" as the basis for selecting works of art that reflect broad human themes. The commonalities that Boyer posits are as follows: all of us experience life cycles, all of us develop symbols, all of us respond to the aesthetic, all of us have the capacity to recall the past and anticipate the future, all of us develop some forms of social bonding, all of us are connected to the ecology of the planet, all of us produce and consume, and all of us seek meaning and purpose.

In 1992 the Regional Institute Grant (RIG) program entered its fifth year, which, according to the original program design, was to be its last. As noted in the prologue and described more fully by Dr. Wilson in the text of *The Quiet Evolution,* the RIGS' work had resulted in

- new versions of DBAE;
- the application of DBAE to performing arts education;
- new understandings about the adoption and implementation of DBAE in K–12 settings;
- a new generation of scholars, teachers, and advocates for discipline-based art education; and
- millions of dollars in matching funding to support arts education reform.

The RIGS' work augmented and strengthened the Getty Education Institute for the Arts' national efforts to improve the quality and status of arts education in the nation's schools—and the extensive grassroots networks they had developed fueled a national movement for arts education reform.

Because of these accomplishments, and the realization that more work needed to be done, the Education Institute decided to reconsider its initial decision to close the program after five years. The Education Institute convened a meeting of its national advisory committee and the regional institute directors to examine what had been accomplished and the potential benefits of sustained funding. As a result of that meeting, the program was extended for another five years.

Building on what the evaluation showed was and was not working in the RIG program, a plan for its next phase was developed by the Education Institute and the RIG directors. It called for a continued effort in professional development and curriculum implementation on two levels:

1 a regional effort focused on strengthening arts education programs in veteran RIG schools and districts through new, advanced professional development programs, improved technical assistance, and expanded networking opportunities—this was called the *core program;*

2 a national effort focused on disseminating "best practices" developed by the RIGS to audiences outside of their regional services areas—this was called the *national specialty program.*

To support long-range planning and program development for this next phase, the Education Institute created two supplemental grant programs for the RIGS. The first supported intensive strategic planning processes by each RIG and involved their key stakeholders, for which each RIG received strategic planning grants. The second supported the design and piloting of national specialty programs, and the Nebraska, Ohio, Tennessee, and Texas RIGS also received grants to design and pilot national specialty programs. They were:

- Nebraska's National Center for Leadership and Collaborative Practice in Discipline-Based Art Education, which prepares leadership teams to develop and implement statewide DBAE reform efforts in their own states;
- Ohio's Leadership Academy, for teams of school or school district personnel, designed to enhance their ability to build and maintain quality DBAE programs, and its national colloquia series on DBAE and contemporary art;
- Tennessee's symposia on the theory and practice of discipline-based music, theater, and dance education; and
- Texas's National Center for Art Museum/School Collaborations—a resource center and information clearinghouse dedicated to improving the quantity and quality of art museum/school collaborations for DBAE.

In 1994, the Education Institute began funding a seventh RIG in California formed from three DBAE summer institutes created in the late 1980s as satellites of the Los Angeles Institute for Educators on the Visual Arts. In 1995, the Education Institute made the difficult decision of ending support for the Minnesota RIG, which had been unable to meet the annual matching grant requirement for two consecutive years.

In 1995, the Education Institute learned that the Annenberg Foundation was willing to consider arts education proposals as part of its $500 million, five-year challenge to the nation to reform the education of children nationwide. With encouragement and financial support from the Education Institute, the California, Florida, Nebraska, Ohio, Tennessee, and Texas RIGs formed the National Arts Education Consortium and prepared a proposal to the Annenberg Foundation for a five-year program called "The Transforming Education Through the Arts Challenge." That program called for the RIGs to work intensively with eighteen schools—clusters of three in each RIG—to demonstrate how a discipline-based arts education linked to whole school reform could contribute to improved student achievement.

While the RIG consortium crafted its proposal to the Annenberg Foundation, the Education Institute obtained new information from a RAND Corporation research team hired to examine options for assessing student learning in RIG schools. The researchers found that because schools defined DBAE differently to meet their students' needs, no common curriculum was in place across schools that would support a national assessment of student achievement. The RAND findings led the Education Institute to reexamine its goals for the RIG program. As a result, it established a new set of goals, which were presented to the RIG directors at their annual meeting in April 1996. Those goals, endorsed by the RIG directors, were to

1 develop models of sequential DBAE curricula;

2 establish strong elementary and secondary DBAE demonstration schools; and

3 determine the impact of DBAE on students' higher-order thinking skills and art knowledge.

These goals fit well with the proposal that the RIG consortium was developing for the Annenberg challenge. The RIGs and the Education Institute agreed that these new

goals would be achieved through the RIGS: (1) working intensively with the eighteen schools funded by the Education Institute and the eighteen schools RIGS hoped would be supported by an Annenberg challenge grant, (2) working as a consortium to develop model curriculum units based on prior efforts, and (3) shifting the focus of the evaluation away from professional development and classroom instruction to student learning.

Having reached consensus about the goals, the Education Institute and the RIG directors agreed that for the next five years, the RIGS needed to work as a national consortium with one overarching governance structure. They also agreed that its curriculum and program development work needed to be done by task forces served by the best qualified people from each of the RIGS. This model would enable the RIGS to function in a unified manner, with common goals, principles, and strategies while still remaining sufficiently flexible to meet regional needs. In addition, it provided the means to create curricula, programs, and ideas that would reflect a melding of best practices developed and tested since 1988.

Shortly after the 1996 directors meeting, the RIGS were awarded a $4.3 million matching challenge grant from the Annenberg Foundation. In recognition of its commitment to the RIG program and of the programs' enormous contributions to the development of DBAE and to arts education reform, the Education Institute extended its funding commitment to the RIG program through the end of the five-year Annenberg grant project. It also awarded the RIG consortium a $1 million grant as the first contribution toward the required match to the Annenberg challenge grant.

In February 1997, the RIG consortium selected 36 of 101 applicants as Arts Partner Schools. Each has made a commitment to place DBAE at the core of its curriculum, link DBAE to school reform strategies, serve as demonstration sites, and participate in a national program evaluation and student assessment. They include rural, urban, and suburban schools in eight states, including fourteen schools that primarily serve at-risk students. Collectively, the Arts Partner Schools serve close to twenty-five thousand students.

What will be the legacy of this multimillion-dollar, fifteen-year research and development effort? Will it be the creation of models of sequential DBAE curricula? Will it be the development of a national network of elementary and secondary schools that demonstrate the power of arts education in a variety of settings? Will it be the creation of successful methods for assessing student learning? Will it be empirical evidence proving the value of placing DBAE at the core of education, at an equal status with math, science, and language arts? Will it be the reform of education through the arts? Or, will the legacy be thousands of students who are able to create art and understand its role in their lives?

It is too early to answer the question of what the legacy of this national research and development effort will be. There is no doubt, however, that it will continue to change the face of arts education for years to come.

Vicki J. Rosenberg
Senior Program Officer
The Getty Education Institute for the Arts

Alexander, C. 1988. A city is not a tree. In *Design after modernism*, ed. J. Thackara, 67–84. New York: Thames & Hudson.

Alpers, S. 1983. *The art of describing: Dutch art in the seventeenth century.* Chicago: University of Chicago Press.

Alpers, S. 1988. *Rembrandt's enterprise: The studio and the marketplace.* Chicago: University of Chicago Press.

Barkan, M. 1962. Transitions in art education. *Art Education* 15(7):12–18.

Baxandall, M. 1985. *Patterns of intention: On the historical explanation of pictures.* New Haven, CT: Yale University Press.

Becker, H. S. 1982. *Art worlds.* Berkeley: University of California Press.

Bjork, C., and **L. Anderson** 1987. *Linnea in Monet's garden.* New York: Farrar, Straus & Giroux.

Boyer, E. 1992 (summer). Educating in a multicultural world. *Access.*

Broudy, H. S. 1983. A common curriculum in the arts and aesthetics. *In Individual differences and the common curriculum: Part 1* (The eighty-second yearbook of the National Society for the Study of Education), eds. G. D. Fenstermacher and J. I. Goodlad, 219–47. Chicago: University of Chicago Press.

Bruner, J. S. 1960. *The process of education.* Cambridge, MA: Harvard University Press.

Bryson, N. 1983. *Vision and painting: The logic of the gaze.* New Haven, CT: Yale University Press.

Bryson, N. 1988. *Calligram: Essays in the new art history from France.* Cambridge: Cambridge University Press.

Clark, G. A., and **E. Zimmerman** 1978. A walk in the right direction: A model for visual arts education. *Studies in Art Direction* 19(2):34–49.

Clark, G. A., **M. D. Day**, and **W. D. Greer** 1987. Discipline-based art education: Becoming students of art. *Journal of Aesthetic Education* 21(2):129–93.

Clark, T. J. 1984. *The painting of modern life: Paris in the art of Manet and his followers.* Princeton, NJ: Princeton University Press.

Crawford, D. W. 1987. Aesthetics in discipline-based art education. *Journal of Aesthetic Education* 21(2):227–38.

Danto, A. 1986. *The philosophical disenfranchisement of art.* New York: Columbia University Press.

Day, M., et al. 1984. *Art history, art criticism, and art production: An examination of art education in selected school districts* (Pub. No. R–3161/2–JPG). Santa Monica, CA: RAND Corporation.

Dewey, J. 1934. *Art as experience.* New York: Minton, Balch.

Dobbs, S. M. 1992. *The DBAE handbook.* Santa Monica, CA: Getty Center for Education in the Arts.

Efland, A. 1992 (April). Knowledge is not a tree: Implications for the curriculum. Paper presented at the annual meeting of the American Educational Research Association, San Francisco.

Eisner, E. W. 1968. Curriculum making for the wee folk: Stanford University's Kettering Project. *Studies in Art Education* 9(3):45–56.

Eisner, E. W. 1991. *The enlightened eye: Qualitative inquiry and the enhancement of educational practice.* New York: Macmillan.

Eisner, E. W., and **S. M. Dobbs** 1986. *The uncertain profession: Observations on the state of museum education in twenty American art museums.* Santa Monica, CA: Getty Center for Education in the Arts.

Fullan, M. 1993. *Change forces: Probing the depths of educational reform.* London: Falmer.

Getty Center for Education in the Arts
1985. *Beyond creating: The place for art in America's schools*. Santa Monica, CA: Getty Center for Education in the Arts.

Greer, W. D., et al. 1993. *Improving visual arts education: Final report on the Los Angeles Getty Institute for Educators on the Visual Arts (1982–1989)*. Santa Monica, CA: Getty Center for Education in the Arts.

Guba, E. G., and **Y. S. Lincoln** 1989. *Fourth generation evaluation*. Newbury Park, CA: Sage.

Hord, S. M. 1986. A synthesis of research on organizational collaboration. *Educational Leadership* 43(5):22–26.

Huizinga, J. 1950. *Homo ludens: A study of the play element in culture*. Boston: Beacon.

Kleinbauer, W. E. 1987. Art history in discipline-based art education. *Journal of Aesthetic Education* 21(2):205–15.

Nochlin, L. 1989. *The politics of vision: Essays on nineteenth-century art and society*. New York: Harper & Row.

Panofsky, E. 1955. *Meaning in the visual arts: Papers in and on art history*. Garden City, NY: Doubleday.

Pepper, S. 1945. *The basis of criticism in the arts*. Cambridge, MA: Harvard University Press.

Pollock, G. 1988. *Vision and difference: Femininity, feminism and histories of art*. London: Routledge.

Ringgold, F. 1991. *Tar beach*. New York: Scholastic.

Risatti, H. 1987. Art criticism in discipline-based art education. *Journal of Aesthetic Education* 21(2):217–25.

Rorty, R. 1992. The pragmatist's progress. In U. Eco, *Interpretation and overinterpretation*, ed. S. Collini. Cambridge, MA: Cambridge University Press.

Sarason, S. 1971. *The culture of the school and the problem of change*. Boston: Allyn & Bacon.

Spratt, F. 1987. Art production in discipline-based art education. *Journal of Aesthetic Education* 21(2):197–204.

Turner, V. Liminality, play, flow, and ritual: An essay in comparative symbology. Unpublished ms.

Turner, V. 1969. *The ritual process: Structure and anti-structure*. Chicago: Aldine.

van Gennep, A. 1960. *Les rites de passage*. Trans. M. B. Vizedom and G. L. Cafee (1908; reprint, Chicago: University of Chicago Press).

Wallace, R. 1969. *The World of Van Gogh: 1853-1890*. New York: Time-Life Books.

Wallach, A. 1993. Revisionist art history and the challenge of cultural diversity. In Getty Center for Education in the Arts, *Seminar proceedings: Discipline-based art education and cultural diversity*, 47–48. Santa Monica, CA: Getty Center for Education in the Arts.

Weitz, M. 1959. The role of theory in aesthetics. In *Problems in aesthetics: An introductory book of readings*, ed. M. Weitz, 145–59. New York: Macmillan.

Wilson, B. 1966. An experimental study designed to alter fifth and sixth grade students perceptions of paintings. *Studies in Art Education* 8(1):33–42.

Wilson, B. 1971. Evaluation of learning in art education. In *Handbook on formative and summative evaluation of student learning*, eds. B. S. Bloom, J. T. Hastings, and G. F. Madaus, 499-558. New York: McGraw-Hill.

Winter, J. 1988. *Follow the drinking gourd*. New York: Knopf.

Getty Education Institute National Evaluation Team

B. Stephen Carpenter, Jr., is assistant professor and program director for art education at Old Dominion University in Norfolk, Virginia. From 1989 to 1991 he taught art in Montgomery County, Maryland, at the elementary, secondary, and special education levels. In May 1996 he received his PH.D. in art education from Pennsylvania State University. Dr. Carpenter was a member of the national evaluation team from 1992 to 1994.

Bonnie Lee MacDonald is a doctoral candidate in art education at Pennsylvania State University. In 1994 she received her M.A. in art education from the Rhode Island School of Design in Providence. She is the recipient of the Academic Computing Fellowship sponsored by Bell Atlantic at Penn State for 1995–98. Ms. MacDonald served as a member of the national evaluation team in 1995.

Melinda Mayer holds the position of lecturer in the School of Visual Arts at the University of North Texas. She was an instructor in the art department at Brookhaven College in Dallas from 1981 to 1988. While pursuing her doctorate at the Pennsylvania State University, she received a doctoral dissertation fellowship from the Getty Education Institute. She served as an evaluator from 1992 to 1995.

Kathie Kirk McBride teaches art at the Buckley School in Sherman Oaks, California, where she has taught since 1992. She earned her M.A. at California State University, Northridge. Ms. McBride served as assistant evaluator on the national evaluation team from 1992 to 1994.

Juliet G. Moore is a doctoral student in art education at Pennsylvania State University. She earned her undergraduate degree in archaeology from the University of London and her M.S. in anthropology

from Penn State. In 1994 she received a doctoral fellowship from the Getty Education Institute. Ms. Moore served as a member of the national evaluation team in 1991, 1993, and 1994.

Blanche Rubin is currently head of the national evaluation team for the Getty Education Institute for the Arts. She was co-evaluator of the Los Angeles Institute for Educators on the Visual Arts from 1984 to 1990. Dr. Rubin has a doctorate in art education from Indiana University and has taught at Northern Illinois University and California State University at Northridge. She served with Brent Wilson from 1993 to 1996 as coevaluator of the national evaluation team.

Billie Sessions is an assistant professor of art education at California State University, San Bernardino. A recipient of both a Fulbright scholarship and a grant from the National Endowment for the Humanities, in 1996 she received a doctoral dissertation fellowship from the Getty Education Institute. Ms. Sessions served as a member of the national evaluation team in 1995.

Pamela Taylor currently teaches art at Christiansburg High School in Virginia. Before becoming an art teacher she worked as a newspaper graphics editor, book illustrator, and ballet instructor. She served on the national evaluation team in 1995 and 1996.

Mary Tien received a certificate to teach public school art prior to becoming a candidate in the Pennsylvania State University PH.D. program. She received two degrees in art history before changing her major to art education. She served as a member of the national evaluation team from 1994 through 1996.

John White is assistant professor of art education at Kutztown University in Pennsylvania. He received his MFA degree in painting before he began his art teaching career in private schools in Pennsylvania and California. He received a Getty Education Institute doctoral dissertation fellowship in 1992. Dr. White was a member of the national evaluation team in 1990 and 1991.

Brent Wilson is professor and head of art education at Pennsylvania State University. From 1982 to 1985 he was a member of a team of seven researchers who conducted an inquiry into art education (reported in *Beyond Creating*). In 1987 he served as a consultant to the National Endowment for the Arts to conduct research and draft *Toward Civilization*, a report to the president and Congress on the status of art education in the United States. Professor Wilson served as principal evaluator of the national evaluation team from 1988 to 1996.

Anne G. Wolcott is the fine arts coordinator for Virginia Beach City Public Schools. She received a PH.D. in art education from Pennsylvania State University. From 1991 to 1994 she was an assistant professor of art education at East Carolina University in Greenville, North Carolina. Dr. Wolcott served on the national evaluation team from 1988 to 1990.

Shirley Yokley is currently assistant professor of art education at Kent State University in Ohio. From 1986 to 1991 she was state art consultant in the Tennessee Department of Education. She taught art in public schools from 1974 to 1986. Ms. Yokley served as a member of the national evaluation team in 1992.

Regional Institute Grant Program Guidelines
and Application Procedures (1986)

Introduction The goal of the Getty Center for Education in the Arts is to improve the quality and status of arts education in elementary and secondary grades of United States public schools. The Center supports the establishment of visual arts education programs which integrate content and skills from four disciplines that contribute to the creation, understanding, and appreciation of art: art-making, art history, art criticism, and aesthetics. This approach is known as "discipline-based art education."

One means by which the Center can achieve its goal is through the training of school personnel. To this end, it is initiating a two-phase grant program involving the planning and the establishment of regional institutes for visual arts education programs.

The Regional Institute Grant Program is based on two premises. The first is that development of district-wide visual arts education programs integrating content and skills from the four art disciplines can be achieved through staff-development and curriculum-implementation programs. The second is that to ensure that the discipline-based approach is widely used, such programs need to be developed by a greater number of school districts throughout the country.

There are many models for staff development and curriculum implementation. The Center currently is piloting one model through its Getty Institute for Educators on the Visual Arts in Los Angeles. While this model is effectively preparing school personnel to plan and implement discipline-based art education programs in elementary grades, the Center is interested in supporting the development of regional institutes in other parts of the country which adapt or replicate the Los Angeles model, or which provide new models for staff development and curriculum implementation. A brochure describing the Getty Institute/Los Angeles is enclosed for your information.

Regional institutes should primarily be designed for elementary and secondary school personnel. Applications for planning grants requesting up to $20,000 are due December 1, 1986. Recipients of planning grants may apply for multi-year implementation grants in September 1987. Guidelines and application procedures are covered on the following pages.

Regional Institute Grant Guidelines

The purpose of regional institutes is to prepare school personnel to implement district-wide discipline-based visual arts education programs. The discipline-based approach is characterized by the use of written sequential curricula (written lessons for each grade) which enable students to develop their abilities for making and examining art, as well as reading and talking about art.

Applicants should consider the following when developing proposals for planning and implementation grants:

1 Regional institutes should be planned for three-to-five year periods and should be comprised of staff-development and curriculum-implementation components.

2 Participants in these institutes should include school board members, superintendents and other district administrative personnel, principals, art specialists, and general classroom teachers.

3 Applicants may determine whether their plan will focus on elementary, junior high, and/or senior high grades.

4 Applicants may determine a) the geographic area to be included in the proposed institute (city, county, state, or multistate area) and b) the number of participating school districts.

Eligibility Regional institute grants will be awarded in two phases: 1) planning and 2) implementation.

Eligibility for *planning grants* is limited to consortia comprised of representatives from university art, art education, art history, aesthetics and/or education faculties, school districts, art museums, and other relevant cultural organizations. Collaboration with state arts councils and education agencies is encouraged but not required.

Eligibility for *implementation grants* will be limited to recipients of planning grants.

Planning Grants: Guidelines and Application Procedures

Guidelines Planning grants of up to $20,000 each will be awarded based on competitive review by a panel of experts. No cash or in-kind match is required, although both are encouraged. Overhead is not normally an eligible cost. Costs which are eligible include:

- consultant services, including fees and expenses (fees not to exceed $250 per day);
- meeting costs;
- expenses for two members of the consortium to attend the 1987 Getty Institute for Educators/Los Angeles; and
- literature searches and other relevant research costs.

Application Procedures There is no application form. Proposals should be no longer than 15 pages (excluding attachments) and should include the information requested below. A separate, clearly labeled section should be devoted to each item.

Please submit five complete copies of the proposal and attachments by Monday, December 1, 1986. Notification of awards will be given by March 1987.

Planning grant proposals should include:

1 A one-to-two page summary of the proposed planning project.

2 A narrative proposal no more than 13 pages long presenting the following:

- Identification and description of each consortium member organization involved in the planning process, including a) a letter from each expressing intent to be a consortium member and b) the names of project personnel from each and their responsibilities in the

planning process. Also, please indicate why each was selected.

- Discussion of the planning process to be followed, including the identification and expected outcome of each task, and the process for selecting the art curricula and other instructional materials to be used during curriculum implementation.
- Name consultants — including representatives from art education and the four art disciplines — and identify their responsibilities during the planning process. (Include a resume of no more than three pages per person and a letter from each expressing intent to serve.)
- Discussion of state art education policies, including K-12 requirements. (Enclose copies of state guidelines and/or policies.)
- Time line for planning tasks.
- Budget including a) amount and narrative explanation for each budget item and b) amounts and sources of any non-Getty funds (cash and in-kind).
- For the consortium member designated as fiscal agent, attach its current operating budget, financial statement (preferably audited), and proof of Internal Revenue Service nonprofit designation.

Reporting By September 14, 1987, planning grant recipients will be expected to submit five copies of the following:

1 A detailed narrative description of the activities completed during the planning process and the outcomes of each.

2 A full financial reporting of the grant.

3 A proposal for a regional institute implementation grant (see guidelines starting on page 9).

Receipt of a planning grant does not necessarily imply receipt of an implementation grant. All applications will be subject to competitive review by a panel of experts, with awards contingent upon:

- the outcomes of the planning process and proposed implementation plan;
- evidence that grant finances have been soundly managed; and
- the consortium's potential to raise the required matching funds for implementation. (See page 12 for information on the match.)

Notification of implementation grants will be made by February 1988.

Implementation Grants: Guidelines and Application Procedures

Guidelines Implementation grants of up to $125,000 per year for three to five years will be awarded based on the outcomes of the planning process, the proposed implementation plan, evidence that planning grant finances have been soundly managed, and the applying consortium's potential to raise the required matching funds.

Application Procedures There is no application form. Proposals should include the information listed below. A separate, clearly labeled section should be devoted to each item.

Please submit seven complete copies of the proposal and attachments by September 14, 1987. Notification of awards will be given by February 1988.

Implementation grant proposals should include:

1 A narrative description of the goals, activities, and time line for a three-to-five year regional institute comprised of a staff-development and a curriculum-implementation component (number of years to be determined by applicant).

2 Discussion of the proposed program and time line for staff-development activities, including, but not limited to, a discussion of:

- sessions for different categories of school personnel (school board members, superintendents, principals, art specialists, and general classroom teachers);
- expected outcomes of these sessions (i.e., what participants attending these sessions are expected to do as a result of their participation);
- program schedule including, for example, proposed lectures, small group sessions, museum visits, and other activities; and
- written sequential art curricula and supplementary instructional materials to be used.

3 Discussion of the proposed program and time line for the curriculum-implementation component, including, but not limited to, a discussion of:

- expected outcomes for all categories of participants;
- monitoring progress of district-wide implementation; and
- assessing student learning.

4 Identification of individuals who will serve as the institute's consultants and faculty (including art educators and representatives from the four art disciplines), and a discussion of their responsibilities. (Attach their resumes and letters of intent to participate.)

5 Job description for key institute personnel and three-page resumes of individuals proposed for these positions.

6 Discussion of how the institute will be evaluated and who will do the evaluation. Locally based evaluators are preferred. (Attach a resume for evaluator(s) to be used.)

7 Detailed outline of printed materials to be prepared for participants' use during staff development and curriculum implementation.

8 Discussion of the characteristics and number of school districts to participate each year of the institute, including the process by which the districts will be selected.

9 Discussion of how participating school districts will assume increasing responsibility for curriculum implementation over the course of their involvement in the institute and how the district will maintain the program.

10 Detailed budget for each complete year of a regional institute (three to five years), including preparation, implementation, and evaluation of the staff-development and curriculum-implementation components (see Appendix 1, page 19).

11 Discussion of potential funding sources for the required annual match described below. The Center's share of the total cost will not exceed $125,000 per year. At least 50 percent of the first year's match must be secured by grant recipients within six months of

notification by the Center. In years two through five, the required match must be secured at least two months prior to the start of each year.

The first year, the Center will provide a payment of $50,000 prior to notification of matching funds. The remainder of the grant will be released in increments of $25,000 or more upon receipt of a letter indicating that recipient has raised the matching funds; copies of the award letter(s) or other satisfactory evidence must also be included.

In years two through five, the Center's funds will be released in increments of $25,000 or more upon receipt of proof of the match.

Matching Requirements **Year 1**: A 50% match ($0.50 to $1) is required, of which up to 25% may be in in-kind services. **Year 2**: A 75% match ($0.75 to $1) is required, of which up to 25% may be in in-kind services. **Years 3, 4, and 5**: A 100% match ($1 to $1) is required, of which up to 25% may be in in-kind services.

Reporting Instructions for reporting on regional institute implementation projects will be given in the grant award letters.

For More Information, Contact:

Vicki Rosenberg
Program Officer
Getty Center for Education in the Arts
1875 Century Park East, Suite 2300
Los Angeles, California 90067
213 277.9188

Background and Philosophy The Getty Center for Education in the Arts was established by the J. Paul Getty Trust in 1982 because of the conviction that the ideas and values communicated through the visual arts should be an essential part of every child's education. The Center's goal is to improve the quality and status of arts education in United States public schools. Its primary focus is on visual arts education.

Art has not been recognized in United States public school systems as a subject vital to educational development and to a balanced curriculum. In order to help make art central to general education, the Center is committed to supporting an approach which integrates content from four disciplines: art-making, art history, art criticism, and aesthetics. This approach is called "discipline-based art education."

Instruction in each of these four disciplines contributes significantly to an understanding of art, not only enriching children's artistic creations but also building their ability to grasp art's various cultural and historical contexts and examine the powerful ideas art transmits. An effective discipline-based program enables children to develop increasingly sophisticated abilities to produce, describe, interpret, and analyze artworks.

The Center has undertaken a series of projects designed to demonstrate and further develop the concepts of discipline-based art education. Included among these are the

National Case Study Project and the Getty Institute for Educators on the Visual Arts, a pilot staff-development and curriculum-implementation program involving 21 public school districts in Los Angeles County.

The findings from these two projects are relevant for potential grant applicants because they provide useful information about developing and maintaining discipline-based programs.

Findings of the National Case Study Project During 1983–1984, the Rand Corporation and five art education and education researchers prepared case studies, at the Center's request, of seven school districts around the nation attempting to implement visual arts programs in grades K-12 which integrated content and skills from the four art disciplines identified above.

Each case study was analyzed to determine those characteristics present in all seven programs which contributed to their successful implementation. These characteristics were:

- a clearly stated set of goals and objectives;
- a written sequential curriculum comprised of lesson plans with content from the four art disciplines;
- support from superintendent and other central office administrative personnel in school districts;
- leadership and commitment from principals;
- collaboration with museums, artists, and other community cultural resources;
- staff-development programs for teachers, art specialists, and school administrators;
- procedures for assessing student achievement;
- strategies for annual program review and evaluation; and
- availability of adequate instructional time, space, financial resources, and expert consultants.

Findings of the Getty Institute for Educators on the Visual Arts/Los Angeles In 1983 the Center initiated a pilot staff-development and curriculum-implementation program with public school districts in Los Angeles County. The purpose of this program is to help establish art as a regular and basic course of study in elementary schools by preparing school personnel to implement district-wide discipline-based programs.

A five-year program was designed for the 21 participating districts which includes an annual summer staff-development component and a year-long curriculum-implementation component during the school year.

The pilot program begins its fourth year in summer 1986. During the past three years, the following factors have been identified as contributing to the Los Angeles Institute's effectiveness:

1 Commitment of superintendents and school board members to establishing and maintaining an art program as a part of a balanced curriculum.

2 Districts' participation involves teams comprised of school board representatives; central office personnel (i.e., assistant superintendent for curriculum); art and general classroom teachers and their principals.

3 Staff development program of sufficient duration to extend participants' knowledge about art.

4 Content of staff-development program delivered by art educators and by representatives of the four art disciplines (artists, art historians, art critics, aestheticians).

5 Presentation of theoretical information combined with practical-application demonstrations and practice teaching opportunities.

6 Giving district teams responsibility for developing and carrying forward their own district-wide implementation program.

7 Adoption of written sequential curricula selected from those available commercially or developed by the district and supplemented with instructional resources. "Curricula" is used here to mean sets of lesson plans for each grade level which are written, sequenced to encourage cumulative learning, and which present content and skills from the four art disciplines.

APPENDIX 1

Budget Format Source and Amount

Budget Item	Total Budget	Grant Amount	Cash/In-Kind Match
No.[1]	No.[2]	No.[3]	No.[4]

Instructions No.[1] Identify the item (e.g. Consultants) and provide detailed information, including how the total amount was arrived at. For consultants this would be the daily consulting fee, travel, and expenses. No.[4] Please identify whether the match is cash (c) or in-kind (ɪ ᴋ) and the source of the match.

In order that the Center may see the project's total cost, please include all expenses — even if funds to cover that expense are not part of the grant request.

Regional Institute Participants and Partners, 1988–95

FLORIDA INSTITUTE FOR ART EDUCATION

DIRECTORS
Jessie Lovano-Kerr
Nancy Roucher

STAFF
Bonnie Bernau
Sandra Bird

EVALUATORS
Mary Ellzey
Catherine Emihovich
Cornelia Orr

FACULTY
Bonnie Bernau
Elizabeth Delacruz
Philip Dunn
Carol Edwards
Marilyn Stewart
Ron Yrabedra

CONSULTANTS
Marianna Adams
Lynn Anderson
Tom Anderson
Charles Benbow
Debi Barrett-Hayes
Terry Barrett
Almando Alvarez Bravo
Harry S. Broudy
Larry Cahill
David Courtney
Bruce Crowe
Michael Day
Elizabeth Delacruz
Sandra Dilger
Suzette Doyon-Bernard
Jerry Draper
Carol Edwards
Diane Elmeer
Dwaine Greer
Glenn Harper
Janice Hartwell

Susan Hazelroth
Robert Hobbs
Dorothy Johnson
Janet King
Helen Kohen
Sally McRorie
Randy Miley
Vicki Miley
Margaret Miller
Gene Mittler
James Murphy
Robert Neuman
Dale Olson
Mark Ormond
Michael Parsons
Martin Payton
Patricia Rose
Jean Rush
Michele Scalera
Arthur Shapiro
Ronald Silverman
Esther Smith
Patrick Smith
Patricia Thompson
Sydney Walker
Susan Weinstock
Catherine Westcott
Maude Wohlman
Ron Yrabedra

PARTICIPATING SCHOOL DISTRICTS
Brevard County
Citrus County
Collier County
Columbia County
Escambia County
Indian River County
Jackson County
Lake County
Leon County
Levy County
Manatee County
Marion County
Martin County
Okaloosa County

St. Lucie County
Santa Rosa County
Sarasota County
Florida State University School
Maclay School
Holy Comforter School
Thomasville, GA

PARTNERS
 Museums:
Appleton Museum
Brevard Art Center and Museum
Daytona Beach Museum of Arts and
Science
Harn Museum of Art
Museum of Art Fort Lauderdale
Norton Gallery and School of Art
Orlando Museum of Art
Pensacola Museum of Art
Ringling Museum of Art
Wolfsonian Foundation

 State Agencies:
Florida Department of Education
Florida Department of State, *Division
of Cultural Affairs*

 Professional and Art Associations:
Florida Alliance for Arts Education
Florida Art Education Association
Florida Association for Public School
Administrators
Florida Association of School Boards
Florida Council for Parent Teacher
Associations

 Colleges and Universities:
Florida State University

 Other:
Very Special Arts Florida

 Funders:
Florida Arts Council
Florida Department of Education
Florida State University Research

Foundation
John E. Galvin Fund
Gannett Foundation
Jessie Ball duPont Fund

THE MINNESOTA DBAE CONSORTIUM

CODIRECTORS
Margaret DiBlasio
Thomas McMullen
Susan Rotilie

STAFF
Mary Apuli
Susan Euler
Carol Wickland

FACULTY
Michael Day
Marcia Eaton
Mary Erickson
Susan Euler
Allison Kettering
Richard Kimpston
Kent Nerburn

FACILITATORS
Mark Baden
Roger Tom

MUSEUM PROGRAM COORDINATORS
Allison Aune, *Tweed Museum*
Martin Dewitt, *Tweed Museum*
David Henry, *Walker Art Center*
Kate Johnson, *Minneapolis Institute of Art*
Susan Kual, *Talley Gallery*
Colleen Sheehey, *Weisman Art Museum*
Kris Wetterlund, *Minneapolis Institute of Art*

NORTH TEXAS INSTITUTE FOR EDUCATORS ON THE VISUAL ARTS

CODIRECTORS
D. Jack Davis
R. William McCarter

PROJECT COORDINATORS
Nancy Cason
Nancy Elizabeth Walkup

GRADUATE RESEARCH ASSISTANTS
Rebecca Arkenberg
Cassandra Broadus-Garcia
Jo Carlson
Pam Stephens
Kay Wilson

OFFICE MANAGER
Harriet Laney

FACULTY AND CONSULTANTS
Nancy Berry
Harlan Butt
Jacqueline Chanda
Russ Chapman
D. Jack Davis
Mary Erickson
Larry Gleeson
Karen Hamblen
Sam Heath
Barbara Ivy
Lois Jones
R. William McCarter
Monica Michell
Pam Morrison
Celia Muñoz
Connie Newton
Eva Orr
Pamela Patton
Susan Platt
Don Schol
Alisha Slough
Mary Lynn Smith
Pam Stephens
Marilyn Stewart
Scott Sullivan
Mark Thistlethwaite
Nancy Walkup
Kay Wilson
Jeff Young
Jon Young

EVALUATORS
Joan Bush
Joann Canales
Pam Stephens
Kay Wilson

ASSOCIATE DIRECTORS/SITE COORDINATORS
Lynda Alford, *Plano*
Beverly Fletcher, *Fort Worth*
Sylvia Russell, *Pilot Point*
Jan Schronk, *Hurst-Euless-Bedford*
Rhonda Sherrill, *Denton*
Janice Wiggins, *Dallas*

INSTITUTE DISTRICT LEADERS
Jane Bayne, *Plano*
Lynda Smith Collier, *Dallas*
Jill Davis, *Hurst-Euless-Bedford*
Kathy Davis, *Dallas*
Jan Dodd, *Hurst-Euless-Bedford*
Amy Field, *Plano*
Deborah Gentile, *Fort Worth*
Laurie Gowland, *Hurst-Euless-Bedford*
Jill Gregory, *Dallas*
Susan Green, *Hurst-Euless-Bedford*
Anita Hilburn, *Plano*
Lauren Killam, *Denton*
Don Lawrence, *Dallas*
Diane McClure, *Fort Worth*
Berniece Patterson, *Denton*
Jonelle Peters, *Plano*
Suzi Alost Reid, *Fort Worth*
Sylvia Russell, *Pilot Point*
Gloria Sepp, *Fort Worth*
Barbara Shafer, *Hurst-Euless-Bedford*
Carolyn Sherburn, *Fort Worth*
Rhonda Sherrill, *Denton*
Gene Simmons, *Fort Worth*
Bobbie Sniderwin, *Plano*
Donna Stovall, *Hurst-Euless-Bedford*
Chris Thomason, *Dallas*
Sharon Warwick, *Hurst-Euless-Bedford*
Bill Yarborough, *Keller*
Denise Zwald, *Hurst-Euless-Bedford*

MUSEUM PROGRAM COORDINATORS
Nancy Berry, *Dallas Museum of Art, University of North Texas*
Gail Davitt, *Dallas Museum of Art*
Melinda Mayer, *Amon Carter Museum, University of North Texas*
Maria Teresa Garcia Pedroche, *Meadows Museum, Southern Methodist University*
Aileen Horan, *Dallas Museum of Art*
Marilyn Ingram, *Kimbell Art Museum*
Allison Perkins, *Amon Carter Museum*
Linda Powell, *Modern Art Museum of Fort Worth, Kimbell Art Museum*
Terry Thornton, *Modern Art Museum of Fort Worth*

PARTICIPATING SCHOOL DISTRICTS
Dallas Independent Schools
Denton Independent Schools
Fort Worth Independent Schools
Hurst-Euless-Bedford Independent Schools
Pilot Point Independent Schools
Plano Independent Schools

TUITION-BASED SCHOOL DISTRICTS
Allen
Argyle
Aubrey
Birdville
Carroll
Clear Creek
Corpus Christi
Country Day School (*Private*)
DeSoto
El Paso
Everman
Grapevine/Colleyville
Highland Park
Highlander School (*Private*)
Keller
Lewisville
Little Elm
McKinney
Mesquite
Midway (*Waco*)
Northside (*San Antonio*)
Northwest
Ponder
Round Rock
St. Philips School (*Private*)

PARTNERS
Museums:
Amon Carter Museum
Dallas Museum of Art
Galveston Arts Center
Kimbell Art Museum
McNay Art Museum
Meadows Museum
Modern Art Museum of Ft Worth
Museum of South Texas
San Antonio Museum of Art
Tyler Museum of Art

State Agencies:
Texas Arts Commission
Texas Education Agency

Arts Councils:
Greater Denton Arts Council

Colleges and Universities:
The University of North Texas

Funders:
Amon G. Carter Foundation
Arts Guild of Denton
Crystelle Waggoner Charitable Trust

Edward and Betty Marcus
Foundation
Greater Denton Arts Council
Individual Donors

THE OHIO
PARTNERSHIP FOR
THE VISUAL ARTS

CODIRECTORS
Nancy MacGregor
Michael Parsons

STAFF
Cassandra Broadus
Richard Ciganko
Debie Drew
Donald Glenn
Bryan Grove
William Harris
Don Killeen
Laurel Lampela
Jill Markey
Sevenda Newell
Betty O'Brien
Mary Louise Poling
Sally Shumard
Paul Sproll
Cheryl Williams

EVALUATION
Cassandra Broadus
Dennis Cannon
Aryes D'Costa
Timothy Gerber
Bob Kimball
Sue Shafer

FACULTY
Bonita Agnew
M. J. Albacete
Dianne Almendinger
Mary Angeli
Anna Araca
Carole Arnold
Robert Arnold
Sharon Aunchman
Terry Barrett
Tim Best
Judith Beckman
Paula Benfer
Betsy Blodgett
Joe Bonifas
Margaret Brand
Gerald Brommer

Carol Brown
Ernestine Brown
Lee Brown
Rhonda Brown
Penny Buchanan
Jay Bumbaugh
Sharon Butcher
Dennis Cannon
Jacqueline Chanda
Laura Chapman
Michael Chipperfield
Richard Ciganko
Ron Clark
Gerald Coburn
Liz Cole
Don Cramer
Carol Cruikshank
Shawn Crumb
Deb Cummings
Lynette Dakoski
Ayres D'Costa
Willis Digman
Vesta Daniel
Willis Bing Davis
Kathleen Desmond-Easter
William Dowling
Arthur Efland
Chip Edelsberg
Roberta Ehre
Mike Estes
Edmund Feldman
Paul Ferguson
Linda Fisher
Maria Fleming
Lois Flinn
Mark Foradori
Sally Ford
Farrell Forman
Carole Genshaft
Timothy Gerber
Jim Gertz
Carol Gigliotti
Bryan Grove
Sue Guenther
Susan Hadley
Janice Hamilton
Andrea Harcher
Bill Harris
Donald Harris
Ann Heineman
Mathew Herban
Jerry Hertenstein
Paul Hooge
Judith Hubble-Smith

Michael Huffman
Jim Hutchens
Amy Ivanoff
Gerald Karlovec
Elizabeth Katz
Sue Kennedy
Sandy Kight
Judith Koroscik
John Kratus
Don Krug
Sue Ladd
Laurel Lampela
Louis Lankford
Sun-Young Lee
David Lepo
William Loadman
Nancy Lohr
David Lyman
Kenneth Marantz
Kay Mason
Jerry Mallet
Jill Markey
Elaine Mason
Jim Mason
Peter Massing
Roger Masten
Robert Mazur
Bev McCoy
Craig McDaniel
Mike McEwan
Robert McLinn
Mark McQuire
Jack McWhorter
Bill Mease
Edie Mellen
Susan Meyers
Juliette Montague
Brigid Moriarty
Diane Muth
Richard Myer
Kathy Nasara
Ellen Nelson
Janet Nicodemus-Reger
Sandra Noble
John Owens
Michael Parsons
Louis Pernell
Donna Peters
Doris Pfeuffer-Guary
Jan Plank
Mary Anne Popovich
Amber Potter
Mallagros Quesada
Kay Raplenovich
Glenn Ray
Francis Richardson

Martin Russell
Vonnie Sanford
Tony Scott
Claire Schaefer
Connie Schalinske
Marjorie Schiller
Steven Schneider
Sarah Schuster
Sue Shafer
Sue Sherlock
Tim Shuckerow
Sally Shumard
Judy Singer
Babette Sirak
Pat Smith
Mina Smoot-Cain
Katherine Solender
Susan Spero
Paul Sproll
Anne Stellwagen
Robert Stearns
Patricia Stuhr
Patricia Trumps
Jerry Tollifson
Diana Turner-Forte
Tom Tuttle
Linda Vaughan
Linda Walker
Sydney Walker
Franklin B. Walters
Robyn Wasson
Elaine Weber
Sue Weirick
Margerie Williams
Sally Windle
Dick Worthing
Mary Zahner

CONSULTANTS

Terry Barrett
Gerald Brommer
Jacqueline Chanda
Laura Chapman
Vesta Daniel
Arthur Efland
Edmund Feldman
Carole Genshaft
Timothy Gerber
Carol Gigliotti
Jim Hutchens
Judith Koroscik
Don Krug
Louis Lankford
William Loadman
Kenneth Marantz

Michael Parsons
MaryAnne Popovich
Victor Rentel
Vonnie Sanford
Jerry Tollifson
Sydney Walker

PARTICIPATING SCHOOL DISTRICTS

Allen East Local Schools
Alliance City Schools
Bath Local Schools
Beechwood City Schools
Boardman Local Schools
Brooklyn City Schools
Bryan City Schools
Bucyrus Schools
Canton City Schools
Canton Local Schools
Cleveland Public Schools
Columbus Public Schools
Crestview Local Schools
Dublin City Schools
Elida Local Schools
Euclid City Schools
Galena City Schools
Jackson Local Schools
Lake Local Schools
Lakewood Schools
Lima Public Schools
Lucas Local Schools
Madison Local Schools
Mansfield City Schools
Massillon City Schools
North Ridgeville Schools
Northwest Local Schools
Ontario Local Schools
Parma City Schools
Paulding County Schools
Perry Local Schools
Plain Local Schools
Sandy Valley Schools
Shaker Public Schools
Shawnee Local Schools
Southwest Schools
Spencerville Local Schools
St. Charles Parochial Schools
Tuslaw City Schools
Upper Arlington City Schools
Waynesfield Local Schools

PARTNERS
Museums:
Akron Art Museum
ArtsSpace Lima
Canton Art Institute
Cincinnati Art Museum

Cleveland Museum of Art
Columbus Museum of Art
Contemporary Art Center
The Dayton Art Institute
Mansfield Art Center
National Afro-American Museum
The Ohio Historical Society Museum
OSU Wexner Center for the Visual Arts
Taft Museum
The Toledo Museum of Art

State Agencies:
Ohio Alliance for Arts in Education
Ohio Department of Education

Professional and Art Associations:
Ohio Museums Association

Colleges and Universities:
Ashland University
Case-Western Reserve University
Cleveland State University
Kent State University
The Ohio State University, Columbus
The Ohio State University, Lima
The Ohio State University, Mansfield
The Ohio State University, Marion
University of Cincinnati
University of Dayton
University of Toledo

Other:
The Martin Luther King, Jr. Center

FUNDERS
Ohio Arts Council
Ohio Department of Education
The Ohio State University

PRAIRIE VISIONS: THE
NEBRASKA CONSORTIUM
FOR DISCIPLINE-BASED
ART EDUCATION

DIRECTOR
Sheila N. Brown

STAFF
Audrie Berman
Nicolette Bonnstetter
Christine Filbin Hoffman
Linda L. Lyman
Margaret Proskovec

EVALUATION
Gary Hoeltke
Tad Waddington

CONSULTANTS
Lana Danielson
Gary Day
Michael Gillespie
Martin Rosenberg
Joanne Sowell
Frances Thurber

FACULTY
Deb Babbitt
Karen Bolton
Penny Businga
Melody Cejka
John Clabaugh
Carl Clark
Charles Collins ·
Cindy Cronn
Carole DeBuse
Jean Detlefsen
Gail Dickel
Barbara Dinslage
John Dinsmore
Sandy Dreiling
Donald Dynneson
Mitch Egeberg
Mimi Ernst
Gail Erwin
Linda Freye
Pearl Hansen
Milton Heinrich
Sheila Hubbard
Karen Janovy
Jan Jones
Linda Jorgensen
Deborah Kippley
Christy Kosmicki
Ellen Kuhl
Kathy Lewis
Cindy Mangers
Larry Mannlein
Sally Mannlein
Gail May
Arlen Meyer
Jeanine Mohr
Elaine Morgan
Elizabeth Murphy-Brill
Betty Nelson
Gary Nickels
Gretchen Peters
Dennis Restau
Pat Schulz
Sharon Seim

Jeff Stern
Bev Stitt
Amy Tomasevicz
Linda Weinert
Tom Wise
Lance Wurst
Gary Zaruba

CONSULTANTS
Graham W.J. Beal
Katey Brown
Erik Clark
Nancy Dawson
Margaret DiBlasio
Anne El-Omami
Donna Flood
Elizabeth Garrison
Pat Geary
Ruth Gendler
Dwaine Greer
Jerry Gronewold
Jerome Horning
Margo Humphrey
Matthew Sitting Bear Jones
Karen Kunc
Christin Mamiya
Rhinehold Marxhausen
Jim May
Nancy McCleery
John McKirahan
George Neubert
Jan Norman
Connie Tometich
Larry Peterson
Norman Ronell
Nancy Round
Toni Santmire
Martin Skomal
Marvin Spomer
Mark Thistlethwaite
Suzanne Wise
Carol Wyrick

PARTICIPATING SCHOOL DISTRICTS
Alliance
Arlington
Arnold
Arapahoe
Auburn
Banner County
Beatrice
Bellevue
Benedict
Blair

Bloomfield
Brady
Bridgeport
Broken Bow
Burwell
Cairo Centura
Callaway
Chadron
Chappell
Clarkson
Columbus
Dawson County
Elba
Elm Creek
Gering
Gothenburg
Grand Island
Grand Island Northwest
Grant
Gretna
Henderson
Hemingford
Holdrege
Hyannis
Imperial
Kearney
Lewiston Consolidated
Lexington
Lincoln County
Lincoln Diocese: *Hastings St. Cecelia,*
Lincoln Pius X, Nebraska City Lourdes,
Wahoo Neumann
Lincoln Public Schools
Lincoln Lutheran
Louisville
Loup County
Millard
Minden
Mitchell
Morrill
Nebraska City
Norfolk
North Platte
Ogallala
Omaha Archdiocese:
Bellevue St. Mary/Gross,
Blessed Sacrament, Christ the King,
Columbus Catholic, Elgin St. Boniface,
Fremont Bergan, Holy Cross/Mercy,
Holy Ghost, Marion High School,
Mary Our Queen, Norfolk Catholic,
Skutt High School, Sts. Peter & Paul,
St. Philip Neri, St. Bernard/Roncalli
High, St. Cecilia, St. Margaret Mary,
St. Thomas More, St. Wenceslaus
Palmyra

Papillion-LaVista
Phelps County
Pierce Zion Lutheran
Plattsmouth
Rising City
St. Edward Public
Santee
Scottsbluff
Seward
Seward St. John Lutheran
Shelby
Sidney
Southern Valley Schools
Stapleton
Sterling
Syracuse-Dunbar-Avoca
Tecumseh
Valley
Wallace
Weeping Water
Westside Community Schools
Wheatland-Madrid
Winnebago
Wymore Southern
York

PARTNERS
Museums:
The Joslyn Art Museum
The Museum of Nebraska Art
Plains Art Museum, North Dakota
The Sheldon Memorial Art Gallery
The West Nebraska Arts Center

State Agencies:
Educational Service Units (19)
Nebraska Department of Education
Nebraska Humanities Council

Professional and Art Associations:
Nebraska Art Teachers Association
Nebraska Association for Supervision
and Curriculum Development
Nebraska Association of School Boards

Colleges and Universities:
Concordia Teachers College, *Seward*
Creighton University, *Omaha*
Dana College, *Blair*
Peru State College, *Peru*
Shadron State College, *Shadron*
University of Nebraska at Kearney
University of Nebraska–Lincoln
University of Nebraska at Omaha

Funders:
The Community Discovered
Cooper Foundation
Nebraska Art Association
Nebraska Arts Council
Nebraska Department of Education
Nebraska Humanities Council
Phillips Petroleum Foundation
Seacrest Foundation
University of North Texas Foundation
Woods Charitable Fund, Inc.

THE SOUTHEAST INSTITUTE
FOR EDUCATION IN THE
VISUAL ARTS

DIRECTORS
Anne Lindsey
Helen Arthur, *assistant director*
Kathryn Cascio, *assistant director*

EVALUTORS
Ed Asmus
Ted Miller

FACULTY
Kay Alexander
Liz Aplin
Deborah Arfken
Garry Barker
Eugene Bartoo
Gaye Bradley-Ogle
David Brodsky
Andree Caldwell
Jacque Casey
John Cline
Jim Collins
Susan Cooper
George Cress
Christie Cundiff
Phillip Dunn
Ruth Gassett
Joe Giles
William Gottlieb
John Guinn
Glenn Harper
Dana Hatheway
Joe Helseth
Frances Hostetler
Richard Hunt
Cynthia Irace
Margaret Johnson
Alan LeQuire
Sally McRorie
Eugene F. Kaelin

Ed Kellogg
Tomaoki Kudoh
Steve LeWinter
Jimmie Matthews
Bill McClure
Ted Miller
Jeffrey Morin
Norihisa Nakase
David O'Fallon
Michele J. Olsen
Sandra Packard
Jennifer Pazienza
Ann Poss
Steve Prigohzy
Talley Rhodes
Elmer Rousch
Molly Sasse
Ellen Simak
Shirley Spiers
Caryl Taylor
Gavin Townsend
Mary Uchytil
Angela Usrey
Valarie Walker
Cynthia Watson
Betsy Whitaker
Colbert Whitaker
Alan White
Inez Wolins
Shirley Yokley
Melanie York

PRACTITIONER FACILITATORS
Kent Anderson
M. K. Bowen
Jola Burch
Christina Campbell
Yvonne Candis
Durinda Cheek
Penny Clark
Judy Copeland
Danny Coulter
Cheryl Dodson
Gerry Dowler
Nancy Frey
Mary Fulghum
Lynne Ginsburg
Sher Kenaston
Hazel Lucas
J. R. McKinney
Marion Mitchell
Lachone Roe
Scott Sanders
Lydia Schultz

Martha Scott
Remell Sorrells
Terry Stevenson
Nan Swanson
Cindy Swope

PARTICIPATING SCHOOL DISTRICTS
Alabama
Baldwin County
Lauderdale County Schools
St. James School
Selma City Schools
Tuscaloosa County Schools

Georgia
Atlanta Public Schools
Camden County Schools
Catoosa County Schools
Clarke County Schools
Clearwater Elementary School
Coffee County Schools
Dade County Schools
Dalton Public Schools
DeKalb County Schools
Floyd County Schools
Hancock County Schools
Lumpkin County Schools
Murray County Schools
Paulding County Schools
Savannah-Chatham County Schools
Troup County Schools
Walker County Schools
Whitfield County Schools
Whitley County Schools

Kentucky
Cumberland County Schools
Monroe County Schools
Perry County Schools

Louisiana
East Baton Rouge Public Schools
New Orleans Public Schools
St. Martin's Episcopal School
St. Tammany Parish
Washington Parish Schools

Mississippi
Canton Public Schools
Lee County Schools
Tupelo Public Schools
Vicksburg Catholic Schools

North Carolina
Asheboro City Schools
Currituck County
Elizabeth City/Pasquotank County

Tennessee
Alcoa City Schools
Athens City Schools
Baylor School
Bradley County Schools
Bright School
Cedar Hill Head Start
Chattanooga Christian School
Chattanooga City Schools
Cleveland City Schools
Eakin Elementary School
Early Learning Workshop
Franklin County Schools
Girls Preparatory School
Greene County Schools
Grundy County Schools
Hamilton County Schools
Jasper Elementary School
Marion County Schools
Notre Dame High School
Orange Grove Center
Scenic Land School
Sequatchie County Schools
St. Joseph's School
St. Nicholas School
St. Peter's Episcopal
Warren County Schools

Virginia
Lee County Schools
Bristol City Schools

PARTNERS
Museums:
Birmingham Museum of Art, *Alabama*
Creative Discover Museum, *Tennessee*
Dalton Creative Arts Guild, *Georgia*
Fine Arts Museum of the South, *Alabama*
High Museum of Art, *Georgia*
The Houston Museum, *Tennessee*
Hunter Museum of American Art, *Tennessee*
King-Tisdell Cottage of Black History Museum, *Georgia*
Knoxville Museum of Art, *Tennessee*
Marietta/Cobb Museum of Art, *Georgia*
Montgomery Museum of Fine Arts, *Alabama*
New Orleans Museum of Art, *Louisiana*
North Shore Gallery, *Tennessee*

River Gallery, *Tennessee*
Telfair Museum of Art, *Georgia*
Wiregrass Museum of Art, *Alabama*

State Agencies:
Alabama Department of Education
Georgia Department of Education
Kentucky Department of Education
Louisiana Department of Education
Mississippi Department of Education
North Carolina Department
of Education
Tennessee Department of Education
Virginia Department of Education

Professional and Art Associations:
Tennessee Art Education Association

Arts Councils:
Alabama Arts Council
Georgia Arts Council
Kentucky Arts Council
Louisiana Arts Council
Mississippi Arts Council
North Carolina Arts Council
Tennessee Arts Council
Virginia Arts Council

Colleges and Universities:
Armstrong Atlantic State
University, *Georgia*
Kennesaw State University, *Georgia*
Loyola University, *Louisiana*
Mississippi Gulf Coast Community
College, *Mississippi*
Nebraska Wesleyan University, *Lincoln*
The University of Tennessee
at Chattanooga

Other:
Alabama Institute for Education in
the Arts, *Alabama*
Alabama Shakespeare Festival, *Alabama*
Alliance Theater, *Tennessee*
Arts in Education, *Louisiana*
Barking Legs Theater, *Tennessee*
Chattahoochee Valley Art
Association, *Georgia*
Chattanooga Theater Center, *Tennessee*
Chattanooga Symphony and
Opera, *Tennessee*
Cleveland Symphony Guild, *Tennessee*
Dalton Little Theater, *Georgia*
Knoxville Symphony League, *Tennessee*
Louisiana Institute for Education in

the Arts, *Louisiana*
New State Theater, *Mississippi*
North Georgia Institute for Education
in the Arts, *Georgia*
Savannah Institute for Education
in the Arts, *Georgia*
The Southeast Center for Education
in the Arts, *Tennessee*
The Southeast Institute for Education
in Music, *Tennessee*
The Southeast Institute for Education
in Theatre, *Tennessee*
Young Audiences of Atlanta, *Georgia*

Funders:
Allied Arts of Greater Chattanooga
Mary N. Bailey
Benwood Foundation
The Captain Daphne Marjorie Painter
Memorial Art Education Fund
JoAnn J. Cline
Coca Cola Foundation
Elizabeth L. Davenport
John B. Dethero
ELD Associates
Linda and Russel Friberg
The Gherkin Foundation
Ruth S. Holmberg
Charles F. Landis
Lyndhurst Foundation
Olan Mills
National Endowment for the Arts
Everlyn D. Navarre
O.N. Jonas Foundation
Betty Probasco
SCEA/NEA Endowment Fund
Southern Foundry Supply
Tennessee Arts Commission
Tennessee Collaborative
Tremaine Foundation
University of Chattanooga Foundation

The Savannah Institute for Education in the Arts

DIRECTORS
James Anderson, codirector
Nancy Hooten, codirector

EVALUATORS
Monica McDermott
Ed Asmus
FACULTY

Jim Anderson
Barbara Archer
Tom Cato
George Cress
Harry DeLorme
Danise Egan
Velma Graham
Carroll Greene
Cathey Handley
Lonnie Holley
Nancy Hooten
Alisa Hyde
Judith Kolodny
Anne Lindsey
Bruce Little
Marian Marshall
Minnie Miles
Patricia Newton
Haywood Nichols
Colleen Hodge
Jeffrey Patchen
Jane Rhodes
Beverly Smalls
Gavin Townsend
Harriet Walker
Valarie Walker

INSTITUTE LEADERS
Marian Marshall
Valarie Walker

FACILITATORS
Cathey Handley
Alisa Hyde
Judith Kolodny
Valarie Walker

Note: The above information is accurate
to the best of our knowledge. Please note
that the California Consortium for
Visual Arts Education became a
Regional Institute in 1994. The
Minnesota DBAE Consortium did not
receive funding after 1995.

CREDITS

Our thanks to the regional institute staffs, participants, and partner museums for providing photographs for The Quiet Evolution.

Executive Summary: p. 9, Linda Story, Story Images; p. 10, Bryan Grove; Phil Bedel; Phil Bedel; Ringling Museum, courtesy of Susan Hazelroth; p. 11, Linda Story, Story Images; p. 12, Linda Story, Story Images; p. 15, Linda Story, Story Images; p. 16, Nancy Walkup; p. 19, Phil Bedel; p. 20, Carole DeBuse; p. 23, Don Farber; p. 24, Jade Gates

Introduction: p. 31, Bryan Grove

Chapter 1: pp. 36–37, Linda Story, Story Images; p. 41, Linda Story, Story Images; p. 40, Laura L. Hunter Null; p. 42, Linda Story, Story Images; p. 43, paintings by Jeremy Emerson, photograph by Jean Detlefsen; p. 44, Nancy Walkup; p. 45, Linda Story, Story Images; p. 46, Bryan Grove

Chapter 2: pp. 54–55, Linda Story, Story Images; p. 57, Linda Story, Story Images; p. 59, Linda Story, Story Images; p. 62, Nancy Walkup; p. 63, Nancy Walkup; p. 64, Collection of the Modern Art Museum of Fort Worth, The Benjamin J. Tillar Memorial Trust, Courtesy Celia Alvarez Muñoz; p. 67, courtesy Bemidji Visitors and Convention Bureau; p. 71, Bryan Grove; p. 74, Kim Wheetley

Chapter 3: p. 81–82, Linda Story, Story Images; p. 83, Phil Bedel; p. 87, both paintings, Algur H. Meadows Collection, Meadows Museum, Southern Methodist University, Dallas, Texas; p. 93, Laura L. Hunter; p. 95 (left) photograph © 1994, The Art Institute of Chicago, all rights reserved, (right) courtesy Museum of Nebraska Art, Nebraska Art Collection; p. 99, both paintings courtesy Art Resource, New York; p. 108, Phil Bedel

Chapter 4: pp. 112–113, Nancy Walkup; p. 113, Getty Education Institute for the Arts; p. 122, Marian Hughes; p. 124, California Afro-American Museum Foundation; p. 129, Nancy Walkup; p. 130, Bryan Grove; p. 131, Bryan Grove; p. 136, Don Farber

Chapter 5: pp. 138–139, Phil Bedel; p. 141, Nancy Walkup; p. 150, Bryan Grove; p. 153, Hunter Museum of Art, Chattanooga, TN; p. 157, Solomon R. Guggenheim Museum, New York, Gift, Mr. and Mrs. Gus and Judith Lieber, 1988, photo copyright Solomon R. Guggenheim Foundation, New York; p. 161, Linda Story, Story Images; p. 162, Don Farber

Chapter 6: pp. 164–165, Carole DeBuse; p. 167, courtesy of John and Mable Ringling Museum of Art, Sarasota, Florida; p. 168, Getty Education Institute for the Arts; p. 177 (left) John and Mable Ringling Museum of Art, Sarasota, Florida, (right) Southeast High School students, John and Mable Ringling Museum of Art, Sarasota, Florida; p. 178, John and Mable Ringling Museum of Art, Sarasota, Florida; p. 181, Phil Bedel; p. 183, courtesy of Erv Kuutti

Chapter 7: pp. 188–189, Don Farber; p. 191, Laura L. Hunter; p. 193, Getty Education Institute for the Arts; p. 194, Linda Story, Story Images; pp. 196–197, John and Mable Ringling Museum of Art, Sarasota, Florida; p. 198, Getty Education Institute for the Arts; p. 200, John and Mable Ringling Museum of Art, Sarasota, Florida; p. 201, John and Mable Ringling Museum of Art, Sarasota, Florida; p. 202, Hunter Museum of Art, Chattanooga, TN; p. 205, Nancy Walkup

Chapter 8: pp. 210–211, Jade Gates; p. 211, Getty Education Institute for the Arts; p. 212, Nancy Walkup; p. 216, Nancy Walkup; p. 217, Phil Bedel; p. 219, Craig Combs; p. 220, Linda Story, Story Images; p. 222, Linda Story, Story Images; p. 225, Nancy Walkup; p. 226, Nancy Walkup

255

DESIGN:
Tracey Shiffman and Meryl Pollen

COVER ILLUSTRATION:
Roland Young

PRINTING:
Alan Lithograph Inc.

MANAGING EDITOR:
Kathy Talley-Jones

COPY-EDITING:
Greg Dobie, Judy Selhorst

EDITORIAL ASSISTANCE:
Julie Abel, Dell Bleekman, Lori Weisgerber

EXECUTIVE SUMMARY:
Nita Whaley

PHOTOGRAPHY COORDINATION:
Samantha Chilton, Madeleine Coulombe,
Adrienne Lee, Rachel Rosenthal

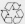